Emblem and
Expression

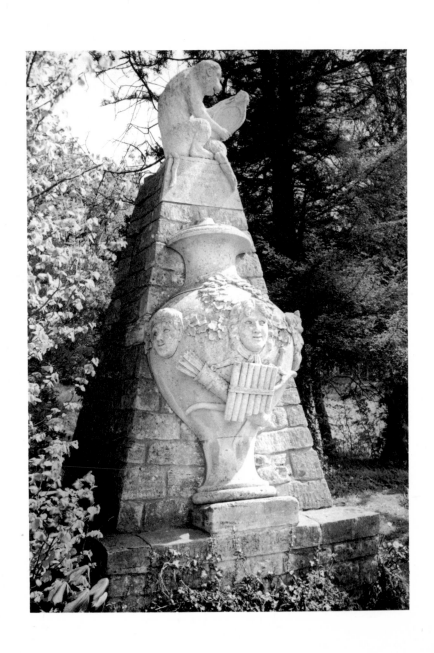

RONALD PAULSON

Emblem and Expression

Meaning in English Art
of the Eighteenth Century

HARVARD UNIVERSITY PRESS
CAMBRIDGE, MASSACHUSETTS
1975

FRONTISPIECE

Stowe: The Congreve Monument (1736). Kent's memorial to William Congreve employs a pyramid, often used for funerary monuments because, according to iconographical commentators, it represents the shape of fire. Both flame and pyramid have a wide base, signifying matter or man's earthy mould, but taper to an apex that points to heaven and the immortality of the soul. Kent's pyramid to Congreve, however, has a blunted point, atop which sits a monkey regarding himself in a mirror. The motto is 'Vitae imitatio,/ Consuetudinis speculum,/ Comoedia' (Comedy is the imitation of life and the mirror of fashion). The 'apish' imitation that was the subject of Congreve's comedies activates other aspects of a highly verbalizable structure. The ape is seated on the apex (another pun) of the pyramid, covering the aspiring immortality of the human soul with this animal traditionally considered the imitator of man. (Cf. the pun on 'Temple' in the nearby Pebble Alcove, p. 24.)

Library of Congress Catalog Card Number 74-31988

ISBN 0-674-24778-7

Printed in Great Britain

Contents

Acknowledgments

In a rather different form Chapter 2 originally appeared in *The Listener*, XC (27 December 1973), Chapter 5 in *ELH*, XLI (1974), and parts of Chapters 7, 9 and 11 in *Eighteenth-Century Studies*, IV (1971), and III (1969). I thank the Regents of the University of California for allowing me to reprint portions of those last two articles here. Parts of Chapter 8 appeared in an essay in *The Varied Pattern: Studies in the Eighteenth Century*, ed. Peter Hughes (Toronto, 1971).

The writing of this book owes a great deal to a few friends: John Dixon Hunt, who conducted me around the gardens of Castle Howard, Stowe, and Rousham and corrected many of my erroneous notions about gardens; George Clarke, who added his authoritative assistance at Stowe; John Russell for many kindnesses, not the least of which was introducing me to Thames and Hudson; Michael Kitson, with whom I argued various of the art historical problems; Michael Fried and Frances Ferguson for reading and liking the manuscript; the students of my seminar on visual and verbal structures at The Johns Hopkins University (1972), and especially Ranice W. Crosby and Peter M. Fitz. As I bring this project to a close, my thoughts are most directly on the late E. R. Wasserman, with whom I first talked about parts of it, and my wife Barbara, who both read and made the writing possible, and whose book this is.

Baltimore, November 1974

Introduction

As Poetry admits not a Letter that is insignificant so Painting admits not a Grain of Sand or a Blade of Grass Insignificant much less an Insignificant Blur or Mark. (Blake, 'A Vision of the Last Judgment')[1]

Whatever the strokes, the words and the colours arranged on a page, the figure obtained is always full of meaning.

To want to interpret it—in order to prove some kind of freedom—is to fail to recognize an inspired image, and to substitute for it a gratuitous interpretation which might become in turn the object of an endless series of superfluous interpretations. (René Magritte)[2]

THIS BOOK is based on the assumption that every work of art, visual as well as verbal, has a meaning—in its own peculiar way, whether representational or non-representational, however contingent or however absolute every line and every area of colour seem to be. Edward Hopper's insistence that his sole concern was with light is no more acceptable, or plausible, than Henri Rousseau's that he placed a female nude in one of his jungle scenes because 'I simply wanted a patch of red there'.[3]

But then there is Hugh of St Victor's warning that 'the meaning of things is also much more multiple than that of words. Because few words have more than two or three meanings, but every thing may mean as many other things, as it has visible or invisible qualities in common with other things.'[4] And E. H. Gombrich has made the distinction that language conveys meaning while images are things to which meaning is given.[5] Of course, Hugh of St Victor was referring to 'things', while Magritte and Gombrich refer to 'images'. Words have conventional or assumed meanings just as images do. Words and images bear the same relation to things. The thing itself, however, may carry no single intrinsic meaning, and one of the pitfalls of hermeneutics in graphic art is the failure to limit the possible range of meanings in the representation of a thing when different images (or words) are equally evoked.

Gombrich's distinction is true in another sense. While there is simply a conventional relationship between word and thing, to convey the same relationship between image and thing, words are also required. The word is necessary to verbalize the conventional meaning of the image. In our own time Roland Barthes has noted that 'it appears increasingly more difficult to conceive a system of images and objects whose *signifieds* can exist independently of language: to perceive what a substance signifies is inevitably to fall back on the individuation of language: there is no meaning which is not designated, and the world of signifieds is none other than that of language'.[6]

There are problems here too: first the matter of degree. As a painting becomes more abstract, its relationships of colour, form, and texture more emphatic, words fail; as is obvious if one turns from a Raphael Cartoon of *The Acts of the Apostles* to a Raphael *Madonna and Child*.

Conversely, the higher the level of denotation, the more particular the objects represented (particular as to person, time, and place, as well as to conventional meanings), the greater its potential for verbalization. But however high the denotation, as Magritte suggests, one is all too aware that the image is ultimately, of its very nature, *not* reducible to words—however much words may be necessary adjuncts to the image to project the full complexity of its meaning.

Herein lies the danger of borrowing conceptual terms from literary criticism, philosophy, or linguistics to describe graphic art. Poetry and painting, verbal and visual structures, are inherently different, and yet the difference is perhaps less between the arts themselves than between historical and cultural epochs. Both a poem and a painting can vary widely between the poles of existence and meaning. Here is a recent statement of the case: 'Painting, in the Renaissance, is just as significant, "meaning-ful", as poetry. Literature, in our time, is just as involved in self-questioning and just as hostile to referential meaning and extractable content as the visual arts are.'[7] Botticelli's *Primavera* exists as a re-creation of a lost picture described in a literary text, as a visualization of doctrine through allegory, and as a complex artistic structure—as Hugh Kenner has put it, a 'many-layered building-up through which Lorenzo would have known he was looking as the Platonic eye looks through appearance, all seeing a seeing-into: so much did a Renaissance secular picture contain, else it had been just paint'.[8] The operative phrase is the last one, because at the other end of the spectrum is the art that is determinedly 'just paint' on canvas, a pattern of form and colour and texture. The artists with whom we shall be concerned were living at the end of the Renaissance with its view of painting as moral philosophy or suasion and at the beginning of the modern age and painting as only paint on canvas, and so had the choice of following past practice, or reacting against it, or doing something between these typically eighteenth-century polarities. Magritte, in our own time, was connecting himself with a single aspect of the tradition when he 'refuse[d] the name of artist, saying that he was a man who *thought*, and who communicated his thought by means of painting, as others com-

municated it by writing music or words'; and was moved to tears at the realization that 'painting could be made to speak about something *other than painting*' and that 'what should be painted was more important than how to paint'.[9]

An eighteenth-century case is William Hogarth, in whose engravings the resemblance between art and literature is very close; they represented in their time—and they represent today—an interesting test of the relationship of verbal to visual meaning. However, just past Hogarth, who is sometimes given as a hostage to literary critics, one encounters among art historians the assumptions of aestheticism. It is at first sight odd that after the work of Panofsky and his school the notion can still be argued that a painting is only a formal construct. But pure aestheticism has largely carried the day in every field except the Renaissance and the study of iconography or *traditional* structures of meaning. The eighteenth century was a period (possibly *the* transitional period) in which iconography in this sense was moribund, and so other structures of meaning were in process of being sought and developed. These have not yet been accurately described, though Michael Levey, for one, has asked the correct questions and come up with some tentative conclusions about the situation in French art.[10]

The proponents of formalism might argue, with some justice, that hermeneutics at this point becomes rather impressionistic; that after the Renaissance the limiting of possible meanings becomes increasingly difficult. Some of the fanciful interpretations of Watteau's *fêtes galantes* may support the argument. Let us inquire how we narrow the many possible meanings of, say, Hopper's light or Rousseau's jungle nude to an acceptable maximum (or minimum). Gombrich's answer in art, E. D. Hirsch's in literature,[11] is the establishment of intention. A careful definition of historical context in all its ramifications will confirm that Hopper's and Rousseau's statements of intention do indeed tell us how differently these representations function in their work than in Caravaggio's or Titian's; but it will also tell us that light (sun or artificial) in empty or desolate urban rooms and a nude in the midst of a lush jungle do mean something specific, though possibly secondary, within the particular historical moment in which they were painted.

Moreover, Renaissance art as well as literature was regarded as mimesis and/or rhetoric. Meaning referred to the questions, What does it *imitate* or what does it *do* (to the viewer)? To ask, alternatively, What does it or its painter *intend* is only to try to get at one of the above questions, or to narrow (sometimes ungenerously) the range of possibilities they offer. I shall, I hope, be concerned with what Hirsch and Gombrich call *meaning*, the 'intended' sense of *Industry and Idleness* in 1747 or of *The Tribuna of the Uffizi* in the 1770s, and perhaps some of its 'implications', but not with its 'significance' (changing with the age) to a Roger Fry in the 1920s or to a literary scholar in the 1970s.[12]

22–33
77

Historically, the continued dominance of the eighteenth century by formalist art historians is peculiarly appropriate. For in fact the rise of aesthetic appreciation with the Earl of Shaftesbury and Joseph Addison, who distinguished between reading and seeing a picture, did (despite their own moralism) play down moral structures of meaning of any complexity. There is a real sense in which aesthetic formalism is part of the anti-academic movement, of the reconstitution of graphic sign systems in the eighteenth century, and as such an important part of the present study. Meaning in the object is replaced by aesthetic appreciation in the viewer or by the artist's self-expression. It will be a test of critical method to see whether both the verbal and visual extremes of eighteenth-century English art can be accommodated.

As Robert Rosenblum's title *Transformations in Late Eighteenth-Century Art* shows,[13] process and change are primary concerns in a study of this period. What I find most interesting is the way in which artists brought up on verbalizable structures of graphic art try with varying degrees of success to find substitute languages of meaning or non-meaning. If Hogarth (as I hope to show) was in some sense making fun of traditional iconography, and subverting and fragmenting it to make a new meaning of his own, then the next stage may well be the questioning of any traditionally accepted visual significance adhering to an object. It may then lead to a search for a private language or for no language or meaning at all; to an emphasis on the purity of the thing as itself only, without any shred of *Vanitas*, or on its construction or integrity; or to primitive things like horses or

lions, which do have an unarguable sense of their own being, far removed from the analogical, heraldic, or hieroglyphic.

My examples are limited to the generation following Hogarth, and within that almost exclusively to those artists involved in some way with—deriving from—Hogarth's St Martin's Lane Academy, which is to a large extent the organ of change. If it were not too paradoxical, considering the presence of Gainsborough for instance, this book might be called 'The Followers of Hogarth'. They are artists who were born in the 1720s and 1730s, who began to produce their mature paintings in the 1760s and 1770s, most of them connected with an anti-academic bias (none was a pillar of the new Royal Academy).

We are talking then about only two periods, one reaching up into the 1750s, the prime of the Hogarthian mode but also the moment of transition from *Marriage à la Mode* to *Industry and Idleness*, from meaning based primarily on explicit readable structures to meaning based primarily on spatial or formal structures. This is also the period in which Reynolds and Gainsborough were emerging and the so-called poetic garden was changing into the English Landscape Garden of Capability Brown. Then the period of the 1760s and 1770s when Gainsborough, Brown, Adam, Zoffany, Stubbs, and Wright of Derby did their first major and characteristic work, established their forms and modes, and when Gavin Hamilton and Benjamin West initiated English neoclassicism.

Ellis Waterhouse, in *Three Decades of English Painting*,[14] admitted the originality of the art of the St Martin's Lane group in the 1730s and 1740s, but he went on to conclude (somewhat sadly) that the great art that followed derived rather from the Italianate influence of the 1750s. He refers, of course, to monumental Reynolds and the 'great' art of Wilson, Gainsborough, Romney, West, and so on. On the contrary,

I would argue, the *great* art of the 1760s and 1770s—the best work of these artists as well as the work of Stubbs and Wright—developed the ideas of Hogarth and his little group (Hayman, Gravelot, Highmore). Further that the great English artists of the eighteenth century (including Reynolds himself) were not the high-flying history painters but the painters who continued to develop the possibilities of humble or intermediate subjects, or who mixed style and subject, whose poet was not Milton but the Pope of *The Rape of the Lock*, the Cowper of *The Sofa*, or the Wordsworth of the *Lyrical Ballads*, and, above all, the great novelists who revolutionized prose fiction as these painters did the English art of their time.

At the other end of the Hogarthian visual-verbal complex is William Blake's engraving of *The Laocoön*, that prime art object of eighteenth-century aestheticians and connoisseurs, completely surrounded by graffiti—verbal inscriptions that place, subvert, explain, and qualify the visual image of the reproductive engraving of the art object in as interesting a way as (for example) in Hogarth's *Boys Peeping at Nature*. But Blake, born in 1757, comes too late for inclusion, and he was in fact antipathetic to the epistemology we are dealing with, which from Hogarth to Gainsborough to Wright is basically empirical. Far from presupposing that man gets all human knowledge through his senses and from them fabricates abstractions, personifications, and fictions, Blake defines 'the Most Sublime Poetry' as 'Allegory addressed to the Intellectual powers, while it is altogether hidden from the Corporeal Understanding'—from the empirical, sensory-directed reason.[15] Blake sees the physical world as only a way into the world of the visionary imagination, which is the true world. None of the artists I deal with would accept that premise.

I

Visual and Verbal Structures

1 Illustration and Emblem

REVELATION in the New Testament is visual, through the Logos or the Word Incarnate. But in the Old Testament, and so to a large extent in the Protestant strain, it is aural, the Word of God, and not His image—the Tablets of the Law, which were spoken and written, and not the Golden Calf waiting below. 'Literary' England was a country that traditionally hewed to the religion and world view that preferred the word to the image (idol), religious or secular. Its greatest creative imaginations belonged to writers like Shakespeare, while its painters and sculptors were imported from abroad.

The case of the eighteenth century can be introduced by a pair of truisms:

The English, whose genius is literary, had by 1745 given a decidedly literary turn to the whole thing and out of the French stage-set had created the poetic garden.[1]

His [Hogarth's] graphic representations are indeed books: they have the teeming, fruitful, suggestive meaning of *words*. Other pictures we look at—his prints we read.[2]

The names we associate with the English garden are of literary men—Temple, Vanbrugh, Addison, Pope, Shenstone, Lyttelton, Horace Walpole, and that very literary politician the elder Pitt; a poet who planned a garden might naturally make it as like a poem as he could. The names we associate most often with Hogarth are not of painters but writers: Butler, Swift, and above all Fielding, who named the Hogarthian genre 'comic history-painting', and who apostrophized: 'O Shakespeare! had I thy pen! O Hogarth! had I thy pencil!'[3] An Englishman who wished to be both Englishman and history painter might well abstract those clauses of the classic art treatises that linked the highest kind of painting to poetry or moral philosophy, the image to the word. Jonathan Richardson, in his *Theory of Painting* (1715), invited the viewer of the Raphael Cartoons, or of any history painting, to invent dialogue to accompany the pictured actions; and his elaborate verbal analyses of paintings helped to provide the climate for 'readable' structures of Hogarth's works.[4]

Since the basis of all the arts was thought to be in one way or another the imitation of nature, and 'nature' meant a great variety of things, the question is *to what degree* a literary text, rather than a natural setting or another painting, was the imitated. For imitation of a literary text alone hardly distinguishes either the English garden or Hogarth from their continental forerunners. The original inspiration of gardens in the Renaissance had been literary in the sense that they were based on descriptions in Pliny and other ancient writers; and by the seventeenth century some Italian gardens illustrated texts almost as schematically as paintings of the same period.[5] In the lives of painters by Ridolfi, Bellori, and Baldinucci art works were described not as examples of skill or formal excellence but as if they were literary texts. Analysts sought the verbalizable content as eagerly as Jonathan Richardson a century later, 'reading' paintings 'as moral, literary, and philosophical texts', often by bringing them into conjunction with examples of poetry.[6]

In Renaissance art, as in book illustration, the imitated was primarily a written text—assisted of course by objects in the external world, the art tradition of representation, and the artist's own sensibility. The history of art is to some extent an account of the different texts chosen by the artist: whether Homer or St Matthew, Shakespeare or Milton; and of the extent to which the artist conveys information, merely provides repose or distraction from the labour of reading, develops some aspect of the meaning that is of significance to himself or his patron, or shows off his own particular (or personal) way of illustrating a text.[7]

The artist could, of course, rearrange the known elements of a text into a more universal fiction or allegory.[8] Veronese joins Mars with Venus, War with Love, to make (in effect, illustrate) a topos—a literary or philosophical commonplace—about the effect of love on warlike valour (Metropolitan Museum). He has a specific text, the story of the love affair of these gods, but if he were merely illustrating the text he might have included Vulcan somewhere in his picture. Instead he constructs from the *relationship* of Mars and Venus an allegory

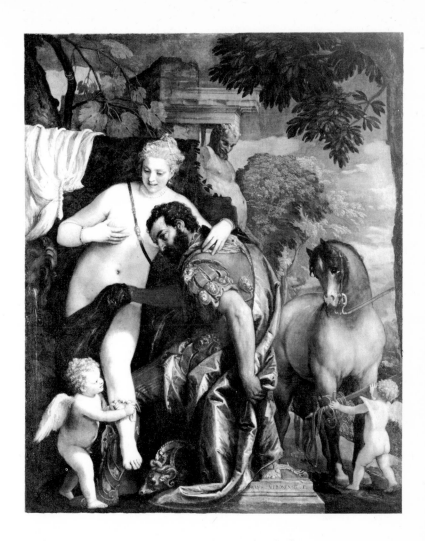

1 Paolo Veronese, *Mars and Venus*.
New York, Metropolitan Museum.

concerned with the nature of warlike valour and love acting upon each other, a message somewhat more general than an illustration.[9] His protagonists are posed as lovers, but Venus is squeezing milk from her breast and Mars is disarmed, without his more warlike attributes. A Cupid ties together their legs. Mars' horse, a conventional symbol of base passion, is tied by his bridle to a tree and restrained by a Cupid holding up a sword of which he has disarmed Mars. Cupid and the sword, I take it, are parallel curbs on base passion; passion, as both war and lust, is restrained. Both Venus and Mars are transformed by the marriage: he gentled and domesticated, she transformed from a symbol of sexual love to one of charity (the milked breast). A satyr, sculpted on a piece of masonry to the rear of the human figures, looks down on the restraining of the horse: he is base

passion too, but only a memorial in stone. Emblems of lust, passion, warlike valour, ultimately Love and War, are 'married' or placed in a *concordia discors*. Every one of the emblems brought into conjunction contributes to this one easily understood topos.

In such a way does much Renaissance art operate, according to art historical essays, whose end is usually to find the correct topos that covers the image in a picture or, alternatively, to discover the text illustrated. This modus operandi applies not only to mythological allegories but to many of the northern scenes of eating, drinking, and love-making, which 'illustrate' topoi of the Prodigal Son, the Five Senses, Four Seasons, Four Elements, and *Vanitas*, in all of which a variety of emblematic objects or figures contributes to one account of the nature of something. In an Allegory of

13

Sight every object, including the subjects of paintings on the walls and art objects on the tables, will pertain to the sense of sight. In some cases the realistic detail, the genre scene, may be the real stimulus to the painter; but every realistic detail is subsumed under the topos, folk-saying, or allegory it illustrates.[10]

A consequence is that a painting of a nude woman, if not an illustration to the story of Bathsheba or Susannah or Venus, was a *Vanitas* emblem. A woman searching her person for fleas illustrated the 'sense of touch' or became an admonitory image of the Prostitute: She will use you as she uses this flea.[11] Even when the moral is omitted, the image carries something of its memory. Honthorst's *Merry Flea Hunt* (Öffentliche Kunstsammlung, Basel) shows the whore and her bawd gleefully pursuing the flea; but G. M. Crespi's painting of the subject (*c.* 1730, Uffizi) omits the merriness of the bawd, and we have to decide to what extent the simple hygienic act means more than itself. Crespi's intention may in fact be anti-*Vanitas*, anti-conventional, but if so the topos remains part of his meaning.

The topos itself is not a visual structure but a concept, illustratable by a variety of visual commonplaces—traditional poses, gestures, relationships, that have come to be associated with the concept *Vanitas*—or conceivably illustratable by a newly invented shape of a woman hunting a flea or regarding a skull. The object of the art historian, besides identifying the text or topos, is to discover the graphic models through which the illustration is rendered. Crespi may simply be revealing a graphic model: if a source, it may be hidden to all (including the artist) except the assiduous art historian, or it may be part of a vocabulary shared with most viewers of the picture. But, though inevitably enriching the picture's total meaning, a source tells more of the artist's intention than of the overt, communicable, affecting meaning: it can only *do* something to the ordinary viewer who recognizes it. The source that is intended to be recognized becomes an allusion, and allusion is the basic mode of the gradual replacement of illustration.

The artist's dropping of—or dispensing with, or dissociating himself from—the 'text', is a major development of post-Renaissance art, a part of the large transition from fidelity to the imitated text to fidelity to 'nature' and ulti-

mately to self-expression. In so far as an artist imitates the art or literature of the past not as an illustration but as an allusion, we have to ask whether he alludes to it as an ideal, as material out of which a new reality can be constructed, or as oppressive structures deserving to be overturned. In literary terms these possibilities are already commonplaces: 'the use of accepted structures to define reality by comparison and contrast, as in *Absalom and Achitophel* and the *Dunciad*; the transformation of those structures into new forms, as in *Joseph Andrews*; and the deformation of the structures by colliding them with reality, as in *Tristram Shandy*'.[12]

A transitional form, of great importance to all European artists but in a peculiarly crucial way to the English, was the 'emblem'—in the sense not of a single iconographical figure but of a visual-verbal art form derived from Alciati's *Emblemata* (1531). To carry the linguistic analogy a step further than we have, let us say that words are to sentences as simple images are to complex images, or emblems. In the emblem the meaning emerges only through an interplay of a title, a motto, and a visual image, to which has often been added a prose commentary or verbalization of all three.[13] If there is a text prior to the emblem, it is known only to the artist, and the reader's duty is to reconstruct it by inference. In other words, the emblem is not merely illustrating a device (motto), a known adage, or an apothegm; it may use one or more of these topoi as its raw material, both visual and verbal, in order to produce a total image that is more than the sum of its parts, that is independent, problematical, to be deciphered.

In 1709 when Cesare Ripa's *Iconologia* (1593) was translated and published in an English edition (addressed to orators, poets, painters, and sculptors) its iconography was so thoroughly accepted that the artist could rely on it as a lexicon. This was, simply, a primitive linguistic system; Liberty is a woman with a sceptre in one hand and a 'Cap of Liberty' in the other, Sincerity a woman with a dove in one hand and a human heart in the other. If the first offers sceptre and hat to a young man wearing laurel around his head, and the second offers him a heart, as in Salvator Rosa's *Genius of Salvator Rosa*, a verbal statement is generated about the sincerity and freedom of Rosa's genius—which carries no further substantiation

2

in the print except perhaps in the free use of the etcher's needle.[14] There is also an elementary syntax. If the first woman withheld her gifts and the second turned her back on Rosa, the meaning would be the opposite. Yet another part of the vocabulary is the system of 'expression' (formulated in the late seventeenth century by Le Brun): you can add to the first woman an expression of *contemplation, crainte,* or *tristesse* to further modify the visual text.

D. C. Allen has pointed out the relation of the *Emblemata* of Alciati to the *Tabula Cebetis,* the immensely influential school text in which Cebes describes a complex allegory painted on a wall.[15] Alciati's emblems appeared just one generation after the first printing of the *Tabula,* with its simultaneous description and explanation of the visual symbols, its instruction in visualizing the verbal and verbalizing the visual. In the emblem each viewer is the equivalent of Cebes, the versifier or commentator on the emblematic image, who educes the meaning from the metonymically or metaphorically related objects in the picture, silently or not so silently supplying the words; in fact, often talking about them in pairs. This meditation was itself materialized for the garden in printed commentaries on the Leasowes, Stowe, and Pope's Twickenham garden; and for Hogarth's progresses in contemporary commentaries by Rouquet and others, and later by Trusler, Lichtenberg, Steevens, and the Irelands; in each of which there is so close a cooperation between the object and the reader that the ontological reality is in the transaction rather than strictly speaking in the object itself. The modern concept of 'feedback' is relevant, for whether written or oral, a spectator's articulated reaction to such a work of art modifies it however slightly by conditioning the way in which it is thereafter perceived.[16] The result in its broadest terms is a social occasion in which viewers verbalize and interpret, interacting with each other and with the complex of the visual-verbal image.

In England at the beginning of the eighteenth century the Ripan semantics and syntax prevailed. The painter used them to produce simply stereotyped but acceptable texts; the learned artist built upon them in ingenious ways without fear of losing his learned audience; and the formalist or decorative painter played his own games, however abstract or colourful,

2 Salvator Rosa, *The Genius of Salvator Rosa.* Etching.

without sacrificing a general meaning. History painting, the depiction of heroic human actions from classical or Biblical stories, was still the highest artistic genre according to the art treatises, not least because it was the most literary. It imitated the most exalted texts and topoi, employed the most intellectually structured meaning, and portrayed (another mental operation) the most idealized figures of man in his environment to show that painting, at least at this height, was one of the Liberal Arts with poetry.

With history painting as the norm, the development of painting through the seventeenth century had been a series of reactions and counter-reactions between extremes of learned or literary structures and formalism, of idealism and realism, and of the instructive and the

decorative, associated with the names of Caravaggio, Annibale Carracci, Poussin, Rubens, Rembrandt, and Velasquez. In the eighteenth century the learned tradition continued in history painting in great allegorical designs derived from the Poussin–Le Brun tradition, usually glorifying the monarch, and often so complicated that a book of commentary was required to explain all of the references. The England of 1700 was very closely derived from the France of Louis XIV, however much William III may have hated that monarch personally. If the relation of poetry to painting had originally been their 'common ability to achieve verisimilitude', the seventeenth century, the century of the Counter Reformation, turned this to the common aim of persuasion. The didactic, whether in support of religion or of state, offered a particularly fruitful way for writers and artists to emphasize the common ability of poetry and painting to move; the response was what mattered more than whether the stimulus was to eye or to ear; and it was often to both at once.[17]

The most celebrated example in England of the learned propaganda piece for the monarchy was the *Allegory of the Protestant Succession* in the Great Hall of Greenwich Hospital, painted by Hogarth's father-in-law, Sir James Thornhill, the first Englishman to achieve a reputation as a history painter. The allegory across the huge ceiling of the Great Hall and around three walls and the ceiling of the Upper Hall, had to be supplied with a commentary, probably by Thornhill himself, to make every detail of its meaning clear to visitors.

There is nothing, however, uniquely English about Thornhill's ceiling; he is quite consciously making an English adaptation of a continental tradition, best illustrated in England itself by Rubens' great ceiling in the Banqueting House in Whitehall. Here, in Thornhill's own words, is the centrepiece of his allegory:

In the Middle of the great *Oval*, under a Canopy of State, and attended by the four *Cardinal* VIRTUES, are *King William* and *Queen Mary*, *Concord* sitting between, *Cupid* holding the Scepter, while *King William* presents PEACE and LIBERTY to *Europe*, and tramples on *Tyranny* and *Arbitrary Power*.

Underneath is a Figure of *Architecture* holding a Drawing of Part of the *Hospital*, and pointing up to the Royal Founders.

Near them is *Time* bringing *Truth* to Light: below them is *Wisdom* and *Virtue* represented by PALLAS and HERCULES destroying *Calumny*, *Detraction*, and *Envy*, with other Vices.[18]

I have omitted the description of all the other figures around this central group (the twelve signs of the zodiac, the four seasons, etc.). But they continue in the same way to define the nature of the Protestant Succession in England. The royal founders of the Succession and of the Hospital are in the centre, and moving out from them are emblematic figures whose identities simply explain aspects of the happy Succession. With this succession, Time brings Truth to light, William III joins Peace and Liberty to Europe, and so on. No detail turns away from the central conception; and this is one aspect of the unity of the painting.

Thornhill's chief rivals in all categories of historical and decorative painting were the Italians, and these were specifically Antonio Pellegrini, Jacopo Amiconi (or Amigoni), and other followers of Sebastiano Ricci, who brought his wonderfully facile decorative style to England shortly after 1700. The point about this version of the illustration of a text is perfectly made in Reynolds' answer to the French Academy's question 'on the conduct of Paul Veronese, who, though a Painter of great consideration, had, contrary to the strict rules of art, in his picture of *Perseus and Andromeda* [Rennes], represented the principal figure in shade'. The answer, says Reynolds, is that the rule of a history painter does not apply to a decorative painter:

His intention was solely to produce an effect of light and shadow; every thing was to be sacrificed to that intent, and the capricious composition of that picture suited very well with the style which he professed.[19]

And Veronese was simply offering to Ricci and his followers the Venetian solution to the problem of overly learned and overly complicated iconography. Ricci, at any rate, was reacting against the heavy literary quality—complex, propagandizing, verbalizable—of the art advocated by the French Academy which criticized Veronese.

Ricci's kind of representation—hardly more than excited patterns of form and colour playing variations on stories—became popular in English country houses, and even Thornhill (and his son-in-law) regarded it with am-

3 Sir James Thornhill, *Allegory of the Protestant Succession*. Greenwich Hospital, Department of the Environment.

bivalence, learning much from its colour and texture, but refusing to see it as the solution to history painting in eighteenth-century England. They reserved it for their modelli, painting their large historical works in a heavier style, with the particularity of representation tending toward readable structures.

But what does this distraction do to meaning in the decorative painting of the Venetians? What are we to make of Michael Levey's comment on Ricci's *Apotheosis of S. Marziale* (ceiling of S. Marziale, Venice)? 'The saint himself is compacted into being hardly more than a knee, a piece of tilted head and that long, dislocated,

uplifted arm so ardently clasped by an angel.'[20] What of that prominent knee? Is it a refusal to be significant though still employing the old iconography of saints' lives? Is it, as Levey and Reynolds would believe, only about form and colour? Or is it one way of using the old iconography in order to get at a meaning that is not merely the old, conventional one? The *Perseus and Andromeda* may suggest a playful and disrespectful attitude toward the subject, which may be one characteristic of the Venetian treatment of myth. The *S. Marziale* we might conclude is *about* that knee. Originally such pictures were, of course, about the Ascent, and

17

4 Sebastiano Ricci, *Apotheosis of S. Marziale*. Venice, Church of S. Marziale.

the meaning was largely tied up with the aim to move the passions of the viewer; the primary effect was of the height and the light and the violent foreshortening. Ricci seems to be concerned about the relationship of the saint's prominent knee and the miraculous ascent. The intellectual dimension is, in the sort of painting from which Ricci derives, minimized in favour of the emotional; but Ricci now seems to be, playing with the idea of emotion itself, which leads him to focus on that prominent knee.

To establish the meaning of a work like the *S. Marziale* Gombrich has added to the necessity to identify the text or the topos the necessity to uncover the programme—the patron's commission—and the place where it was to hang and what purpose it was to serve.[21] This is an integral part of the study of Renaissance iconography; it still applies to Thornhill's Greenwich decorations, their precise definition reflected in the published explanation. It is also an integral part of our understanding of many of Ricci's and Amiconi's (and even Hogarth's) chapel and house decorations. When we turn to the viable tradition of easel painting, however,

it is not always possible to determine the artist's programme. Patronage of the programme-desiring sort all but disappears in eighteenth-century England, and the artist's own sensibility may determine his subject as much as a patron's desire.

Especially relevant is the fact that the picture could be moved about. If Ricci's *S. Marziale* (or even a copy of it) were moved to a London bedroom it might reveal overtones that were muted or meant something quite different on the ceiling of a Venetian church. The old master paintings in the house of a collector served a purpose of the collector's own, and the statues of Venus and Mars in a garden merely became elements in a syntax of structures of meaning worked out by the collector. We are dealing with a period, in England at least, when patronage for contemporary native art was moribund—an age of collectors, and so of art works of great mobility and shifting intentionality. The characteristic mode was to create meaning by a restructuring of the intentionality of past art—by rearranging the art objects in a room or a garden, or the iconographical elements in a painting.

2 The Poetic Garden

IF YOU visit Castle Howard, a short way north of York, and walk straight through the house and out the garden front, you will find yourself looking down the central axis of the old formal garden. This is an extension of the house into a room out-of-doors with clipped hedges, parterres, and a monumental fountain. The lateral axis is closed on the left at some distance by an urn at the top of a hill. But veering off to the right of this axis, following the curve of the hill and the edge of the wood, is a wide curving path which wanders away from the geometrical layout into we know not what, its destination concealed by the crest of the hill.

Once there were statues at irregular intervals along this path, but now only a Hercules and a Meleager and some bare plinths remain. The statues would have caught and guided the eye as one walked along the path, allowing an alternation between the close-ups of these artifacts and the deep, wide perspective over a lake and a natural landscape reaching to the horizon. But only the classical figures along the path prepare a visitor for the temple that comes into sight over the hill and around the bend—that emerges in fact as part of a picture, a three-dimensional version of a landscape painting by Claude Lorraine. There in front of you, in the left foreground, is the domed and pedimented Temple of the Four Winds; then in the far distance a circular domed structure modelled on the so-called Temple of the Sibyl at Tivoli, and further to the right in the middle distance a stone bridge over a river. A range of trees appears to connect the two temples and another closes the scene on the right.

These are the elements and the structure of a Claude landscape, and they carry its associations of Roman ideals and of an art which unites landscape and history painting. But the meaning to a visitor is even more precise, for the Temple of the Four Winds, a belvedere for picnics with views to the four corners of the compass, is architecturally a variant and functionally a miniature of Castle Howard itself, and the temple in the far distance was the mausoleum of the Howard family. We recognize not only the Roman ethos with which English aristocrats of the early eighteenth

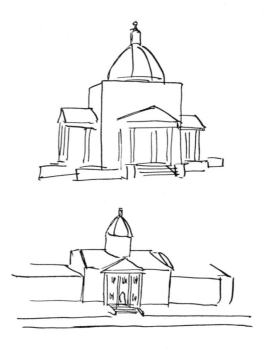

century liked to associate themselves but a juxtaposition of mortal and immortal homes, of the joys of life and sobering thoughts of death. The reference to the Roman landscape is only one element in an emblem whose meaning is to be considered by the visitor.

The garden I have described can be located somewhere between the formal—classical, geometrical—garden the English imitated from the French and England's own unique contribution to European art, the so-called English

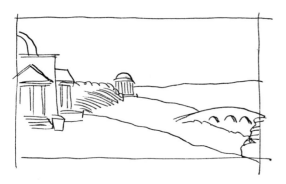

Landscape Garden of 'Capability' Brown. The intermediate garden developed by Englishmen in the first half of the eighteenth century might be called either the poetic garden or the emblematic or learned garden. It led into Brown's smoothly-flowing parkland because it was dedicated to altering the ratio of art and nature in the formal garden. It replaced the superimposed geometrical order by what Pope called a development of the Genius of the Place—which was only a more mythic way of referring to what Brown was to call the 'capabilities' of the place. Pope's *Genius Loci* implies a nature god, a nymph to whom the place was sacred and by whom it might with a little effort be reclaimed. Brown, though he liked to use a grammatical metaphor to describe how he 'punctuated' the existing natural landscape, was removing all that was mythic and literary from the garden, as he removed its statues and temples.[2]

I do not wish to overstress the originality of the poetic garden's form: if it was a reaction against the formal geometry of the French and Dutch, it was a return to what was thought to be the garden of the ancient Romans, which was in practice the Italian Renaissance garden or certain aspects of it that appealed to both poet and politician—links to classical Rome, allusions to the heroic past, and the mingling of formal with natural gardens. The English contribution was to reject emphatically the rule of geometry, focus the poetic emblems in the natural part of the garden, and—the result of all this—replace geometrical symmetry and subordination as a structure of meaning with a much less regular or predictable one.

Allusion is, I suppose, the most literary of the devices employed by the English. As Pope naturally drew for his poems upon the relationship of his form with the epic, so the landscape gardener built on the norm of Pliny's descriptions of Roman gardens, on surviving remains like Hadrian's Villa at Tivoli, on Renaissance imitations, on paintings of all of these (primarily by Claude), and on stage designs that used the same elements. The complex of associations was especially rich in the Renaissance garden, combining the norm of the classical garden and its nymphs, satyrs, and spirits of the place with the Garden of Eden, the Fall, and Man's Redemption from the Christian tradition.[3] It was natural for the English Augustans, pre-

occupied with the *Aeneid* and *Paradise Lost*, with their own relationship to the Roman Augustans, with the classical-Christian literature of retirement which was implicit in the garden's setting, to emphasize the moral aspect. And since it was an age of literature, not of art, literary structures played their part.

Four great examples of this kind of garden survive in England: Castle Howard, Stowe, Rousham, and Stourhead. Castle Howard is the earliest in conception, dating from the 1720s; but Stowe, near Buckingham, contains historically the most important of all English gardens, for it includes traces of the formal, the emblematic, and the English gardens; it embodies the conceptions of Vanbrugh (who probably planned the Castle Howard gardens),[4] Bridgeman, Gibbs, Kent, Brown, Pope, Pitt, and its owner Lord Cobham.

The formal garden is now almost obliterated, but in the 1730s the more and less artful gardens coexisted as they did at Castle Howard. Looking from the south (garden) front down what was once the central axis of the formal garden you can still see the two Lake Pavilions closing the prospect at left and right. The connecting alleys are now gone, replaced by a large Capability Brown-style lawn, and the lakes have been softened until they furnish a continuous serpentine shoreline leading away from the formal garden and the Lake Pavilions. Follow this path, at times passing along the very verge of the garden, at times along the lake, and you will experience a number of scenes something like the one I described at Castle Howard.

In this part of the garden you pass a Hermitage, a Temple of Venus, a monument to Queen Caroline, and a 'Dido's Cave'—and in the eighteenth century there were others. Each is laid out to make a picture, closed on either side with foliage so that the eye does not wander. The visitor, sometimes supplied with a bench to sit on, saw a carefully-arranged scene, something between a stage set and a landscape painting, with statues, temples, and other objects of a high degree of denotation arranged to express a topos on which he could meditate or converse. Linguistically the process was one of labelling. As William Shenstone put it, the landscape architect would begin with a beautiful spot and 'somewhat strengthen its effect, . . . supporting its title by suitable appendages—

For instance, the lover's walk may have assignation sea^s, with proper mottoes—Urns to faithfull Lovers—Trophies, Garlands, &c. by means of art'.[5] 'Strengthen its effect' means increasing the specificity of denotation or connotation in various ways. A river is accompanied by the statue of a river god, a dell by a wood nymph, and appropriate areas are dedicated to the memory of worthies by means of Roman portrait statues or columns.

The statues were invariably copies of known antique originals, and the temples drew on a vocabulary of Roman buildings. As Margaret Jourdain has said, 'The more vividly the visitor realized the ancestry of these buildings, the greater his enjoyment.'[6] In effect, these known elements were used like words to make new sentences. Venus plus Mars in a garden setting equals the fruitful marriage of Love and War; a relief of Pan's pipes may extend the subject to poetry, and an inscribed quotation from the *Aeneid* may bring in *patria* and *civitas*. Sometimes even the bench the visitor sat on bore a motto that contributed to the deciphering of meanings. What he saw was virtually a page from an emblem book, and page followed page as he strolled along the garden path, each temple or urn a separate experience. To judge by the accounts we have of visitors of the 1730s and 40s the emblem was primary, for although obviously they enjoyed the walk between the scenes, they never mention this, nor the shapes of the trees and the lawns.[7] Beauty and meaning may sometimes be synonymous, but the meaning was crucial, not to be confused by the colours of flowers that change with the seasons. The effect of the different textures and shades of green was essentially one of chiaroscuro, to define by shadow and light, but not to distract by colour.

Commenting on the relatively discrete scenes of which this sort of garden was composed, Robert Morris wrote in the 1730s that its function should be as a place to retire and 'contemplate the Important Themes of Human Life'. Therefore, the garden should be laid out in segments.

Care should be taken so to lay out and dispose the several Parts, that the Neighbouring *Hills*, the *Rivulets*, the *Woods* and little *Buildings* interspers'd in various Avenues, . . . should render the Spot a kind of agreeable *Disorder*, or *artful Confusion*; so that by shifting from Scene to Scene, and by serpentine or winding Paths, one should, as it were, accidentally fall upon some remarkable beautiful Prospect, or other pleasing Object.[8]

This poem manqué reflected eighteenth-century ways of opening its very closed literary and painterly forms. The garden scene, like the Popean couplet, is formally closed but open as a generator of allusions and as a participant in not always rational relationships with adjacent scenes (couplets). However, while the couplet is a form that contains, or creates a tension with, the irrational material it describes, the garden scene in its context embodies an imbalance in favour of the accidental and irrational. Whereas the closed couplet was Pope's norm, the relatively unstructured larger natural expanse is the norm of each garden scene.

The garden scene is open in a literal sense, for the experience does not end with the bench. After the general view of the scene, the visitor could leave the bench, step off the path, and circle and even enter the temple or grotto. The multi-dimensionality must be stressed, because experienced in a central cultural event like the garden it left its imprint on all the concerns of the period. We shall find the same sort of emblematic meditation, which involves looking at something from a distance, then from close up and inside, and then from other perspectives, in paintings and in works of literature. In a way that derives from poetry but exceeds it, the garden introduces spatiality and the dimension of time—of walking through, of the passing seasons, and of the past to which this present scene is meaningfully related. It also allows for the possibility of rearranging scenes and episodes out of a chronological order into another which the reader can reconstruct for himself.

We should pause a moment to consider one difference between the formal and the natural gardens at Stowe. Notice how easy it is looking from a house down the axis of a formal garden to form a mental map of the parterres—how in a way this is what is asked of you. The geometrical French garden was meant to be seen from the house or from a raised terrace on the garden's axis; it was an extension of the house first as a view from it, then as a continuation of its coherent architectural structure, ordered like a periodic sentence with all its members subordinated to one end. The natural garden is

more intimate and more paratactic—one scene follows another, apparently unsubordinated but in fact related by clever juxtapositions.[9] In this sort of structure, perhaps ultimately an extrapolation of the maze (a microcosm of the world as a 'mighty maze! but not without a plan'), the visitor lacks a sense of the whole and does not know exactly where he is in the total structure until he has reached the end. The general feeling is of *going down into*, of *being in* and *moving through*. You do not know what is over the hill or around the bend until you see it, and then were you to go beyond the emblem placed before you and try to project a ground plan you would probably produce a faulty one. The trees, for example, are often arranged to deceive you into thinking this or that feature is closer or further away than it actually is. There is, in fact, no need for an accurate ground plan, for the visible relationships are all that matter; space is a metaphor for morality, and by implication morality is something that would be oversimplified if constricted within a geometrical structure.

There is yet another part of the experience that obviously took place, though it was not recorded until the late 1740s by another visitor with a somewhat advanced sensibility. William Gilpin, standing in front of one temple, noted that you could see across a lake or over a hill other temples or columns, and from the next building you could regard with a different perspective the one you left behind—see them not as part of an over-all geometrical plan but as isolated elements in a natural landscape, from each view virtually a different object. A temple, he says, makes a 'beautiful Figure in a Variety of fine Views from several Parts of the Garden'; elsewhere he notices that 'we have a Variety of very elegant Prospects centred on this Point', and in general 'how many Uses each Object served; and in how many different Lights it was made to vary itself'. Shenstone's remarks of around the same time on the Leasowes are very similar.[10] And Pope, speaking of Homer's repetition of similes in the *Iliad*, draws attention to the garden analogy:

But may not one say Homer is in this like a skilful Improver, who places a beautiful Statue in a well-disposed Garden so as to answer several Vistas, and by that Artifice one single Figure seems multiply'd into as many Objects as there are Openings whence it may be viewed.[11]

Maynard Mack has noted that this device, offering possibilities for 'the disposition of a single figure to answer several points of view', relates to pun and zeugma and is 'a species of economy and polysemousness wholly characteristic' of the Augustan mode of poetry.[12] The effect is something like that of 'take' in Queen Anne 'does sometimes counsel take—and sometimes tea'. Pope is probably thinking of a *patte d'oie*, however, and at Stowe the clipped paths down which you look have been opened into invisible lines of vistas in all directions determined only by the locations of eye-catching objects and by the stops along the path. Of course in any garden one object may be seen from different places, but the English in the eighteenth century show more awareness of the device, write about it, and tend to arrange walks around lakes and in many cases around the garden itself, constructing what came to be known as a pictorial circuit or perimeter belt. (The most fully developed examples were Wooburn Farm, Hagley, the Leasowes, and Stourhead.)[13]

At Stowe the statues and temples seen from different places serve to orient the visitor in an open maze of paths that have no geometrical let alone architectural superstructure. With every stop (another temple or column) not only a new scene but a new relationship to old ones emerges, and so a new gestalt is formed, which is again modified at the next stop, until at length the whole garden has a certain spatial-moral shape which has been made by the relationship of one image to another.

In the Home Park part of the garden you walk around one side of the lake, and around what is now a golf course but was then a field of grazing cattle and sheep, moated by a ha-ha. The main feature was (and is) the Rotondo, seen from the Hermitage and the Temple of Venus across the lake from Queen Caroline's Monument, and in the past from Gibbs' British Worthies, Vanbrugh's Pyramid, and other structures; and each of the other elements was also visible from most of these spots.[14] But the Rotondo, on the garden's mount, focal point of all the views, is significantly the one apparently unchanging element: being round and above the trees, simply a circle of columns, it appears the same from all sides, while all the other structures change with the perspective. Inside

the Rotondo was a copy of the Venus de Medici, both garden deity and goddess of love, the changing figure within the unchanging circle, who faced you or turned her back depending on the direction from which you approached.

Love, I take it, is the loosely unifying theme of this garden, supported by the buildings called the Temple of Venus, the Cave of Dido, and so on. The love expressed is a fairly randy and cavalier one, Romantic (or Courtly) Love undercut at every point by reality. Representations of satyrs appear here and there, and the Temple of Venus is decorated with paintings of the story of Malbecco from *The Faerie Queene*, while on the outside are busts of Nero, Vespasian, Cleopatra, and Faustina. The temples thus tell of wives running away from their jealous husbands to consort with satyrs, Dido seducing Aeneas, and even a saint who finds it hard to resist sexual temptation in his grotto. The last of these, St Augustine's Hermitage (looking rather like Crusoe's hut), was inscribed with comic verses about the hermit's sexual problems, including one about the solution of fortifying himself against temptation by making an imitation girl of snow, 'the Life resembling so, / That th' one from t'other scarce you'd know. / This done, the good Man Side by Side / Lay down t'enjoy his new-formed Bride'.

A Temple of Bacchus supports the saint's grotto in pushing love toward the closely related theme of weakness of the flesh; and at the end of this garden a 'Sleeping Parlour' invites the visitor to enter and merely sleep, exhausted, under an inscription, 'Since all Things are uncertain, indulge Thyself.'[15] This inscription, in retrospect, seems to cover the whole area, connecting the theme of love with that of retirement, and that with various others of the sort that were merely extended to their logical libertine conclusion in Sir Francis Dashwood's Medmenham Abbey garden in the late 1750s.[16] Even the three statues in the area, of men fighting, share a common denominator with the garden. *Hercules vanquishing Antaeus* was at the entrance to the Home Park proper, separated by a ha-ha from the rest of the area. Then a copy of Giovanni Bologna's *Samson slaying a Philistine* terminated the great terrace that descended from the house; and *Two Roman Boxers* terminated the diagonal Great Cross Walk. I would speculate that these subjects were chosen because Hercules vanquishing the earthy element and Samson the Philistine are related to the combat going on in Augustine's grotto and Dido's cave, as also to the battle of the sexes engaged in by Malbecco and Hellenore.[17] The satire on courtly love conventions as a whole was not, of course, unrelated to the reaction against formal-geometrical structures in this part of the garden.

If this is a garden devoted to the pleasures and temptations of retirement, the second part of the natural garden, the whole other side of the formal parterre, was devoted to public life, the life of action expressed in allegory. This area includes not only the Elysian Fields but the Temples of Friendship, of the Queen, and of Liberty (the Gothic Temple), which make a shallow triangle around the Queen's Valley (or Hawkwell Field). The valley called the Elysian Fields originally opened off the formal garden, where there were statues of Apollo and the nine muses, the patrons of the garden as a whole, and a statue of George I (now on the north front). You still follow a path from the garden front to the left away from the open spaces and down a slope. You have no sense of your direction until you emerge in a clearing before the Temple of Ancient Virtue, a round Doric structure: it is based on the same Temple of the Sibyl used by Vanbrugh and Hawksmoor for the mausoleum at Castle Howard, but its general shape also resembles the Rotondo—and it is visible from the Rotondo, the Cross Walk, and other parts of the garden.[18] The similarity of form suggests a relationship between the two centres of the gardens that flanked the parterre—one to Venus, deity of the garden and of love, the other to Virtue; one to nature, the other to *civitas*; one to the private, the other to the public life.

Over the door of the Temple of Ancient Virtue to make the meaning clear, is the motto 'Priscae Virtuti' (to ancient virtue), and inside there were statues of the great philosopher, poet, lawgiver, and general of the ancient world—Socrates, Homer, Lycurgus, and Epaminondas—with inscriptions, and two further inscriptions over the inside of the doors. Beyond this temple was a consciously-constructed ruin (now only a few chunks of stone), with a headless statue adjacent, which in juxtaposition with the sturdy classical temple

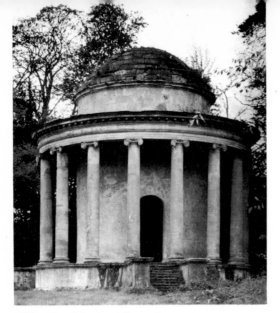

5 Temple of Ancient Virtue, Stowe.

6 Temple of Modern Virtue, Stowe. Engraving by G. Vandergucht, from *Stowe: the Gardens of the Right Honourable the Lord Viscount Cobham* (1763), Plate V.

7 Temple of British Worthies seen from the Temple of Ancient Virtue, Stowe.

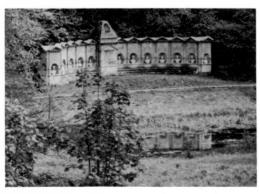

was recognized as a Temple of Modern Virtue. The third element, on the other side of the pond that runs through the valley, is the Temple of British Worthies, a long uncovered semicircle of niches holding busts of the great Englishmen of the past, with a contemporary poet-satirist, Alexander Pope, and an Opposition politician, Sir John Barnard, included at the ends, facing to either side like sentinels.

This garden, worked out in the 1730s by Kent, probably from the instructions of Lord Cobham, Pope, Pitt, and other 'Patriots', was a single unified allegory on the subject of Walpolean politics. A model has been found in a dream allegory in *Tatler* No. 123,[19] and many others could also be cited, for these are the three elements of any Pope or Swift satire: the ideal in the past, the shambles of contemporary vanity, and the indication of an Alexander Pope or Jonathan Swift, one or two people in the present who are trying to maintain those past virtues. With the great emphasis on 'fame', the plainest analogue would be Pope's two dialogues called 'Seventeen-Hundred-and-Thirty-Eight'. The comments of contemporary visitors show that the point was not missed: 'A very elegant Piece of Satyr, upon my Word!'[20]

The relationship to a Pope satire is very close indeed; the garden is almost a verbal construct. The Temples of Ancient and Modern Virtue summon up verbal equivalents, 'soundly-built' or 'permanent' for the one, 'ruin' and 'shoddy construction' for the other. The verbalism of ruined virtue and ruined temple, though as old as the emblem books, is also analogous to the Popean zeugma—to the double meaning of 'stain' in 'stained her Honour or her new Brocade'. The Temple of Ancient Virtue itself in this political context recalls the name of its builder, Richard Temple, Lord Cobham. A verbalism hovers over the whole of Stowe Gardens, beginning with one of its earliest structures, the Pebble Alcove, which bears the family crest and motto: 'Templa Quam Dilecta'—How delightful are thy Temples. Cobham was 'visually illustrating' his own family motto, itself a pun, when he filled his garden with temples, and when the nature and condition of the temple become relevant he is merely extending the same reference.[21]

The inscriptions over the British Worthies are virtually small Popean satires. Hampden is

8 Elysian Fields, Stowe.

an emblem of the 'Opposition' which relates his heroic time to the present: 'Who with great Spirit, and consummate Abilities, begun a noble Opposition to an arbitrary Court, in Defence of the Liberties of his Country. . . .' Raleigh and Drake are placed side by side, the one 'who endeavouring to rouze the Spirit of his [royal] Master for the Honour of his Country, against the Ambition of Spain, fell a Sacrifice to the Influence of that Court', by which is meant Spain but also the English court that drove out Cobham; and then Drake, who 'carried into unknown Seas and Nations the Knowledge and Glory of the English Name', recalls the ignominious policy of Walpole, who resisted taking the Spaniards to task for the humiliation of Jenkins' Ear.[22]

The complexity of allusion thickens in a particularly Popean way: the visitor, or the member of the Pope-Cobham circle, would have recognized the Temple of Ancient Virtue as an allusion to the Roman Temple of the Sibyl, and perhaps registered the sense of divine inspiration and prophecy, but he would also have known that its English reincarnation was as a mausoleum at Castle Howard.[23] It is of course appropriate to relate the Temple of Ancient Virtue in the time of Walpole to a tomb. It is spatially—and allegorically—appropriate to separate the Temple of Ancient Virtue from the British Worthies by a river called the Styx, and call the valley the Elysian Fields, because the immutable fact of death does separate modern attempts at virtue from the ancient ideal.

The visual experience should be defined: you are not able to encompass all three elements in a single scene, as for example at Castle Howard. You are not aware of the British Worthies or of Modern Virtue until you stand on the porch of Ancient Virtue. You walk up the steps and into Ancient Virtue, read the inscriptions and examine the statues;[24] then walk out the back door to see, from left to right, the British Worthies across the river (a double image, with its reflection in the water), the steps leading down to the path around the pond to the Worthies, and the ruins of Modern Virtue. In other words, from the vantage of Ancient

8

Virtue—one's knowledge of Homer and Lycurgus and the classical moralists—you look *down* upon the British Worthies, off across the Styx, and at the ruins of Modern Virtue, camped on the slope of Ancient Virtue's mount to gain height and shelter in the manner of the Moderns in Swift's *Battle of the Books*. Then once across the river at the Worthies, you look up to the Temple of Ancient Virtue, as these Englishmen 'looked up' to the great models of the past in the metaphorical sense of emulating them. This was a kind of visualizing of the elements of a Swift-Pope satire, but not one that involved seeing them all in a single emblematic composition: you saw one, then from it you saw another, and with each the meaning changed and grew.

In the centre of the row of British Worthies (also dead), in the oval niche at the apex of a pyramid used to be the head of Mercury, the messenger of the gods who leads the soul of the just over the Styx into the Elysian Fields.[25] It may even be significant that the statues in the Temple of Ancient Virtue were full-length, above the visitor in niches, while the modern British Worthies are busts only, at eye-level. The Worthies are put into final, human perspective by one other reference. If you go around the back of the semicircular structure, which at one time could be approached without, as now, climbing through nettles, you find in the central arch (directly behind Mercury), a mock-heroic memorial to Signor Fido, one of Lord Cobham's dogs. The inscription is a satire, with thrusts in every line, praising the fidelity of this appropriately-named gentleman, but at the end admitting that it is not (cannot have been) a man: 'Reader, / this Stone is guiltless of Flattery, / for he to whom it is inscrib'd / was not a Man, / but a / Grey-Hound.'

A garden like the Elysian Fields can be regarded as an emblem or as an illustration: there may have been a text or 'programme' in the *Tatler*, or merely a common topos of Augustan satire; but the result is complex enough to require a text after the fact. All English gardens of the eighteenth century were, of course, laid out according to a patron's intention; but except at Stourhead we have no record of this intention, only the general fact that such iconographical programmes tended toward aggrandizement and political or personal commemoration (and as such fitted into a long tradition of iconographical programmes, including not only the Villa d'Este but the Palazzo del Tè, the Villa Lante, and Bomarzo). The statues and temples at Stowe were put up by different architects at different times and with different intentions on the part of architect and patron. The Venus in the Rotondo was originally intended as a compliment to the statue of the Queen at the opposite end of the 'Queen's Theatre', and Bridgeman's Eight Worthies and Vanbrugh's Pyramid had their own intentions. I have been talking about the Stowe of the 1740s and 50s, by which time the Venus had been absorbed, both formally and iconographically, into another plan, and the Worthies had been moved out to the Temple of British Worthies in the Elysian Fields and the Pyramid simply left unabsorbed, a neutral counter in the new plan. The Venus was retained and the other old elements that were not removed or ignored were made to play a part in a loose confederation of elements on the theme of love. Formally, the Rotondo with its Venus started as termination of a vista off from the central axis of the house, and then it became the centre of a circuit of perspectives constructed on Venus-Love.

It is not altogether a misfortune that we cannot establish much except by inference of the patron's intention. For the English garden is an art in which meaning lies to a very large extent in the transaction between object and viewer. Unlike the patron's instructions, viewers' responses have been written down and preserved. Even the patron's programme or his official guide, in the context of the garden, becomes commentary serving very much the purpose of the poem and commentary under an emblem. Recall Dodsley's comment that after Shenstone's death people who visited the Leasowes were disappointed with what they saw: part of the experience had been his guiding the visitor around the grounds and pointing out the beauty and significance; which was one reason for Dodsley's guidebook.[26] Seeley's *Guide* to Stowe, which by the 1740s was picked up by the sight-seer at the inn before he proceeded on his tour of the gardens, simply served as one explanation alongside which he developed his own complementary response. Anyone walking in the garden with a guidebook or with a second person would develop

a commentary of his own in pace with his responses.[27]

The difference between the reactions of visitors like Gilbert West and William Gilpin is plain enough, but within his *Dialogue upon the Gardens . . . at Stow* Gilpin epitomizes the situation by presenting the divergent reactions of two people of very different temperaments. He shows the way a single scene will seem to the informed, the novice, the moralist, and the aesthetician of the Picturesque. The speakers show that the gardens themselves operated in the same way, revealing different perspectives and different aspects of a subject. Shenstone argued that from different viewpoints the same object might appear under different aesthetic categories: 'the grand, the savage, the sprightly, the melancholy, the horrid, or the beautiful'; or 'the sublime, the beautiful, and the melancholy or pensive'.[28] The pictorial circuit sets up different and discrete views of an object which is itself various, its different aspects revealed by different contexts. In one sense the circuit is an acknowledgement of nature's variousness, or (to take Pope's sense) of the poet's ability to bring out nature's variousness. But in another it is a paradigm of the eighteenth century's realization that how something looks, what sort of response it gets, depends on the point of view from which it is seen, and so implicitly by whom it is seen. The same object seen from different angles or distances by the same person is not very different from the same object seen by a number of different viewers with different sensibilities. As a radical loosening of the Augustan pun or zeugma takes place, the emphasis shifts from the many-facetedness of the object to the various responses of different observers. One explanation of this shift might be that the world order—the shared myths—having dissolved, or no longer proving viable, polysemous meaning was no longer possible:[29] the viewer could no longer see the object as a whole, and so each brought his own meaning—symbolized by the different viewpoints along the pictorial circuit.

If you follow the path from the valley of the Elysian Fields north into the Grecian Valley, by Kent and/or Brown in the late 1740s, you walk from the poetic-emblematic garden into the English Landscape Garden, for though there were once statues glimpsed along the edge of the woods, and a Grecian Temple still over-

looks the valley, the landscape itself is simply a long serpentine area of grass, defined by the contours of the valley and by the way the trees are planted and cut along its edges.[30] Here you walk with nothing to focus your thoughts, nothing to impede the movement of the feet or the eyes, no denotations or markers, no pictorial allusions, and only the open spaces and the shifting sunlight and shadows. But this is, in a way, an extension of the epistemology of the poetic garden. Gilpin has mentioned a wood that 'hides a great Part of what is to be seen from your Eye' and to this we need only add the empty areas of grass and foliage in the Grecian Valley: 'This is a most delightful manner of pleasing: A grand Object left to a good Imagination to improve upon, seldom loses by its Assistance.'[31] It is easy to see here how the ambiguous object seen from different perspectives becomes the leafy or grassy space that can be filled in by the viewer's mood. Into this space you are asked to project your own imagination, and meaning is determined by your state of mind, by the weather, by the time of day, and by your movement along one edge or the other of the valley: in the morning, in the sunlight, happy thoughts; in the later afternoon, in the shadow, melancholy ones. Gardens, concludes Gilpin, are 'a very good Epitome of the World: They are calculated for Minds of every Stamp, and give free scope to Inclinations of every kind. . . .'[32]

As I have said, the whole story of the garden in England is laid out at Stowe. But two more perfectly preserved examples remain: Rousham and Stourhead. Kent's garden at Rousham begins again with an axial formal space behind the house, anchored in this case by a copy of the lion-horse combat that was later to interest Stubbs. From the lion-horse statue you look down a steep hillside and off across fields—other people's properties and now a railroad track—to the horizon and a ruin Kent placed there as an eye-catcher. Once again from this spot at the foot of the formal garden you go off to your left into a vale, past a term of Minerva and down a dark winding path, across the brilliant open space of the Praeneste Terrace, and down into further scenes—with views both into the garden proper and across to the world beyond. The effect is not unlike that of the Elysian Fields where, as you walked around the

93

Styx you saw bits of the Worthies revealed through foliage. One of the characteristics of Kent's gardens was the effect of glimpsing something through a screen of trees.

As you descend now from the Praeneste Terrace you enjoy glimpses of the Vale of Venus. The total scene is a fountain or cascade topped by a *Venus*; on each side is a Cupid riding a swan, a bird sacred to Venus; and further to each side, just on the edge of the framing forest glade are statues of Pan and Faunus with their double connotations of woodland spirits and lusters after young maidens who venture into their domain.[33] And at the centre of the structure, just under Venus, is the bathetic touch that sets the whole scene in the *Vanitas* context: a mock-heroic memorial plaque to one Ringwood, 'an Otter-Hound of extraordinary Sagacity'. The pond that reflects the scene and the surrounding woods are part of a structure of meaning that includes the relationship of love to lust to animal to nature.

And yet if you turn away from this closed picture you are looking unimpeded to the horizon—and the scene is also observed from other directions and distances. You have begun to glimpse it sidelong as you approach down the path before coming face to face with it; and from the lower cascade you see not only this but the Praeneste Arcade (below the Terrace), 'Bridgeman's Theatre', the statue of 'the Colossus' (Apollo) at the end of the Long Walk (a long narrow alley of trees and hedges), and the distant eye-catcher. You are constantly drawn both into the emblematic forest and ponds and out toward the wide spread of fields and the horizon.

Deception is essential. A very small area has been arranged to suggest that the garden extends indefinitely, whereas a few feet away is another's property or a wall beyond which the attentive visitor can hear cars passing, as he can occasionally see trains passing in the distance. If there is a particular sense to this garden it is the interplay between deep inner experience, as you move down and toward its centre, and the great sweep of the outside world as you skirt its boundaries. Much of the garden stretches along the winding Cherwell, which bounds the property, with views both out and in—those inward being more or less closed set pieces like the Vale of Venus and outward being wide unfocused expanses.

As in the relationship between the closed formal gardens (with its hedged rooms) and the natural, there is here an insistent alternation between the enclosed and the open: a tension that will be resolved in Brown's opening of the garden into great serpentine lines that defy closure. But in the gardens we are discussing the effect is one of relating complementaries; we study the emblem and turn with relief to the extensive landscape in another direction— which, however, may well include a building we examined in an enclosed scene earlier or even entered as an enclosure. Something of their relationship may be sensed by a quotation from Addison and its echo fifty years later at Stowe by Gilpin:

The mind of man naturally hates everything that looks like a restraint upon it, and is apt to fancy itself under a sort of confinement, when the sight is pent up in a narrow compass. . . . On the contrary, a spacious horizon is an image of liberty. . . .
There is nothing so distasteful to the Eye as a confined Prospect . . . especially if a *dead Wall*, or any other such disagreeable Object steps in between. The Eye naturally loves Liberty, and when it is in quest of Prospects, will not rest content with the most beautiful Dispositions of Art, confined within a narrow compass. . . . [34]

Elsewhere Gilpin makes the point that a hedge or wall that cuts off the extensive view is useful as a break that makes us better appreciate the extensive view when it emerges again.[35] Openness, of course, carried connotations of liberty that were understood by Whig politicians. But here it is the interplay of two kinds of knowledge which remain complementary.

Stourhead is an example of a garden constructed along the principles of Rousham but by the owner himself and according to his own programme. The garden was conceived and undertaken by the banker Henry Hoare in the 1740s, though not completed until the 1760s. (In the 1770s irrelevant Gothic elements were added; and the Temple of Ceres at some point before 1800 was called the Temple of Flora, changing Hoare's original meaning.) Hoare saw his estate as a place of retirement from the business world of the City, and he had a particular message he wanted his garden to convey—so particular that he insisted that the visitor 'keep to the right-hand walk, which

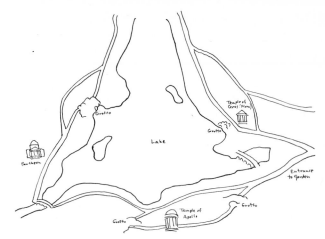

will lead us to a small temple', the Temple of Ceres.[36] If he turned to the left, he would have begun at the Temple of Apollo, where the garden in fact came to a climax. Stourhead was laid out like an allegory with a beginning, middle and end.[37]

The path begins with an emblem of Rome, very like that at Castle Howard. This is a scene that cannot be photographed, but the visitor, as he moves his eye over the panorama from left to right, is aware of the Claudean elements: the bridge, the Roman Pantheon across a body of water, and the portico of a temple emerging at the right. It is even possible, as Kenneth Woodbridge has proposed, that Hoare may have intended the allusion more specifically to a particular Claude landscape showing Aeneas' arrival at Delos, where he entered the temple and prayed to Apollo, 'grant us a home of our own. We are weary'.[38] Certainly the first temple, originally called the Temple of Ceres, carries over its portal a quotation from *Aeneid* VI: 'Procul, o procul este profani' ('Away, away all you who are unhallowed'). 'But you, Aeneas,' the priestess continues, 'whip blade from scabbard and step forth on your way.'[39] And she conducts him down into the underworld to learn of his founding of Rome. (On the edge of the lake, below the temple, is a grotto.) From here the visitor looks across the lake to the Pantheon and now first sees high on a hill to the left the Temple of Apollo, the ultimate end of the journey.

As you follow the winding path around the lake you gradually lose sight of these objectives behind trees; the larger part of the walk is through varying terrain and kinds of scenery without any idea of when you will again glimpse the destination with which you have now lost touch. At last you see the Temple of Apollo, high in the distance, and then lose sight of it again. You descend gradually, windingly, into a grotto, the allusion being to Aeneas' descent into the underworld. 'I have made the passage up from the Sousterrain Serpentine,' wrote Henry Hoare, '& will make it easier of access facilis descensus Averno.'[40] Hoare is echoing the sibyl's words, 'Light is the descent to Avernus! Night and day the portals of gloomy Dis stand wide: but to recall thy step and issue to the upper air—there is the toil and there the task.'[41] He therefore made the way out, climbing up over rocky steps, steep and uneasy.

Inside the grotto you first see, straight ahead and illuminated by light from an opening overhead, Father Stour, an allusion to Father Tiber who told Aeneas, 'here is your home assured and here for the Gods of Rome is their sure place'. An inscription from *Aeneid* I also originally linked it to the cave near which Aeneas landed in North Africa on his flight from Troy.[42] Looking to your left through an opening in the cave wall you see across the lake the bridge and the Temple of Ceres, and to your right a statue of the nymph of the grotto.

The steep climb out of the grotto leads toward the Pantheon, from whose porch the Temple of Ceres is visible to the left and the Temple of Apollo far above to the right. Inside the Pantheon is Rysbrack's statue of Hercules, Heroic Virtue, the destroyer of lions and boars that ravage harvests and fruitful countrysides.

Hercules is present—and the temple was originally called the Temple of Hercules—because Aeneas, following Father Tiber's advice to seek the Arcadians as allies, visited the Arcadian king and discovered him 'paying anniversary honours to Amphitryon's mighty son Hercules', who had killed Cacus the destroyer of herds on that spot.[43] (At the other end of the room are statues of Diana and Meleager: Meleager slew Diana's boar to stop his ravaging of crops, and Diana accordingly killed him.)

But Hercules' statue is flanked to left and right by statues of Flora and Ceres, with his head turned toward the latter. The distinction is presumably between happy-go-lucky natural fecundity and the order of crop planting and harvest, between spring and autumn, flowering and harvest—and Hercules makes the proper choice for industry over idleness. Though Rysbrack's Hercules is based on the Farnese Hercules, bearded and with his lion's skin, the placement between two women, with his head inclined toward one, strongly suggests that Hoare had in mind the element of choice—invoked in other parts of the garden by alternative paths. The two basic school texts in eighteenth-century England for verbalizing the visual and visualizing the verbal were Prodicus' *Choice of Hercules* and the *Tabula Cebetis*: the first involving a choice between virtue and pleasure, the second tracing the rocky path to virtue which invariably ended at a Temple of Wisdom atop the hill (toward which Virtue is gesturing in the Choice of Hercules representations).[44] The Choice of Hercules dominated, for example, the iconography of the Villa d'Este and its garden; Hercules was a favourite figure in the iconography of English country houses, especially after the accession of William III. And choice, from its deeply English and Puritan sources, was of primary interest to Hoare and his contemporaries. It may not be carrying the structure too far to see it also at Stowe in the contrast between the garden of Venus and the garden of public virtue in the Elysian Fields. At any rate, Hoare included a Hercules in his Pantheon and had Poussin's *Choice of Hercules* hanging inside his house.[45]

Finally, up a steep hill from the Pantheon, through another grotto, the visitor emerges before the Temple of Apollo, the ultimate destination, the Temple of Wisdom that marks the end of the pilgrimage beyond the rewards of fame. Once again it appears in the general shape of the Temple of the Sibyl,[46] and inside is a copy of the Apollo Belvedere: associations of prophecy, beauty, the sun, and wisdom. From here you could at one time see the whole journey laid beneath you, and on the horizon the obelisk at the foot of the formal garden, linking the two areas. The basic elements, besides the long journey through the wilderness, are temples of tillage and harvest, of fame, and of wisdom, in that ascending order.

The continuing element is the parallel to the journey of Aeneas, to his founding of the New Troy on the shore of Latium.[47] The *Aeneid* was generally interpreted by the Christian exegetes as a parable of the Christian soul's journey through life, echoed in the *Tabula Cebetis* and other classical texts and in the metaphors of Puritan devotional literature. Although the basic structure of the garden at Stourhead is a pictorial circuit, and the architectural elements are seen from a variety of different positions, the point is their positions in an onward moving allegory, with the visitor's sense of moving at least part of the time through a maze; as I have said, most of the garden experienced is out of sight of the temples.

All of this, however, seems peculiarly fitting for Henry Hoare, the second-generation City banker. He makes his garden almost literally a poem, creating a series of emblems whose statement at its most general is about the course of man's life on earth and ultimately about his choice between a life of duty and a life of retirement and contemplation. But 'read' at a somewhat more particular level, by someone close to Hoare or by Hoare himself, it is saying: Here the City merchant builds his new Troy; leaving behind him the squalid battle and din of burning Troy, he settles on this sacred soil, works his crops, or lets the flowers grow unmolested, withstands temptations, and founds an empire (a family) that will last as long as Rome and share its virtues and glories.

Hoare's garden may sound megalomaniacal to us—and to some extent it was.[48] But this is to forget that he is expressing a way of thinking common among cultivated eighteenth-century men. So sophisticated and self-aware a writer as Henry Fielding, when he kept a journal of his trip to Lisbon to regain his health, automatically made this prosaic voyage meaningful by

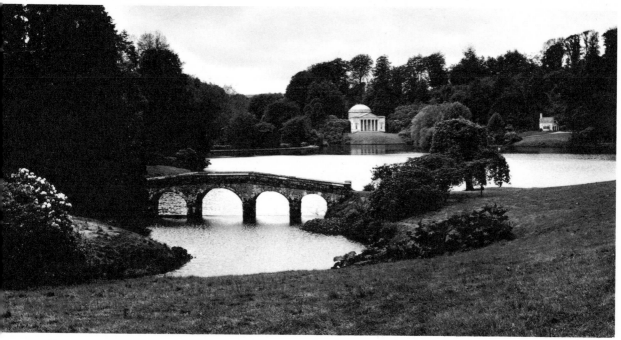

9 Bridge and Pantheon across the lake, Stourhead.
10 Temple of Ceres (Flora) and Temple of Apollo, Stourhead.

seeking parallels in the epic of Odysseus return-
ing from Troy. Fielding departs London as
Odysseus departed Troy after the Greek
victory. With the Greeks almost ready to give
up and go home, Odysseus conceives the plan
of the wooden horse, and after its success sets
out for well-deserved rest in Ithaca—but has
many delaying adventures on the way. Fielding,
the London police magistrate, is about to leave
for recuperation in Bath when the government
asks him for a plan to destroy once and for all
the London underworld (a much more than
ten-year running battle), and after its successful
completion he leaves for rest and recuperation
across the sea in Portugal (ironically, by no
means his Ithaca or home)—and suffers as many
hardships and delays as Odysseus including a
Circe-like innkeeper named Mrs Francis. This
was simply a way of generalizing his personal
experience, making it accessible to the general
public by investing it with meaning.

The gardens at Stowe were as self-serving, as
self-glorifying as Stourhead. Besides the Elysian
Fields, the Temple of Friendship was filled with
busts of Cobham and his political colleagues,
the 'Patriots' of the Opposition, and the walls
were covered with cartoon-like paintings
satirizing the Walpole Ministry. The official
guide noted that on the ceiling you saw Britan-
nia, holding up on one side her glorious annals,
the reigns of Elizabeth and Edward III, and 'on
the other is offered the Reign of . . . which she
covers with her Mantle, and seems unwilling
to accept'.[49] The paintings and reliefs that
originally covered one wall of the Palladian
Bridge were also political, and visible on the
house's skyline was the Whig allegory of
Religion pointedly joined with Liberty, and
Peace joined with Plenty.[50]

Pope's garden at Twickenham was dedicated
to his mother and, more generally, to the idea
of Motherhood and other virtuous qualities.
But while a universal topos of this kind was
being expressed, a personal mythopoeia was
also being worked out. The really significant
element was the grotto that connected the
garden and the Thames-side. Through the
grotto the peaceful, retired, private world of
the garden could be seen in one direction and
the Thames traffic on its way to London and all
it stood for in the other (while overhead went
the busy road to London), and this was an
emblem of Pope the poet whose satire is

written from the strength of a particular
situation between involvement and retirement.[51]
Any poet is the subject, but also this particular
poet, with his particular mother, who is
making his garden express his own ethos.

Pope and Fielding still write in the Augustan
tradition, generalizing their experience and
seeing it in terms of their own inherited literary
conventions. Cobham and Hoare see their
experience as important and seek public icono-
graphy that will enhance this importance. They
might have been seen by an unsympathetic
contemporary as closer to a James Boswell,
who used public stereotypes like Captain
Macheath, the Benevolent Man, and the Great
Lover to lend importance to his own most
fleeting emotions, but with an interesting sense
of self-irony absent from Stowe and Stourhead.

But if the garden at Stourhead was basically
a propaganda piece, Hoare was also concerned
with aesthetic and psychological effect. He
structured his paths like those at Stowe and
Rousham with shifting perspectives along a
pictorial circuit of his lake, and pictorially his
temples and grottos appear in different relation-
ships to water, foliage, and sky. He commented
to Joseph Spence: 'The greens should be ranged
together in large masses as the shades are in
painting: to contrast the *dark* masses with *light*
ones, and to relieve each dark mass itself with
little sprinklings of lighter greens here and
there.'[52] This formalism is also not absent from
Pope's garden: he noted from one bench that
'you lose your eyes upon the glimmering of
the Waters under the wood, & your ears in the
constant dashing of the waves'.[53] And he
arranged his streams in his grotto to reflect
different moods and elicit different responses.

At Stowe by the late 1740s when Gilpin
arrived, the two aspects of the garden were
equally appreciated. Probably representing two
aspects of Gilpin himself, his speakers also
divide into the old moralizing reading and the
new aesthetic. After one of Callophilus' long
moralizations of nature, Polyphon replies:

What an happy Man you are, thus to find an Oppor-
tunity of moralizing upon every Occasion! What a
noble View you have displayed before me: when
perhaps if I had been alone, I should have entertained
myself no otherwise than in examining the Busts; or if
I read the Inscriptions, they would only have drawn a
Remark from me, that they were well wrote.[54]

Cobham's iconography extended inside his house, to the decorations in his Hall and Saloon, to such designs as the ceiling oval by Kent showing him receiving a sword from Mars, while a portrait of William III is held up nearby. The meaning was that this king, whose Protestant importance is emphasized throughout the property, first commissioned Cobham and inaugurated his successful career.

Hoare too fancied some sort of a relationship between the garden and the house—between, for example, the Claude landscape in his garden and the Claude paintings in his gallery. By 1762 the Poussin *Choice of Hercules* and the Claude *View of Delphi with a Procession* were both hanging in the sky-light room.[55] We know that Hoare chose and commissioned his pictures by subjects as carefully as he did the statues and temples in his garden. The most documented of these commissions was the *Octavius and Cleopatra*, a relatively unusual subject, which he commissioned from Anton Raffael Mengs as a pendant to Carlo Maratti's *Apollo conducting the Marchese Pallavicini to the Temple of Fame*. He had been attracted to Guercino's painting of the subject (Capitoline Gallery, Rome) but the final arrangement of these two paintings with the large equestrian portrait of himself by Dahl and Wootton in the house's entrance hall was surely symbolic.[56] The two subject pictures share the theme of patronage of the arts. The magnanimous gesture of Octavius parallels that of the Marchese, and (the quality Hoare stressed in his instructions) the 'nobility' of Cleopatra parallels the dignity of the artist whom the Marchese is patronizing. The third picture is the monumental portrait of Hoare, the patron in the pose and composition of Titian's equestrian *Charles V*.[57]

Horace Walpole, who records the placement of these pictures, also remarks that in the great saloon hung a *Midas preferring Pan to Apollo*, which gives us the other side of the theme of patronage;[58] and Colt Hoare later, when he moved the Maratti and Mengs into the saloon, made the centrepiece a Cigoli *Adoration of the Magi*, extending patronage to the religious sphere. There was also in Henry's time a copy of Van Dyck's *Family of Charles I*, a symbol of family (so stressed in the *Aeneid* parallels of the garden), and I suspect that if enough information were available it would prove that the iconography of the interior of Hoare's house, in the public rooms at least, was as carefully worked out as in the garden.

With behind it a long tradition of domestic iconography in Italian palaces and villas, the meaning of the house in eighteenth-century England is fairly specific and singular. Domestic architecture determinedly *meant*, and in a particularly English way. Palladio, the model for the Burlingtonian school, had sought not so much meaning as ideal harmonies, employing analogies with music and divinity.[59] He adapted a Roman temple or public building for his house—because he thought this had been its historical source. The Burlingtonians, however, were specifically alluding to Palladio and through him to an ideal Roman past. The temple front signified something about the English lord whose house it introduced: it was a public, not a private, entrance.

In Kent's Holkham Hall the temple front was not even an entrance: it was seen as you approached along the long, straight road toward the garden front, and simply designated the kind of structure—Roman down to the bricks, specially baked in the Roman shape and colour. The real entrance, on the other side and through a small door, was a gigantic hall shaped as a Roman basilica, its colonnade of African marbles recalling the Temple of Fortuna Virilis in Rome, and its entablature from the portico of the Temple of Antoninus and Faustina. The owner, Thomas Coke, is the subject of this structure, as an inheritor of Roman ideals, a person who has devoted himself to the public virtues. Through the spectacular entrance hall one passes into the great saloon, and through its windows and doors (through the temple portico) to the garden and the view out over the great park. As visible from the garden front as from the entrance front are the triumphal arches, avenues of ilex, and obelisks laid out on the axis of the house, which imply the ordering force that controls an unlimited landscape, a total environment, at the centre of which stands this house.

Coke saw himself as a collector, and so the entrance hall was lined with statues and the original plan was to have placed the colossal Jupiter, the prize of his collection, on a pedestal in the middle of the stairway. A sculpture gallery was given prominence in the floorplan of the house, and the rooms in general, as the

current guidebook says, were 'designed to show off' art objects. 'When Thomas Coke built Holkham he intended it to be not so much a home as a place suitable to show off his unique collection of classical art treasures. . . .'[60] So it was constructed around the entrance hall, the saloon, and the statue gallery.

Conscious symbolism of this sort had been exploited by Louis XIV in the iconography of Versailles with the representations of the Sun King, Apollo, surrounded by the fruits of the earth; and for those interested in the most recondite details, the explanation had been published as a guide book.[61] The English royal family enjoyed its own celebration in civil architecture and decoration, as in the great hall at Greenwich Hospital, with accompanying guidebook. And in the private houses of the great and not-so-great the iconography was more or less explicitly self-aggrandizing.

If the temples in the garden were purely moral or aesthetic objects, however, the house had other functions that had to be allowed for. Thus with domestic architecture the element of function or use is more important than—or different from—that in a picture or garden. The former must not only be aesthetically pleasing and/or morally instructive, it must also serve as 'a machine for living'. So it becomes important in ascertaining the house's meaning to notice the ratio of symbolic rooms to living rooms, and the hiding away of private apartments, kitchens, and business offices, as well as the nature of decoration. What can be said of the early eighteenth century in England is that symbolic function far outstripped use.

There is a certain value in considering architecture, of house as well as garden, as a sign system.[62] Signifier and signified can be either verbal or visual, depending on the stage of the process. The patron's instructions (or stated needs) can be the signifier, and the architect's interpretation, the house, the signified. But if architectural signs are taken to be the forms of contruction, their designata (or the signified) are the persons using the house, and the signs become a force or influence on the inhabitants' behaviour. This was the Augustan intention of domestic architecture for the great, participated in by Henry Hoare and even Alexander Pope.

In this sense the facts of the house's make-up and decoration both express function and define the owner-inhabitant. The house is made for his needs, for a person who, collecting Roman antiquities, urges Roman virtue *and* wants to see himself as part of a continuum with the Roman Empire or Republic. In fact, the house is a tendentious structure in that if successful it shapes the owner to his duty. This means that the patron and his family are consecutively both signifier and signified, both active and passive: the patron sets out his programme, 'Patron as Roman Senator', which is signified in a house, garden, and total landscape reaching to the horizon. But once the house and garden become the signifier, the patron and his family and descendents become the signified, shaped to their duty to conform to the symbol.[63]

Throughout we have had to distinguish between the patron-owner and his private circle and the tourists who responded via a guidebook and other commentaries, conversations, and the like, morally and/or aesthetically, to the experience. The patron, of course, carries with him a precise knowledge of intention that makes his response a much more limited affair than that of the general public; and he bequeaths this response to his heirs.

Thus the Palladian country house, beginning as a sentimental link between modern England and ancient Rome, was filled with the portraits —often to make the allusion more direct, with Roman busts—of forebears, friends, sovereign, great contemporaries, and heroes of the past. While the idea that statues could serve as moral exemplars goes back at least to Cicero, by the 1730s it had become a cult in England: in 1732 Kent erected for Queen Caroline the busts of Locke, Newton, Wollaston, and Clarke in the Hermitage in her garden at Richmond. They became notorious in story and song, satire and lampoon. So too history painting of heroic deeds from the past were often chosen and arranged with the same attention. Such 'old masters' were assiduously collected by the 'great', but also by the nouveaux riches who wanted to pass for great, to accept the sign for the reality. These objets d'art were signs of status, but their purpose, as contemporary art treatises made abundantly clear,[64] was to inspire emulation, and so history paintings showed heroic actions as portraits showed great men, and their owners and casual sightseers 'looked up' to them.

3 The Hogarthian Progress: Iconography Reinterpreted

IT IS of more than passing interest that Hogarth was invited by Henry Hoare to contribute a history painting to Stourhead, and that nothing came of the negotiations.[1] For the experience inside one of Hogarth's progresses was very like that in the house or garden at Stowe, Rousham, Stourhead, or Holkham.[2] Hogarth chose as his scene a room in a contemporary house.

I venture to say that his syntax—his verbal-visual structuring of reality—would have been very different had he not lived at a time when these houses and gardens, and the frame of mind they expressed, were flourishing. His introduction to the subject was through the cultural and social fact of people making gardens and houses and collecting objects to furnish them. The houses of such people as Hogarth portrayed were full of bogus old master histories and portraits, or at the very least the endless Houbraken heads of great men, the penny portraits of the notorious—all in some sense models. This aspiration, acting according to fashionable models instead of one's natural instincts, was Hogarth's theme in the 1730s and 40s. And his interpretation of the theme saw the house and the pictures, originally constructed to fulfil a signified function, becoming themselves signifiers that stamped their owner and his actions. The paintings and statues, Hogarth shows, are as dead a weight on the owners as on artists like himself. He would have understood Constable's dread at the foundation of the National Gallery that it would mean the end of the British School of painting.[3]

Hogarth's structure takes a step beyond the garden and house in that it uses their mode of communication (their iconography) but at the same time criticizes it. In heraldry beasts are given their noblest interpretation: foxes are wise not crafty; but in Hogarth not only are they crafty, but so are clergymen and pretty virgins. The one iconography is positive, dedicated to decorating or beautifying a room in a house or a landscape, injecting thoughts of greatness and duty; the other questions, probes, and subverts, and finally refuses to come out with any positive, formulated commonplace. In this respect Hogarth is closest to the libertine tendencies of the Garden of Venus at Stowe. But he is not concerned with cynical negation; as his subscription tickets and his own polemical writings show, he feels he is producing a viable alternative to the old stultified iconography.

His practice may recall James Harris' words in 1741 on the subject of language as the single quality that distinguishes men from brutes:

> The Leading Principle of BRUTES appears to tend in each Species to *one single* Purpose—to this, in general, it *uniformly arrives*; and here, in general, it as *uniformly stops*—it needs no Precepts or Discipline to instruct it; nor will it easily be *changed*, or *admit a different Direction*. On the contrary, the Leading Principle of MAN is capable of *infinite* Directions—is convertible to *all sorts of Purposes*—equal to *all sorts of Subjects* . . . In a word, to oppose the two Principles to each other—The Leading Principle of *Man*, is *Multiform, Originally Uninstructed, Pliant and Docil*—The Leading Principle of *Brutes* is *Uniform, Originally Instructed*; but, in most Instances afterward, *Inflexible and Indocil*.[4]

In his engravings Hogarth expresses something not very different from modern linguistic theory that distinguishes closed from open systems of communication. Systems employed by all the species other than man allow for the transmission of a finite and relatively small set of distinct 'messages', and the meanings of these are fixed before transmission, as if to be sent by semaphore. In the same way, 'Mars curbed by Venus' pre-exists the painter's version. The run-of-the-mill painter of the period may infinitely vary the intensity of the elements that make it up, but he cannot introduce anything that will change or contradict the original meaning.[5]

The primary property of human language is what the linguistic theorists call its creativity or open-endedness—the individual's ability to produce (and understand) an infinitely large number of 'new' sentences in his native language—meaningful sentences he has never heard before and that may never have been produced

before.[6] In practice, this is the ability to construct new combinations of discrete units, rather than varying continuously the stable elements in topoi. What is sacrificed in intensity and unity of effect, Hogarth would argue, is made up for in complexity or truth-to-nature of the utterance. The contrast is between a kind of art that merely evokes or adumbrates a topos and one that creates its own 'story'.

Historically, Hogarth found himself in a situation in which the whole system of iconography, including the rigid structure of genres, had become burdensome. This was especially so in England where native artists had fallen into the habit of repeating at second and third hand the generalizations of their more esteemed brothers on the continent. That very influential journal *The Spectator* had laid out the case in the 1710s for discarding the old iconography of Greek gods and heroes and their pursuit of nymphs and urged that the artist develop a relevant modern moral subject. Hogarth fulfilled the *Spectator*'s call by connecting contemporary subject matter with the iconography of history painting. His aim was to make history viable for his own time.

He begins by rendering traditional iconography dead. It is a series of old, dead, inappropriate postures, displaced to the paintings on the wall, now fit only to be hung in a gallery. In the second plate of *A Harlot's Progress* (1732) he does not show Anger and Jealousy aroused by Suspicion, but rather hangs representations of these topoi on the wall above the head of the merchant, the Harlot's keeper.[7] The fact that he is Jewish and they are Old Testament subjects tells us more than an allegorical representation could about his anger. To raise his status from Jewish merchant he collects history paintings by continental 'dark masters' of Old Testament scenes of violence and destruction, of jealousy and harsh judgment, which reveal something of his past, or the sort of man who bought them, his aspirations, and the treatment he can be expected to accord the young Christian girl he has made his mistress (probably because she is Christian, a rare collector's item) once he finds she has betrayed him. Simultaneously, a more general comment is being made about the subject matter of the pictures bought by connoisseurs, the nature of those connoisseurs, and the art of the revered 'masters' of the past and their bloodthirsty and stereotyped iconography. These pictures dominate the people beneath them, who begin to assume similar poses.

Above the Jew are Jonah cursing God's lenience toward Ninevah and Uzzah being struck down for trying to steady the Ark of the Covenant. Jonah, with fists clenched, is looking straight at the second picture, at Uzzah's repayment for his 'charity'. Hogarth has made one crucial change in the Biblical text, replacing the divine bolt of lightning with a human priest who stabs Uzzah in the back. Beneath, the Harlot's departing lover carries his sword under his arm, and by a trick of perspective he appears to stab the Jew in the back, paralleling the priest's gesture. But of course the real stabbing is projected ahead into the human retribution brought to bear on the Harlot in the subsequent scenes.

This 'reading' is arrived at through the parallel shapes of the tea table and the toppling Ark, both falling, both at the same angle; and these shapes activate the allusion to the story of the Ark, which causes the viewer to draw imaginary lines to the parallel figures in the scene below. Likewise, in the third plate there is the rectangle of the picture itself and the roughly similar shape of the print on the Harlot's wall of *Abraham sacrificing Isaac*: the shapes support a parallel between the microcosm of Abraham-Isaac and the macrocosm of the magistrate and the Harlot in the picture itself, between the divine justice and the human.

The expressive-readable form is translated by the viewer into a statement to the effect that the Jewish merchant acts this way—keeping the Gentile girl and then casting her out—because he collects pictures and other status objects, because he emulates the 'great' collectors and their history paintings in fashion. And the Harlot herself behaves analogously, living up to her model of 'great ladies' by cuckolding her keeper, and to his example by maintaining appearances with finery, a servant woman, a tea service, and her own pitiful collection of penny prints of *Abraham and Isaac*, *Captain Macheath* and *Dr Sacheverel!* (yet other models of harlotesque conduct). These artistic and architectural formulae are what do in fact define and control, but they also contract, change, and destroy Hogarth's people. They are not ideals to emulate or against which to measure contemporary behaviour.

12

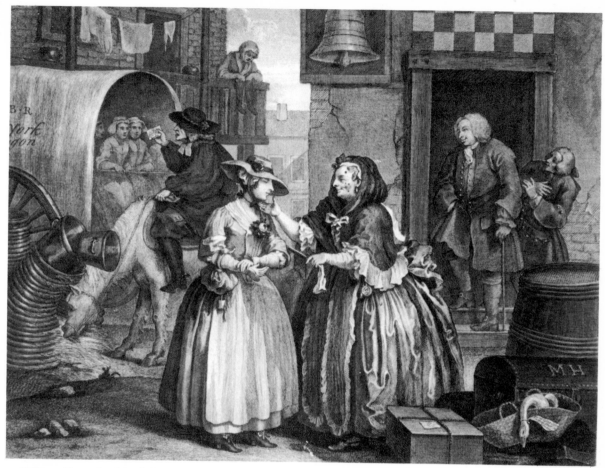

11 William Hogarth, *A Harlot's Progress*, Plate 1. Engraving (1732).

The rectangular boxes of frames, of rooms, and of windows emphasize a grid that is artificially imposed on experience by society and by the victim himself. They also delimit and compartmentalize the scene into pieces of more or less accessible information. They are visually related to the conventional shape of the engraved plate, and as the repeated shape of the plates, placed side by side, is what calls for a sequence, so within a plate the shape of the picture on the wall is the same as that of the story—the plate itself—and establishes a parallel between two dimensions of story.

A Harlot's Progress begins with a scene in which no identifiable art objects appear. Contemporary newspapers are the source of its iconography. An old woman is identifiable by her face patches and the context of an inn yard,

the shady-looking characters to her rear, and the pretty countrified girl she addresses, as a bawd. And then at a higher level of denotation as a particular bawd, Mother Elizabeth Needham.[8] The man who lurks in the doorway was recognized as Colonel Francis Charteris, a man who for a contemporary represented more general concepts: lust, exploitation by the rich and powerful of the poor and helpless, and a world of corrupt glamour and crime that is excused because of friends in high places. The girl herself, identified by inscriptions as 'M. Hackabout', bore a name familiar to newspaper-readers of 1731. The other major figure was recognizable by his dress as a clergyman, if not a particular one.

The old iconography remains, however, a ghostly presence in the general composition, a

37

12 William Hogarth, *A Harlot's Progress* (1732), Plate 2.

remembered paradigm against which this contemporary story is played out. The girl between the clergyman and the bawd makes a parody Choice of Hercules composition—parody because the clergyman's (Virtue's) back is turned and the bawd (Vice) is successfully persuading the girl.

What allows us to sort these figures into such a configuration? Nothing probably in the paintings one would have seen in Hogarth's shop—the paintings that would have lured a customer into subscribing for the set of engravings. But once he had subscribed he was given the subscription ticket, which told him through images of putti and the many-breasted Nature (used for example by Gerard de Lairesse as Painting's model in the frontispiece to his influential art treatise), and inscriptions from

Virgil and Horace, that this series was concerned with changing the traditional iconography of high art.[9] Through the burlesque use of the 'Art imitates Nature' topos in the ticket, the purchaser would detect a similar procedure in the engravings.

Not only was the Choice of Hercules a commonplace of the pictura poesis tradition, invoked in the ticket by the quotation from Horace's *Ars poetica*; it was the example chosen by the Earl of Shaftesbury in his well-known argument concerning the reform of history painting (1713). Shaftesbury even commissioned a graphic version for inclusion in his treatise and he uses it to set forth the difference between what he disparagingly calls the old enigmatic and the new probable use of iconography based on a 'rule of consistency'.[10] He

21

38

13 William Hogarth, *A Harlot's Progress* (1732), Plate 3.

explains at length how the Choice of Hercules ought to be portrayed by history painters so as to appear probable and 'modern'. At the same time he is instructing the history painter in just what the correct moment in time should be, what phase of the action should be chosen for portrayal.

The setting, he writes, should be 'in the Country, and in a place of Retirement, near some Wood or Forest' to suggest 'Solitude, Thoughtfulness, and premeditated Retreat'. Hogarth, however, places his scene in busy London: his Hercules has come from the country to the city. A lazy, inattentive young lady, says Shaftesbury, should be used to represent Vice; a vigorously-arguing, rational young lady, Virtue. Hogarth arranges the young girl so that on one side of her is the in-attentive clergyman and on the other the bawd vigorously arguing her case; and he treats the choice not, as Shaftesbury wished, at the moment when Virtue is winning but when Vice is about to overcome.

I should mention that in older emblems of the Choice of Hercules—of the sort Shaftesbury is trying to improve—Virtue is indeed repre-sented by an old man and Vice by an old, false-seeming hag.[11] Hogarth has blended the two versions, but essentially made the chooser not a sturdy Hercules but a weak young girl, as if turning the tables on the male-female relationship of the original story.

Shaftesbury adds that it is permissible in terms of probability to use a bridle to symbol-ize steadfastness (recall the bridle that ties Mars' horse to a tree in Veronese's painting),

15

1

39

14 Paolo Mattheis, *The Choice of Hercules*. Engraving by Simon Gribelin, in Shaftesbury's *A Notion of the Historical Draught or Tablature of the Judgment of Hercules* (1713).

15 *The Choice of Hercules*. Emblem, in George Wither, *A Collection of Emblemes* (1635).

and so Hogarth puts his clergyman on a horse with his hand loose on the bridle, allowing the horse to effect the collapse of a pile of symbolic buckets, analogous to the effect his master is having on the Harlot. In Choice of Hercules pictures, the arm of Virtue is always raised in a gesture toward the distant rocky road up the hill. Hogarth's clergyman lifts his arm but only toward a paper containing the address of the Bishop of London, who (Hogarth's audience knew) dispensed ecclesiastical preferment in Walpole's England.

In his first print cycle Hogarth makes it clear that he accepts Shaftesbury's claim that choice between paths of virtue and vice (or pleasure) is the proper subject of history painting, but he also places it in a contemporary context: how minimal is free will in modern times, with Virtue's back turned, the 'lofing cosen in Tems Stret' missing who was to meet the girl upon her arrival in London, and Vice-Pleasure supported by the satyrish figures of her employers. This is the real situation of Heroic Virtue in modern London, where choice is largely vitiated by fashion. The topos certainly does not fit M. Hackabout's situation, but its very unfittingness helps to define just what her situation is; among other things, one that is not conformable to a comfortable, commonplace adage.

If the clergyman-harlot-bawd group echoes a Choice of Hercules, the harlot and bawd grouped with Colonel Charteris standing in the doorway derive from the figures in a *Visitation*, Mary being met by Elizabeth, with Zacharias in the doorway. The art historical context of a series of pictures of a woman's life included not only the sub-literary lives of harlots but the religious prints of the *Life of the Virgin*, inverted into a life of that other Mary, the Magdalen, or a 'Mary' of our time (the 'M' of M. Hackabout). This particular equation was made explicit by Hogarth in a joking way in the *Magdalen* painting he shows attacking the *Harlot* in *The Battle of the Pictures* (1745).

How far Hogarth intends us to carry the connotations of the *Visitation* group is a part of the *modus operandi* of his progress: once the lateral limits of reference are defined, the reader can plunge as deeply between them as his ingenuity will allow him. For ingenuity is one element Hogarth plainly wants to share with his audience, and another is the verbal response

of one viewer exchanging explication with another. The social dimension is as important in the Hogarthian progress as in the garden. Often, as I have passed a Hogarth 'modern moral subject' in a gallery, I have overheard two or more people explaining the picture to each other.

'The story in Luke (I.34–55)', one viewer may say, 'tells how Mary goes to see Elizabeth because the angel has told her, who cannot imagine that she can be pregnant never having known a man, that old and barren Elizabeth has also conceived: "For with God nothing shall be impossible." ' 'And,' interjects a second viewer, 'Mother Needham's Christian name is Elizabeth.'[12] Viewer One: 'The sight of Elizabeth is proof to Mary that the impossible can happen, that "he that is mighty" can do many "great things". And that refers at the moment to Colonel Charteris, the "great man" who has twice been pardoned on rape convictions.' Viewer Two: 'But its application is wider two plates later in the composition of an *Annunciation* of all things, with the angel replaced by that rabid bawd-hunting magistrate, Sir John Gonson, come to arrest the Harlot.' Viewer One: 'And in the last plate the Harlot in her coffin has become a kind of table around which celebrate the number of Christ's apostles at the Last Supper, with her son himself seated in the middle down front. What are we to make of that?' Viewer Two: 'The eucharistic overtones are not out of place: the *Harlot's Progress* is about a ritual sacrifice, not of the son but of the mother.' Viewer One: 'I might add that the Biblical commentators saw the Visitation as embodying the lesson that "Nothing is impossible with God", and the purpose of the meeting was "to strengthen [Mary's] own Faith, as to the Revelation which she had received" from the angel, i.e. what brought the Harlot to London.'[13] In short, if we learn nothing else from the allusion to the Visitation, the fact that Mary is going on a kind of pilgrimage to learn something from Elizabeth provides the suspicion that this young girl is not just arriving in London but is here for a purpose, in some sense *seeking out* Mother Needham—a suspicion that is supported by the expression of eagerness on her face, and subsequently by what we see of her in the second and third plates.

The first plate of the *Harlot's Progress* also illustrates the difference for Hogarth between

16 Albrecht Dürer, *The Visitation*. Woodcut, from *Life of the Virgin*.

17 William Hogarth, *A Harlot's Progress*, Plate 1 (detail).

18 Antoine Watteau, *La Diseuse d'Aventure* ('Clairvoyant and three young Ladies'). Engraving by Laurens Cars (1727).

a source and an allusion, or *mimesis* and *imitatio*. While he is alluding to the composition of a Choice of Hercules and a Visitation, he has also consciously or unconsciously imitated the two central figures, especially the bawd, in an engraving by Laurens Cars after Watteau's *La Diseuse d'Aventure* (1727). Although the pose of the fortune teller and her dupe can have been recognized by only the smallest fraction of Hogarth's audience, its presence placed the picture in a tradition of genre painting shared by Watteau; and it was not entirely fortuitous that this representation rose to the surface of his memory when he needed figures of a bawd approaching a young country girl with city aspirations. *La Diseuse d'Aventure* further substantiates the meaning projected by the Visitation.

M. Hackabout is, in short, a Mary (Virgin or Magdalen) and yet is not: in the context of her story it is merely a role that does not fit; it is a projection of the innocence and then the melodrama through which the girl sees herself and her world. Like the Rake, the Harlot is essentially a role-player, the point being how uneasy she is from the start in her assumed characters (as in the fancy dress she still wears in her garret and in prison). This is equally true of the other roles Hogarth's audience would have recognized at play. The popular series of harlot-lives also rise to the mind only to fall away as unfitting: she is not an ordinary harlot; nor is this really a 'progress', whether royal or a pilgrim's or a Mr Badman's, Poesie's or *Studiorum*. Popular topoi as well as learned (or even hieroglyphic) are invoked to be discarded, sub-

verted, or transformed into a structure of probability.

We may think of the process as a demythologizing, in which a Visitation or Annunciation is shown to herald not the Holy Ghost but the young man who is making his escape from the Jewish keeper's house; or as a secularizing, in which divine justice has been replaced by human, God by a priest stabbing Uzzah or by Jonah cursing Nineveh *after* God has decided not to (or in *The Sleeping Congregation*, 'Dieu' removed from 'Dieu et mon droit').

Boys Peeping at Nature, the subscription ticket for the *Harlot*, is filled with outrageous visual and verbal puns: from the 'Seek out your ancient mother' of the Virgilian quotation, and its references to the fawn's quest under Nature's skirts, to the Latin-English tergiversations of 'licentia' and 'pudenter', to the connection between 'matrem' and 'mother' as contemporary slang for bawd (and the Harlot's, in a sense, *seeking out* her ancient Mother Needham).[14] We are therefore not surprised to find the Harlot's departing lover producing an optical pun with his sword which requires the reader's silent (or not so silent) verbalism: without 'stab in the back' the meaning is incomplete. So too the monkey and the mask introduce 'aping' and 'masking'. Within the larger situation of the parallel of facial expressions between monkey and Jew, and of the escaping lover and the mistress' betrayal, there is the necessary verbalizing—in its eighteenth-century terms—of the Harlot's 'making a monkey' of her keeper.

We follow the same procedure in each of the six plates. In Plate 1 the limp goose's head resembles the girl's, attentively inclined toward the bawd's blandishments, and the parallel indicates that (we have to verbalize again) she is a 'silly goose'. In Plate 3, as the magistrate creeps up on the Harlot to arrest her, the watch she holds reads 11.45 and may be translated: 'Time is running out.' To a greater or lesser degree Hogarth continues this procedure into *Marriage à la Mode* and on to his very last print, the *Tailpiece*, in which the rope's 'end' and the shoemaker's 'last' appear among other verbalizations of eschatological images.[15]

This is, quite simply, the introduction of another sign system, that of popular graphic art with its direct correspondences and visualizations of the verbal. Brueghel's *Netherlandish Proverbs* (Berlin) is an anthology of visualizations of the verbal or of actions that label themselves—'beating your head against a wall', 'counting your chickens before they are hatched', and 'armed to the teeth'—which the viewer re-verbalizes as he identifies. But Hogarth follows the example of the seventeenth-century Dutch genre painters who hid their symbolic meanings 'behind a plausible pseudo-realistic façade'.[16] Thus the lover does not actually stab the cuckold in the back but only appears to; horns do not sprout from his head but are visible behind him in his wallpaper. As the art objects do their work upon their owners, one form changes into another: visual image into action or word.

In a sense Hogarth is reversing the order of the *Tabula Cebetis* by seeking visual equivalents to the verbal or moral structures and then letting the viewer verbally unravel them, working back from the visual puzzle to the verbal original—as in the trick visual games played by the Carracci brothers. In these games the artist draws a simplified form:

Then the viewer either guesses the correct identification or the artist tells him: a mason with a trowel working behind a wall; a Capuchin preacher resting in his pulpit; a blind beggar with stick and cup coming around a corner; and a sergeant with his pike going into an alehouse accompanied by his dog. The last is Hogarth's own contribution to the game.[17]

Hogarth is participating in the popular tradition of graphic satire, but, as with his use of the Choice of Hercules and the Visitation, his imitation of art is largely for the purpose of allusion: he wants his viewer to sense the incongruity of popular motifs jostling sublime. Mimesis proper for Hogarth is less of graphic than of literary structures. The Harlot in her first plate owes less to the convention of the innocent Christ hemmed in by a crowd of threatening figures of evil in the paintings of Bosch than to the cool distinctions between

fools and knaves in a satire by Swift. The ironic juxtaposition of separate elements in the placement of the affianced couple next to a pair of manacled dogs (*Marriage à la Mode*, Plate 1) shares its effect with Pope's 'A hero perish, or a sparrow fall' or 'When Husbands or when Lapdogs breathe their last.'[18] And there is little doubt that Hogarth's source for the use of his art objects is the mock-heroic mode. When Pope describes Colley Cibber—

High on a gorgeous seat, that far out-shone
Henley's gilt tub, or Fleckno's Irish Throne,
Or that where on her Curls the Public pours,
All-bounteous, fragrant Grains and Golden show'rs,
Great Cibber sate. . . . (*Dunciad*, II, 1–5)

—the reader sees the lines in *Paradise Lost* (II, 1–5):

High on a Throne of Royal State, which far
Outshone the Wealth of Ormus and of Ind. . .
Satan exalted sat. . . .

Were he to be portrayed by Hogarth, Cibber might have a picture of Milton's Council of Hell above his chair in a room of unexceptionable eighteenth-century decor. Hogarth uses these allusions in the same way as Pope: the figures beneath the pictures try to act up to them, as Cibber does to Dulness' image of him; but he removes any sense of the alluded-to (e.g. *Paradise Lost*) as ideal, still preserved in Pope's *Dunciad*.

Hogarth is imitating *The Dunciad*, though, in order to place himself somewhere within the ambiance of its tradition, just as Pope, by referring to Flecknoe, recalls his own source: not *Paradise Lost*, to which he alludes, but Dryden's description of Flecknoe, his mock-emperor of the realm of Nonsense: 'The hoary prince in majesty appear'd, / High on a Throne of his own labors rear'd.'[19]

Hogarth's basic assumptions in his engravings were those of a man brought up on books. The verbal for him extended to the typographical. He seems to have firmly grasped the fact that on the printed page both visual and verbal structures were visual; and that two qualities of the printed page could be reproduced graphically—its left-to-right linearity and its 'exactly repeated pictorial statements' (Ivins' term) or homogeneity (McLuhan's term).[20] His shapes were expressed through the conventional patterns of parallel lines and cross-hatching—

as conventional and style-less to his audience as half-tone plates to us. Unlike most other artist-etchers, he sought no more variations between impressions than would a printer; and like the printer he distinguished only between deluxe and ordinary qualities of paper. He was in a sense producing a graphic version of the page of a book, appealing to the growing reading public, exploiting the book's potential at the same time that he avoided many of its limitations. Perhaps the single-sheet of type like *The Spectator* papers or a penny ballad or broadside is the real intermediary between the book and a Hogarth print.

For the Hogarthian progress was structured by the linearity of prose narratives as they appear on the printed page. His prints, he wrote, are 'designd in series and hav[e] something of that kind of connection which the pages of a book have'.[21] Hogarth and his readers naturally read as they wrote, from left to right; and he arranged his prints for the left-to-right movement of the eye on a printed page—in each print as well as in the set of six or eight. The plates could not be rearranged; they portray a series of successive moments and convey a pattern of temporal progression, of cause and effect or act and consequence, and of beginning, middle, and end. The Harlot comes to London, goes into keeping, is expelled, and declines from prostitution to prison, disease, and death. Past, present, and future also proceed from left to right across the plate: the Harlot's arrival from the country is implied by the York wagon on the left, in the immediate present she is listening attentively to the bawd in the centre, and her future is indicated by Colonel Charteris, his pimp, and the dead goose on the right.

But Hogarth also employs the conventional graphic syntax based on a Renaissance perspective box, a room, a square, a street, or even a landscape with enough architectural structures to simulate a stage set. Architecture was first a principal means of the artist for securing clarity of composition, but it also served him as a way of establishing a sense of realism and readability, as would have been demonstrated for Hogarth by artists from Raphael to Poussin. The norms of axis and orthogonals directed inward draw the viewer's attention from all sides: as soon as the eye tries to move away it is caught by the orthogonals and forced

into the depth of the composition. This is always from the near to the far, or from the periphery to the centre of perspective, the central axis.[22] And so in a generally baroque composition—or one mildly baroque like the *Harlot's Progress*—the recession has to be longest and most gradual from left foreground to right background where the orthogonals meet, and that is the way the viewer reads the action. It never works the other way in Hogarth's prints (though his paintings, made with reversal in mind, are satisfied to block movement and produce a more static and less readable effect). The horizontal lines lead the eye in toward the further elements of the story, but the verticals cause the eye to stop or pause, isolating some parts, subordinating others, and in general keeping the viewer from flowing too rapidly along horizontal or serpentine lines.

The perspective box has also served as a convention to relate spatial and temporal dimensions. Space can be a metaphor for time, the earliest event being placed in the foreground, later events on a series of planes in the background or to the sides. The different planes are areas within a coherent stage-like structure, indicating the progression of an action in meaning as well as time. For Hogarth the theatrical, slightly artificial feeling is essential, for these are structures created by the people who live in them and by their illusions.

Time was a matter of much concern in Hogarth's prints, which not only show the Harlot changing in time—in a series of successive, separate, boxed moments—but evoke time by surrounding a few stable elements (the protagonist herself, her noseless servant) with changes of scene, setting, clothing and associates; and by representing objects that indicate time passing or the transience of things: broken mirrors, over-boiling pots, cracked walls, or torn playing-cards. In the great age of clock-making in which he lived, Hogarth portrays more clocks than any other artist. The clock is present to admonish (*tempus fugit*, time is running out), to emphasize time's power, and to indicate yet another object of furniture people put in their rooms to govern their lives by. Like Gulliver's watch which the Lilliputians took to be his god because he never did anything without first consulting it, the clock is the great mechanical model to live by. Perhaps Hogarth remembered those portraits

in which clocks raise the question of whether time or the painter's art is more powerful.[23] Clock and old-master painting, perspective as time and as space both narrowing to a closure, are parts of a single metaphor.

The perspective box serves the purpose of locating the spectator himself in relation to this structure. He is an extension of the left foreground and so emotionally involved in the scene, closely connected with that immediate moment that is related to the receding durations of time past and future. Objects or figures in the left foreground naturally assume greater importance, arousing in the spectator a greater sense of identification; and distance, angles, and lighting act upon him in the same way.

Hogarth's false—sometimes we might think shaky—perspective in fact emphasizes these relationships. His *Satire on False Perspective* (1754) proffers the rationale: in a serious picture these errors of perspective are ludicrous; but in a comic one they can be useful, creating, as with the sword and wallpaper antlers in *Harlot*, Plate 2, visual metaphors. The overly steep walls of Plate 4 (and of *Rake*, Plate 8) suggest the temporally endless channel of the protagonist into a hopeless future. But Hogarth's uncertain perspective also emphasizes the dominance of his human characters; as on a contemporary stage, their relationship to each other is more coherent than to their paste-board setting, with which they are always slightly at odds.

All of this is appropriate because the settings Hogarth portrays extend from a cell in Newgate with the highwayman Captain Macheath, the inside of the Fleet Prison for debtors, and locked rooms of a madhouse to smaller, more enclosed rooms that only resemble and are metaphoric prison cells. The Harlot is imprisoned in Bridewell, the prison for women, but from her last glimpse of sky in the first plate to her final encasement in a coffin she is in rooms that are ever more confining. The Rake never ventures out of doors except once, and then he has hidden himself in a sedan chair to escape creditors and is pulled out into the open air by a beadle. Then he descends from a cell in the Fleet to one in Bedlam.

The sense of enclosure in rooms may have had purely personal origins for Hogarth, in the years of his youth spent within the Liberties of the Fleet (and his father, probably for a time at least, in a cell)—that is, in a room that may

have resembled a room but was in effect a prison cell. So in his imagined rooms windows and doors open on to closed scenes or are merely pictures on the walls that may appear to the characters to be windows of fantasy and self-expansion but are false openings; they do not look out into the natural world but only into a world of art that constrains the people within the room. This haunting image shared the age's fear of prisons and interest in stories of escape (like those of Jack Sheppard) and even lay near the surface of much of the talk in Pope and Addison about the geometrical vs. the natural garden. Certainly it echoes dimly that dark room of the mind by which Locke figured the process of perception.[24] The world of Hogarth's prints *is* that closed room with small access to the outside world and meagerly stocked with impressions, the objects and collections which make up the owner's character. The imprisonment is self-imposed in that he has chosen these objects himself, but in a sense they were also imposed on him because they were all that he saw looking out through those narrow chinks upon the external world, which was itself only a reflection of older, more cruel times perpetuated in art.

That these humans cannot always be quite contained by their closed perspective boxes is significant; somewhere in the Hogarthian topos is the impression that the human vital forces cannot be stifled, however closed the rooms in which they labour. But in general an ideal exists, often fragmentary and distant, in the open countryside glimpsed between buildings or through an occasional open window. For if he developed a powerful myth of life as a prison, Hogarth also indicated the way out, toward non-linear, non-geometrical visualizations and spatializations.

His own account of the effect of his progresses begins with literature and left-to-right reading—the need to 'follow the well-connected thread of a play, or novel, which ever increases as the plot thickens, and ends most pleas'd, when that is most distinctly unravell'd' —but also stresses the non-linear potential of his graphic images in a natural 'love of pursuit':

It is a pleasing labour of the mind to solve the most difficult problems; allegories and riddles, trifling as they are, afford the mind amusement. . . . Intricacy in form, therefore, I shall define to be that peculiarity in

the lines, which compose it, that *leads the eye a wanton kind of chace*, and from the pleasure that gives the mind, intitles it to the name of beautiful. . . .[25]

In a painting the verticals and horizontals and diagonals only regulate but do not subordinate the serpentine and irregular lines and shapes that lead the eye here and there, from object to object, never quite allowing it to rest. For Hogarth it is a principle of the most basic sort that geometrical structures should not finally regulate the vital Lines of Beauty of life. The plates are in fact constructed on a tension between the linearity of the book (and reading time) and the simultaneity of the picture. Made synchronous the separate temporal steps in the Harlot's first scene produce a 'character' of the Harlot; they relate as parts to a whole, signifying varying degrees of innocence and guilt which may be also a microcosm of English society.

Iconography then, learned and popular, is only one of the systems of signification used by Hogarth. He has fitted his allusions to art history and literature into a context of his own iconography based on stimuli in his immediate environment, on his own age's cultural sign systems, as if (living today) he were to employ a triangular shape to mean 'yield' or an octagonal one to mean 'stop'. His pictures are groupings of familiar environmental signs, from the shapes of walls and chairs and pictures to particular people known to his contemporaries.[26]

The relationship of the Hogarthian progress to the contemporary garden may by now be evident. The garden was constructed entirely out of a small vocabulary of signs—temple, Venus or Apollo, grotto—which were known copies, not original creations. These were refined upon and related in different configurations but represented basically a closed system. Yet placed in a natural setting, among the variety of trees and lakes, the known art objects acquired a certain openness, allowing for multi-perspectives and multi-dimensionality. In fact the same sort of emblematic meditation, which involves looking at something from a distance, then from close up and inside, and then from other perspectives, can be sensed in looking at a Hogarth progress, where you see one plate, then go in and explore all its inner relationships, and then,

proceeding to the other plates, see it in relation to these, see indeed all six or eight of them arranged spatially on a wall. They are automatically read both diachronically and synchronically. The sort of audience participation invited is very similar in both: in the actual penetration into the garden scene to examine the objects first glimpsed at a distance, in the increasing pursuit of the viewer into the depths of Hogarth's prints in search of meaning, and in the social event of the unravelling. Also notice that without the foil of certain formal elements —for example the presence of a formal garden nearby—the natural garden, which in itself is basically anti-geometry, would lose its effect; and Hogarth keeps history painting as a referent in his picture's composition, geometrical forms in its architectural structures, and both in the history paintings on the walls.

The effect is plainly not that of simple morality if, with Roger Fry, we define that as 'the need for responsive action [which] hurries us along and prevents us from ever realizing fully what the emotion is that we feel';[27] but neither is it the aesthetic emotion that 'requires no responsive action' but allows the viewers enjoyment of purely formal relationships unconfused by meaning. To a greater extent than in the garden, formal relationships in Hogarth's 'comic histories' are subordinated to iconographical relationships. There are a great many 'intellectual recognitions' (Fry's phrase), a part of the subject that is 'outside of and apart from, the form', and an 'intrusion of intellect'.[28]

The cognitive attitude called for by a picture like Hogarth's is of the problem-solving variety: standing before it the viewer asks questions, solves mysteries, poses and verifies theses. Perhaps one of the aesthetic pleasures that should not be overlooked is the verbalizing we associate with the *Tabula Cebetis*—or the graphic work's capacity for being put into words, analysed verbally, and talked about. It is also true that in Hogarth's case the sense of pursuit and discovery is a primary source of comedy, of the laughter that emanates from his prints—sometimes mysteriously, considering the grimness of their content. (Only at a later stage of his career does he depend on the more conventional comic structure of incongruity, which he also describes in the *Analysis*.)

Historically, Hogarth's progresses represent a withdrawal from extreme situations (saints' martyrdoms) and complex learned iconography to the commonplace and simple stories of harlots and rakes; and from a simple unified form to one that is relatively disunified. In a sense, the Venetians were seeking the highest formal and iconographical unity; Hogarth (or later Reynolds) might believe they placed an over-emphasis on unity of effect—which was replacing unity of a topos, reducing representation and the emphasis on parts, coalescing forms, and in the process accentuating a single feature (a knee) to which all the others are subordinated.

Hogarth's response was a disintegration of the interior and emancipation of the parts; a relative autonomy of details, which are therefore carefully represented. The general impression of a Hogarth composition is an initial unity that is increasingly broken down into first a relative independence of parts as we examine them and then a new interrelation. Take again the first plate of the *Harlot*: our initial impression of the transaction in the centre is soon broken down into other configurations, the clergyman-Harlot-Bawd, the Harlot-Bawd-Charteris; then the horse-bucket related to Clergyman-Harlot, the goose-Harlot, and so on. Each is emphatic in a way that does not quite allow integration with the whole; or at any rate at odds with the sense of unity, formal and iconographical, emphasized by Veronese's *Mars and Venus* or Ricci's *S. Marziale*. The result is materially coherent but not quite formally interrelated. These parts are over-emphasized and new relationships follow that are also over-emphasized to the disunity or breakdown of the original unity. Perhaps it is first seen as the story of the Harlot, and as the emphasis shifts to these other relatively independent figures and configurations, it is also about the Bawd, Charteris, and the Clergyman.[29]

4 Transition: *Claritas and Difficultas*

I HAVE BEGUN with the garden and the Hogarthian progress because, while opposed in some of their social and cultural assumptions, these two phenomena of the 1720–30s tended to adapt 'readable' structures from literary forms while also exploiting to the end of readability the iconographic traditions and plastic characteristics of their own media. But they were also verbal in the particular sense that they made visual certain ideas that are ordinarily expressed in words but that are too complex to be adequately so expressed. They offered possibilities of spatialization that went far beyond the ordinary capability of literary narrative and a few new ideas that were important for their time.

Built into the English garden's poetic subject matter was its hostility to the geometry of the French garden. The garden was central to the age because it served as the great example of 'nature'—artfully neglected shapes and serpentine paths—against geometrical patterns imposed on nature. This was the example Hogarth rephrased in comic contrasts between human nature and the constricting, imprisoning shapes men try to adopt. In *Taste in High Life* (1742) he showed beautiful girls being pared and corseted to conform to the fashion, with an example of topiary gardening nearby. His *Analysis of Beauty* codified the assumptions expressed by Addison, Pope, Stephen Switzer and others on the garden, and by Hogarth himself in his satiric prints. It may have been through the mediation of his prints as well as of the garden that writers became aware of those structural potentialities of their own medium that had been borrowed and adapted by art. It seems clear that the importance—the centrality —of Hogarth and the garden lies in the fact that while the interaction between the arts in the eighteenth century went both ways, the powerful pull was from the direction of the visual (the sense of sight, the immediately perceptible) and the over-all result was less a verbalization of the visual than a visualization of experience usually conveyed by verbal structures, which now seemed no longer adequate.

A spokesman for the age, Joseph Addison, defined the pleasures of the imagination as seated primarily in the sense of sight: 'Our Sight is the most perfect and most delightful of all our Senses.'[1] In the empiricist model of the mind no ideas are innate but all arise from sensation and reflection,[2] and the empirical philosophers tended to reduce sense perception to variations of sight (e.g., the blind man who 'saw' scarlet when he heard the sound of a trumpet) and described the operations of the mind in a language borrowed from the observation of visible phenomena. In Locke's basic metaphor of sight our ideas are 'clear and obscure' in the same way as 'what we call clear and obscure objects of the sight'. And the other side of the coin was also pointed out by Locke: 'That which has most contributed to hinder the due *tracing* of our *Ideas*, and finding out their Relations, and Agreements or Disagreements one with another has been, I suppose, the ill use of *Words*.'[3] Twenty years after Locke wrote, Bishop Berkeley began his *Principles of Human Knowledge*: 'We need only to draw the curtain of words, to behold the fairest tree of knowledge, whose fruit is excellent, and within the reach of our hand.'[4]

The distrust of the word—that mainstay of the English genius—can be traced for our purposes back to the seventeenth century, to Bacon, Hobbes, and the Royal Society, and in the eighteenth to the duncical proliferation of writings of all kinds deplored by the satirists of the Scriblerus Club. The idea that error stems from our tendency to think in words instead of about the things the words signify, and indeed that English culture of the period was felt to be dominated in some unhealthy way by words and the book, by concepts rather than percepts, is easily documented. *The Dunciad* and *Tristram Shandy*, Hume's *Treatise* and Burke's *Enquiry*, the poems of Blake and Wordsworth are preoccupied with this problem. In their different ways they all show attempts to escape the tyranny of certain syntactic and semantic structures and seek in others a more immediate intuitional mode of communication.[5] Hume went to great lengths in his *Treatise* to show that

logical and other verbal structures have no more real validity than any other 'beliefs', and that the truth is merely an immediate, wordless sympathy. The final extension of these assumptions was *Tristram Shandy* ('Well might Locke write a chapter upon the imperfection of words'), which had to do with attempts on all levels to substitute a linguistic experience for a real happening—most obviously in Uncle Toby's efforts to explain 'where were you wounded?' and Walter Shandy's attempt to communicate all possible experience unexperienced by the use of auxiliary verbs. Verbal structures—by which we mean all non-perceptual or directly experiential structures—conceal rather than communicate, and contact is possible only by the sympathy that occasionally breaks through them.

For writers like Fielding and Sterne, as well as Richardson, Hogarth was the *pure* artist of the time, doing with visual language what they attempted with the faulty vehicles of words. As they realized, nature is more immediately apprehended in a painting than in a poem because the objects are without the counters of words, and so without as much opportunity for confusion and misunderstanding. Words themselves may bear connotations, while in a painting only the objects do. As Jonathan Richardson wrote in his *Science of a Connoisseur*, 'Painting is another sort of writing', but it has the advantage over writing that ideas

come not by a slow progression of words, or in a language peculiar to one nation only; but with such a velocity, and in a manner so universally understood, that it is something like intuition, or inspiration.... What a tedious thing would it be to describe by words the view of a country (that from Greenwich Hill for instance) and how imperfect an idea must we receive from hence! Painting shews the thing immediately, and exactly.[6]

Obviously, if one believes that everything of knowledge derives from the senses, even words from the naming of a particular object that has turned to abstraction ('Spirit, in its primary Signification, is Breath'), then the visual image is going to be more immediate, more powerful, and effective than a complex statement of abstractions—whether these be words ('spirit' as the opposite of matter) or visual images like Ripa's that have themselves

lost their particularity, lost contact with their sense-origin.[7]

The basic linguistic process of the century from 1660 to 1760 was nominalization. The Baconian ocular examination of particulars, and the Royal Society's preference for things to words, led to systems of classification (one being the picture collection), and in language to an emphasis upon the noun as norm. Language as a system of names is an obvious way to interpret the scenes in Hogarth's prints, and also to describe the lists of particular objects in the novels of Richardson. But Hogarth, we have seen, constantly dramatizes the discrepancy between the name and the thing named, showing his awareness (with Hugh of St Victor but also with Swift and Pope) of the limited meanings of a word and the unlimited significance of the object designated. In effect, the noun phrase *carried sword* (*Harlot*, Plate 2) has to be *reverbalized* as *sword stabs in the back*, and (in Plate 3) *curtain knot* as *face screams*. The conventional name becomes inadequate, and an apparent nominalization reveals a verbal action; noun changes to verb as a static object is revivified to an act of screaming or stabbing.

Hogarth's structure draws on a backstairs tradition of the emblem, somewhat different from its analogue the poetic garden: this is the satire that presents (or imitates) a suspicious verbal structure and then explicates it. In the rehearsal plays and their prose equivalents (from Buckingham's *The Rehearsal* to Marvell's *Rehearsal Transpros'd*, Prior-Montague's *The Hind and the Panther Transvers'd*, and ultimately Fielding's rehearsal plays and *Shamela*) what is presented is a text, either true or manufactured, whose accepted meaning has to be repudiated and replaced by a true—the apparent sublimity of a Dryden heroic play with its real silliness, the feigned Pamela with the real Shamela. Involved is a reinterpretation the same as that at the heart of a Hogarthian print: those images of Hercules, the Visitation, and Abraham and Isaac do not mean what they have traditionally been thought to mean; they have to be *reverbalized* as much livelier and more complex structures of meaning.

Hogarth's theme of the oppressive visual image that is framed and sanctioned by time finds its equivalent in those books, sermons, letters, marriage contracts, legal opinions and other documents that constrain vital activities

12

13

in the novels of Fielding and Sterne. The obverse, his attempt to create a new narrative *ab ovo*, was also implicit in the 'true histories' of Defoe (whence he may have obtained his idea for the Harlot) and was taken up by Richardson and Fielding, who sought to tell a story that is *not* the same old myth.

Illustration, in this respect, was the crucial historical step for the artist (Hogarth and also his colleagues of the St Martin's Lane group) because it was one of the ways to make the break with the great stereotyped subject and style, as well as with patronage. Indeed illustration is as clear a case as exists of literature influencing art, for as literature broadened and dealt with different and more contemporary subjects, the artist was drawn to develop, or found a sanction through illustration for developing, the same concerns graphically. In the eighteenth century through the agency of book illustration an artist could introduce other, more immediate or contemporary texts; he could shift his attention from Homer, Ovid, or the Bible, to Cervantes, Molière, or even Butler and Swift, and thence to his real interest, contemporary scenes, the stage, and comedy or satire. Hogarth and his tradition are inconceivable without *Don Quixote*, the various picaresque novels, *Pilgrim's Progress*, and the writings of Defoe, Butler, Swift, Pope, and Gay.

Hogarth's own progress is from the actual text on the opposite page in the illustrated book to the large independent illustration for *Don Quixote* and *Hudibras* which assumes the text in the viewer's mind and reminds him via a few lines and references underneath, at least by a caption. *Hudibras* served him best, because it was already assuming prior texts—*Don Quixote* and, with it, tales of chivalry and heroism— which it flaunted and exposed as utterly inappropriate to its hunchbacked hero. Next was the assumed general text, like the *Don Quixote* beside a *Hudibras*—or a criminal biography beside the life of a harlot, or beside the life of a rake both spiritual biographies and Hogarth's own progress of a harlot, as well as ironically other kinds of progresses and lives, with scenes from the Bible or Homer, the paintings of Raphael or Rembrandt. With Cervantes and Butler, Swift and Pope, and above all Gay's *Beggar's Opera* (which he 'illustrated' repeatedly between 1728 and 1732) Hogarth had a text that opened up the possibility of the mock-text,

of juxtaposing the heroic, romantic, the plainly fictional with the contemporary everyday.

Hogarth, however, was making a break with tradition that was impossible for either a William Kent (or Henry Hoare) or an Alexander Pope, who still used forms of the past as honoured structures by which truth is defined. Pope understood the distinction between the detestable actions of the epic hero and the great poetry of the epic and noticed a 'shocking Spirit of Cruelty' in Homer's heroes.[8] But his great mock-epics retain undiminished confidence in the grandeur of the heroic norm and do not distinguish hero from poem. Only with Butler, and then with Defoe, perhaps Gay, certainly Hogarth and Fielding, does heroic morality become unacceptable, and with Hogarth to some extent heroic art itself.

The verbal phenomenon parallel to Hogarth's progresses was the novel, which broke with the literary assumptions informing poetry in a way that had never happened before. Both Hogarth and the novelists were seeking new structures, and however various their intentions they all transformed the old structures beyond recognition. But of course there is no absolutely new meaning. Hogarth creates structures that violate the simplicity and stability of topoi, but in practice he has to produce topoi of his own which he then repeats. Out of the infinitely many possible messages he has to choose a limited number permitted by the codes available to him in the 1730s and 40s. In all of his works only *some* structures actually emerge, and the most obvious one is the myth made out of the fragments of the old, which is *about* the danger of oppressive structures and the old and irrelevant. This is not precisely demythologizing in the name of realism and a new truth so much as satirizing certain structures that affect humans adversely. And then we notice that only certain myths are treated in this way: the process is not by any means total secularization. While the classical myths and the Old Testament stories tend to be discredited, along with many traditional saws, two areas remain relatively unscathed: the New Testament ethic of charity and the *Vanitas* topos, which subsumes so much as to be almost (but not quite) meaningless, but remains nevertheless intact and behind much of Hogarth's work.

Perhaps the heavy reliance on *Vanitas* explains the peculiarly English emphasis on sincerity as

plain-speaking, the opposite of role-playing, as natural vs. artificial or stylized. Sincerity to the English, as Lionel Trilling has noticed, is communication 'without deceiving or misleading', i.e., being oneself; it is not, as among the French, and supremely in Rousseau, 'to know oneself . . . and make public what one knows', but rather 'to be oneself, in action, in deeds'.[9] Sincerity is the assumption behind Hogarth's distrust of art so long as it may be confused with nature, in Fielding's distrust of literature unless it is clearly understood to be literature, and in Sterne's distrust of it in any case—roughly parallel to Rousseau's attack on most literature (especially the drama) with the exception of the novel. Initially a distrust of distorting form, this implies and also becomes a positive concern for sincerity and authenticity in the sense of needing 'some word which denotes the nature of this being and which accounts for the high value we put upon it'.[10]

Thus Richardson writes a kind of romance, certainly recalling Patient Griselda, Cinderella, and other romance heroines, but he materializes it in letters reproduced as a printed page. The printed signs on the page 'do not refer to a situation, they *are* the situation', and 'typography itself becomes a form of mimesis'.[11] Pamela's interruption by the sudden arrival of Mr B. is a white gap on the page; Clarissa's rape is followed by her disordered thoughts rendered in jumbled lines darting every which way on the page. These letters are symbolic visual objects, Clarissa's writing of them symbolic actions, expressing far better than words alone her independent will, and their disintegration and extinction represent the last shreds of her earthly identity that disappear after the rape. Her silence and the chattering of the letters of other writers around her represent Richardson's message about spiritual victory through physical defeat. The visual strategy is carried much further by Sterne in *Tristram Shandy*, where in order to make himself understood Tristram must rely upon dashes of varying length, curious typography, blank or marbled or completely black pages, and sundry diagrams showing the corresponding non-linearity of the narrative itself.

Clarissa's letters and Tristram's *aperçus* are segments, like the stops in the garden or the plates of a Hogarthian progress, and indicate a narrative line that is by no means straight. They not only do not progress in a chronologically straight line, their arrangement forces the reader to cross-reference from one account or time or place to another to fill in the action. And Fielding, while telling his story in linear chronology, complicates it so by his own ironic commentary that it becomes a matter of some importance to relate scenes and speeches spatially as well as chronologically. Tristram Shandy makes the point explicit when he tells his reader to go back and re-read chapters he has not retained, and in fact attempts to replace the linear structure he inherited from the writer of narrative with a spatial, painterly one. He urges his readers to read his book not as if it were a book but a picture.

In this period writers and artists found themselves moving into the same problem of what literature and art are and might be. 'Comic epic in prose' and 'comic history-painting' are terms that lead at length to questions raised by Fielding's puppet show and Hogarth's broadside prints and only half-facetious exhibition of signboards (1762). Once the old iconography was understood to be just that, the question of how to use it, what to put in its place, and where to go from there occupied Hogarth into his last years and the artists who followed him into the 1760s and 70s.

We must now entertain the paradox that the victory of visualism which made Hogarth central to English literature as well as art in the 1730s and 40s also led to the reaction against a synthesis of visual and verbal in favour of a totally visual and immediately-graspable impression. (The reaction may explain something of the intensity of Sterne's response, which virtually repudiates Hogarth himself as a formulator of experience into words.) The sort of cognitive experience enjoyed by 'reading' Hogarth's prints was recognized and understood in the early part of the eighteenth century, but it has gone against the main line of art appreciation and/or criticism since the 1750s. Kenneth Clark speaks for our age when he says he is first attracted by 'a general impression, which depends on the relationship of tone and area, shape and colour', whose 'impact is immediate'.[12] And his sentiment is essentially an echo of Shaftesbury's assumption that 'the fewer the objects are . . . the easier it is for the eye, by one simple act and in one view, to

PAPER X.

LEAD me, where my own thoughts themselves may lose me;
Where I may dose out what I've left of life,
Forget myself, and that day's guile!——
Cruel remembrance!——how shall I appease thee?

—— Oh! you have done an act
That blots the face and blush of modesty;
Takes off the rose
From the fair forehead of an innocent love,
And makes a blister there!

Then down I laid my head,
Down on cold earth, and for a while was dead;
And my freed soul to a strange somewhere fled!
Ah! sottish soul! said I,
When back to its cage again I saw it fly;
Fool! to resume her broken chain,
And row the galley here again!
Fool! to that body to return,
Where it condemned and destined is to *mourn!*

Oh, my Miss Howe! if thou hast friendship, help me,
And speak the words of peace to my divided soul,
That wars within me,
And raises every sense to my confusion.
I'm tottering on the brink
Of peace; and thou art all the hold I've left!
Assist me——in the pangs of my affliction!

When honour's lost, 'tis a relief to die:
Death's but a sure retreat from infamy.

Then farewell, youth,
And all the joys that dwell
With youth and life!
And life itself, farewell!

For life can never be sincerely blest.
Heaven punishes the *bad*, and proves the *best*

Death only can be dreadful to the bad;
To innocence 'tis like a bugbear dressel
To frighten children. Pull but off the mask,
And he'll appear a friend.

I could a tale unfold——
Would harrow up thy soul—

By swift misfortunes
How am I pursued!
Which on each other
Are, like waves, renewed!

19 Page from Samuel Richardson's *Clarissa* (1747–48).

C H A P. XL.

I Am now beginning to get fairly into my work; and by the help of a vegitable diet, with a few of the cold feeds, I make no doubt but I fhall be able to go on with my uncle *Toby*'s ftory, and my own, in a tolerable ftraight line. Now,

Inv.T.S *Scu*

Thefe

20 Page from Laurence Sterne's *Tristram Shandy* (1762).

comprehend the sum or whole', and of Sir Joshua Reynolds' denial that a picture can be 'read' like a book: 'What is done by Painting, must be done at one blow.'[13]

By the 1740s and 50s Locke's distrust of words was being turned by Condillac and the French Encyclopedists into a reverence for those arbitrary signs which when properly used make thought possible. The obstacle of 'speaking by action' has to be surmounted before the possibility of 'natural signs' can lead to 'instituted signs' or abstract thought; this is a great leap, but Condillac is aware of the implicit loss as well as gain:

Persons not yet accustomed to institute signs have the liveliest imagination: consequently as the mode of speaking by action or gesture is the immediate work of the imagination, it ought to have more energy and force.[14]

The post-Hogarth generation could no longer use visual images with the freedom and confidence that he did. Visual was visual and verbal was verbal: one was sense, the other reflection, and though there was an obvious, and still Lockean, relation, the first was just a stepping stone to the second—or, for Sterne and his generation, 'speaking by action' became a fortunate regression into primitivism prior to

language, or a leap forward to the ineffable beyond language. But they were now, as they had not been for Hogarth, separate and distinct.

The change is most obvious in the garden, where the object-cluttered poetic garden becomes the long unbroken serpentine lines of Capability Brown's park in the 1750s and 60s. Brown in fact removed many of the statues that, however meaningful, broke the lines he wanted his viewer's eye to follow unimpeded. Looking back from 1770 Thomas Whately recounted all of these 'devices' and concluded that they 'are rather *emblematical* than *expressive*; they may be ingenious contrivances, and recall absent ideas to the recollection; but they make no immediate impression, before the whole design of them is well understood. . . .'[15] He sees gardens as progressing from structures that require examination, 'reading', reflection, and even guidebooks, to structures that are simply expressive. Better than incongruous objects from Italy or the interior of a house, one should employ familiar shapes that can be expected to appear in a garden; and better yet, arranged so that the effect is immediate and requires no thought, discussion, or discernment.

This is, of course, only the positive part of the Hogarthian proposal, ruling out the pleasure of pursuit and discovery through all that clutter that leads to the conclusive judgment against clutter and closure. Hogarth's method looked back if his doctrine looked forward. He was one of the last and most consistent adherents of the old *difficultas*, which began significantly as a literary concept, with respected witnesses like Castiglione and Boccaccio ('You must read, you must persevere, you must sit up nights, you must inquire, and exert the utmost power of your mind', Boccaccio urged the reader)[16] and, closer to Hogarth's own time, the Earl of Roscommon, who could write what he took to be a truism:

> For if your Author be *profoundly* good,
> 'Twill cost you *dear* before he's understood.[17]

These literary sentiments were picked up with much else by the Renaissance theoreticians of history painting, and the criteria for excellence in one became the same in the other. Dryden sums up:

The eye cannot comprehend at once the whole object, nor the mind follow it so fast; 'tis considered at leisure, and seen by intervals; Such are the subjects of noble pictures; and such are only to be undertaken by noble hands.[18]

The form taken by *difficultas* in the related genres of epic and history painting is the veil of allegory. In the subscription ticket for *A Harlot's Progress* Hogarth drew on this tradition: lifting the veil is an allusion to the veil of allegory by which the poet traditionally protected the Truth he was conveying from being debased by contact with the multitude.[19] 'The poet obscures the sun with cloud, through which people may see its light, though they cannot tell its exact position. The few, however, can with difficulty pierce the cloud bank and see the truth, and this is the most important function of the veil.'[20] The duty of the philosopher was to strip truth, but of the poet to retain its mystical significance.

In the terminology of Hogarth's own time—and *The Spectator*—he associated his plates with the double meaning of epic allegory, that is with a 'plain literal Sense' and a 'hidden Meaning'.[21] 'The Story should be such as an ordinary Reader may acquiesce in, whatever Natural, Moral or Political Truth may be discovered in it by Men of greater Penetration.' There will be a plain story, let us say of a harlot come to London or of a marriage between an earl's son and a merchant's daughter, with a clear pattern of action and consequence, understood by the 'ordinary reader'; and then, for 'Men of greater Penetration', something more.

The fact of the two audiences in Hogarth's work can be restated in terms of other traditions as well. The exegetical approach he required of the purchasers—or some purchasers—of his prints is too close to Puritan modes of thought to be coincidental. The Puritan's was a world of *seeing*, which meant to see not only literally but to sense the unseen reality within natural objects as well. The Puritan world, like Hogarth's engraved world, with its innumerable things scattered about, was intended for a reader who sees not only literally but senses the unseen reality, however witty and apparently unspiritual. 'In a world charged with meaning by the Creator,' writes a recent scholar, 'the elect are distinguished by their accurate sense of vision, and this in turn involves not only seeing but interpreting correctly.'[22] There was clearly an elect among Hogarth's readers.

21

21 William Hogarth, *A Harlot's Progress*, subscription ticket: *Boys Peeping at Nature*. Etching (1731).

The situation was also implicit in the paradox of the emblem's intention to be both popular and erudite—to teach wisdom 'not only to the mind but to the eye, thus benefiting those who are unable to read', and so produce a sugar-coating, an amusing picture puzzle, for the large public.[23] This was the aspect of the emblem that was exploited by the propagandists of the Reformation in their popular prints. But Claude Mignault, who began the annotating of Alciati's *Emblemata*, explains that the task of the emblematist is to avoid obvious symbols, which are valueless, and employ dark conceits that circle and wind the meaning out of obscurity.[24] To which we might add the testimony of Ripa, another founding father of iconography: the emblematist works with signs that 'present one thing to the eye but meaning [sic] something other to the mind'; and he further praises these because they provide the learned with arcane wisdom while providing the ignorant with enjoyment.[25] There is a contradiction between the desires to avoid 'obvious', specified, formulated meanings and to communicate with the general public. The result is a puzzle which is the contrary of a sign that presents the *same* meaning to eye and mind simultaneously and immediately.

Difficultas in Hogarth's work lies not in his use of esoteric iconography but in his intellectual play with commonly known iconography from all sources. This is not to say that he did not also, upon occasion, introduce images recognizable only to those readers familiar with Ripa and Alciati; and a more than superficial knowledge of mythology and the Bible was necessary for the 'Reader of greater Penetration'. But the only thing approaching ambiguity is the depth to which the reader should pursue the meaning: there is room for a penetrating and a general reader, but their meanings are not contradictory. Notice, looking back at *Boys peeping at Nature*, that the faun-satiric emblem is there to reveal, to lift the veil, and the putto is there to restrain him. They produce a tension or *concordia discors* that was as typical of the emblematic mode as of the allegorical, and, in its own way, of the Augustan satiric mode: '... treat the Goddess like a modest Fair,' Pope wrote, 'Nor over-dress, nor leave her wholly bare.'[26]

It was Hogarth's great accomplishment with the *Harlot's Progress* to capture both audiences.

And it was his continuing problem to hold both. He must tell a story and at the same time, without contradicting himself, interest the learned few.[27] But times were changing, and the superiority of the popular, immediately-understood image was urged by such a learned writer as Addison, who was already shifting his emphasis in the *Spectator* referred to above from the 'Men of greater Penetration' to the 'ordinary Reader'. Corroborating Shaftesbury's advice to avoid the difficulty of the hieroglyphic mode, Addison opposes interpretations based on a learned tradition and says they are merely illustrated metaphors.[28] Charles Gildon's commentary in 1721 on Roscommon's couplet on *difficultas* twists the sense and attributes obscurity in great authors like Homer and Virgil only to 'the distance of time, and the deaths of those languages, the alterations of manners, customs, etc'.[29]

The virtues of *claritas* or *simplicitas* were being advanced at the expense of the ancient charms of *difficultas*. Whatever is difficult is now thought to be confused: 'The man who is not *intelligible* is not *intelligent*.'[30] The perseverance and exertion Boccaccio urged on the reader should be all the author's, and there should be no effort expended on interpretation. What meaning is in the passage is seized upon at once or not at all.[31] What requires, and is only understood through, interpretation and puzzling out is not meaning. With the dwindling of the standards and the cooperation of the reader, went also the value of criticism and explication: 'as perspicuity is the end and supreme excellency of writing,' William Melmoth wrote, 'there cannot be a more fatal objection to an author's style, than that it stands in need of a commentator'.[32] Thus the audience of any work of art should be as wide as possible; a poet should be 'popular among the bulk of readers'.[33]

The direction in which literature was being pushed, as this shows, was toward the visual arts, and the central doctrine was that of aesthetic immediacy—the belief that the perception of beauty is instantaneous; and while morality was not ruled out, the aesthetic experience became in effect an end in itself. Certainly the rational argument usually associated with moral discourse—the careful art of persuasion—was replaced by immediate sensation. 'The Pleasures of the Imagination,' said Addi-

son in *Spectator* No. 411, 'have this Advantage, above those of the Understanding, that they are more obvious and more easie to be acquired. It is but opening the Eye, and the scene enters.' Reading is a Secondary Pleasure of the Imagination, defined in No. 416 as 'that Action of the Mind, which compares the Ideas arising from the Original Objects, with the Ideas we receive from the Statue, Picture, Description, or Sound that represents them'. And yet even the Secondary Pleasure apparently requires no more effort than the Primary. Both avoid the laborious Pleasures of the Understanding, and define an aesthetic experience.[34]

The other side of Hogarth's praise of the pleasure of pursuit in art was expressed by Thomas Tickell when he wrote:

Unless Poetry is taken in at the first glance, it immediately loses its force and point. For Pleasure does not suffer tiresome and indefatigable labour of the mind, and delights not in following, like a nimble acrobat, the tangled thread of reasoning.[35]

In the wake of this view Hogarth and William Kent could be tarred with the same brush. Kent's garden like Hogarth's modern moral subject employed shapes, space, and emblems as 'a kind of chace', and in the 1750s Sir William Chambers was castigating Kent for being so 'very fond of puzzling his spectators' with architectural structures 'which certainly would have added more to his fame had they been less complicated and abundant in variety'. They are, he said, 'too full of incident and movement', keeping 'the spectator's eye in a perpetual dance to discover the outlines'.[36]

Chambers is expressing the attack, most vocal in France, on rococo frivolity and play in the name of seriousness and restraint. In France the simplicity and purity of form was becoming an ideal at one with simplicity and purity of morals—or with art as moral propaganda.[37] Hogarth of course shared the belief in the moral vs. the erotic, and the modern and immediate vs. the classical. But in some basic ways he shared with the rococo a complexity of turns and twists that did not stand up very well against ideals of simplicity and purity. The general impression given by one form of rococo art is unsubordination, forms denying 'the eye stable focusing points round which the rest of the composition could be organized', as

opposed to the 'good' gestalt with its simple stable, compact structure.[38]

Indeed, Hogarth's is an art of multiple gestalts, one shifting into another as in a series of optical illusions. As we have seen, his prints refuse to stand still, continuing to impose new gestalts and defeat expectations as long as we look at them. Sometimes the initial impression is one of visual confusion.

Hogarth uses this effect in his prints first as an expression of moral disarray—the immediately-graspable gestalt—and second as a flickering forest in which the viewer's eye then roams about without coming to final rest, gradually moving from particular to general, from isolated pieces of information to relationships and a coherent moral statement of meaning. This new language has the advantage of a more complex meaning than is possible in illustrated topoi, but with it goes the disadvantage that often, especially when the meaning gets very complex, and a story is implied as well, he must resort to pointing fingers, literal readability, too many objects and too many inscriptions. In a way it is very rococo of Hogarth to have so precise a denotation, so many different denotations, and so much 'information' in a print— 'information almost to the point of incomprehension' a modern might think.[39]

This is the accusation Hogarth answers in his *Analysis of Beauty* (1752) when he sums up both alternatives: 'When lights and shades in a composition are scattered about in little spots, the eye is constantly disturbed, and the mind is uneasy, especially if you are eager to understand every object in the composition.' This is primarily the readable structure we have been examining. But there is another kind of composition, he adds, in which a figure is 'better distinguish'd by its breadth or quantity of shade, and view'd with more ease and pleasure at a distance', in which 'large, strong, and smart oppositions' of form and colour give 'great repose to the eye'.[40]

When he wrote this, he had already moved far toward the second alternative. We can sense the change beginning as early as 1738 in *The Four Times of the Day*, where the basic visual structure of intricacy and disorder within rigid architectural shapes, which is also one of contrast, is modified to one of balance. No longer does Plate 2 follow from Plate 1 as consequence from action, but is juxtaposed with it,

and within each plate incongruously contrasting shapes bring out another form of comic strategy different from the 'love of pursuit' and the surprise of discovery. But contrast can also, as the French theoreticians realized, be a powerful moral structure, and it was in this direction that Hogarth turned in 1747, invoking a popular rather than a sophisticated audience.

However, before turning from theory to practice, we should notice two further mid-century statements on the relationship of visual (immediately graspable) structures to verbal. A few years after the publication of *The Analysis of Beauty* Alexander Gerard picked up Hogarth's implicit distinction between beauty, the aesthetic experience, and (what he considers its components) variety, intricacy, and the 'love of pursuit' that constituted the *difficultas* of his art. In his *Essay on Taste* of 1759 Gerard divided aesthetic effect into several categories including the Beautiful, Sublime, and Novel. The last, deriving ultimately from Addison's middle term between Beautiful and Great, attempts to domesticate *difficultas* or 'intricacy' and make it again presentable. Novelty, according to Gerard, is one kind of aesthetic pleasure that is no whit inferior to Beauty or Sublimity: it pleases by 'enlivening the thought, or exercising the mind', by putting the mind to

a lively and elevated temper. It attains this temper when it is forced to exert its activity, and put forth its strength, in order to surmount any difficulty: and if its efforts prove successful, consciousness of the success inspires new joy.[41]

Gerard is in favour of a 'modest difficulty, such as exercises the mind without fatiguing it'. At the other extreme, 'Even plainness and perspicuity becomes displeasing in an author, when it is carried to excess, and leaves no room for exercising the reader's thought.' While 'great obscurity disgusts us,' he says, we always require 'some degree of it, [which] occasions a suspense of thought, and leaves the full meaning to be guessed at, and comprehended only on attention'. His conclusion is the typically Augustan one Hogarth would probably have accepted: 'The exercise of thought which moderate difficulty produces, is a principal source of the pleasure we take in study and investigation of every kind. . . .'[42]

Rousseau, writing about the origins of language in the 1750s,[43] realized that the purely visual image or gesture, while it can express the passions, fails to extend or redirect them. Some verbal element is required. Looking back from our own perspective we too can see that 'the pure appeal to sight or touch condemns the audience to the emotional poverty of being, in Wittgenstein's phrase, "held captive" by a picture'.[44] What Hogarth recognized was that a purely visual construct, absorbed 'at a blow', prevents its viewer from becoming anything except what he beholds—the very evil he is concerned with in the Harlot and her Jewish keeper. It was then incumbent upon him to produce a work that itself avoided this danger of emulation; and he does this by using verbal structures to complement the visual image. This is much the same problem Fielding sensed in the simple immersive effect of *Pamela* upon its susceptible readers and tried to correct by adding normative commentary and in various ways labelling his narrative as verbal discourse.

But Rousseau was inveighing against written language as a principal agent through which reason supplants passion. 'Writing,' he says, answering Condillac, 'which would seem to crystallize language, is precisely what alters it. It changes not the words but the spirit, substituting exactitude for expressiveness.' And he adds: 'Feelings are expressed in speaking, ideas in writing.'[45] He must, therefore, distinguish three phases of language: the depiction of objects, the visual image which corresponds to passionate language; conventional characters for words and propositions (iconography), which make the viewer form words; and alphabetic writing, which breaks down the speaking voice into a given number of elementary parts, more to analyse speech than to represent it. Alphabetic writing stands at the furthest remove from the passions and the accents through which voice communicates the passions. Hogarth's work has the unique efficacy of employing all three of these forms: the image itself is complemented by verbal structures including writing (within and without the design); the verbally structured, by its problematic nature, serves to activate the spoken; and the spoken accordingly serves to dissolve the written.

5 Industry and Idleness

THE TWELVE plates of *Industry and Idleness*, which Hogarth published in 1747, tell of two apprentices, whose stories are as simple as their names: Francis Goodchild and Tom Idle. In Plate 1 Goodchild directs the thread on his loom as he directs his life by the *Prentice's Guide* and the ballads of *Dick Whittington* and *The London Prentice* toward the Whittingtonian goal of mayorship. Tom Idle dozes, relinquishing control of his spindle; his *Prentice's Guide* is tattered and discarded on the floor and his only models are the ballad of *Moll Flanders*, beer, and tobacco. Light from the window shines in on Goodchild, and in the margin of his side of the plate are the mace of the City of London, an alderman's gold chain, and the sword of state. But Idle, asleep, is away from the light, and along his border are whip, fetters, and a rope, and across the room from him retribution enters in the form of his chastising master. The contrast between industry and idleness and their consequences, in fact the whole story, is summed up in this first plate.

But we have eleven more plates built on the same contrasts. Plates 2 to 9 are structured in pairs, with Goodchild's action followed by Idle's. Plates 2 and 3 contrast their piety: Goodchild inside the church, accompanied by his master's daughter, with light falling on him again, and Idle, outside, with bad company, gambling on the sabbath, suspended over an open grave, among skulls and bones, and with nothing over him but the threatening shape of a beadle replacing that of his master.

Plate 4 shows Goodchild inside his master's counting house, with the master pointing to the shop, saying in effect: 'The shop is all yours: I entrust you with the management of it.' The church is followed by the counting house, obedience to his heavenly master by obedience to his earthly master. In Plate 5 Idle has forfeited his indentures—perhaps as a result of his un-apprenticelike doings on the sabbath, perhaps of his own free will. But his indentures are floating away in the water; he has betrayed first his heavenly and then his earthly master, and he is now outdoors and exposed to the elements. Instead of being in the solid, comfortable, protective shop, he floats precariously

on a choppy sea, accompanied by the figure of his widowed mother, a sad reminder of conscience and duty. As the master points to the shop, which is now Goodchild's, so a sailor points to Idle's immediate and eventual destinations, the ship and the gallows; as the master rests his hand on Goodchild's shoulder, so does a sailor on Idle's, but to show him the cat-o'-nine tails and indicate the misery he will suffer on shipboard. Idle defiantly responds with the cuckold's sign directed at his tormentors, but almost equally at his poor mother. Nooses hang at the side of the boat: they have now moved inside the print.

In Plate 6 Goodchild has married his master's daughter and become his partner. In the morning sunshine Goodchild leans out of his window to pay the serenading musicians, while in Plate 7 Idle is in bed with a prostitute, with stolen earrings, a watch, and a pistol at the ready. Unlike Goodchild's solid brick house, this is a dilapidated garret with fallen plaster, gaping holes in the floor, a crumbling chimney, and broken utensils. Goodchild's door is open, a gesture of charity; Idle's is bolted shut, and as usual he is lying on a bed. The sound of music pleases Goodchild, the noise of the cat and rat terrifies Idle, reminding him of the hostile outside world.

In Plate 8 Goodchild, now sheriff, is at an official banquet, and a constituent appears at the door with a petition for him; in Plate 9 Idle is among brawling, thieving hoodlums in a night-cellar, being betrayed by the girl he was in bed with in Plate 7, accompanied by the same character with the eye-patch and striped cap he gambled with in Plate 3 when he should have been in church. A constable, directed by the treacherous girl, enters to arrest him. And the hangman's noose is again materialized within the picture, hanging from the ceiling.

In Plate 10 the two apprentices are brought together once more: Idle begging for mercy, Goodchild regretfully passing judgment; Idle, who until now has always been asleep or (though never relaxed) nearly recumbent, cowers before Goodchild, his bent form contrasted with the strong unbending verticals of the pillars, the wall, the desk, and Goodchild's

own torso. Finally, in Plates 11 and 12 the order of contrast is reversed, and first Idle is shown on his way to the gallows and then Goodchild on his way to the Guildhall to be inaugurated as Lord Mayor: Idle outside, exposed, under a cloudy sky, with a Methodist minister exhorting him to repent; Goodchild under a clear sky, inside a coach, accompanied by dignitaries, with the sword of state (now materialized within the picture) showing at the coach window.

When *Industry and Idleness* appeared it must have looked very different from Hogarth's earlier series. The prints were smaller, in a cruder style, with the visual image much simpler. The complex reading structure of allusions, puns (both visual and verbal), parallels and contrasts, that reached a climax of intricacy in *Marriage à la Mode*, is replaced by the simple pattern of a morality—right and wrong, reward and punishment, action and consequence, strengthened by the stark blacks and whites of the design. For the greys are largely absent visually as well as morally: the

earlier plates were reproductive engravings which imitated the minutest shades of texture in an oil painting. These plates are simply penny prints, with the art historical context ostentatiously rejected by the turn to a popular twelve-plate cycle with Biblical mottoes at bottom, title at top, and emblematic borders. No longer are connoisseurs of painting or readers of the English and Roman Augustans directly addressed, but rather the people who went to puppet shows and morality plays at Bartholomew Fair and knew their Bible. The audience, for the first time, coincides with the subject of the prints. The *Harlot's* and *Rake's Progress* were obviously not addressed to harlots and rakes but to an audience that could meditate with detachment on such representative types. But *Industry and Idleness* is addressed—in both form and content—to apprentices, and though it was the master who bought the prints, he hung them for his apprentices' enlightenment or gave them sets of their own as Christmas presents. And the master himself was, of course, an ex-apprentice.

22 William Hogarth, *Industry and Idleness*. Plate 1. Engraving (1747).

23 *Industry and Idleness*, Plate 2.

24 *Industry and Idleness*, Plate 3.

25 *Industry and Idleness*, Plate 4.

26 *Industry and Idleness*, Plate 5.

27 *Industry and Idleness*, Plate 6.

28 *Industry and Idleness*, Plate 7.

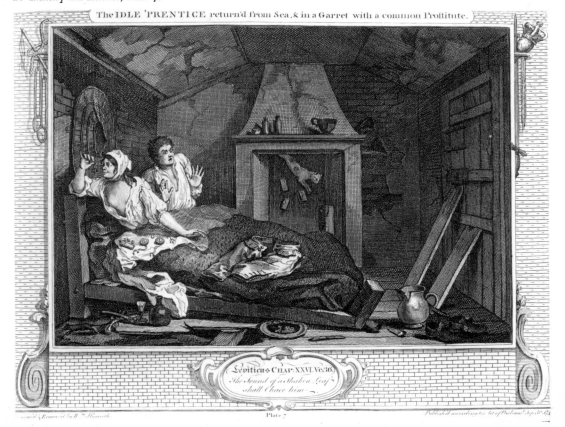

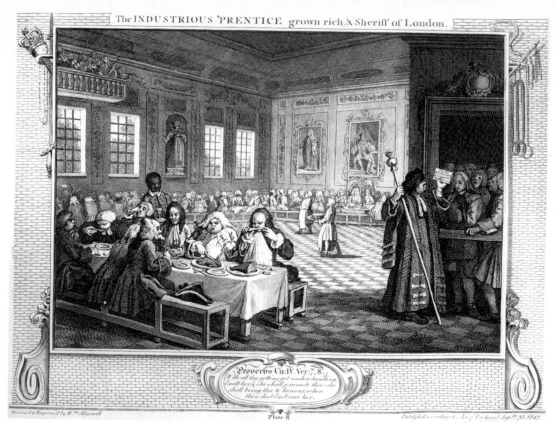

The INDUSTRIOUS 'PRENTICE grown rich, & Sheriff of London.

Proverbs Ch:IV. Ver:7, 8.
With all thy getting get understanding
Exalt her, she shall promote thee; she
shall bring thee to honour, when
thou dost Embrace her.

Plate 8

29 *Industry and Idleness*, Plate 8.

30 *Industry and Idleness*, Plate 9.

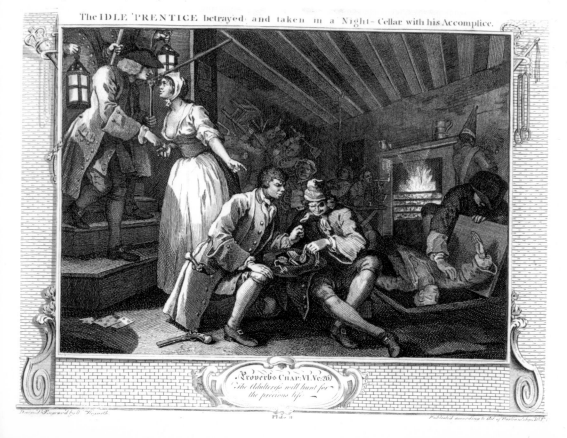

The IDLE 'PRENTICE betrayed, and taken in a Night-Cellar with his Accomplice.

Proverbs Chap:VI.Ve:26
The Adulteress will hunt for
the precious life.

Plate 9

I hope that my initial description of the plates has at least shown Hogarth's ingenuity of elaboration to be still active. Idle's decline, for example, is not haphazard. Like writers on idleness from Bunyan to Samuel Johnson, Hogarth begins with sleep, a pursuit of dreams of ease and Moll Flanders, which has caused Idle to drop his spindle as Christian's sleep on Mount Difficulty caused him to drop his heavenly ticket. The second stage is to extend idleness to acedia or spiritual sloth; and thence to the escape from labour that takes him to sea; which leads to the final stages, illustrating the justification of the Church Fathers for making idleness one of the capital sins. It produces an occasion for sin—any sin that, to use Dr Johnson's phrase, will take 'firm possession of the mind . . . when it is found empty and unoccupied'.[1] Here the void of idleness is filled with thievery and illicit lust, and the final stage is the punishment, first private (betrayal) and then public (hanging).

All of this elaboration, however, is on the basic contrast of Goodchild and Idle: control and negligence, piety and blasphemy, good company and bad, giving and taking, respect and contempt, wife and prostitute, loyalty and betrayal, prosperity and poverty, social and anti-social behaviour, with beyond all this the contrast of the reason and the unreason, the directed and the undirected, order-security and chaos-danger. For the first time, Hogarth has produced a *hero*, a normative counter to oppose the foolish Harlot or Rake, his usual protagonist, who embodied qualities of both good and evil, freedom and compulsion. If complexity is the keynote of the earlier cycles, simplicity is the ostensible keynote here.

Hogarth turned to a more popular audience because in addressing them he could use simpler, more elemental forms, themes and emotions than were available to him in sophisticated art. He was trying one more way of getting away from the stereotypes of contemporary academic art, while responding to the disparagement of rococo art and too difficult reading structures. The pleasure of the imagination which, in Addison's words, 'is but opening the Eye and the scene enters' is precisely the one Hogarth addresses himself to satisfy in *Industry and Idleness*—and in various ways in all his subsequent work, practical and theoretical. The intricate patterns of light and shade that led the eye about in the earlier cycles, never allowing more than momentary rest, forcing one to *read*, are replaced by a simple immediately-graspable gestalt. Before, the death of the Rake might be expressed through echoes of the statues of Melancholy and Raving Madness over the portal of Bedlam and—including the figures around him—by the echoes of a Pietà. But in *Industry and Idleness* the system of analogy on which the earlier series were founded is absent. The shapes are only expressive in themselves: not because the Apollo Belvedere has that pose, but because there is something inherently (or in the 'cartoonist's armoury' of popular graphic convention)[2] straight and unbending in Goodchild's pose and something servile, cringing, and dishonest in Idle's.

Since this is a morality, the basic pattern is simply *this* vs. *that*. The opposition of Idle vs. Industrious Apprentice is emphasized, for example, by placing Idle on the left of the picture and Goodchild on the right, whether they appear together or alone. We come to expect on the left the irregular, flattened visage of Idle and on the right the regular good looks of Goodchild, and inevitably recall, 'He shall set the sheep on His right hand but the goats on the left' (*Matthew* XXV.33). Then we notice that Idle is always kept out in open spaces or in a crumbling tenement, unprotected and unsafe, while Goodchild is shown within solid, well-built architectural structures. (One is reminded of the temples of Modern and Ancient Virtue at Stowe.) Most obviously, the mottoes, which appear under every design, emphasize the stark pattern of contrast and causality in the prints. They are mostly from *Proverbs*, whose verses are verbally equivalent to the visual structure Hogarth has constructed: 'The soul of the sluggard desireth, and hath nothing; but the soul of the diligent shall be made fat' (XIII.14)— a structure of *this* against *that*, or of *this* will bring about *that*. And many of the proverbs were, like this one, concerned with industry vs. idleness.[3] *Leviticus*, the next favourite source of mottoes, carries the related structure, if you do *this*, then you will be punished (or rewarded) *thus* and *thus* and *thus*, to an extreme of rigour.

One might well ask, however, whether this further reaction against sophisticated academic art has not brought Hogarth full circle and produced a work reducible to the simplest

topos, against which he had originally reacted. Has he taken the topos of industry's reward and idleness' punishment and illustrated it naïvely? Or, alluding to it, has he generated something more than the primitive, elemental strength which Alexander Gerard would have praised as 'purity'?[4]

What I first notice when I see the twelve prints on a wall is that there is no way to hang them without breaking up the paired contrasts (2–3, 4–5, 6–7, 8–9). With the notable exception of Plates 11 and 12, the pairing of the pictures on a wall is at odds with, runs counter to, and perhaps undermines the formal-moral contrasts within the series.

The time has come to look more closely at those large simple oppositions we have taken in 'at one blow'. I have said that in every case the idle apprentice is kept to the left side of the plate, the industrious to the right, as goats separated from sheep. With this pattern of expectation established, however, we may notice—or perhaps only sense—that in every one of the plates in which Goodchild appears

alone, on the right, there is also something on the left. This is a repoussoir figure that helps to stabilize the composition, but also leads the viewer's eye into it, establishing its depth: the ugly old pew-opener in Plate 2, the carbuncular-nosed porter in Plate 4, the grotesque beggar in Plate 6, the gourmandizing citizens in Plate 8, and the lascivious and drunken revellers around the grandstand in Plate 12. I think Plate 4 tells us what we are to make of this pattern: the porter, intruding from the outside world, is paralleled by his equally ill-favoured dog in dispute with the bristling cat who stands on the platform with Goodchild and his master. In other words, the other apprentice is a silent presence even when the subject is his opposite. The viewer's habit of left–right association with Idle and Goodchild leads him (assisted by the related shapes) to see the left-hand figure as another denizen of Idle's gross world, which Goodchild cannot escape even in the safety of the counting house, and the contention between these worlds is an aesthetic one now of beauty vs. ugliness.[5]

31 *Industry and Idleness*, Plate 10.

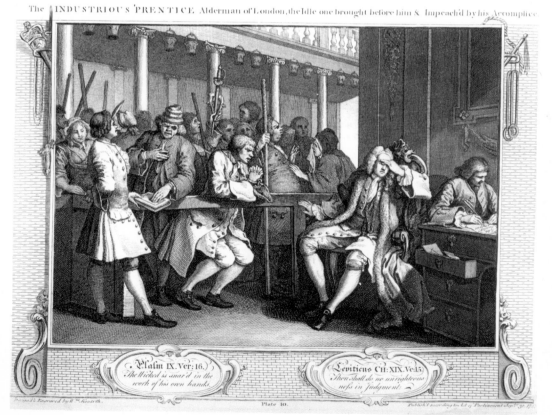

The INDUSTRIOUS PRENTICE Alderman of London, the Idle one brought before him & Impeach'd by his Accomplice.

Plate 10.

The IDLE 'PRENTICE Executed at Tyburn.

Proverbs Chap: I. Ver: 27, 28.
When fear cometh as desolation, and their
destruction cometh as a Whirlwind: when
distress cometh upon them, then they shall
call upon God, but he will not answer.

Plate II

The INDUSTRIOUS 'PRENTICE Lord-Mayor of London.

Proverbs Chap: III. Ver: 16.
Length of days is in her right hand, and
in her left hand Riches and Honour.

Plate 12

In the Idle plates there is no repoussoir figure —no one to anchor the composition down on either side, so that he always appears to be floating over a gulf. Because he is himself on the left the emptiness of the right side is all the more emphatic.

The final plates, however, change all this. In Plates 8 and 9, though still toward the right and left respectively, Goodchild and Idle are moving closer to the centre than in the earlier plates. And in the last two plates the order has been reversed, and Idle comes first; moreover, while the two apprentices are shown proceeding in opposite directions, they have been moved to exactly the same position to the left of centre, and both seem suspended now above the mass of crowd. They are, different as their fates (and the skeletons and cornucopias in their margins), located spatially at the same spot.

The motto under this last plate is 'Length of days is in her right hand and in her left hand Riches and Honour' (*Proverbs* III.16), which in the light of the earlier plates draws attention to the left-right pattern while at the same time minimizing the difference. *Both* long life and riches and honour are things that Goodchild has gained and Idle lost. As it happens, since the general view (following *Matthew* XXV.33 and other texts)[6] was that left=evil and right=good, it was just this text from *Proverbs* failing to distinguish between them that the preachers and exegetes fastened upon for debate.[7]

One inference is that so much emphasis on contrasting values in plate after plate ends by drawing attention to underlying parallels. Take the crowds that surround both apprentices. The contrast was initially between crowd and isolation: in Plate 6 the crowd is celebrating Goodchild; in Plate 7 there is no crowd around poor, solitary Idle. But two musicians in Goodchild's crowd are squabbling, the dog's face is sad and downcast, and the celebration itself is for hire (and by its shapes and placement on the left is associated with Idle). In Plates 8, 9, and 10 both apprentices are surrounded by ugly, greedy, self-interested folk, distinguished mainly by the respectability of the group having dinner with Goodchild. The crowds in Plates 11 and 12 are initially contrasted: the one

watching Idle is shabby, fighting, crying (his mother), stealing, and immoral, presided over by Mother Douglas the bawd; the crowd watching Goodchild is cheering, more prosperous, presided over by the Prince of Wales. But both consist largely of drunk, celebrating, out of control people, including bruisers with sticks (though they are only wielded in Plate 11). But can we say that the people at Tyburn came to watch Idle die, while the people in the City came to wish Goodchild well, and their drunkenness and lechery and disorder only reflect this joy? We must if we carry out the contrast. Or is the point the parallel: that the genteel and the ungenteel amount to the same, as in a sense the roads to Tyburn and to the Guildhall? For these are not the contrasted crowds of *Beer Street* and *Gin Lane*, any more than Tom Idle is the murderer Tom Nero of *The Four Stages of Cruelty*. Recall the old saying: The crowd that cheers him at his coronation would cheer as lustily at his execution. Hogarth may have reversed the order of Plates 11 and 12 and moved both apprentices to the same position on the two plates in order to suggest something about the interchangeability of the fates of the two apprentices.

Disquieting thoughts also arise if we consider the large contrasts of spatial relationships that recur throughout the plates. The perspective itself is very odd: in the first plate the two apprentices are placed within separate perspective systems, Idle's loom having a different vanishing point from Goodchild's, and the room itself having yet a third. The effect is to set up two alien systems of reference, and this fits with the fact we have noticed that Idle's scenes tend to be open while Goodchild's are closed, the one outside ordinary perspective systems altogether, while the other is rigidly constructed along the lines of a perspective box.

At the beginning both apprentices are entirely enclosed in a room, overshadowed and further enclosed by their looms. Goodchild in effect never leaves the closed room; visually his world is fixed within the perspective-defined and closed spaces of a box, hedged in by a labyrinth of pews, covered and safe; he never ventures out of an enclosure, but remains care-

opposite

32 *Industry and Idleness*, Plate 11.

33 *Industry and Idleness*, Plate 12.

ful, comfortable, and protected. His final residence is so safe that a row of fire buckets hangs from the ceiling, an indication that the building is insured by the Sun Fire Office. But Idle, compared to Goodchild, is unlocated, unfixed, and his world is open and uncovered. Though the open door of Goodchild's house is contrasted with Idle's barricaded door (Plates 6 and 7), Goodchild himself is within his house, just protruding his head and arm through a window, while Idle, trying to close himself in, utterly fails: the gaping holes in the floor, the propped and rickety door, the collapsing bed, and the chimney through which rats and cats race show that his room is anything but closed. Idle's is an unprotected, unordered world of liberty but of temptations and dangers as well, with the threat of some sort of retribution always hanging over him and a chasm yawning beneath his feet. Once the choice is made between idleness and industry, outside all is hostile and fearful; inside is religion, shrewd business sense, money, a wife, status, and order.

Only in Plate 10 is he finally caught within the sturdy architectural world of Goodchild, which ends within the loomlike framework of the triple gallows of Tyburn. Meanwhile Goodchild too is receding. The expressively exaggerated perspective of the City banquet (Plate 8) emphasizes the giant guzzlers in the foreground against the tiny figure of Goodchild, so diminished as to hint that he may have gained the office of Sheriff at the expense of his individuality. In his next appearance his face is shielded behind his hand, and in the last obscured within a closed coach. The parallel is unmistakable between the Anglican clergyman in his covered coach (vs. the Methodist preacher uncovered, helping Idle in his last moments) and Goodchild in his covered coach, guarded by the sword of state.

Read in the context of Hogarth's earlier work, these spatial relationships carry associations that cannot be dismissed. Outdoors was initially associated by him with freedom and one's natural self, an association sanctioned by Addison in the *Spectator* and confirmed in the year of *Industry and Idleness'* publication by William Gilpin in his *Dialogue upon the Gardens at Stowe*.[8] As the Harlot declined, her room, her container, shrank until in the last plate she was enclosed in a coffin, and much the same was true of the Rake. The Distressed Poet (1736) was

cut off from his wife and the world of unpaid bills and unfed babies by the heavy architectural lines of the alcove in which he sequestered himself to write his poem 'On Riches'. The Enraged Musician (1741), has enclosed himself in his house, visible through his window (rather like Goodchild in Plate 6), trying to order the lively noise-makers outside in the street who are disturbing him. Hogarth has begun to develop another meaning inherent in the closed room: its comfort and security. These qualities were present in the dark, overfurnished room of the Harlot's keeper, but in *Industry and Idleness* they are associated with a protagonist who does not come to grief. It is the ostensible hero of the series, the respectable man who spends his life in metaphoric prison cells, while the bad man remains out in the open. There *is* no prison cell in this series concerning a real criminal—it is only implied by the gap between the scenes of courtroom and gallows. So the ambiguous contrast of the idle and industrious apprentices relies on the one being unprotected, out in the open, vulnerable to both criminals and the law; the other always enclosed, and with the associations from the earlier works a feeling of counter-movement against the purely schematic pull of the series begins to be felt. For the world of ordered, rigid architectural shapes in *Industry and Idleness* is also the world of the contrasted plates, of vice and virtue, of left and right, and this is the orderly world of Goodchild, which is increasingly impinged upon by Idle's world of undifferentiation and chaos.

Let us now look more closely at the emblematic structure of image and motto in which Hogarth couches his plates. The proverbs emphasize the simple pattern of contrast and causality in the prints, but they also, for the viewer who was familiar with Hogarth's earlier print series, carried a particular meaning. These readers would notice that all but one of the mottoes are from the Old Testament, and remember Hogarth's use of Old Testament stories in his *Harlot's Progress*: where Uzzah was shown being struck down for trying to steady the Ark of the Covenant or Abraham was about to sacrifice Isaac, and these were used to support a theme concerning strict justice vs. mercy. When the magistrate approached the unsuspecting Harlot in Plate 3 of that series, the composition was very like Plate 1 of *Industry*

THE ENRAGED MUSICIAN.

34 William Hogarth, *The Enraged Musician*. Engraving (1741).

and Idleness, except that above on the wall Hogarth placed the admonitory print of *Abraham sacrificing Isaac*. As it happens, the single New Testament motto used, for Plate 4, is from the parable of the talents (*Matthew* XXV.14–30), one of the very few places in the New Testament where an 'unprofitable servant' meets an Old Testament punishment, being cast 'into outer darkness'.

I see no reason to doubt that his viewers from the trading class were thoroughly familiar with *Proverbs, Leviticus, Psalms*, and the parables of Christ—as much so as the connoisseurs had been with the classical myths and the traditional iconography of western art. How far the merchants saw into Hogarth's use of the Biblical context is, of course, another matter; the 'Men of greater Penetration' who had fol-

lowed his earlier prints would also know the Biblical contexts, the complexity of which depends on the 'penetration' of the reader. At its simplest, as in Plate 4, a motto alludes to the 'good and faithful servant', and the reader naturally infers the other half of the story, the 'wicked and slothful servant' who hid his one talent in the ground; and 'A virtuous woman is a crown to her husband' in Plate 6 is completed by: 'but she that maketh ashamed is as rottenness in his bones' (*Proverbs* XII.4). The contrast of good and bad women is already implicit then in Plate 6, and so in Plate 7, where the other 'wife' (Idle's whore) appears, Hogarth can proceed to: 'the sound of a shaken leaf shall chase him' (*Leviticus* XXVI.36).

But often the surrounding verses or the whole chapter from which the motto is taken

give it a context that virtually tells the story of the plate.[9] The chapter of *Leviticus* from which 'the sound of a shaken leaf shall chase him' is taken, about the perils of sloth, is a horrible sequence of action-consequence structures with consequence heaped upon consequence: 'And if ye walk contrary unto me, and will not hearken unto me; I will bring seven times more plagues upon you according to your sins.'

At yet other times the motto is twisted to Hogarth's purpose by the context of the plate itself. In Plate 8 the motto becomes, to say the least, ambiguous: 'With all thy getting get understanding. Exalt her & she shall promote thee: she shall bring thee to honour when thou dost Embrace her' (*Proverbs* IV.7–8). Most noticeably, the feminine pronoun in the context of *Proverbs* Chapter IV refers to Wisdom. But Hogarth has omitted the referent (his quotation should accordingly refer to Understanding, which however he has not honoured with capitalization), and so in the context of the plate and the two immediately preceding Goodchild plates, 'her' and 'she' apparently apply to the only familiar 'she' present, the wife who sits next to Goodchild on the dais: 'Exalt her & she shall promote thee'—marry her and she will get you her father's business; 'she shall bring thee to honour when thou dost Embrace her'—not the spiritual but the physical embrace (which Hogarth *does* capitalize) that has brought him to honour. The word 'getting' in 'with all thy *getting* get understanding' sounds, in the light of all those London politicians busy gorging themselves, like a necessary admonition.

Hogarthian irony is at work here; and this interaction of motto and image draws us back to Plate 2. (Remember that the plates would have all been visible at the same time as they hung on a wall.) That motto, 'Oh how I love thy Law it is my meditation all the day' (*Psalm* CXIX.97), raises the question, settled in Plate 8, of whether 'love' and 'thy Law' that is to be Goodchild's meditation all the day refer to God or to the master's daughter, who stands next to him. Then when Goodchild next appears in Plate 4 in his master's counting house, what are we to make of the almanac emblem of Opportunity taking Time by the forelock? Plate 4 itself refers to his industry in the shop, but the daughter is so emphasized in the surrounding plates that, as we look back from

Plate 8, she is another strong contender for the role of Opportunity.

The motto of Plate 11 sums up Idle's fear and desolation as he goes to his death and concludes: 'Then they shall call upon God, but he will not answer.' Hogarth has changed 'me', which refers to Wisdom (the speaker in both the surrounding verses), to God. In the verse before, Wisdom is responding to the fool who did not heed her words: 'I also will laugh at your calamity; I will mock when your fear cometh.' The chapter ends, 'But whoso hearkeneth unto me shall dwell safely, and shall be quiet from fear of evil.' In the final motto of Plate 12 it is still Wisdom who is speaking, explaining that the 'merchandise' of wisdom (*Proverbs* III.14) is 'more precious than rubies' (v. 15), making it clear that wisdom is what leads to this end. This follows all the proverbs that say if you honour the Lord, 'so shall thy barns be filled with plenty, and thy presses shall burst out with new wine' (v. 10), as they do here. The motto itself (v. 16), 'Length of days is in her right hand; and in her left hand riches and honour', is followed by 'Her ways are ways of pleasantness, and all her paths are peace' (v. 17), and a bit later by 'Keep sound wisdom and discretion' (v. 21). The reiterated 'her' of course applies to Wisdom in the Biblical context, but we recall those earlier 'hers' in the plates' context. The consequences are spelled out: longevity and riches and honour; Goodchild is not being hanged, he is rich, and he is mayor of London. *Proverbs* is full of wisdom about industry and idleness, about the prudent man and the foolish, the righteous and the wicked; and Hogarth pointedly omits the last category, the moral, leaving the emphasis on the prudential, though introducing the name of God as a synonym for Wisdom. Good and evil are only alluded to in the characters who affect the two protagonists.

So much for the mottoes. The images themselves derive from popular graphic art rather than from the emblematic tradition. Were we to go to Ripa's *Iconologia* to see how Idleness was represented, we would find that it is 'an old Hag cloth'd in Rags' with her head bound about with a black cloth. As Ripa explains the significance of this hieroglyphic, she is '*old*, because at that Age, Strength and Activity to work, begin to fail; her Rags denote that Idleness produces Poverty; the black Cloth about

her Head signifies her senseless Thoughts'. Now it is significant historically that Hogarth does not employ the hieroglyphic—the veiled—symbol for Idleness, but rather the unlearned, the probable representation, simply a young man dozing over his loom.[10] But it is equally characteristic of him that, with his primary meaning established in this way, he also introduces the emblematic figure, with its traditional but enigmatic meaning; for the old lady, the black cloth bound about her head in widow's weeds, first introduced as the pew-keeper in Plate 2, by the fifth plate is Idle's mother; and the idleness of old age, weakness, and helplessness is contrasted with the wilful idleness of youth. This is not, of course, merely a gathering of both kinds of iconography to complicate meaning; real idleness is in the natural representation, not in the enigmatic—the poor mother industriously follows her son step by step to the gallows, not seeking handouts but trying to help him.

A few learned, but widely-known emblems do appear in the plates of *Industry and Idleness*. Goodchild's covering his eyes in Plate 10 is an allusion to Blind Justice, who, not a respecter of persons, cannot recognize favours or friends.[11] But Goodchild, assuming the pose, is the one who alludes to Blind Justice. And in its immediate context, Goodchild's covering of his eyes also prevents him from seeing the treacherous girl friend bribing the clerk and the man with the eye-patch (who lured Idle into crime) taking his oath illegally with his left hand as he swears away Idle's life. (Behind, the weapons being held up form a caduceus, emblem of Mercury the thief.) The motto under Goodchild, *Leviticus* XIX.15, deals with blind justice ('ye shall do no unrighteousness in judgment'), but the verses preceding are about stealing and lying with an admonition 'ye shall not swear by my name falsely' as the one-eyed man is doing.[12] The verse following the motto is about tale-bearers and those who 'stand against the blood of thy neighbour', and the next two admonish one not to 'rebuke thy neighbour': 'Thou shalt not avenge . . . but thou shalt love thy neighbour as thyself.' Though far less direct, this interaction of image, motto, and context is saying very much what the print of *Abraham sacrificing Isaac* said on the Harlot's wall as Justice Gonson and his constables approached to seize the poor girl.

The reader is drawn back to Plate 8 and the statue holding a dagger in a niche on the wall, whom Hogarth's City audience, from Lord Mayor down to apprentice, would have recognized as Sir William Walworth, the Lord Mayor who without warning struck down Wat Tyler—a sudden blow that saved the king, as perhaps Goodchild strikes down Idle.[13] The message is that the idle, who have sunk into crime, get what they deserve; the bribery and lying *are* justice, according to the Old Testament injunction 'an eye for an eye', for Idle has loafed, cheated, robbed, and must expect equal treatment. But implicit also is the sense that justice is cruel and that the legal system is quick, almost unthinking (like Walworth's blow), but not perfect—for one guilty man apprehended, many escape. The wicked, the temptors and corruptors, continue to flourish, and Goodchild's world is one in which he not only cannot rid himself of the Idles but must overlook bonds of friendship, the crimes of his own subordinates, and the guzzling grossness of his colleagues.

Goodchild's world of enclosed architectural spaces is further clearly delimited as the City of London, of which he becomes sheriff and then mayor. The porter in Plate 4 wears the badge of the City, the almanac with Time seizing Opportunity by the forelock is a 'London Almanac', Walworth was a London mayor and his dagger became part of its escutcheon, and the insignia of London's mayor appears in the margins.[14] Hogarth goes far beyond the necessary when in Plate 6 he ignores the impossible distance and the scale to reproduce the inscription on the London Fire Monument indicating that this 'Protestant City' was once burned as the result of a Catholic Plot. To some extent he may be suggesting something ironic about the danger to be feared by London from a Tom Idle (cf. the fire buckets in the scene of his condemnation), but mainly he is establishing that the values represented here are Protestant ones (it was Defoe who in *The Complete English Tradesman* called idleness the sin against the Holy Ghost).

This inscription, I believe, tells us something about how the 'veil of allegory' operates in these popular prints. The City (from aldermen to apprentices) probably still believed—and certainly preserved—the inscription; but anyone with detachment knew by this time that it

was a Protestant myth, and may have recalled Pope's lines about 'London's column pointing to the skies, / Like a tall bully, lifts the head, and lyes.'[15] As Pope uses the Monument (in his 'Epistle to Bathurst') to place Sir Balaam in a particular economic and moral code of Protestant capitalism, so Hogarth uses it to locate not only Goodchild but the audience to whom he is directly addressing himself and their assumptions about industry and idleness. The 'Men of greater Penetration' are certainly a smaller group now—smaller perhaps than ever before—and yet they are the objective men who will be able to place both industry and idleness in relation to Protestant and other systems of values, and perhaps even remember that the sin of the 'wicked and slothful servant' who hid his one talent was (as his master put it) not 'to have put my money to the exchanger', so that at 'my coming I should have received mine own with usury'. The large, popular audience to which he turns for his 'ordinary reader' offers him a way into simpler, more basic images, but also into a parochialism which he is careful to define.

The elaborate play with the emotions and the active involvement of the different audiences may perhaps be subsumed under a very English and contemporary use of irony. The discrepancy between the City-merchant view and the larger, more inclusive view, like that between Fielding's prejudiced and understanding readers in *Tom Jones*, is related to the larger Augustan reliance on irony, or in general saying (or showing) one thing and meaning another. Such an ironic structure can act as an instrument of metaphysical knowledge, evoking the power of thought, or it can induce confusion and uncertainty in the reader, or both. Hogarth is in fact setting up stereotypes of popular thought and art in order to scrutinize them as well as draw upon their undeniable vigour.

One can imagine some of the authoritarian commands couched as adages that were in his mind, doubtless to be heard any day walking through the City: 'The better gamester the worse man. What else is it to dance but to play the fool? So much money so much credit. He hath not wherewithal to buy a halter to hang himself.' The contemporary Protestant feeling about idleness, expressed so staunchly by

Defoe, found its most popular expression in the apprentices' guides, a popular sub-literary form that flourished in great abundance throughout the 1730s. These works, which achieved an apotheosis of a sort in George Lillo's play, *The London Merchant* (1731), habitually contrasted the industrious and idle apprentices, the latter demonstrating 'the fatal Consequence of his Neglect' of his duty to God and his master, 'with Regard both to his *temporal* and *eternal* Happiness'.[17] The idle apprentice was assured that even reading, 'or any Amusement, however laudable at *proper* Times', carried on during 'the Hours of Business' 'would be directly robbing' the master. Even someone who accompanies an apprentice in his delinquence 'knows he contributes to a Robbery at the same time', for the master is being 'defrauded of his Apprentice's Time'.[18]

In his *Apprentice's Vade Mecum* (1734) Samuel Richardson virtually outlines the scenario for *Industry and Idleness* (in terms, however, available in almost any apprentice's guide): 'how naturally, as it were Step by Step, Swearing, Cursing, Profaneness, Drunkenness, Whoredom, Theft, Murder, and the Gallows, succeed one another!' Indeed, he concludes with the dangerous lure of fashion for idle apprentices:

I wish, to complete the Ridicule, and shame such Foplings into Reformation, the ingenious Mr *Hogarth* would finish the Portrait.[19]

Which, in a sense, Hogarth did: but unlike Richardson (and Lillo), he did not allow his apprentice to proceed from theft to murder. He added also a rather aristocratic awareness, which had more in common with Fielding than with Richardson, of the master's vested interest, his concern with profits, concealed under warnings to idle apprentices.[20]

Hogarth prejudiced the case against industry from the start by choosing as his illustration the profession of weaving. Contemporary sources on the weavers all emphasize that it was the poorest paying of London trades for the weavers themselves, with the supply usually exceeding the demand, and Englishmen being discharged for the cheaper labour of women, children, and Irishmen. There were bloody riots in 1736 against the Irish interlopers, and the trade was known for its violence. Only the masters prospered, and the pamphlets emphasize the frequency with which the master

weaver's children (sons as well as daughters) marry other weavers in order to perpetuate the family business.[21]

The undermining of the industry half of industry vs. idleness brings into question the whole pattern (and assumption) of choice itself. I have referred to Hogarth's use of the Choice of Hercules topos in his earlier works; in fact Hercules' choice, as Prodicus explained it, was essentially between industry and idleness, the difficult way and the easy or pleasurable. In *A Harlot's Progress* Hogarth reversed the roles of rational industry and irrational idleness and blurred the distinction between them by making the clergyman's industry his place-seeking and the bawd's idleness her vigorous persuasion to employment of the young girl. It is the girl's lackadaisical attention to her employment that gets her discharged by her keeper and apprehended by the police. The distinction is not, Hogarth is saying, an easy one to make. But idleness is what leads the merchant's son away from his business to the life of an aristocratic rake. The series concerning Goodchild and Idle, then, builds on the most basic and elemental of Hogarth's earlier structures, materializing both paths of the journey, and making the original choice explicitly one of industry and idleness. We would appear to be at the bottom of the matter, concerned with pure choice; but if we think the choice is being made by the apprentices, we are clearly mistaken: it is being made by the readers, and it is not so simple as the readers are at first led to believe.

As I have tried to show, on one level at least the structure of choice itself is emphasized until it is seen as something that oversimplifies the complexity of real life. If this is done much more sharply than in *A Harlot's Progress*, it may be because although the Choice of Hercules was throughout the half-century a part of every schoolboy's, every educated man's, consciousness, the interest seems to have become intense in the 1740s. To take only one example, Joseph Spence, in his *Polymetis* (1747), published Robert Lowth's poem, *The Choice of Hercules*, and preceded it with an essay on the subject.[22] There 'can be no virtue without choice' is his message. Spence is a good example of a contemporary who looks back to antiquity and sees choice between *virtus* and *voluptas* as the basic pattern not only in Prodicus and Cebes but in Philostratus, Silvius Italicus, Horace, and

Ovid; he adduces Ulysses' choice between Circe and Penelope, Paris' between the goddesses (which Hogarth used in *Rake*, Plate 2), Aeneas' between Dido and Latium, Persius' between *avaritia* and *luxuria*, and Lucian's between Eloquence and Sculpture.

All of this evidence contributes to a general tendency of the age 'to simplify morality into a decision between opposing alternatives', as E. R. Wasserman has put it.[23] There certainly seems to have been a general assumption that human happiness was attainable if the right choice was made between clearly defined alternatives, especially between *virtus* and *voluptas* or *luxuria*. As a study of eighteenth-century gardens, poetry, and prose demonstrates, 'everything is bipolar, not multiple; reality is made up of opposites'—whether structured into a choice or resolved into a *concordia discors*.[24]

Hogarth repeatedly uses the bipolar choice in order to show its inadequacy: earlier in his career because of the forces internal and external on contemporary man, and now because of the very structure of choice itself. It is only the final example of his awareness—perhaps the great Hogarthian insight—that his age has inherited and moulded itself on a system of cultural formulae, reaching from old master paintings to an *Apprentice's Vade Mecum*, that simplify and create order.

Hogarth must also have been aware of the poems written in the 1740s that questioned the oversimplification of choice. A straightforward case was Akenside's use of Shaftesbury's account of the Choice of Hercules in his *Pleasures of Imagination*, Book II (1744). Here the goddesses of Virtue and Pleasure are regarded not as antagonists but as supplementary companions, 'the shining pair', while a third figure, the son of Nemesis, is introduced as antagonist of both.[25] A much less straightforward and more interesting case was James Thomson's *Castle of Indolence*, which though not published until 1748 had been in various stages of composition since the early 1740s. In the first canto the wizard Indolence tempts weary passers-by in search of refreshment into his castle with the enchantments of euphoria and narcotic dreams, seductively described; in the second canto the Knight of Arts and Industry frees them. But, as was well known, the stanzas began as Thomson's own self-defence against his friends'

chiding of his own notorious indolence, and his attitude toward the subject was decidedly ambivalent.[26]

Hogarth and Thomson were in circles that impinged at more than one point; their mutual friend, Joseph Mitchell (whom Hogarth had known as early as 1731), had written an ironic poem called *The Charms of Indolence* in 1722, in which indolence equals dullness.[27] Another close friend, Thomas Morell was, we know, aware of *The Castle of Indolence* as early as 1742 when he wrote verses on it.[28] Even if Hogarth did not know of the poem directly from Thomson, he would have known from Morell, who later assisted Handel with a libretto on the subject of the Choice of Hercules. Thomson, who includes dullness, inertia, and sluggishness (idleness) in his meaning of indolence, is actually concerned with a refined hedonism, a cultivation of the choicest pleasures on the one hand, and a virtuous and philosophic retirement on the other. The ambiguity with which he plays depends on awareness of both the shop-keeper's idleness as 'the devil's cushion' or his couch or pillow[29] and the gentleman's sense of 'the sweetness of being idle' (Inertia dulcedo), or 'Dolce far niente' or 'Vis inertiae' and other well-known catch phrases.[30]

Idle's attempt to escape from duty by going to sea or on to the highway is a rough parody of the classical retirement theme; recalling Indolence's argument that if you withdraw with him you will avoid all 'the Filthy Fray; / Where the Soul sowrs, and gradual Rancour grows, / Imbitter'd more from peevish Day to Day'. Despite his conclusion in favour of the Knight of Industry, Thomson is well aware of the lovely ambiguity in classical references to *otium*—peace, leisure, or idleness—as in Virgil's close of his fourth *Georgic* when he remarks that at the very time when Augustus was winning victories in battle and giving laws to the Roman people,

> *illo Vergilium me tempore dulcis alebat*
> *Parthenope studiis florentem ignobilis oti,*
> *carmina qui lusi pastorum audaxque iuventa,*
> *Tityre, te patulae cecini sub tegmine fagi.*

(sweet Parthenope cared for me, Virgil, happy in my studies of ignoble idleness, who once played at shepherd songs and bold in the season of youth sang of thee, Tityrus, under the shade of spreading beech.)

This is idleness in that it avoids *negotium* but peace and leisure in that it produced Virgil's *Pastorals*.

The same readers who were the 'Men of greater Penetration' in the matter of epic allegory were these men of cultivated aristocratic values who would remember that the Golden Age was, after all, the time of pleasure and virtuous idleness, unmotivated by ambition or paltry desires for gain, and replaced by the love of profit in the Iron Age; from the Renaissance pastoral they would recall that the ideal of *otium* vs. *negotium* preferred leisure for contemplation and intellectual pleasure over vulgar money-grubbing.

But something more was at stake, for indolence, as the motto to Thomson's first canto suggests, was part of the Country Party's polemic against luxury, which (according to their formulation) derives from excessive commercial prosperity and political corruption, made possible by the new Walpolian finance. Bolingbroke, the chief of propaganda for the Opposition in the 1730s, indicts the 'sloth' of the idle harpies (financiers) and the 'luxury' of all classes consequent to corruption and commerce. Thomson picks up both Bolingbroke's emphasis and, from further back, Shaftesbury's description of the psychological traits of the indolent, and places indolence in a specifically political context.[31]

In turn, he attaches the unsatisfactory connotations of 'industry' to those of 'indolence': the merchants of the City are now 'idly busy'. This stage is developed more fully by John Brown in his *Estimate of the Manners and Morals of the Time*. Though not published until 1757, Brown's views were very much a part of the arguments of the 1740s and may have been known to Hogarth, who was a personal friend. Brown argues that we should try to stop industry at the second level of its development, because at its third and final level it produces luxury, effeminacy, and indolence among most classes, especially the nobility, and avarice among the merchants. At moments Thomson too admits that commercial prosperity leads to universal indolence, which in this sense lies at both the beginning and the end of the commercial cycle. Primitive man is slothful; industry arouses him; but beyond a certain point it results in universal luxury, and so further indolence, and along the way the

merchants who bring prosperity through industry generate avarice.[32]

This is what industry has led to in Plate 6 and the following plates of *Industry and Idleness*. Goodchild's industry has produced (besides, of course, the responsibilities of a magistrate) another kind of idleness—eating and drinking or sitting in state; in fact, as Goodchild's industry pays off, Idle's idleness gives way to a kind of frantic industry of stealing and vending. Industry produces idleness, and idleness leads to industry, and both in this way tend toward further undifferentiation.

Not many years after *Industry and Idleness* appeared, Samuel Johnson published *Rasselas* (1759), a tale which poses a similar 'choice of life' and comes to a similar conclusion about the nature of choice:

Those conditions which flatter hope and attract desire, are so constituted, that, as we approach one, we recede from another. There are goods so opposed that we cannot sieze both, but, by too much prudence, may pass between them at too great a distance to reach either.

No man, the characters in *Rasselas* learn, 'can, at the same time, fill his cup from the source and from the mouth of the Nile'.[33] Driven by the hunger of imagination, man will choose the mouth only to desire the source, and once at the source only desire the mouth again. There is no possibility of choosing one over the other, nor of a happy median between the extremes, nor of having a *concordia discors* of both. And so one's choice is finally a matter of indifference: the industrious apprentice will envy the idle as much as the idle will envy the industrious, which is one way of explaining what happens when Hogarth sets about drawing the progresses of these antithetical apprentices.

Although there are no Biblical mottoes to point the way, the real moral context of *Industry and Idleness* is less *Proverbs*—which is another constricting form like the choice between opposites—than *Ecclesiastes*, and the famous series of fruitless alternatives beginning 'To every thing there is a season' which ends: 'What profit hath he that worketh in that wherein he laboureth?'[34] The success of labour shows the Industrious Apprentice getting more riches, power, and honour (II.4–11) but ends: 'Then I looked on all the works that my hands had wrought, and on the labour that I had

laboured to do: and, behold, all was vanity and vexation of spirit, and there was no profit under the sun.'

With the views of Hogarth's personal friends, Thomson and Morell and Johnson, we move a step closer to defining the complex effect involved in an experiencing of *Industry and Idleness* in 1747.

The Spectator, from which Hogarth drew so much of the commonplace wisdom of his age, saw in idleness a potential for both good and evil—for good if one can only know how to be idle without slipping into vice or folly. For idleness is at the heart of the new aesthetic Addison is explaining in these essays on the Pleasures of the Imagination: an aesthetic enjoyment gained by merely opening the eyes and eschewing the time-consuming labour of reason and exegesis.[35] But *The Spectator* also carried a sense of the terms that touched Hogarth's own case: in No. 83, characterizing the different schools of painting, Addison uses Industry to personify the Dutch School. 'His Figures were wonderfully laboured; if he drew the Portraiture of a Man, he did not omit a single Hair in his Face; if the Figure of a Ship, there was not a Rope among the Tackle that escaped him.' Hogarth's detractors called him a laborious Dutch painter, and in the late 1740s he was trying to extricate himself from the shadow of Rembrandt and the Dutch School by returning more self-consciously to the simplified compositions of Raphael. It is worth speculating on the extent to which the characterization of the Dutch School by Addison (and by others like Jonathan Richardson) was in his mind when he embodied Industry in Francis Goodchild. Hogarth perhaps associated with the word not only money-making and success but also the Dutch School's laboriousness and mere mechanical ingenuity.[36]

Johnson is, of course, the best-known example of an eighteenth-century idler, and the agony he suffered all his life from idleness led to many strong expressions of detestation together with some signs of ambivalence.[37] His moral horror of idleness in his prayers, his *Dictionary*, his essays, and his conversation is well known. Idleness extends for him from 'laziness, sloth, sluggishness, aversion from labour' to 'barrenness, worthlessness, and ultimately 'unreasonableness, want of judgment, foolishness, mad-

ness'.[38] He uses it as his contemporaries did in a large way to cover a general area of unreason which sucks down the rational part of man that knows he must work and produce.[39]

But, as his indulgent attitude toward that idler Richard Savage shows, his feelings about idleness were sometimes affectionate and humorous. They emerge in the persona of an Idler he adapted for his eponymous periodical (1758), who equates idleness with 'peace', the end to which the 'busy' are striving; for 'Every man is, or hopes to be, an Idler' (No. 1). And therefore, he adds, there is 'no appellation by which a writer can better denote his kindred to the human species'. He is quite serious when he argues that man is not basically either a reasonable or laughing animal, as he has been called, but an idle animal. Man is the only animal 'that does by others what he might do himself, or sacrifices duty or pleasure to the love of ease'. Moreover, having withdrawn from competition, he is the only man with 'no rivals or enemies. The man of business forgets him; the man of enterprise despises him. . . .'[40]

Hogarth himself, in *Industry and Idleness*, has replaced the two levels of readability with a conscious level on which the ordinary viewer would sympathize with industry and abhor idleness, and another on which comparison as well as contrast exists. I suppose we might conclude that he is simply repeating the old pattern, addressing himself to one audience that settles for the contrasts, and a more sophisticated one that has followed his works since *Boys peeping at Nature* and sees beneath the veil to subtler, more ironic meanings. But in this case the subtlety does not reach to further distinctions so much as to lack of true differentiation. The primary process, which does not distinguish between opposites, allowing all firm boundaries to melt in a free chaotic mingling of forms, is brought into play by both author and audience.

We have now come very close to the artist himself. For contemporaries—those who knew him or even his London-wide reputation—would have perceived an obvious parallel between the industrious apprentice and Hogarth himself who married his 'master's' daughter and succeeded to his business (so to speak),[41] continuing his efforts as an English history painter, carrying on his art academy, and defending his reputation as an artist long after

his death. But surely one would also have noticed that there is no resemblance whatever between Hogarth's and Goodchild's idealized face—his handsome, bland, almost sheeplike features. One recalls the look of self-satisfaction on his face, the heartlessly academic poses he assumes, the affected manner in which he holds his cup (perhaps trying to emulate the manners of the West End) in Plate 6. It is perhaps significant that Hogarth originally called him *William* Goodchild but, thinking better of it, changed his name to Francis.[42]

It is, on the contrary, Tom Idle's face that resembles Hogarth's own puggish, plebeian profile, which can be seen in *The Gate of Calais* (another personally-oriented work executed a year later), or in his self-portrait of a few years later (somewhat idealized in the print), or in Roubiliac's bust.[43]

Whether for purposes of self-irony to balance the saccharine self-portrait of Goodchild, or at some less conscious level, Hogarth has introduced his opposite. Perhaps it is simply Plato's 'generation of opposites', which W. J. Bate has described sensitively in relation to Johnson:

Psychologically, this may be described as the tendency of the mind to react defensively against what another part of it is reacting toward. While it loves, it also resists; while it says yes, it generates a no; while going in one direction, it finds itself sensing the attractions of

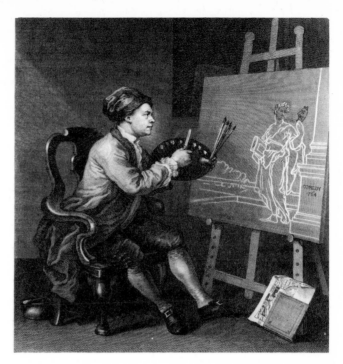

35 William Hogarth, *The Gate of Calais*
(detail). Engraving (1748).

36 William Hogarth, *Self-Portrait with
the Comic Muse*. Engraving (1758).

another. So 'labour and rest, hurry and retirement,' and all other opposites, said Johnson, 'endear each other'.[44]

Being so successful, working so hard, doing his own engraving continually, makes a 'habitual dislike', as Johnson called it, steal into any occupation. And yet one side of Hogarth plainly sought, as he put it a few years later in his autobiographical notes, his 'pleasure' as well as his 'studies'. Looking back on his time as an apprentice, both in silver engraving and in painting at Vanderbank's academy, he emphasized his idleness, saying that he required a technique 'most suitable to my situation and idle disposition'; the mnemonic system he hit upon for recording his ideas was useful because it allowed him 'to make use of whatever my Idleness would suffer me to become possest of'.[45] Though perhaps written with tongue-in-cheek, 'idleness' is one of the key words he applies to himself in those years. It sounds very much as if there is a self-portrait included in Tom Idle, hinting at that aspect of Hogarth that kept him from finishing his own apprenticeship, liked to go wenching or on 'peregrinations', was deluded by illusions of ease and grandeur, and, perhaps, unconsciously associated the creative act (as opposed to the successful businessman's practice) with punishment and death.

To confirm that Hogarth was capable of a personal irony concerning his own marriage to his master's daughter, and his ambivalence toward that choice, we might note that a decade later in his celebrated painting *Sigismunda* (1759) he chose to illustrate Boccaccio's story of a duke who raises up a young plebeian to be his protegé but when he discovers the youth has fallen in love with his daughter forbids the match. When he comes upon them making love, he revenges himself by killing the boy and sending his heart in a goblet to Sigismunda, who fills the goblet with poison and drinks. In his subscription for an engraving of the picture, Hogarth cited Dryden's version of the story in his *Fables*, the only version in which the young couple elope and are married before the discovery. And according to contemporaries, Hogarth used as his model for Sigismunda his wife Janè, with whom he had eloped from the home of Sir James Thornhill, who was only with some difficulty (we do not know how much) reconciled with the couple.[46]

One way to put our conclusion is that Hogarth's sympathy embraced both apprentices, both value systems. Another is to say that *Industry and Idleness* marks the end for Hogarth of a long-standing dichotomy of concentration and distraction in the Harlots and Rakes who will not fulfil their given calling but are distracted to the lives of ladies and rakes; vs. the

implied ideal of the concentration of those who achieve identity and happiness by total absorption into a profession or calling. The one involves shifting, unstable role-playing; the other a fixity that balances happiness with security. Take Plate 2 of *A Rake's Progress* where the Rake is drawn in all directions by the group of individually-concentrated professional men, each completely absorbed in his own particular role. Ultimately Hogarth shows us Idle who simply exchanges one role for another, and his opposite Goodchild, who is all concentration, and abrogates the sense of difference.

A third way is to conclude that a private meaning has been introduced that was perhaps also present in the *Harlot*, perhaps even in *Marriage à la Mode* (with its emphasis on clandestine marriages), but which did not alter or even contradict the straight—the popular—meaning in those works. Hogarth is changing the audience ratio in *Industry and Idleness*, increasing the number of general readers and reducing the readers of greater penetration until at times they may be only one or two people, and he has also begun to widen the discrepancy between their two meanings—meanings no longer supporting but nearly contradictory. *Industry and Idleness* is in more ways than one a turning point for Hogarth. Thereafter his works become in general more publicly accessible, but at the same time more personal, more private. There is a clear movement away from readability toward expressive form, but in fact that is the addition of new modes of communication, whose end is again meditation. Within the large simple contrasts complete understanding requires also a knowledge of the painter's own oeuvre, and even of his personal life, past and present. Moreover, the reaction against commonplaces of meaning, with which he began his career, far from mellowing, has led him now to present a staring commonplace —so staring that most viewers will give it their unthinking assent—and then so subtly, or perhaps I should say cynically, undercut it that the reader can come to no solution or final moral judgment.

What is effected incidentally is the planing away of distinctions until a moral structure has been virtually transformed into an aesthetic one. That this was an undercurrent earlier in Hogarth's career can be seen by comparing the moral contrasts of the *Harlot* and *Rake* with the largely aesthetic ones of *The Enraged Musician*. *Industry and Idleness*, which appears to be all morality, transforms Tom Idle into a figure not altogether unrelated to the one William Gilpin discusses somewhat later in his account of the Picturesque:

In a moral view, the industrious mechanic is a more pleasing object, than the loitering peasant. But in a picturesque light, it is otherwise. The arts of industry are rejected; and even idleness, if I may speak, adds dignity to a character. Thus the lazy cowherd resting on his pole; or the peasant lolling on a rock, may be allowed in the grandest scenes; while the laborious mechanic, with his implements of labour, would be repulsed.[47]

Gilpin's scenes require men doing 'for what in real life they are despised—loitering idly about, without employment'.[48] He is also, of course, talking about the draining of meaning out of moral emblems: with the industrious and idle apprentices, so too the ass as emblem of dull, meaningless, stupid labour is replaced by the shaggy-coated beast who, Gilpin informs us, is preferable to smooth-coated horses, as a bearded is to a smooth-cheeked man, because roughness is a picturesque element. When morality is removed, and iconographical (to a large extent moral) meaning is reduced, one result is the Picturesque.[49]

A final conclusion is to emphasize that, however much the result is qualified by irony, the aim of Hogarth's works of the late 1740s and 50s is to achieve simplicity, return to original sources, and communicate through formal relationships. As some of his later paintings may suggest, Hogarth's aim was related to that of the movement that came to be known as neoclassicism. But instead of going back to Rome and Greece, he went to the most basic and popular forms and subjects, embodied in penny prints, ballads, and broadsides. Like the best of the neoclassical painters he did this without sacrificing the sophistication with which he had regarded earlier art forms. And we shall see that the other members of his 'school' follow the same procedure, substituting some version of the essential which is usually taken from the low rather than the high road.

II

Alternative
Structures of Meaning

6 Reynolds: Painter and Academician

THE ALTERNATIVE tradition of literary painting in England was represented by Hogarth's younger contemporary, Sir Joshua Reynolds. It would seem appropriate, since we began discussion of Hogarth with his subversion of the Choice of Hercules, to examine Reynolds' adaptation of the same topos in *Garrick between Comedy and Tragedy* (private collection). Reynolds painted this, his first fully allegorical portrait, in 1761 and exhibited it with the Society of Artists in 1762, the year Hogarth exhibited instead with the Society of Sign-Painters, his parody of academic exhibitions.[1]

Reynolds keeps close to his topos: the scene is the country, the figures are obviously allegorical (not, as in Hogarth, the sort of people Hercules would meet today if he arrived in London on the York wagon), and even Virtue's arm is raised in the proper way pointing toward the hard, steep path. But he compensates by making them obviously actors and the whole a scene from a play. Comedy and Tragedy are *playing* Pleasure and Virtue, as Garrick is playing Hercules (in a vaguely Shakespearean attire). And while Garrick, as an actor, is as mighty a figure as Hercules, he differs in that he is unable to choose between his two charmers. This is not, however, indecision, for the polarity of good and evil in Virtue and Pleasure has been subtly transformed into equal goods; and whereas the proper choice for Hercules was Virtue, for Garrick the accomplished actor it is the highest praise to show him unable to choose.

Unlike Hercules, he has *not* chosen; in fact though his head is turned toward Tragedy, his smile shows that his thoughts are on Comedy, toward whom the lower part of his body inclines; he seems to be striding in her direction but is stopped in mid pace by Tragedy.[2] The topos has been reshaped—or Garrick's presence has reshaped it—to conform to his own circumstances: one of the chief talking points of his fame was precisely that he was equally good in comedy and tragedy. He was Joseph Warton's example of the one contemporary who could do both well, in contrast to Pope, Hogarth, and others who were superb at comedy but fettered when they tried their

hands at higher modes. One suspects that Reynolds, who had already sent verbal shafts Hogarth's way in some *Idler* essays, was well aware of Warton's pronouncement (and the acute discomfort it had caused Hogarth) and that his painting is also about himself, the Garrick of painting, who can equally paint Tragedy in the Bolognese manner and Comedy in the style of Correggio without threatening the unity of his composition.[3]

Both Reynolds and Hogarth redefine the basic topos and produce a more complex meaning than they originally found. But Reynolds has found a topos that fits in most particulars; he has emphasized the congruence rather than the difference between actor and role, and where there is a difference it is a flattering one to the contemporary subject. There is also, last but not least, an implicit comment on the art of the painter himself who has understood and rendered the topos.

Hogarth and Reynolds have much in common, in particular their intellectualism. Reynolds' remark in Discourse XIV that Gainsborough had seen the world 'with the eye of the painter, not the poet' was meant, with the authority of Horace's *ut pictura poesis* upon which Hogarth also drew, to place him a bit down the ladder of art. Throughout the *Discourses* Reynolds emphasizes the necessity of the 'element of mind' in the composition of a painting, by which he means careful construction like that of a poem, with the actual execution something that could largely be left to assistants. In his own practice, execution was far more important than he let on, but the view expressed is that the structure of communication in a picture is parallel to that in a poem; and one of Reynolds' most acute scholars writes that he 'was deliberately experimenting to translate into the language of painting the movement, metaphors, allusions and emotional surprises of poetry'. This was his 'attempt to produce literary reactions by visual appeal'.[4]

When poetic models have been educed they have been Pope and the Augustans,[5] and this is accurate in the important sense that Reynolds accepts the heroic values of Achilles and Hercules without questioning their dangerous

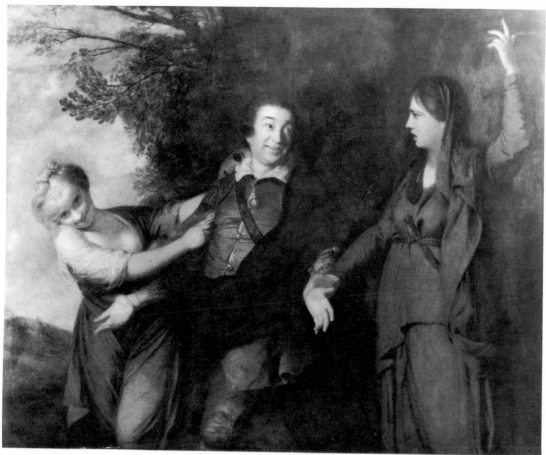

37 Sir Joshua Reynolds, *Garrick between Comedy and Tragedy* (1761). Private collection.

and destructive side. Being a portrait painter, he was naturally dedicated to *laus* rather than *vituperatio*, whether of the heroic past or the heroic present. The continuum evoked by Hercules is the universality of a contemporary actor. The slight difference within the basic structure of similarity makes it a witty, perhaps comic metaphor: however mighty an actor Garrick may be, a difference at least (with no real derogation implied) does exist between Hercules the hero of the twelve labours and Garrick the great impersonator of heroes. The two, though they are not at every point quite parallel, may be said to rhyme.

The linguistic model in general asks to be tested in Reynolds' case. In his second Discourse he sets out the painter's learning process in verbal terms: first the artist learns his 'grammar' ('drawing, modelling, and using colours')

of 'the language of the Art'. The next stage is to 'amass a stock of ideas, to be combined and varied as occasion may require' and 'a variety of models'—poses, expressions, configurations. The art of the past, in its subject as well as its form, is essentially a language to Reynolds; if his subject is Garrick, the sentence in which he conveys this subject is made up of semantics and syntax from the past. It is a language in the eighteenth-century sense, with a grammar and lexicon established, a system of constants which the painter arranges, without violating or creating solecisms, in known syntactic patterns. This is the contrary of Hogarth's conception of an infinite number of new sentences projected into the future. Like the decoration in Holkham or Stourhead, it tends toward a language based on the validity, not the questioning, of a topos. Charles Mitchell has gone so far as to refer to

81

'Reynolds' scheme of education in the grammar and syntax of a dead language'.[6] He is not creating a new language but conserving an old, making his contemporary sitters fit or approximate it—by idealizing just short of a likeness, for the point is that the face is being changed to approximate the universal.

Eclecticism is another word for the sort of elegant arrangement of known elements that go to make up a neatly subordinated sentence. Since Reynolds is a portraitist, this involves relating a particular subject to a general predicate. 'Thus if a portrait-painter is desirous to raise and improve his subject, he has no other means than by approaching it to a general idea.'[7] In Discourse VI he shows how an artist can advance beyond the mere imitation of models to a more specific kind of imitation: 'the borrowing a particular thought, an action, attitude, or figure, and transplanting it into your own work.'[8] The way Reynolds takes an arm here, a leg there, a facial expression from somewhere else: whatever one may say about the judgment, discretion, or wit with which he does it, he is illustrating what is meant by academicism as defined in the *Discourses*, and what is meant by a linguistic model as applied to his paintings.

His lexicon is perhaps more purely graphic than Hogarth's. In *Garrick between Comedy and Tragedy* he is alluding less significantly to a text of Prodicus than to forms and styles of painting. The style of the Bolognese School, which he associates throughout the *Discourses* with the great style, and the style of Correggio are appropriate to the painting of, respectively, tragedy and comedy. Once the painter recognizes historical style as such, he can move toward the possibility of a variety of styles and make these one of the expressive modes of his painting. Anyone who could paint a religious picture in one style and a genre scene in another was aware of the decorum Reynolds presupposes; but his *Discourses* argue for a variety of styles in portraiture, a complex and learned eclecticism that nobody else developed so subtly or fully as Reynolds himself.

If we take the coordinates of art history to be form-style-representation, we can reconstruct a simple lexicon for Reynolds' portraiture. As the sitter's importance is emphasized, the representation rises to the decorum of history painting, to the forms and neutral colours of the Bolognese style, and to mythological or Biblical allusion, or Ripan personification. Titian supplies most of the models for men of power, Van Dyck for the boys and the more delicate men, and Rembrandt for the literary and artistic types. For the mothers and children, naturally the Raphael *Madonna and Child* offers the proper associations; for children by themselves Correggio or Murillo. Of course there are infinite variations on these; whatever model or style or form is called for by the circumstances of the sitter is drawn upon.

Reynolds is able to 'say' a good deal within the limits of his vocabulary of form and style. Just how delicate a sense of nuance and decorum he had can be seen in the self-portrait in which he stands next to a bust of Michelangelo but is painted in the style of Rembrandt (1773, Royal Academy). He is attired in the robes of his honorary Oxford degree (which give him the Rembrandt-style headgear) and with his hand supported by the table holding the bust, but he is not portrayed in the grand style of Michelangelo. The ideal, usually united with the sitter by form and style, is detached into a second image; the effect is to designate the human discrepancy and his own awareness of it. The Rembrandt style was patently not the highest (though its vagueness could by this time be associated with one aspect of Burke's Sublime), but it was appropriate to Reynolds himself, the portraitist who, however much he wrote and spoke in advocacy of the grand style, knew his own talent to lie in a lower range.

Painting from the 1750s onward, Reynolds was literary in a sense very different from Hogarth. He says himself, contrasting the effects of painting and poetry: 'What is done by Painting, must be done at one blow; curiosity has received at once all the satisfaction it can ever have.' It cannot, like a poem, lead 'the mind on, till attention is totally engaged'.[9] What he calls the 'elegant' in art, and can be applied to Hogarth's paintings, 'may be produced by repetition; by an accentuation of many minute circumstances', but anything 'great' must be 'a single blow'. The self-portrait, with its shadowy, barely-indicated bust—almost an extension of Reynolds' body—is such an image. The most obvious change is from precise, verbalizable meaning to general impression—from what Whately called em-

38 Sir Joshua Reynolds, *Self-Portrait with Bust of Michelangelo* (1773). Royal Academy.

blematic to expressive form. Emblems of course remain, but Reynolds reduces the emblematic detail to a single unambiguous gestalt.

This compression is strongest in a portrait like *Mrs Siddons as the Tragic Muse* (1784, Huntington Library and Art Gallery), in which sitter and ideal are one. Mrs Siddons is an actress, and so Reynolds portrays her exclusively in terms of art, generalizing her face toward 'tragic actress' or 'tragic muse' and leaving a large dark space beneath her that can be taken to be either a stage or the clouds under the ideal figure of Tragedy. The dagger and

cup, attributes of Melpomene, the tragic muse, have been removed from Mrs Siddons' hands, where they would interfere with the simplicity of the central image, and given to the two supporters behind her, who are vague enough to be either human figures or painted scenery. They are identifiable, out of Aristotle's *Poetics*, as Pity and Terror, and anyone familiar with Le Brun's *Traité sur les passions* would have recognized their expressions. Reynolds' desire for simplification of forms and response combines with his need for iconographical richness. He includes even a slight verbalism— in the most private level of the picture's

39 Sir Joshua Reynolds, *Mrs Siddons as the Tragic Muse* (1784). Henry E. Huntingdon Library and Art Gallery.

40 Michelangelo, Prophet Jeremiah. Sistine Chapel.

41 Michelangelo, Prophet Isaiah. Sistine Chapel.

meaning—in his signature inscribed 'on the hem' of Mrs Siddons' skirt. 'I have resolved,' he told Mrs Siddons, 'to go down to posterity on the hem of your garment.'[10]

Forms and colours appropriate to the great style are used, with perhaps something of Rembrandtesque lighting. Mrs Siddons' pose is specifically that of a Michelangelo prophet (a pose Reynolds could have used in his self-portrait had he thought it decorous), closest perhaps to Isaiah, and, as if to underline the allusion, her left supporter is taken from the figure behind another of the prophets, Jeremiah. The viewer might not have distinguished the particular prophet, and Isaiah carries no particular significance for Mrs Siddons. But the allusion to a Michelangelo prophet on the Sistine ceiling would not have gone unrecognized: it would have elicited awe and respect, both for Mrs Siddons and for the artist who employed the allusion.

As a literary allusion, the Michelangelo prophet adds a religious dimension—perhaps of prophecy—to the idea of tragedy. Beyond that is a general area of association that Reynolds could expect a Michelangelo prophet to summon up. The literary element is only slightly more firmly present than in James Boswell's experience of *The Beggar's Opera* in the 1760s:

. . . I own, I should be very sorry to have *The Beggar's Opera* suppressed; for there is in it so much of real London life, so much of brilliant wit, and such a variety of airs, which, from early association of ideas, engage, soothe, and enliven the mind, that no performance which the theatre exhibits, delights me more.[11]

These are nostalgic and not precise associations; they are not the associations Hogarth experienced when he first saw and heard *The Beggar's Opera*, or the sort a reader of *A Harlot's Progress* experienced a few years later when he first perused that series. And probably every member of the audience by Boswell's time brought his own particular associations from his own past, vaguely similar, to bear. Although Gay's juxtaposition of old songs with new words was at its time a typical example of Augustan literary imitation, Boswell's terminology suggests the shifting of meaning from thought (knowledge of relationships) to feeling (the associations of Boswell's youth).

85

The change, expressed I believe in Reynolds' paintings, is from literary allusion to psychological association, based on shape and form, but also of course on a complex of associations somewhere between conscious and unconscious. The Augustan poet had made specific allusion to Horace, to a passage in a particular poem, and to its context; Reynolds' reader-viewer was expected to see the relationship between a Michelangelo prophet and grandeur, or sunset and hope, but grandeur and hope could be many things; and the prophet might elicit hope and the sunset grandeur without destroying the general feeling of awe. Presented, as Edmund Burke argued, with certain sense stimuli in soft curves and the like, *anyone* will respond in approximately the same way. And then (to adapt David Hartley, the exponent of associationism) if enough people know Michelangelo's prophets through popular engravings, when Mrs Siddons appears in a painting posed as one, the viewer will respond accordingly.[12]

Associationism as uniform response (rather than multiple, divisive, or relative) would have been assumed by the Hogarth who claimed that an S curve always elicits an impression of beauty from the viewer; but the relativist interpretation would also be present in Hogarth's doubts about the associationist unity of response, even in his own audience, but certainly in the figures he portrays, for whom an objet d'art can mean two or more things. Reynolds, with behind him the tradition of imitation and the new empirical theory of Burke, is the main representative of an artistic point of view that sees the mind as productive of constitutive rather than divisive forces. He accepts a certain arbitrariness about the association of ideas, is dubious about real vs. apparent truths (disagreeing with Hogarth's claims for his Line of Beauty), but believes that a certain association is fixed by 'custom and prejudice':

Whilst these opinions and prejudices, on which it is founded, continue, they operate as truth; and the art, whose office it is to please the mind, as well as instruct it, must direct itself according to opinion or it will not attain its and.[13]

I am, however, supposing too simple a constituency for a Reynolds portrait. Once seen at the Royal Academy's annual exhibition, it was then probably mezzotinted and generally distributed (as with *Garrick between Comedy and Tragedy* and *Mrs Siddons as the Tragic Muse*). But it was seen first and last by the family: for example the Montgomerys, who knew that when a portrait of the eldest of the three sisters, and the first to be married, included a bas relief of *The Judgment of Paris* it meant that like Venus she was chosen from among the three by her Paris.[14] And there was another specific group for whom the picture was significant in a somewhat different way from the majority of ordinary viewers: the artists and connoisseurs to whom *Garrick between Comedy and Tragedy* spoke about the artist's mastery and painting's claim to the status of a liberal art.

A case in point is the portrait of Commodore Keppel that established Reynolds' ascendancy in 1753 (National Maritime Museum, Greenwich). No specific meaning is contributed by the well-known analogy between Keppel's pose and that of the Apollo Belvedere, but only a sense of the appositeness of an immortal ideal to a gallant naval officer who has recently escaped shipwreck. But there was also a very specific reference, which his artist contemporaries and perhaps those sitters who saw the painting in his studio (where it remained for some time) could have known. His model is, first, a reversed copy, perhaps an engraving, of the Apollo Belvedere; and second, Allan Ramsay's *Chief of Macleod* (1748, Dunvegan Castle, Skye). It was Ramsay who reversed the Apollo, and Reynolds, by taking advantage of this stunning portrait, by 'scoring it for a full orchestra' as Waterhouse has aptly remarked,[15] filling in a stormy sky, rugged seacoast, rocks and waves, has shown (as he was later to describe in the *Discourses*) what he can do with the marriage of history painting and portraiture. Reynolds was in various ways (both visually and verbally, in painting and in writing) using, superseding, undercutting, and satirizing his chief rivals in the early years of his London career;[16] and Ramsay's *Chief of Macleod* is one of the coordinates of *Commodore Keppel*, as would be all the works of rivals year after year in the R.A. exhibitions. Both the *Discourses* and the annual exhibitions forced contemporaries to witness Reynolds' own practice in the context of art history. 'It is this deliberate display' of his learning, his 'quotations', and his monumental decorum, as Gombrich has seen, 'rather than the practical use of traditional types and

42 Sir Joshua Reynolds, *Commodore
Keppel* (1753–54). Greenwich,
National Maritime Museum.

formulae that distinguishes a work like
Reynolds' *The Graces* [*adorning a Term of
Hymen*] from earlier cases of adaptation.'[17]

The artist's fame, the unitary response, and
the grasping of a picture 'at a single blow' are
all closely related to the aspiration of Reynolds'
sitters toward unity with the universal.
Reynolds declares himself an image-maker
analogous to Titian in his great portraits of
Francis I of France or Charles V of Spain, of
Aretino or an anonymous man in a fur collar
or holding a glove. But Reynolds was aware

that in his time there were various universals,
many of which could by then be expressed
only in terms of art. The painter, with his
antique analogies, seeks to elicit the Genius of
the Place in his sitter as the gardener does in a
natural setting; Reynolds the painter, Pope the
poet, and Kent the gardener are in this respect
parallel artists.

While his use of antique art is allusive and
normative, it is therefore also taxonomic.[18] He
chooses a Hercules for representing Garrick not
just because he wants to raise his status but

43 Sir Joshua Reynolds, *Master Crewe* (1776). Private collection.

shapes, and in *The School of Rome* (1751, Dublin, National Gallery) the figures themselves expressed their essences in terms of the grotesque, but they were posed in the composition of Raphael's *School of Athens*—their ideal of Renaissance art and patronage, to which they aspired. Reynolds, a not unsatiric man at heart, was amused by the relationship, one which was not too different from that recorded many years later in his own self-portrait with the bust of Michelangelo. And this was essentially the Hogarthian way of portraiture: to paint a likeness and juxtapose it with the bust of an Apollo or Holbein's painting of Henry VIII, keeping them separate.

Some of Reynolds' portraits praise in such a straightforward way that we do not question the obvious discrepancy. In the portrait of the eldest Montgomery sister (Viscountess Townshend), we merely smile at the artist's ingenuity that has found a connection between the three sisters and the three goddesses, Paris and Miss Montgomery's suitor. The most interesting and successful of his large, complex allegories are concerned with actors and the sense of discrepancy that is implicit in the fact of the theatre; this is certainly true of *Garrick between Comedy and Tragedy*, which plays with the discrepancy, and of *Mrs Siddons as the Tragic Muse*, which denies it; and also of *The Daughters of Sir William Montgomery as 'The Graces adorning a Term of Hymen'* (1774, National Gallery, London), where the sisters, who happened to be amateur actresses, appear to be putting on a *tableau vivant*.[19]

Young Master Crewe is also play-acting, trying on a Henry VIII costume, his green everyday coat lying nearby. He has the build, and perhaps the imperiousness, of Henry VIII, but he is only a little boy with his dog sniffing suspiciously at his right leg. And then there is Nelly O'Brien (Wallace Collection), a courtesan whom Reynolds painted more than once, seated in a prim but intense pose of a Madonna —which for Reynolds was at the least a Mothertype—with her pet Pekingese in her lap instead of a (or *the*) child.[20] The dog is not very prominent, or in quite the pose of a Christ Child, but I do not think the juxtaposition of woman, profession, and archetype too daring or too wickedly witty for the Reynolds who painted either the *Commodore Keppel* or *Cupid as a Link Boy*.

because as portraitist he *classifies* him as a man of heroic labours, of heroic choices; Garrick falls within this general category of ancient representation. Bringing a Hercules together with Garrick, a Rembrandt with himself, or the Apollo Belvedere with Commodore Keppel may be equally appropriate, but it might be less so to paint Keppel as Hercules or Garrick as Apollo, and amusingly incongruous to bring together a young Master Crewe and Henry VIII (Marquess of Crewe). The artist's task is to find the apposite image and to show the relationship—the congruence or noncongruence—of the general and particular, or of the art of the past and the nature of the present.

The king would be a unity of the particular George III and the idea of kingship (visually perhaps expressed as Titian's Charles V), but there are other approximations to that degree of unity such as Mrs Siddons and the Tragic Muse. Reynolds, in his youth, sought an essential image in caricature as well as in ideal

In one way or another in his portraits of his contemporaries Reynolds is trying to make the figure as far as possible—within reason—into the universal. But only if there is an appropriateness, and then never quite. He remains always aware, as must his sitter, of the slight, not unpleasant sense of difference, the discrepancy between particular and general, and even ultimately nature and art: Garrick's complacency between two pretty women, his desire to satisfy both, or whatever sets off the individual Garrick from the type (the role, the antique representation) of Hercules. He is portraying not a failure to measure up to the hero or personification but uniqueness remaining within the universal to which the figure can otherwise be fitted.

In a portrait not concerned with acting or social life the allusion to art is less appropriate. There is no such allusion in the portrait of Lord Heathfield (1788, National Gallery, London): the shape of the man is simply related to the shape of his calling. His hulking, craggy form, emphasized by the diagonal of the turned-down cannon behind him (aimed down into the harbour, its line and the line of the rock on which it sits continued in the shape of Heathfield), resembles the mass of Gibraltar, the fort he commands and to which he holds the massive key. In some sense he *is* the Rock of Gibraltar; at the least he is an embodiment of his function, and his shape, jutting up like a rock from the bottom of the canvas, isolated against the sky, approximates the universal of Indomitable Old Man (used also in portraits of Keppel in old age [Tate Gallery and Milton Park]), much as Mrs Siddons does a Tragic Muse or mothers do Raphael Madonnas.

This is true of many of Reynolds' finest portraits: Joseph Bareti is concentrated to a squint at a book held up to his eye, and Samuel Johnson to a clenched fist, as clenched as the great, closed face above it.[21] Although he is toga'd and simplified to resemble a classical bust, any antique source would be irrelevant. In the portraits of close friends, Johnson, Burke, Boswell, and Goldsmith, there are no referents outside themselves, often not even a gesture: mere head-and-shoulders, creating by means of powerful chiaroscuro and simple masses an expression which is also an emblem of the man and of the universal which he projects, and of Reynolds' art itself.

44 Sir Joshua Reynolds, *Nelly O'Brien* (1760–62). Wallace Collection.

45 Sir Joshua Reynolds, *Lord Heathfield* (1788). London National Gallery.

46 Sir Joshua Reynolds, *The Infant Johnson* (1781–82).
The Hyde Collection, Somerville, New Jersey.

The simplest version, almost the paradigm, of the relation between particular and general ideas as Reynolds conceived it, is the child. The child portraits work in two ways: the child plays the adult, and the discrepancy is noticed, or the child embodies the idea of the adult in its purest form, without wrinkles or warts, but with still an amusing sense of difference. Master Crewe dressed as Henry VIII is an example; or *The Fortune Teller* (1775, Huntington), in which the allusion to Caravaggio, like that to Holbein, is only by costume and pose. The style, befitting the child subject, is Correggio's, and the wit of the picture has to do with children filling the roles of the adults in a fortune-telling scene. Far more complicated are the pictures of a child acting as contemporary equivalent to a god or goddess. Cupid's torch with which he sets lovers' hearts afire becomes a torch by which a link boy lights lovers home, but also a phallic shape echoed in the chimneys behind him and emphasized by the bawdy gesture he makes with his supporting hand. To correspond to his modern function, his angel wings have been transformed into bat wings (1777, Albright-Knox Gallery, Buffalo).

The paintings of mythological or historical figures in their infancy sum up the general thrust toward the fulfilment of the universal. Reynolds imagines the child who would grow up to be the man Hannibal, John the Baptist, Samuel, Daniel, Jupiter, Hercules, or Bacchus. He is the particular seed related in a teleological sense to the man as ideal. St John (Minneapolis Institute of Art and Wallace Collection) appears as a child with his cross and lamb, as he does in many *Madonna and Child* pictures, and Samuel did in fact receive his call to prophecy when, at twelve, he was placed in the temple. The point is that these childhoods allow Reynolds to get closer to the ideal form he is seeking for each individual without (most obviously in the case of Johnson) the particularities and oddities and twitches picked up over the years. The child is the general truth from which the man will increasingly, with experience and age, particularize himself.

There is no discrepancy, as there always is in role-playing; there is only an indication of potentiality. This is the same St John or Samuel Johnson but as a child, with the adult inherent in him. And it is this potential that Reynolds seeks in every one of his sitters. He does not paint Shadwells who think they are Virgils or heroes from the *Aeneid*, let alone low life types who try to imitate 'great men'; but Shadwells who *are* potentially Virgils, or Heathfields who are potentially Rocks of Gibraltar. Reynolds' paintings of children point toward what is most characteristic in his greatest paintings. The Reynolds gestalt we have been trying to define, like these child portraits, is essentially a matter of concentration, the quality that is most prominent in Reynolds' portraits despite his copying of arms, legs, attitudes, and perhaps whole compositions from artists of the past.

The most noticeable sign of this concentration is the sculptured quality of his faces and often of whole figures. The faces give the impression of having been polished and rubbed down to the bare essentials (perhaps a better word than the universal); at other times they are equally rough and antique-looking. Then there is the solidity of the figure, which seldom in any way blends into its surroundings. These figures tend to be cut off from, isolated from nature or their environment, almost like statues

(as if the compositional unity of the figure and of the ground have been conceived separately).[22]

His sitters, male and female, have a strong tendency to close upon themselves or as nearly upon themselves as possible within the limits of an organized picture space; they seldom move outward with gesture to relate to other objects. Within the composition the oval is the basic form, but even when a Lord Heathfield rears up like a hill from the bottom of the canvas he is a complete, self-sufficient, and self-contained form—in this case the complete shape of Gibraltar. Usually when a hand is away from the body Reynolds points it downward and inward, so that the eye supplies a line closing with the body shape once again.

He distinguishes, however, between men and women. The full-length men strike a balance or a tension between the self-enclosing and the outward-flung gesture. *Captain Robert Orme* (National Gallery, London), *Captain Winter* (Lord Swaythling),[23] and *Colonel George Coussmaker* (Metropolitan, New York) are good examples: the great downward curve of a horse's neck closes the subject in, though Orme's horse's hoof retains a balance by pointing out from the otherwise centripetal movement. In *Coussmaker* Reynolds constructs a sculpturesque group that is internally complex and intertangled but as a whole set off from the rest of the scene. Coussmaker's crossed legs and the various intersections of his arms and uniform parts make a complex of lines and converging planes, with every line directing us into him, at the same time surrounding and encasing him. Pointing slightly outward are the horse's hoof and the looped branch of the tree, and perhaps the lightly-sketched leaves on the tree above his head. There are connections with the outside world, primarily through the horse, but the tendency of the man himself is to turn inward, his arms closing rather than opening—not in subjectivity so much as in an inner compactness, a storing up of energy that is restrained but about to burst out. Never weak or passive, these are immensely charged figures.

Reynolds' women are completely rounded within the canvas, bound about with their classical robes, often criss-crossed with bands to make them appear even more compact; their gestures close upon themselves or protectively upon their children. The group, which always acts as a single unit, finds its model in Raphael's *Madonna and Child* pictures. With two children the one clasps the other, and with groups of men their shapes intertwine as closely as Coussmaker and his horse.[24] The effect is totally unlike the separateness of the figures, with their relationship to objects in the external world, in the scenes of Hogarth, Watteau, and the painters of conversation pieces (below, Chapter 8). In Reynolds' group portraits the people overlap, tied together by intersecting and surrounding lines.

In many canvases the picture space is constructed like a womb, with the compact figure

47 Sir Joshua Reynolds, *Colonel George Coussmaker* (1782). New York, Metropolitan Museum.

of the foetus floating within it, reducible ulti-
mately to those baby figures, most of them
absolutely compact with heads down-turned
and hands in their laps. The form is summed up
46 in *The Infant Johnson, The Mob Cap* (1781–82,
private collection), and the posing figures in
The Infant Academy (1782, Kenwood House).[25]
A baby in a completely closed posture, Johnson
with even his eyes closed, is the essential figure
that haunts Reynolds. Even when he paints an
open figure like *Puck* (1789, T. W. Fitzwilliam)
he closes his spread legs by seating him on a
toadstool and his spread arms by the branches
and foliage that continue their lines into another
oval over his head resembling the mob cap in
the picture of that name.[26]

The very greatest of Reynolds' paintings are
those in which the holding-in is interrupted, the
centripety fracturing into controlled centrifu-
gality. *The Duchess of Devonshire and her Son*
(1786, Duke of Devonshire) is a fine example,
or *Augusta, Lady Cockburn and her Children*
(1774, National Gallery, London).[27] The latter
is typical of Reynolds: the family is related to a
'Charity' composition, an appropriate para-
digm,[28] and the composition, though complex
with arms flying in all directions, is neverthe-
less a group that is completely self-contained.
Lady Cockburn is looking fixedly at the one
baby who is most obviously pulling away; and
the one absolutely separate unit, a spot of red-
white-blue, is the parrot, who is facing away
from the family group.[29] In *The Graces adorning
a Term of Hymen* (National Gallery, London)
the three young ladies all hold together in a
closed undulating shape, but a shape that is
stretched to the breaking point.

One of Reynolds' sketches for a history
48 painting, *A Mother and her Sick Child* (1768–69,
Dulwich), is divided into two closed, womb-
like areas. At the right is the mother and child,
the mother's protective gesture enclosing the
child emphasized by the long parallel curve of
her blue robe. Far to the left—a great empty
space intervening—is the angel trying to ward
off Death, his gesture both preventive and
protective. Death himself is a continuation of
that protective gesture, and his own extra-
ordinarily long arm parallels the curve of the
mother's robe and extends in the curve of his
scythe. The forms express the protectiveness,
'motherliness', of Death, of the angel, and of the
mother, with the sinister terror of Death's

protectiveness emphasized by the wide space
between him and the baby.

Above all, returning to *Garrick between
Comedy and Tragedy*, one sees at once the
separateness of the figures—the element of
choice—and yet how inextricably they are
bound together; this is, of course, the centre of
Reynolds' meaning, and he cunningly indicates
the tension between unity and separateness by
the chiastic structure of his composition: the
three figures make a giant X, running from the
bent legs of Comedy and Garrick up to
Tragedy's uplifted left arm, and from Comedy's
smiling tilted head down across her arm and
down Garrick's extended left hand, down
Tragedy's skirt. These lines are supported by
the various crossed lines within the composi-
tion, such as the X made by Garrick's chest
strap and his cloak, his and Comedy's right
arms, his left and Tragedy's right arms, and
so on, even down to his crossed legs.

What I have described is the most charac-
teristic Reynolds mode of his maturity,
connecting with his search for unity of all sorts,
of iconography and form within a picture and
of response without. It also connects with his
attempts to find ways to express the universal—
by simplifying drapery and expression, as in his
final reliance on children as the very essence of
the grown man; and his simplification of
history to a single agonizing woman, of sitter,
pose, and costume to a single gestalt. This is
what it means to bring everything together
from diverse sources into a tight unity that can
be seized at once, 'at one blow'.

The paintings are also related to Reynolds'
ordering of disorderly particulars into a unified
structure of generalization—what has been
called an ordering of the arts—in his own *Dis-
courses delivered before the Royal Academy*, or in
Charles Burney's (and Hawkins') ordering of
music, Thomas Warton's of English poetry,
and Burke's of political theory in *Thoughts on
the Causes of the Present Discontents*. These
works are very different from the piles of notes
George Vertue left behind him, or Rouquet's
State of the Arts in England (1755) or Hogarth's
Analysis of Beauty or his notes toward a treatise
'On the Arts of Painting and Sculpture parti-
cularly in England' (*c.* 1760). The latter are all
too close to immediate experience, too descrip-
tive of the real situation of art and artists in

48 Sir Joshua Reynolds, *A Mother and her Sick Child* (1768–69). Dulwich, Picture Gallery.

Georgian England. They are all empirical and pragmatic works, personal or eccentric and blatantly anti-academic.

This is not to deny that Reynolds' *Discourses* are in a sense as pragmatic as his paintings; they *use* the past according to contemporary needs; but it is the past that they use and not something else. Despite the *concordia discors*, the compromise and approximation—the eclecticism—of Reynolds' own lectures, they gave the sense to the audience of the 1760s and 70s that there *is* a complete work on the subject of art which sums up the possibilities of painting and the hierarchy of painters; and their underlying assumptions were reiterated until there was little doubt about rules of precedence, the

ranking of genres and of the schools on the model of a ladder, analogous to the Great Chain of Being. As their modern editor has said, 'Read by the president before his Colleagues and students, the Discourses were tantamount to a statement of policy for the young institution.'[31]

The complex situation of the French Académie, with a hundred years of experience, mellowed by the Rubenisme-Poussinisme conflict, tells us little of the very simple situation of the English Royal Academy in the 1770s. The basic facts were the English desire for academic practice and tradition: they had been told the lack of this kept them provincial so many times that (in spite of Hogarth's loud disclaimers) they had come to believe it. Many artists, of

course, continued to go their own way; but the ambitious and potentially interesting ones were alike affected, either positively or negatively, by the ideas and rules of the Academy.

As to the 'old masters', Reynolds told the students that 'those models, which have passed through the approbation of ages, should be considered by them as perfect and infallible guides; as subjects for their imitation, not their criticism'.[32] These are sentiments that Reynolds himself qualified in practice, but to a student they were powerful and simple guidelines, and to an artist who retained traces of the St Martin's Lane training and atmosphere they bore the heavy weight of authority that would sink the British School.

While taken as a whole the *Discourses* may seem to function as a pendulum, balancing praise and blame for all the possibilities of art, in the first decade at least the precedence and emphasis fell resoundingly on history painting and 'the great style'. The Venetians are good at colouring, but 'even that skill, as they have employed it, will but ill correspond with the great style'. And on the same page Reynolds speaks of 'treading the great walks of history'; and he praises a painter like Poussin because his 'eye was always steadily fixed on the Sublime'.[33] In 1780 Reynolds was saying of the art of painting: 'the more we purify it from every thing that is gross in sense, in that proportion we advance its use and dignity; and in proportion as we lower it to mere sensuality, we pervert its nature, and degrade it from the rank of a liberal art. . . .'[34]

It is reasonable to suppose that Reynolds may have been over-compensating for his own attraction to the Venetians and the Dutch, and that perhaps later he tried to right the balance by praising those qualities that distinguish the other schools, genres, and styles. But the students who heard the lectures, the contemporary connoisseurs who read them as they appeared, and the painters who were academically inclined caught the emphasis and it is conveyed in their works: the paintings of Barry, Northcote, Mortimer, and later Benjamin Haydon are there to prove the existence of the chimera.

Reynolds himself, in practice, was hardly more or less academic than Hogarth, but merely one whose personal way of adjustment to academic art was to emphasize the past over the present, the universal over the particular; one who put on record in its most persuasive form doctrines which in many cases he preached rather than practiced, and over the long span of the *Discourses* sought in various ways to qualify. But they were on record, especially in those crucial first ten years or so, and Reynolds' academicism came to represent the Enemy or the Other to artists whose responses were as various as Zoffany and Gainsborough, Stubbs and Wright, Blake and Rowlandson.

Two questions worried all of the painters of the next generation: Why aspire to 'grandeur and sublimity'? and: Is Reynolds' Bolognese style via classical and Biblical myth indeed the way to the end of sublimity or the greatest art? It should be noticed that the basic trend of the academic tradition as laid out by Reynolds was to synthesize, to combine, to produce a super history painting genre to which paintings of humans, horses, landscape, and still life were subordinate. Reynolds himself tried to raise one element, portraiture, to almost equal importance by giving it all the accoutrements of history. But this may be thought of as letting the part usurp the whole, rather than the real alternative of developing separately the potential of each part. In a sense Hogarth's own attempts were parallel to Reynolds', only his solution was a 'comic history-painting' genre; and one important characteristic of both was eclecticism of various sorts, based in a general way on the allusive use of the past. The alternative tradition, however, which Hogarth also stimulated by his staccato isolation of parts and which bore permanent fruit of another sort, was a fragmentation into smaller genres and subgenres, into emphasis on one aspect that would have been integrated and lost sight of in the more comprehensive mergers proposed by Reynolds. If Reynolds goes the way of Francis Goodchild toward unification, concentration, and the Lord Mayorship, Hogarth and his followers pursue Tom Idle toward subjects and forms of distraction, separation, particularity, and multiplicity. The possibilities available to an artist were by no means exhausted with Hogarth's 'comic-history painting', which was not really imitated as such by anyone. In England and on the continent other alternatives to the old iconography, some of them far more radical than Hogarth's, were being constructed.

7 The Continent

Watteau and Chardin

IN FRANCE in 1750 Jean-Jacques Rousseau was saying much the same thing the *Spectator* and Hogarth had said in England:

Our gardens are adorned with statues and our galleries with pictures. What would you imagine that these masterpieces of art, thus held up to public admiration, represent? The men who have defended their country, or those still greater who have enriched it by their genius? No. They are images of every perversion of heart and mind, drawn ingeniously from ancient mythology and presented to the early curiosity of our children, doubtless that they may have before their eyes models of vicious actions, even before they have learned to read.[1]

Rousseau is thinking of the post-Watteau generation of rococo frivolity whose guiding principle was to please. The extravaganzas of the Boucher generation were, however, themselves the last gasp of the reaction against the official art of the age of Louis XIV.

The portrait of the Grand Monarque being packed away in *L'Enseigne de Gersaint* (1720–21, Berlin) is something more than a picture or shopsign; in the context of all the paintings on the walls of Gersaint's shop it alludes to a heavy authoritarian, meaning-ridden style which had died officially only in 1715 with its namesake.[2] What Watteau had found when he came on the scene a decade earlier was the thick reading structure of propaganda art made of heroic representations of Apollo (*le roi soleil*) and Alexander the Great that dominated everything from palace decoration to easel painting. A general reaction was already under way in the paintings of La Fosse and others who withdrew into themes of a more private nature, primarily of love.[3] Watteau's recoil was from mythology and traditional iconography as such.

Watteau aimed, writes René Huyghe, summing up much analysis of Watteau's paintings, 'only at creating an impression that would act, like music, directly upon the heart. A picture no longer had to be understood: it had to be felt and imagined'.[4] This basically correct formulation, however, allows for interpretations that are fanciful or indeterminate. Here is a typical response to *The Pleasures of Life* (Wallace): 'for no reason that I can adequately explain, I am haunted by it. It is in this that Watteau's magic defies analysis.'[5] We can arrive at a more precise sense of what has to be 'felt and imagined' by tracing the stages of Watteau's reaction to official art.

There was, first, his Flemish background. His earliest response to the Louis XIV style (or regression into his native tradition) was to turn 'history' as glorification of victories on the battlefield into a series of quite unheroic war scenes following upon the defeat at Oudenarde. The Flemish tradition meant a fidelity to sense experience in everyday life, descriptive scenes of domestic life, and so in warfare a humanizing of the heroic; but it also tended to reveal in everyday experience the *Vanitas* significance or the reality underlying illusions. Watteau chose to portray the boredom of encampments that negates the rhetoric of heroic combat in official battle scenes.[6]

The *Vanitas* attitude also underlies, and perhaps determines, his relegation of mythological and allegorical iconography to the statues of contemporary art collections. Not Venuses and Adonises in love but contemporaries in contemporary settings appear in his *fêtes galantes*, and the goddesses are domesticated as statues in a garden. It is the garden into which the old myths go, scattered about in stone. Their presence retains the relationship between fleeting amours and permanent ideals, but only as 'furniture'. A statue of a woman stands behind Mezzetin playing his lute, and her back is turned to him: the statue, one critic says, 'is deaf and stone, and perhaps the same is true of the living woman'; or, says another, she 'clarifies the theme of longing and still unrequited love'.[7] It is true that when Mezzetin plays his lute it is understood that it is a love song; also that the statue is dressed like a contemporary woman and she is meant to be stone. Love itself, when reached on the Isle of Cythera, is a statue, an artifact, armless and barely more than a stump with a head on it.

49 Antoine Watteau, *Le Mezzetin* (1718–20). New York, Metropolitan Museum.

These are the traces of myth in a world of impermanence, remaining as fragmentary ideals and memories of ideals.

Watteau is an ironist and balances the statue of Venus with, at the other side of the picture space, the prow of the ship that has brought the pilgrims to the island: its figurehead is a siren,[8] one of those creatures who lured mariners with their love songs and devoured them to the bones. (The ship was once the mariners' refuge from the sirens, but now the possibility of choice between ship and siren is annihilated.) There are also putti flying about the Isle of Cythera. The one nearest the goddess' statue and the loving couples is dressed as a member of the expedition, only his tell-tale quiver of arrows giving away his true identity; but around the boat itself cupids swarm unattired and unashamed. The scene is allegory at the left merging into reality at the right; and in the *fêtes galantes* the goddesses, though isolated on plinths, are sometimes painted in such a way as to blur the demarcation between stone and flesh, ideal and real. Watteau's is not yet

Hogarth's totally secularized world in which there is no reality or efficacy in illusion.

Watteau's major innovation was to replace the old iconography with the conventions of the contemporary theatre. Instead of the gods, nymphs, and personifications he gives us a new cast of characters from the Commedia dell'arte: not a Venus but an Isabella or Colombina, accompanied by a Pierrot, a Harlequin, and a Mezzetin. These figures, sometimes with persons not of the company, offer much subtler variations on the love theme than could be found in the old figures and expressed in the old topoi. But Watteau instinctively fastens on the idea of the discrepancy between people and the roles they play, the same *Vanitas* subject he explored in his encampment pictures of humans playing at being soldiers or heroes. He makes the Commedia figures into people who are partially defined by their roles. Pierrot or Colombina, with their dual identities, which include roles as clowns and charlatans as well as lovers and 'protectors', project a world that is a personal secularization of the moralized world Watteau inherited.[9]

Watteau is not content, however, with the conventional arrangement or role-playing of the Commedia types. He shows them not in just their traditional poses, scenes or relationships but slightly rearranged, as Hogarth rearranges the conventional structures of his Biblical and classical sources. The Dottore and Pantalone, usually central, are at the very periphery of the scenes Watteau portrays. Isabella and Orazio, the noble lovers, are often separated, and Isabella appears instead accompanied by one of the comic servants. The disturbance to decorum is not in focusing on the servants or mingling noble lover and servant but in doing this in the soft, somewhat idealized style in which the noble lovers should be portrayed. Yet the Harlequin may be trying to trick, frighten, or seduce Isabella precisely because he is a noble lover disguised as Harlequin.[10] The situation is further modified by introducing a portrait: Gilles or Mezzetin is given the face of Vleughels or some other friend, or of Watteau himself, and the sense changes again.

Mezzetin and Pierrot are the two figures singled out by Watteau. Mezzetin, the coarse servant, has become a rather delicate figure, his artistry and musicianship emphasized: with

his song he injects the theme of art into that of love. Pierrot (or Gilles) is the spiritual simpleton, the comic butt, placed always somewhat apart from the other figures: decorum does require, whether he is Pierrot or a noble lover playing Pierrot, that he not attack the Isabella as if he were a Harlequin. His head rises alone and isolated at the back of a crowd or he stands out with open spaces on either side or, ultimately, he towers above the other players and the donkey they have brought with him as an emblem of his stupidity. By painting an impassive expression on his face and isolating him spatially from his fellows, by removing the sense of comic excitement that would have remained on a live stage, Watteau changes Pierrot from the comic butt into a sad modern anti-hero. At the end of his career he places him in two great compositions with Biblical echoes: in the position of Christ in an *Ecce Homo*, with memories of Flemish versions in which a lone spiritual centre is surrounded by mocking figures of reality (National Gallery, Washington, and Louvre). The echo brings Gilles the Commedia type back to life in much the way the painting of stone-flesh animates a statue of Venus.

The formal elements of the painting, its composition and colours and textures, make a single point that substantiates the iconography: day is blending into night, trees into architecture and painted sets, people into Gilles and Christ or Isabella and Venus, and they move away from us into a dim distance. Ordinarily Watteau avoids the flat floor of a room with stable horizontals and verticals as a normative structure. He may include some such structure, but he subordinates it to the rise and fall of the land, the great S curves along which the figures appear and disappear, approach and recede. The general movement of the serpentine lines connecting foreground and background is back and to the left. While Hogarth's and in general all western paintings move from left to right, Watteau's almost always unfold in the opposite direction, back into the distance as if to represent an unwinding or regressing. *Le Pèlerinage à l'isle de Cythère* (1717, Louvre) is the prime example, where the twilight sky, the pilgrims turning away from the shrine of Venus, moving back down the hill to the ship, follow exactly this retrogressive curve. Something is in process of change, coming to an end,

50 Antoine Watteau, *Gilles* (1717–21?). Louvre.

people going home, the party over or about to be. In painting after painting, as René Huyghe says, this backward movement contributes 'to the paintings' pervasive poetry of nostalgic decline'.[11] In this world it is not the threat of a Pantalone or Dottore, the older generation, that hangs over the young lovers but the threat of time.

As the sky and landscape colours blend so as to suggest a time between day and night, there is also a tension between the movement backward, from right to left and into the distance, and the absolute stillness of the setting, the foliage and statues which we are told Watteau painted first and into which he then inserted his lively figures from his notebooks. This in turn is related to the tension between the dreamy, languorous scene and its melting tones and Watteau's darting, vigorous brushstrokes.

The significant point is that Watteau sought his iconography in the most popular entertainment of his time, which was the theatre and particularly the Italian Commedia. In the same way, Hogarth later sought his in the theatre, the

97

51 Antoine Watteau, *Le Pèlerinage à l'isle de Cythère* (1717). Louvre.

popular print, newspaper, and broadside. He transformed his into a new public, moral, and didactic form, while Watteau transformed his into what has come to be called a private and personal form. Huyghe speaks for most art historians when he writes of Watteau: 'He was perhaps the earliest artist to create, first for himself, then for us, a new, intimate, private universe. . . .'[12] We can say 'private universe' because, although his scenes still reflect the structuring of the *Vanitas* topos, they also in a sense react against the austere everyday reality of the genre scene.

Concerning an artist who is creating a 'private world' (as we shall see with Watteau's closest English equivalent, Thomas Gainsborough), much is to be learned from a study of his drawings. Watteau's are a pattern book from which he contructed his compositions, and so they show the ingredients, the com-

ponent parts of his world. In some ways he can express himself here—as he admitted—with chalk and line better than with paint. It is also his closest contact with the real world, as opposed to the imaginary compositions in oils into which he later fitted these figures. And yet the sketches are his best opportunity for a personal statement, because in them he shows how the shapes are related to each other when there is no need to conform to a picture-frame concept.

The mere juxtaposition of figures on a blank sheet—from life or from a painting by Rubens or Veronese—is itself significant. The artist has a whole range of choices as to what he will copy and where he will place it determined by the need to balance the other drawings on the sheet, but never by the need for verisimilitude or normal compositional requirements based on representation. Perhaps only for some

personal reason of subject or relationship does he place this figure next to, or above, or below, that one. There is a tripartite drawing in the Louvre which shows reversed views of a mother and child.[13] The second mother and child formally balances the first—one an enclosing gesture to the right, the other to the left. But it is the third and final sketch that balances both of these, and Watteau adds above the mother and child a roistering scene of sex play, with the enclosing arm now that of the lover.

Leafing through the catalogue of Watteau's drawings, one notices all those views of backs. He is *the* artist with whom we associate this difficult view. Here he can explore the interesting patterns in the folds of the dress, the straight lines of the stays against the billowing skirt, and the textures of materials. The real pattern is often the system of lines he uses for texture and shadow played against the folds themselves. But also, of course, the back is more suggestive than a front view, leaving more to be imagined, and implying daydream or immersion in self.

Then we notice the unusual tilts of the head, the difficult twists and turns, which appear almost for the sake of the skill displayed. In fact the heads are never caught, are always in movement and uncompleted movement at

52 Antoine Watteau, *A Lady and two Gentlemen.* Drawing; Dublin, National Gallery of Ireland.

that; they are turning out of sight or disappearing behind a fan.[14] Most often they seem to be receding from us—moving away, turning their backs, withdrawing.

More than backs and odd, elusive poses, there are the pages showing the same figure in different poses. This is the kind of drawing most closely related to the compositions—and the spirit—of the paintings. The point is that drawn on the same sheet, they look like a Muybridge series. In a few paintings (e.g., *Soldiers on the March*, engraving 1729), the effect is transferred to a representational context: the same model used for each soldier gives him a peculiar anonymity while also suggesting that variations in space relate to variations in time. In the *fêtes galantes* the figures are different, male and female pairs, but their very peculiar movements, bows, pirouettes, and bends in such similar (almost identical) couples, seem to make a series of simultaneous incomplete gestures or movements unfolding in space. As the gestures unwind through adjacent figures they take on again a suggestion of the dimension of time as well as space.[15]

Note that in the sketches, however, the figures *do* ordinarily move from left to right; a movement Watteau consciously reverses when he turns to the painting. The drawings give us in a pure form Watteau's elementary assumption, beneath even the retrogressive movement of the figures in a *fête galante*, about temporality and permanence. Something is always something else, another pose, seen from another direction, at a different time. There is no permanent essence or form, only aspects or perspectives. The different figures on the same page are usually the same scale, but sometimes they are different sizes, as if seen from a greater distance, in a wider perspective; or sometimes only a part of the figure is enlarged and turned or redefined by a clearer focus.

It has been argued that these figures across a sheet or a landscape reflect Watteau's early interest in *gravures de modes*, series of figures illustrating fashions (by Picart, Simpol, Fuflos, and himself).[16] This compositional type may have conditioned his arrangements of figures on paper. Certainly he is not searching for the right composition or grouping but for the reality of the thing itself, all its aspects, poses and expressions.[17] As in the heads of his women and men, or the bodily, marching positions of

53 Antoine Watteau, *Study of three Soldiers*. Drawing; F. Lugt, Institut de Paris.

54 Antoine Watteau, *Three Seated Women*. Drawing; Louvre.

The ultimate form for Watteau, I am suggesting, is the blank sheet on which he can arrange people or objects so as to reveal their absolute transience and isolation in a momentary gesture, which he seems to have regarded as their essence. The composition on a canvas he made as loose as possible to accommodate this vision. Architecture requires more schematic relationships, more public and social ones, than he desired.

Most elements of the *fête galante* are present in the *Fête Venétienne* (Edinburgh, National Gallery). A couple is dancing with a semicircle of audience behind them, concerned in a more direct and less formalized love-play, one young man being rebuffed for his advances. In the background natural foliage is juxtaposed with the classical architecture of either a garden setting or a Serlio-type stage set, with one of those ambiguous statues of a nude. At the edge of the architecture is a young man gesturing in a very stagey manner at nothing in particular. The conformations range from this pure play (or performance) to formal courtship and the dance to physical assault, all in a setting that is itself an amalgam of art and nature, with a piper supplying music. At least one dancer is in costume, and this Turkish figure has the strange, ugly face of Vleughels, Watteau's friend (and imitator-copyist).

A certain kind of world is quite literally in process of being created by these people, one in which order or permanence is sought by the arranging of *fêtes* and other attempts to approach the status of art. That man can never fully succeed, Vleughels illustrates: his physical appearance, his shape and costume show him hardly cut out for the role he is playing and stress the fact that these are all, in a sense, people trying futilely to be something they are not—a theme to be developed at great length in moralistic terms by Hogarth.

But opposite the grotesque dancing Vleughels in his Turkish costume is the delicate, thin, aristocratic figure of (probably) Watteau seated alone in peasant attire with his bagpipes. It is this figure, incongruous in the opposite direction from Vleughels, who makes the over-all art which animates the dance, the courtship, and even perhaps the statue (who appears to be looking down at him from her pedestal). Then, of course, the brushstrokes of the artist Watteau animate the whole scene: the bagpiper is

his soldiers, the seated-on-the-ground, leaning-toward-a-lover postures of his women: in each case he has isolated not just what he needed at the moment (he had no picture yet in mind) but the aspect that was important to him. He fragments the object into these multiple versions of a soldier or a lutist, not in order to show the responses of different viewers but the different aspects that constitute the figure itself—in effect its absence of a fixed and single essence.

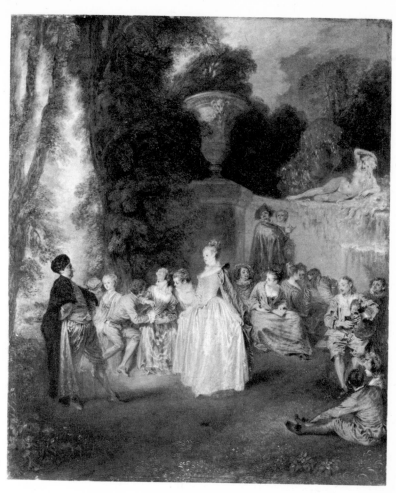

55 Antoine Watteau, *Fête Vénétienne*
(1717–19). Edinburgh, National Gallery
of Scotland.

only a metaphor for the larger engrossment of
the painter. The irony of the bagpiper is that
the maker of art is the one man who is himself
in touch with the reality held at arm's length
by the others, and yet he is isolated by his rustic
costume, his spatial separation, and his oafish
musical instrument. Bagpipes were, as in
Ripa's *Iconologia*, a symbol of the simple
country life and the pastoral poet, but they
were also rude and cacophanous, and (as he
shows elsewhere) Watteau was well aware of
bagpipes' connection in the popular tradition
with the male genitalia.

In *The Shepherds* (or *Dancing Couple, Bag-
piper, and Eight other Figures*; Berlin) the bagpipe
is juxtaposed with the dog lying in the fore-
ground attending to his privy parts, which are
visible and pointed at the viewer (and may
recall the woman in a similar posture in the
Dresden *fête galante*). The bagpipe was perhaps
always both a sign of the rustic and of the

physicality underlying the dance. But in *The
Shepherds* architecture is absent, and art
appears only as the rustic bagpiper and the
formal patterns his music gives to love-making.
Our eyes are led through the painting from
left to right following a horizontal serpentine
line along which we find forms of life ranging
from low to high, from nature through animals
to man. Within the human category there is a
kind of 'range' from the almost loutish couple
at the extreme left to the finely-clothed couple
dancing in the centre of the picture. All with
varying degrees of fineness are engaged in the
pursuit of love: from the clumsy physical
assault of the young man on the left, whose
face expresses simple lust, to the ritualistic
formality of the dancers in the centre. Between
these extremes are the semi-formal and super-
ficially innocent play of the girl on the swing
with her lover and the languorous, sensual
embrace of the couple seated next to the piper.

101

56 Antoine Watteau, *The Shepherds* (1716). Berlin, Charlottenburg Castle.

The dog may retain its conventional associations with animal appetite (carnal or gustatory), but it needs in this context only its reality as animal to activate a scale of being.

What the picture is *not* is a contrast of ideal and physical love. The prospect of physical pleasure merely acts as a common denominator among the various figures. But these figures, formed in a serpentine line, conclude not with the dancing couple but with the sheep and the open field, a large stretch of landscape and empty sky which is nearly a third of the picture. The great emptiness is the end of the romantic-pleasureful-illusory Line of Beauty. And the male dancer's turned hand indicates the division of the composition into a golden section and the artist's control over the apparently random disposition—an ordering that encompasses dance and bagpiper's song.

The separation of the people on the canvas, the relative autonomy of each grouping (especially of the dancing couple), and the deliberate spaces between them are the salient features. Their function, of course, is 'to loosen the texture of the Baroque Rubensian design, to admit a more natural casualness and contingency';[18] or, restated in less purely formal terms, emphasizing 'contingency', perhaps to show a concern with psychological relationships in terms of a metaphor of distance (temporal, spatial, spiritual, psychological). Because the basic form is the serpentine line the term 'spectrum' is not quite appropriate: the figures are receding into the distance; but along this twisting line they are clearly distinguished in terms of refinement by manners or lack of manners, by the formality of the dance or direct action, by age or youth.[19]

At the very end of his career Watteau took his *fête galante* indoors and produced *L'Enseigne de Gersaint*, which is also by far his largest painting (ten feet wide).[20] Aside from its intrinsic merit—and it is one of the greatest paintings of the eighteenth century—the shop-sign is an important link between the conversation piece and the English 'comic history' or 'modern moral subject' of Hogarth. It was engraved by Pierre Aveline and published in 1732, not in time for *A Harlot's Progress* or the conversation pieces, but in time for the first

57 Antoine Watteau, *L'Enseigne de Gersaint* (1720–21). Berlin, Charlottenburg Castle.

plate of *Marriage à la Mode*, which it most resembles, and which is itself a modification, if not a parody, of the conversation piece genre. The pictures on the walls, as we might expect, maintain a much lower level of denotation than those in *Harlot*, Plates 2 and 3, or in *Marriage à la Mode*. They exist at the general level of imaginative creations, fantasy, or what Lord Clark has called 'shadowy promises of escape';[21] they represent stories of lovers, a *Mystical Marriage of St Catherine*, a drunken Silenus, and bathing nymphs, and beyond this level of denotation the different painters and styles of painting which constitute the ideal world of art defined by Watteau.[22]

The only noticeable structural parallel between picture and people is in the *Syrinx pursued by Pan*, directly above and in parallel poses to the pink-clad woman and the young man whose hand gestures toward her in a delicate sign of relationship, a pale reflection of the full-bodied metamorphosis in the painting above.[23] The resemblance in shape is unmistakable, because the most prominent form in the picture is the long back view of the lady.

Her figure leads or invites the viewer into the scene, as she is invited by the young man who advances toward her. She is related to the figures who less obviously draw us across the threshold of the outdoor *fêtes galantes*, where there is the depth of nature, into which the figures are retiring, and the threshold of man-made stone, and a kind of beckoning. Perhaps the introduction into the shop, a crossing of the threshold from the more commonplace world of the cobblestone street and the dog and a lounging bystander into another world of love and art, an analogue to the dance in the *fête galante*, *is* metaphorically a kind of metamorphosis. The world inside the shop is, as usual in Watteau's painting, a world of love represented or structured by various forms of art.

There is also the handsome young man, who has been identified by imaginative art historians as Watteau, who introduces the young lady into this particular world. Whether or not he is Watteau, he is related to the artist or musician present in the *fêtes galantes*, who connects the people (costumed and un-costumed) with the poses, the dance, and the statuary.

103

If our eye is led into the canvas by the long pink-shimmering back of the lady, it curves around to settle on the two prominent groups at the right, customers looking at objects they are thinking of purchasing. The foremost group consists of a girl and two men staring into a mirror held up for them by a shop girl. They are looking at the mirror as an objet d'art, something to buy, and yet the expressions on their faces are dreamy, they are looking not *at* but deep *into* the mirror. We do not see the reflection, only their faces; but to judge by their expressions it reflects what each wants to see there—perhaps the girl's face (what the girl and one or more of the men want to see there) or perhaps something else. There are three other mirrors among the paintings around the walls or (in one case) being taken down.

The mirrors tell us how we are to take the parallel group to the left, engrossed in a painting of nymphs bathing—which, says Levey, is 'being examined so closely by the kneeling man who has got down to thigh level'.[24] Then it tells us how we are to take all the paintings on the wall and art in general vis à vis nature. Paintings are mirrors of life, they are illusions, like the one of Louis XIV being packed away: a way of life and a heavy authoritarian style vs. the narcissistic dreams that remain on the walls; with the one ironic comment on this narcissistic adoration implicit in the picture of St Catherine adoring the Christ Child. Here, in Watteau's last and most damaging statement of his theme, those who would make of themselves works of art are merely obsessed with their own image in the mirrors and pictures.

The illusionism of the shopsign itself is the most radical departure from earlier Watteaus. Those were small cabinet pictures, while this looked, from the street, like a view into the shop; which, however, turned out to be rather a narrow, crowded stall than the wide expanse promised by the painting. From the illusion of the shopsign and the mirrors and the amorous paintings to the idea of purchasing, selling, packing up, and delivering there is a spectrum of art and nature. These are illusions that can be sold and packed away, either out of sight or to anyone's address. In a way it is a scene backstage with the prop crew as well as the merchants of illusion and the people who can buy them. The spectrum ends with the lounger at the far left and the dog bothered by fleas in the street at the far right, grounding the world of art in animal reality.

Watteau's importance to the English painters of the Hogarth generation and after was to give a new twist to genre painting, by producing a kind of conversation piece that could flourish in the literary context of England. The importance of intermediate genres cannot be overemphasized: the steady search for them from Hogarth's comic history painting to Greuze's domestic histories to Gilpin's 'picturesque' (between the sublime and beautiful) defines what is most significant about English art in the period. We can say that Watteau not only replaced allegories with a new iconography but changed the structures of meaning in genre painting. The basic topos of *Vanitas* (the Four Ages of Man, the Four Times of the Day, the Four Elements) becomes a sense of loss or regret; the symbolic objects that go along with *Vanitas*, the humorous and matter-of-fact connection with low types in low surroundings, the eat-drink-be-merry topos becomes the aristocratic, masked group among art works in a natural setting.

In the generation after Watteau, and contemporary with Hogarth, Chardin reduced iconography to mere objects in a still life. 'His pictures,' wrote Roger Fry, 'are among the most striking proofs that arrangements of form have a direct and profound effect on the mind quite apart from what the forms may represent.'[25] Malraux saw Chardin as one of the first artists to subordinate subject to picture; as a simplifier who, going beyond the Dutch, sought the essential forms of the pots and pans of the still life tradition.[26] He was interested simply in treating light on different surfaces, whether a pot, a slab of meat, or an orange.

But to arrive at this conclusion Chardin had to shuck off iconography, moral and aesthetic, from the still life and genre piece. For history painting still lurks in Chardin's background; we are told how in later life he deplored his lack of study in 'the humanities', due to his father's poverty, and so how, 'lacking the necessary knowledge, he was debarred from history painting'.[27] He may have been pleased by Gougenot's words, 'the genre of Mr Chardin comes very near to history painting',[28] but in general the same talk surrounded his work that surrounded Hogarth's: as a still-life painter,

58 J.B.S. Chardin,
The Skate (c. 1717–28).
Louvre.

he was said to be among the greatest artists of his time 'in this genre' (Cochin); and as genre-painter he was called 'the pioneer and exponent of a new taste' (Desfontaines) and a creator of 'a genre peculiar to himself' (Lacombe, 1740) and originator of 'a rare, highly personal genre' (Baillet de Saint-Julien). Mariette complained that the engravings after his paintings, which distributed his designs almost as widely as Hogarth's, 'dealt a death blow to the serious engravings of artists like Le Brun, Poussin, Le Sueur and even the Coypels'.[29]

By some of his contemporaries Chardin's genre painting was seen as a return to a tradition that had been extinct since Bosse and the Le Nains, and so as another reaction to the years of sublime history under Louis XIV, another intermediate genre like the *fête galante*. Indeed, we can follow the stages in Chardin's break with the opulence of the Louis XIV style, as he begins with the laden sideboard of *The Skate* and *The Buffet* (both Louvre) and then reduces the number of objects and simplifies by removing any sense of splendour from them until he is painting simple kitchen utensils, vegetables, or meat.

The anecdotal and iconographical vestiges are still plain in the early paintings. Chardin's career began with a signboard for a barber-surgeon—a genre scene of people in a Paris street, with a man wounded in a duel being tended near the centre. Then followed the still life paintings of dead game, sometimes with the addition of a crouching cat who tracks the dead partridge before a reflecting tureen (Metropolitan Museum, New York). The arrangement of the still life of two dead hares, a pheasant, and an apple (National Gallery, Washington) is almost plaintively non-iconographical: just the three kinds of object lying on a counter with a neutral background, a few shades darker than the fawn-coloured hares. And yet I doubt whether, in the mid-eighteenth century, one could have looked at these and not seen them as a conscious negation: this is *not* the rabbit in Ripa under 'Timor' nor the pheasant emblematized in lines like those of Pope:

Ah! what avail his glossie, varying Dyes,
His purple Crest, and Scarlet-circled Eyes,
The vivid Green his shining Plumes unfold;
His painted Wings, and Breast that flames with gold?[30]

105

59 J.B.S. Chardin, *The Soap Bubble* (1731–33). New York, Metropolitan Museum.

Nor is this apple present to recall our human state and the Fall (*our* fall too, the hunters who killed these animals). The painting is virtually a reminder that this is not a *Vanitas* still life. But with this reminder there is a disquieting feeling to be gathered from the deep colours of the pheasant and the pale fawn colour of the rabbits that reconstitutes them as symbols of earthly transience.

59 In the pictures of boys blowing bubbles (e.g., National Gallery, Washington, or Metropolitan Museum, New York), traditionally a *Vanitas* subject, the expression is now day-dream as the boy looks downward at the extended bubble.[31] His shoulder seam is torn—a gratuitous detail unless it is meant to relate to the engrossing bubble to which all his attention is turned.

Of Watteau's *Lady at her Toilet* (Wallace Collection) Donald Posner has argued that the artist began with the physical fact of a nude and a form, and in rendering these he automatically filled in some of the attributes of such a figure as she existed in art history—a Bathsheba or Susannah gesture of lifting her smock, a female attendant, and a dog—but without any longer a sense of *Vanitas* or 'Beware the Prostitute', and with the dog neither fidelity nor animal

lust but mere dog (or perhaps still, as he looks at his mistress, a vestigial analogue of a lover).[32] This is an accurate description of *The Lady at her Toilet*, but I think that with both Watteau and Chardin the process was more consciously one of rearranging the Bathsheba and the *Vanitas* still life into a viable contemporary prototype; of being rid of the mythological prototype without losing—indeed intensifying—the sense of loss in the dead game or illusive beauty in the blown bubble or the fragile house of cards.

With Chardin, however, the process of re-mythologizing began almost at once in the engravings of his paintings. *La Mère laborieuse* (1740) is summed up by the verses printed under it:

> *Et goûtés cette vérité*
> *Que le travail et la sagesse*
> *Valent les biens et la beauté.*

It is impossible to say whether Chardin encouraged or merely tolerated this interpretation which projected a kind of image very shortly to be elaborated and further moralized by Greuze. But, as Levey argues, the verses are surely correct to emphasize 'the importance of truth', which is then expanded by the engraver into 'the necessity for strict guidance of children, the dignity of labour', and so on.[33] The unadorned portrayal of hares and pheasants, pots and pans, bespeaks the aim of 'truth', one of the forms taken in France as in England by the art-nature quarrel. Contingency may have led Chardin to extend this theme to a kind of praise of industry, but I suspect that, as Levey also says, 'the appeal is in the restriction' in those 'simple, windowless rooms, dark and shuttered domestic interiors in which nothing more is happening than the preparing or serving of frugal meals, the education or amusement of children'.[34]

Minimalism is one element of the Chardin still life or genre scene (which is basically a still life with a figure introduced to *use* the objects).[35] But what is the essence to which Chardin reduces *Vanitas*, *vérité*, and 'restriction'? *The Skate* introduces a cat for anecdotal interest, its back raised at the sight of a fish it obviously thinks is alive or edible, and above it the smiling 'face' of the skate (which Hogarth may have seen and adapted for his *Gate of Calais* of 1748).[36] But the interest of the picture lies not in

this anecdote but in the ontological relationships. It starts with the division between animal world and human, the bare stone counter of the cat and fish vs. the tablecloth, knives, pans, and pitchers of the humans, with the skate smiling like a human face between them, a hook through its head and its insides showing through a great gash. The textures are rendered with great care not because they are beautiful but because they are actual; and yet not quite actual, because unlike the illusionistic Dutch painter of such scenes, Chardin never lets the viewer forget that he is creating an illusion with his paint, which the viewer will recognize as he approaches the canvas.

The essential may be the opened skate, which denies the shape's solidity as it does its smile, mediating between the full bodies of the cat and fish on the left and the hollow, empty pitchers and pans on the right. Some kind of an inner area is always implicit in Chardin's definition of outside area. One either sees the interior of the pots and pans or is given such a tactile version of the outside that he is led to imagine the inside. The pots and pans are only the final reduction that proceeded from the revealed inside of a skate or dead animal to the space created by a house of cards or by a bubble, by an urn or an egg. The pots and pans are the most distinctively Chardinesque of the subjects because they express at its simplest the relationship between solid and hollow. As in the series of poses that Watteau draws across a sheet of paper, there is the desire to explain and to understand. But now the spatial, temporal, and psychological relations of a *fête galante* are reduced to spatial only.

The space is not that of a room but only of these isolated objects in relation to each other. The rooms show nothing but a flat backdrop, and space is created, or rather implied, only by the modelling of the figures and the placement of the furniture around them. There are no windows, only uncertain sources of light for the reflections on and in the pots and pans, and when there is an open door at the rear it is not to give the sense of a coherent house but merely to relate an opening into something else— invariably into light and another kind of space, as opposed to the nearer room of relative darkness.

Chardin does not paint a house and rooms in which people fit (as Watteau placed them in an

60 J.B.S. Chardin, *Kitchen Still-Life with Cooking Pots and Eggs* (c. 1734). Louvre.

61 J.B.S. Chardin, *The Water Urn* (1733). Stockholm, National Museum.

already conceived landscape), but rather allows the people and their objects to create the space —a centrifugal space like that created by the jar in Tennessee in Wallace Stevens' poem. In *The Water Urn* (Louvre) space is defined by four containers, three open so that we can see the total shape, the urn closed but clearly containing an interior space as well. The sense of a room is only indicated by a roughly circular floor line, which corresponds to and supports the shapes of the utensils rather than of a room. The

61

women who appear with these urns, barrels, and other pots in the genre scenes are figures of the same shape, painted with a similar tactility that makes the fingers want to search the circumference.

Chardin is the other contemporary who must close the circle begun by Hogarth and Watteau. He reduces iconography to pure space, intervals and relationships, or an almost mathematical precision and descriptiveness. He reduces his subject to pots and pans, or figures tied together by a minimal fiction, a grace or a toilette; but in fact defined only in terms of space and volumes. He carries *simplicitas* much further than Hogarth, to the simplest objects, the simplest forms such as circles, squares, rectangles, and above all cylinders, which dominate the other figures. He is reacting against 'great' art by reducing art to the barest essentials: paint itself and a few objects that completely exploit the possibilities of paint and spatial relations. In the process he demonstrates the folly of the assumption that man is not only the noblest but virtually the exclusive subject of great art. The message of his painting is that great art need not concern itself with heroes and allegories but only with objects in light and space. Looking back at Hogarth from the vantage of Chardin we can see that in terms of his art the object was fighting for precedence with his humans, the setting with the living people who inhabited it. It was a moral battle for him; for Chardin the objects have won and the artist's aim is to describe them with his paint.

Living Space in Venetian Art

Venetian painting to the eighteenth century meant non-academic painting. Reynolds, though himself learning much from the Venetians, placed them below the practitioners of the grand style because they sacrificed seriousness to effects of light and shade on the one hand, and united 'the most sublime ideas and the lowest sensuality' on the other.[37] With Titian a partial exception, Tintoretto and Veronese were the exemplars of a painting that emphasized colour—the transient, sensuous immediacy of experience—over the permanence of ideal forms; a painting that combined idealization with disturbingly realistic detail, decorative pattern with exuberant, par-

ticularizing invention. It was Veronese who, called upon by the Inquisition to explain the irrelevant dogs and dwarves in his religious compositions, gave the formalist's excuse that he needed certain colours and shapes to fill a certain space. The paradox of the Venetian stereotype was an art both realist and formalist-decorative.

In the eighteenth century, when such different artists as Watteau and Hogarth were drawn to new interests beyond the conventional subjects of academic painting, the Venetians obligingly divided along the lines of their stereotype, producing the most stylish of decorative painters in G. B. Tiepolo and the most precise reporters of the actual in Pietro Longhi and Canaletto, with interesting variants in Guardi and G. D. Tiepolo.[38]

Contemporary references to Longhi as author of 'speaking caricatures', as one who replaces 'figures dressed in ancient fashion and characters of fancy' with 'what he sees with his own eyes', and as the graphic equivalent of Goldoni naturally bring Hogarth to mind.[39] Hogarth's prints were easily available in Venice printshops by the 1740s, and the earliest dated Longhi is from 1741. It is difficult, however, to see any meaningful influence in the area to which Terisio Pignatti and other art historians point, the series.[40] Longhi may have been led to paint a series—a Life of a Lady, a Family Life, a Progress of a Cavalier—by looking at Hogarth's print cycles; or, equally, by looking at the many popular Italian print cycles of the lives of whores and rakes. But he transformed the intention completely; his pictures are not related by continuity or causality, and they could be arranged in almost any order; most of his paintings are virtually the same size and shape anyway, and it seems more appropriate to think of them as variations on a theme. A reasonable source is Giuseppe Maria Crespi, Longhi's master, whose *Life of the Female Singer* may have suggested Longhi's *Life of a Lady*, and whose *Seven Sacraments* certainly inspired his series on the same subject.[41]

Only in the seduction paintings are there signs that Longhi probably knew and benefited from Hogarth's prints. Here he begins to structure individual paintings in a rough imitation of Hogarth's story-telling, most obviously in the left-to-right reading structure of *The Milliner* (Metropolitan Museum, New York):

at the left the sleeping milliner, then her pretty young assistant being cajoled by a bawd, and finally at the right an old man holding a coin (the old woman is pointing to him). All of the seduction paintings, which may (but need not) have drawn on the first plate of *A Harlot's Progress*, involve an old man, a young girl, and one or more women acting as go-betweens.

A painting that recalls another aspect of Hogarth is *The Geography Lesson* (Venice, Querini Stampalia)—here the Hogarth of easygoing, ironically titled prints like *The Sleeping Congregation*. For not the globe but the young lady's overexposed bosom is the geography lesson being examined by the two old men. If there is a Hogarth compositional model which is meaningfully related to Longhi, it is this one —not readable but constructed on a single gestalt involving related and contrasting shapes. Here the globe, the bosom, and the old books (including one reproducing another globe) establish a relationship rather than tell a story or explore a theme.

Longhi's *Confession* (Venice, Querini Stampalia) is a good example, with a tall, pale woman standing still, looking toward the viewer, with an enigmatic expression—innocent yet slightly smiling; to one side is the confessional with its priest and a woman confessing; to the other a woman kneeling, doing penance; and a small dog is in the lower left corner looking up at the priest. The central woman is either hesitating whether to confess or standing aloof from both confession and penance. The dog's significance (even if he derives from Watteau, or before him Steen or after him Hogarth) can lie only in the great space between him and the woman and the priest, contrasted with the overlapping of the human bodies. (Longhi's use of intervals can be compared with his master Crespi's in his *Confession* [1743, Galleria Sabauda, Turin], where overlap creates a sense of intimacy, of almost pyramidal unity, among the three figures who are yet separated from each other by the wooden barriers of the confessional box.)

62 Pietro Longhi, *The Milliner* (c. 1745). New York, Metropolitan Museum.

63 Pietro Longhi, *The Geography Lesson* (c. 1752). Venice, Pinacoteca Querini Stampalia.

The Quack (Venice, Ca' Rezzonico) shows a masked couple in the foreground, their black capes merged until they appear a single two-headed figure. In the middle-distance on a platform stands a quack with his drop—a love potion by the look of the women around him, one of whom offers him her purse (even a child reaches up toward the elixir); and above and behind him is a Punch and Judy show, with only a masked Punch and his phallic club showing. On his showcloth a woman is reclining with open arms. The painting is presumably about love, marriage, the relation of the sexes, and illusion; but exactly what Longhi is saying, if anything, is mysterious and undefined.[42]

The most obvious conclusion is that rather than plot or story Longhi is interested in configuration. By his placement—separation, overlapping, congruence—the commonest objects are transformed into mysterious shapes in mysterious relationship: a palette, a cello, and an oval canvas in *The Painter in his Studio* (Venice, Ca' Rezzonico), or the white birdlike masks and black capes of *The Ridotto* (Venice, Querini Stampalia), which, in the scenes of Guardi and Canaletto, we accept as a commonplace of eighteenth-century Venice.

The analogies with Watteau's *fêtes galantes* are, of course, suggestive; for the mystery lies not only in the relationship of costumes to their wearers but in the undefined quality of the relationships between the figures—an ambiguous psychological linking of one figure to another that goes back ultimately perhaps to Giorgione's *fêtes champêtres*. What, for example, is the relation of the fainting woman to her servant in *The Faint* (Washington, National Gallery)? Are the half-opened, upturned eyes a sign of feigning? Is the look of distrust and reproach in the eyes of the servant addressed to the old, robed man at the right? Has the old man—so far to the right of the picture—made her faint, and is he involved with the interrupted card game and the man's hat on the sofa at the far left of the picture? Or is he only trying to offer assistance? Even in *The Milliner*, to

64 Pietro Longhi, *Confession* (before 1751). Venice, Pinacoteca Querini Stampalia.
65 Pietro Longhi, *The Quack* (1757). Venice, Ca' Rezzonico.

66 Pietro Longhi, *The Faint* (1744). Washington, National Gallery.

which I have already referred, one is not certain whether the old man is offering his coin to the child sitting nearby on a stool rather than to the Milliner's assistant.

What separates these from Watteau's *fêtes galantes* is that they seem to be *trying* to tell a story, not through actions alone but psychological relationships; and yet these stories are never quite articulated. We can only say that most often the central figure is a female (as, interestingly, is also the case in Tiepolo's histories),[43] and the figures around her define themselves in relation to her. These are usually present to perform a service of some kind: to teach dancing, perform a concert, arrange her hair, instruct her in singing, treat her real or feigned illness, merely visit her, or even administer a sacrament. In the series that has been called *The Progress of a Cavalier*, the scene is in fact dominated by the girl being introduced to the cavalier by a bawd or by the girl whose

déshabille he is observing (see Pignatti, figs. 84, 85). In the series concerning peasant girls or working girls the people around the central figure still serve her in various ways. In the paintings of girls spinning or making hats an old woman is nearby, spinning flax; sometimes she is patently a procuress, and (with all the versions assembled before us) it is not clear whether the rest of the time she is merely an old woman spinning flax or whether for Longhi she always fills the role of procuress. His small cast may well be a personal version of the Commedia dell'arte: a girl who is the cynosure (whether patrician or plebeian), many servants, a young cavalier, an old man, and an old bawd, with musicians and physicians accompanying them. If so, like Goldoni, Longhi has taken the Commedia conventions and converted them into realistic scenes without the costuming retained by Watteau: they are merely a convenient personal structuring of experience.

The final and most striking difference between Longhi and another anti-academic realist like Hogarth is the use of space and milieu. Longhi's people stand or sit in rooms that are never defined; there is only one flat backdrop wall, usually quite far behind the people, who appear to be huddled out in the middle of a huge space dimly defined by that one wall. There is never any indication of the other, adjoining walls. An occasional picture appears on the back wall; in the more Hogarthian scenes it may be intended as a comment—a *Venus and Cupid* hangs behind lovers meeting in an embroidery shop. There is an occasional fireplace and curtain, and wallpapers are sometimes delineated. But there is never a window and almost never a door that leads anywhere; when a door does appear it is only a vague dark rectangle, and even if it is ajar a line is sometimes visible across the floor as if it were a painted backdrop. No sky ever shows, even when Longhi's people go out into the street: except of course (a significant exception) in his hunting scenes, which deal with an entirely different group of people.

Various explanations offer themselves, such as the size of the rooms in Italian palaces. Some of the paintings, still in their original collections, prove that Longhi was painting a particular wall, a particular fireplace or picture, in his patron's house; perhaps he could not get in another wall unless he reduced the size of his sitters still more. The fact that it is always a flat wall and not a corner may suggest a relation between Longhi's scenes and stage representations. Or perhaps the scene is only determined by Longhi's limitations as an artist: his perspective is utterly incompetent when he does attempt to paint a scene at an angle. His compositions tend to have a simple planar structure, and when more than one plane is used the people on the further one run the risk of appearing to be children.

Longhi's contemporary fame as a portrayer of the real, according to Pignatti, was due to the 'voluntary restriction of his subject matter to the depiction of social customs'. I suspect that it was as much due to his peculiar sense of space as to his subject matter. It is easy enough to explain the praise of his realism by Goldoni and Carlo Gozzi by comparing him with Tiepolo and the heroic style. But anti-academicism in Venice seems to have been politically motivated—a reaction against the oligarchy and the heroic art that supported its worst illusions.[44] With Longhi we have the two apparently contradictory facts—that he was patronized by the patrician families and praised by the men of advanced ideas who yearned for reform. This paradox might suggest that, though he was not himself political, he was taken up by those who saw more in his pictures than he did and used them as an example of modern art—partly because he ignored the grandiose themes, and partly because seen by the right person his exact transcription of noble faces, attire, and pastimes, with his peculiarities of composition, made as damning a record of the Venetian aristocracy as Goya's cold, dispassionate portraits did later of the Spanish. For here was a painter who portrayed the nobility with the childlike eye of a Douanier Rousseau: a nobility seen as doll-like if not childlike figures, completely cut off from the outside world, suspended or huddled in little groups in the centre of huge windowless, doorless, skyless, airless rooms in their palaces; or masked and cloaked, cut off from the rabble, or collecting in equally airless ridotto chambers or colonnades. They are either sitting sipping chocolate or trying to entertain themselves—with dancing masters, bawds and their girls, sideshows, illnesses, or games of blind man's buff. The comment is very like that of Goldoni's *La Locandiera*, with its bored noblemen and vital servants; if one looks carefully at some of Longhi's servants, or remembers his early *bambocciate* peasant girls (influenced by Crespi), it is easy to see why Goldoni was drawn to his work.

In Longhi's own terms, however, the lack of definition of his rooms has a particular meaning, which I would explain as the replacement of living or social space by interpersonal space. The usual box perspective arrangement focuses and places the people, centring attention on the objects portrayed. Longhi's isolation of the people outside such a coherent closed space tends to centre attention on the intervening space between the figures. By eliminating all the defining characteristics of a milieu, Longhi reduces his scene to the involvement of a few people in space, related only to each other, defined by their congruence or the distances between them, their enigmatic expressions, and occasionally a few objects gathered near them.

But most depends on the territorial spaces, the exact distances—which I take to be the best way of telling a genuine Longhi from the mechanical redactions which invariably distort or lose the precise relationships of the original.

We should not omit one other possible explanation for Longhi's effect. He must originally have turned to this kind of painting as a reaction against (or because he could not compete with) the tradition of Venetian decorative history painting, which in his youth reached heights of irrelevance in Ricci and Pellegrini; the painting of the latter was, as Levey has said, 'hardly more than some decorative patches of flesh coloured and blue and white paint—texture being largely undifferentiated', as opposed to the bodies of real women placed 'in relation to each other and to their setting'.[45] Over-unification itself was the original Venetian anti-academic reaction of the sixteenth century, which Reynolds distrusted intellectually but imitated as an artist, and which in the eighteenth century artists like Longhi reacted to by returning to an extremely circumstantial realism which, as in Hogarth's case, involved relative independence of each figure and each detail.

When an artist like Pellegrini or Ricci relates figures the relationships may be purely formal; even the contours of faces are determined by the colour and brushstrokes called for to fill the space rather than the way a face looks or the expression it ought to have in particular circumstances (e.g., Judith's as she holds Holofernes' head). This is not to divorce formalism from a passionate artistic expression, which is intended to move the viewer by its distortions. But in Longhi's paintings there is enough particularity of face, expression, and texture (if not of setting) to convince a viewer that the relationship must be psychological, the mode reportorial. It is possible, however, that Longhi has not shaken off all the Pellegrini in him, and the distances may exist at least partly for formal reasons alone.

Longhi may never have forgotten the grand assumptions of his earliest decorative paintings and may remain vaguely tied to Tiepolo, for whom space is a great empty sky or sea bordered by a fringe of human activity. Perhaps he retained his own peculiar version of the sense of man transmitted by the Counter-Reformation in Italy, which dissolved walls, rooms, and definite surroundings. Light and shadow defined spiritual space, rooms defined living space. Whether he painted ceiling or wall, Tiepolo created a world of infinite space and pure light, and his concern was primarily with the relation of man to the infinite; whereas Longhi, by the same sort of subtraction of contingencies, limited his concern to purely interpersonal relationships.

Even Tiepolo's hero is sometimes merged in a family group, rendered a part in relation to a whole. Tiepolo's ceilings show marriages and apotheoses of families, and in the series of etchings known as *capricci* and *scherzi* he invariably shows something between a figure grouped with heraldic supporters and a family. There is the young man, the old man, a woman, an owl and/or snake, with reflections in sculpted figures on a nearby vase, obelisk, or altar. (The old man's face is almost invariably parodied in the carved face on the vase—sometimes transformed into a different species, but always the authority of a father.) Actually, the situation would seem to be initiatory, with the emphasis on the relation of young man and old, and as in most Tiepolos this is supported by the sense of people standing on a skyline, whether of a peak or a ceiling cornice. Sometimes the group centres around a woman, and there appears to be a gravitational pull toward the Holy Family, which is close to being explicitly portrayed in one or two of the *scherzi*. And in general the small drama of interaction or separation is augmented by one or more groups of interested observers, on the model of the Wise Men adoring the Holy Family.[46]

The phenomenon is more obvious, and its meaning less esoteric, in the next generation. In G. D. Tiepolo's *Flight into Egypt* etchings the Holy Family appears in an almost infinite series of variations, and each time the particular family relation emphasized is the father-to-son, Joseph-Christ, rather than the more usual Mary-Christ relation. Both Tiepolo *père* and *fils* focus on the relation of sage to neophyte and old to young. The relation of father to son takes up a disproportionate space in Giandomenico's hundred drawings of the *Life of Punchinello* made toward the end of the century. An intruder in two of Giambattista's *scherzi*, Punchinello becomes the protagonist of the son's most elaborately sustained work; much as the son's genre subjects intrude into the father's

decorative histories until, after his death, they assume a life of their own.

Looking at the rise of anti-academic art in Venice as part of a secularization process (and including its political dimension), we might say that the elder Tiepolo is still trying to portray a relationship between man and god, though he likes to portray the priests and other intermediaries, and Longhi is exploring one between man and man, removed from any outside interference, celestial or terrestrial. Sunlight and sky are the significant features for Tiepolo, who paints pure light and figures dissolving in light. The sky, the most important symbolic element in his work, can be inhabited, as by Jupiter himself in *Danaë* (Stockholm, University Museum) or by multitudes of sketchy angels, but it is ultimately a blank, pure light and empty space, which fills most of the picture. Even the most sinister of his *capricci* and *scherzi* are in bright light, the figures outlined against a glorious sky. Tiepolo's humans are always trying to rise up to this sky —emphasized by the steep angle at which he often paints them.

This relationship between earth and heaven becomes ironic in the paintings of the younger Tiepolo, who filled in the realistic parts of his father's decorations and occasionally was given a wall or a guest house to paint with his own genre creations. The sky is still dominant, filling the upper two-thirds of the picture space, but his solid, squarish people (often seen only as backs plodding away or turned to look at something) are not looking upward but are preoccupied only with each other. The great space that silhouettes them is empty, *real* sky, without angels or upward communication.

Although almost an exact contemporary of Longhi's, Canaletto would seem to be as different a painter as can be imagined; and yet Owen McSwiny's comment sounds like Gozzi's on Longhi (or various contemporaries' on Hogarth): 'His excellence lyes in painting things which fall immediately under his eye.'[47] His views, especially his early ones, are genre scenes, but—exactly the opposite of Longhi's— with the setting given more emphasis than the people. It is the view-painter's aim to explore the reality of man-made structures of the past and the present, retaining some clearly con-

temporary men and women as representatives of the makers and the users.

View-painting as practised in the eighteenth century has its foundation in a desire to portray the real—a reaction against the ideal landscapes of Claude analogous to the reaction against the decorative mythologies of Tiepolo.[48] Thus behind the *veduta* lie the Caravaggesque representations in chiaroscuro of everyday life, the illusionist studies in perspective (often made for perspective's sake), and, far from least, scenography.

A second base upon which the *veduta* was founded was the desire for information, to which can be related the increasing interest in the past. Rome and Naples, of course, were important spots for the view-painter, and certainly the relation between past and present, most notably brought out in Piranesi's etchings but also in the paintings of Pannini and Hubert Robert, is important. This was a past embodied in ruins and the contrast between imperial Rome in all its glory and these ruins in eighteenth-century Rome. It is not certain, however, what importance such a juxtaposition had for Venice, which became the real centre of the view-painters who spread the Canaletto model to the rest of Europe.

For Canaletto the important influence was to be found in the Venetian tradition itself. In terms of their native tradition—if we think of both Longhi and Canaletto as breaking new ground in style and subject matter—Longhi was a descendant of the history painters, and may never have lost the sense of space learned in his early decorative paintings, whereas Canaletto derives from the backgrounds of Bellini's altarpieces with their precisely realized relationship of setting to figures, and from Carpaccio's *Miracle of the Relic of the True Cross* (Venice, Accademia). A transitional work like Giorgione's *La Tempesta* (Accademia) perhaps contains the seeds of both Longhi and Canaletto: for Longhi the strange isolated figures, related to each other mysteriously and problematically by the distance between, by the direction of their eyes; for Canaletto the part ignored by Longhi, the landscape of buildings and trees which is no longer just a background but equal with the people or itself the true subject of the painting.

Another necessary coordinate for locating Canaletto is the north-European use of per-

spective space as a way of placing the individual not in terms of *istoria* or theme but precisely in relation to his environment. To take only the most fully developed case, Pieter de Hooch's interiors portray an *Umwelt*, a perceptual space generated from a being: out from the individual housewife to the room in which she stands, to the other members of her family (often in separate rooms), to the other rooms of her house, out through windows and doorways to her courtyard or garden, to her neighbours and their houses, to the trees and sky. They are pictorially related in the three-dimensionality of perspective space, but also in the two-dimensionality of the painting's surface, where each window or door frames one element, isolating and juxtaposing it with another. De Hooch is defining a particular seventeenth-century Dutch milieu through the secularized conventions of religious interiors: even the compartmentalization of the house derives from the Nativities and Annunciations in which Joseph is seen in one room, Mary and the Child in another; through Joseph's window appear the town and country, while through the Virgin's only empty sky.[49]

Quite different again was Hogarth's use of carefully defined pictorial space for the generally satiric end of his paintings and prints: openings in the walls are further pieces of information, whether pictures, windows, or doors. The closed perspective of the room always tells us something about the people inside who are trying to come to terms with an oppressive environment; as also in the outdoor scenes, where windows and doorways of houses offer compartmentalized bits of information. The relation of outside to inside, of perpendiculars or horizontals to curves or irregular shapes, of architecture to human occupants—all of this is for Hogarth moral information.

Canaletto's views also tend to be closed, and directly behind them can be sensed such interiors as Antonella da Messina's St Jerome and Carpaccio's St Augustine in their studies—one seen through a window, the other from within the room (London, National Gallery; Venice, Scuola di San Giorgio degli Schiavoni). For Canaletto's orientation is the opposite from De Hooch's. In the latter the house is the centre: you look out from within it and see (separated and compartmentalized) aspects of it and of its milieu. Canaletto makes the square or the street the centre: you look at, and sometimes into, the houses. He removes one wall and stands his viewer just outside looking in, moving the precise perspective, the carefully closed and defined space and relationships of St Augustine's study into the street, into an urban space. In a way Carpaccio himself had already done this, for the great Venetian pageants he and Gentile Bellini painted were in the canals, among the buildings, and inside the squares. Venice was the city par excellence for closed views; its squares, colonnades, passageways, and canals were social space that was more significant than private living space Life in Venice was lived in these walled but unceilinged areas. In this sense, Canaletto's views perpetuate the Venetian myth of the polis, the City State, as powerfully as Tiepolo's mythologies, but in concrete terms.

Canaletto's subject—his particular *Umwelt*—was given him by his city, but his originality is evident if we look at his only Venetian predecessor as view-painter, Luca Carlevarijs, who is still a baroque artist letting his canal lead the eye winding off into the distance,[50] or breaking up space with a high column rising straight out of the picture.[51] The latter may be the Campanile or only, seen up close, one of the pillars in the Piazzetta, looming upon a different scale from the rest of Venice.[52] His is the human and picturesque point of view, from which Venice sometimes anticipates Piranesi's Rome; Canaletto's is the analytic, ordered view of a camera obscura, controlled by the assumption that each view is a stage set with three sides and the fourth removed for the occasion. The viewer's relationship is conventional, not immediate or immersive.

Of course, as all of the commentators acknowledge, Canaletto's early training in stage design contributed significantly, for by his time the Scena all'angolo (the set constructed at an angle to give the spectator a vista down the pillars and porticoes) was popular in the Venetian theatre.[53] But this still does not explain what the art historians emphasize and try to define as the unique discovery of Canaletto. Certainly, through his knowledge of the stage or of painted interiors, or through the accident of being a Venetian with stage-set scenes to paint, he mastered better than anyone before him the illusionistic use of perspective. But the

67

67 Canaletto, *The Stonemason's Yard* (c. 1728–30). London, National Gallery.

closest a critic has come to an explanation of the effect is, I believe, Cesare Brandi's observation of the stereoscopic quality of his pictures—a use of perspective and of light that 'does not construct a receding image, but one that is approaching.'[54] The buildings do not—as in a Claude or a Carlevarijs—withdraw into space but actively fill space, making physical contact with the viewer as through a stereopticon.

If we keep in mind the difference between participation in a Carlevarijs and analytic detachment in a Canaletto, we can see how the stereoscopic effect brings forward details to the spectator, and draws his attention to the relationship of the part to the total structure, rather than allowing him to submerge himself in an atmosphere. The effect is supported by the enclosure of the space which prevents the eye from wandering off into the sky. The spectator follows the relationships between each window or door and its façade, each façade and the rest of its structure, and each building and its neighbours—mentally mapping and reconstructing the whole complex of divided spaces. What he experiences is that pleasure of discovery that is totally absent from a Longhi but which was defined by Hogarth as 'the love of pursuit' and is one pleasure to be derived from his 'modern moral subjects'. If the effect is rococo, it is quite different from Carlevarijs', which is to keep the eye moving or to overwhelm it with one feature; rather the eye moves around but repeatedly comes to rest at a closure.

The information Canaletto conveys, and the spectator 'discovers', is not however moral but relational. He is devoted to the exact relationship of houses, churches, palaces, people, canals, gondolas, and sky in space and in time. Unlike the Roman painters of ruins, only one of his coordinates is the past: Venice past (and its past glory) jostles its recent structures and the

immediately present lawyers, doctors, washer-women, children, maskers, and perhaps even artists displaying their wares.[55] But relationship is expressed by Canaletto through division or demarcation: the lines that divide windows or doors or buildings; that divide the geometrized buildings from the canalized water, itself divided by innumerable squiggles for waves, and these from the equally compartmentalized sky. The incised outlines scholars have noticed in many of his later paintings, and the beautiful calligraphy of his drawings, equally point to the obsession with linear demarcation. Indeed, territorial distances between these divisions are as important a factor in the architecture of Canaletto's scene as in the personal interrelations of Longhi's.

What is characteristic of Canaletto is most plainly seen in the paintings he produced away from Venice, deprived of his relationships of buildings to each other and to canalized water and sky. When in England he naturally focused on the Thames in London, where he had similar geometrical divisions and a river whose edge was defined by architecture—on such a gigantic scale, however, that only the curve of the river and the construction (sometimes the arches) of Westminster Bridge afforded him closure. The

most interesting of his English views are those that look down on courtyards and by divisions 68 and subdivisions separate and define areas of ground, garden, and thoroughfare, some with people, some without. Even such uncharacteristic paintings as the views of Badminton House still identify themselves by their definition of the relationship between the enormous area of green park and the area of the house itself. The very odd view *from* the house con- 69 sists solely of the divisions of gravel terrace, green park, and sky.[56]

It has often been remarked that Canaletto's London was illuminated by Venetian sunlight. He began his career with some rather romantic lighting effects, but very soon came down to the intense noonday light reflected from the water of the canals or lagoon that defines in a precisely, almost surrealistically analytic way. It is the sun that gives the stereoscopic effect and suggests the 'enlightened certainty as to the absoluteness of truth' (or the 'confidence in an absolute truth') by which more than one commentator has characterized Canaletto's realism.[57]

Unlike the great symbolic skies of the elder Tiepolo and the ironic blank ones of the younger, Canaletto's sky is simply another

68 Canaletto, *Whitehall and the Privy Garden* (1751). Bowhill, Duke of Buccleuch.

69 Canaletto, *Badminton, view from the House* (1748). Badminton, Duke of Beaufort.

demarcated area like canalized water; sun is not godhead but the medium for bringing out and defining relationships between things and man in his environment. The simple man-man relationships of Longhi are replaced by relationships between individuals, classes, professions, houses, canals, city, sky—in which sky is only one, though still the defining, element. (Hogarth's pictures were still about the people, and the architectural structures in which they appear were defined only enough to make his point about the struggle for dominance. In Canaletto's perspective boxes the setting subordinates the humans, and the picture is about relationships per se.) And finally, were we to fit Francesco Guardi into the anti-academic scheme, we might add that he dissolves the

Canaletto cityscape in sunlight and moonlight or haze, producing—down to the short jabs of his brush lines—a Tiepolo version of the real.[58] But, far from a spiritualized version, it represents the turn to human subjectivity as the foundation of all things once transcendent authority falls into abeyance. Guardi may remind us that G. B. Tiepolo too was portraying God from a strictly human point of view.

Piranesi is a synthesis of what has been said of Tiepolo-Longhi and Canaletto. In his *capricci* of prisons and his grotesques he has Tiepolo's lightness and delicacy, as also the sense of looking upward and at odd angles that suggest a grandeur one seeks in vain on the spot. Throughout his career Piranesi is concerned

with the arrangement of masses and of parts relating to wholes and to the picture space for a certain effect of magnitude. But formalist fantasy is qualified in the archaeological works by a real interest in how the building was put together, extending to the inclusion of cross-sections that would have interested Canaletto, and even to the laying out of the methods of construction, the dissection of structure into stones, raw materials, hoists, block and tackle, not for their own (or their metaphysical) sake as in the work of De Chirico but as part of the analysis of construction in space. His plates show the process of the artist seeking an archaeological truth which amounts to a breaking apart and putting back together of the standing building, the digging and resurrecting and projecting of the ruin, the pursuit into the ground for the sewers and water pipes, and the underground tanks that were (with the actual rock and methods and tools of construction) the reality underneath the myth of Rome.[59] He dramatizes a search for the basic reality of what happened and how it was done by first establishing the facts and then the laws of structure controlling the complex.

But he does not let go of the past any more than does Canaletto in his depictions of modern Venetians in the ancient metropolis. Piranesi is another case of the eighteenth-century artist's dilemma: he wants to transmit on the one hand the idea or ideal of Rome, and on the other the fact of how it is actually built and operated down to its disposal system—which, however, he invests with a grandeur that is not inconsistent with the idea of Rome.

We might also say that Rome offers him a way into high art now that the sublime is a possibility, one that allows the artist to subordinate human activity to architectural or natural shapes, in fact reduce the humans to tiny irrelevances. To do this Piranesi breaks apart the Claude landscape structure, essentially a perspective box in a natural setting, and rearranges its elements as if seen by a Tiepolo. As a result he is another painter like Watteau about whom impressionistic criticism is written. R. E. Moore mentions the 'floodgates of purple prose from Coleridge and De Quincey down to Aldous Huxley' on the metaphysical sense of Piranesi, and then, before he has finished his essay, is himself comparing the effect of Piranesi's *vedute* to that of Pope's

70 G.B. Piranesi, *Carceri*, Plate 7. Etching (1745).

Dunciad. He refers to 'the palpable obscure, a nightmare world of crushing weight and mystery' and argues that Piranesi's ruins make us 'feel the precariousness of civilization. The despoiled tombs, the naked and decaying stonework stripped of its marble, haunted by cadaverous beggars, stand witness to the grim idea that obsessed Pope in the last *Dunciad*. Periods of light give way to far longer spans of darkness, barbarism quenches the fire of civilization, and the monks finish what the Goths began'.[60]

Pope is an impressionistic, not a historical, analogue to Piranesi; though equally far from being an influence, Gibbon's *Decline and Fall of the Roman Empire* is a closer analogue to the actual mixture of epic and historical intention

119

in a Piranesi view of Rome, and of course on that day when Gibbon sat in the Forum and conceived the idea of a history of Rome's decline and fall he was probably looking at his surroundings through Piranesi's eyes. Both are image-makers who are at the same time deeply interested in research, analysis, and definition. They want to relate, as dramatically as possible but as truly, the illusion of Ancient Rome to the present ruined reality and also to the original structural reality. To do this Piranesi has been led to formal innovations which combine the most baroque perspectives with the isolation of single features—for emphasis but also for purposes of analysis to the point of diagram.[61] To show what he had to show, he used the form of the architectural antiquary, displaying the outer effect but including insets of the other views, plans, and interiors; portraying at once the dissociation and the subsequent reorganization.[62]

71 G.B. Piranesi, *Pons Fabricius*. Etching from *Architettura Romana* (1756).

8 The Conversation Piece in Painting and Literature

HOWEVER WIDE the scholar may cast his net for 'conversation pieces'—gathering ancestors and descendants—his central documents remain English pictures of the eighteenth century. It is therefore odd that none of the authors of books on the subject has ever looked up the eighteenth-century English meaning of the word *conversation*. Etymologically derived from the Latin *conversatio*, it is an abiding or living in a place with other people, which leads to the allied sense of conduct, behaviour, or social interchange, to 'familiar discourse . . . opposed to a formal conference,' and even to connotations of sexual intercourse.[1] All of these senses are reflected in the loose usage of Vertue and Buckeridge, the earliest contemporary sources, and include any lively group or 'droll'; they are still reflected in Hogarth's recollections in the 1760s of his own early practice painting 'Portraits in small conversation Pieces'—implying that he *introduced* into conversation pieces actual portraits, as he continued to do in his progresses and comic histories.[2] In *A Midnight Modern Conversation* (painting, c. 1730, Mellon Collection) all of the senses and connotations are played off against a group of topers who range from festive to stupefied to sick, with the question of whether or not they are portraits left purposely unresolved in the engraving's inscription ('Think not to find one meant Resemblance there . . .').

An etymology of the form 'conversation piece' would include its sense of 'droll' and emphasize its origin as a reaction against such forms of 'high art' as history painting on the one hand and idealized portraiture (including official group portraits) on the other. A historian of the genre would emphasize its use in England in the late 1720s as a corrective to the standardized Kneller mask that dominated English portraiture—in fact the first successful breaking of the mask; its influence on the historical mode Hogarth developed in the 1730s; its importance for Gainsborough as a way into his original brand of portraiture in the 1750s; and its refinement in the 1760s by the second generation of practitioners, primarily Zoffany and Stubbs, into the current scholarly definition, which is essentially 'a portrait group of a family or friends in some degree of rapport seen in their home surroundings or engaged in some favourite occupation', usually painted on a small scale.[3]

The conversation, by its nature, does not contain types or fictitious characters, formal or posed, mythological or ideal portraits. Official portrait groups like a royal family in state robes are too public and formal to be conversations, but not the performances of plays or weddings, which involve the interplay of public and private. Ceremonies that teeter between public and private are in fact the essence of the English conversation piece. They are conversations as long as they show actors in their roles, people at a masquerade party, members of a royal family who are also children or actors for the nonce, or any identifiable person consciously assuming a costume or role within a realistic situation (in which some people are *not* in costume). In the *Beggar's Opera* paintings Hogarth shows a play, several actors in their roles, and an audience who themselves have assumed various roles in relation to the play they are watching—ranging from author and producer to lover of one of the actresses.

The three elements of greatest importance are the surroundings or native habitat, the relationships between the people and between them and their milieu, and the function of these elements to define. The guiding aim of the genre as it develops from the interiors of De Hooch to those of Zoffany is definition. These artists mark the line between the typicality of genre painting, history painting, and even portraiture and the particularity of time, place, and personal definition of the conversation piece.

De Hooch renders pure definition within a maze of rooms picked out by sunlight, and though he seldom places a particularized family within these rooms, Gabriel Metsu and others do. Almost all the elements we shall associate

72 Gabriel Metsu, *Family of the Merchant Geelvinck* (1650s–60s). Berlin, Kaiser Friedrich Museum.

with the conversation are already present in
Metsu's *Family of the Merchant Geelvinck*
(1650s–60s, Berlin, Kaiser Friedrich Museum).
The dominant figure is the father, set off with
the largest space around him, and his small son
nearby to his right holding a parrot as if it were
a falcon; while the wife and three female child-
ren and a maid are bunched together on the
other side of him at a discreet distance. A table
separates them; on it are the father's hat, under
his hand a deed or legal document, and (toward
the women) a bowl of fruit. A cat and dog are
shown playing at the father's feet, and another
dog is playing with one of the girls. Through

a doorway we can see another room and beyond
it a door open to the outside and a neighbour-
ing house. Though the room itself in this case is
little more than a flat backdrop wall, the door-
way gives a sense of space and of the relation-
ship between rooms and the street.

Definition is the picture's thrust: by the
placement and spacing, the relationships and
distances between people, room, doorways,
windows, and art objects; and by the objects
themselves, from the prominent legal docu-
ment that defines his official relationship to his
family, the hat that relates him to the outside
world glimpsed through the doorway, to the

fruit (conventional symbol of 'family') associated with the women.[4] Definition is largely through a careful delineation of possessions, the particular room chosen, the architecture, and its relationship to the rest of the house and to neighbouring houses. The objects may be symbolic, but in the context of a family portrait they are more representative and defining than exemplary or admonitory.

The basic formal structure, not surprisingly, is the triangle with the father its apex and his family related to him in a hierarchy of status and affection. One iconographical source may have been the pictures of the Ages of Life, often shown as a pyramid or triangle rising from birth to maturity and then down to old age and death. In the Geelvinck conversation the father makes a pyramid with his favoured son and the rest of his family an adjunct rectangle. Another formal pattern, the golden section, distinguishes the two parts of the family, balancing the small pyramid with the drawn-out line of the women. In Jacob van Oost the Elder's *Family on a Terrace* (Musée, Bruges) the father is the largest figure, standing at the right with a *fiat lux* gesture over his family and property. There is a tendency in seventeenth-century conversations for the husband to be both emphatic and separated by some distance from his wife and children, as in groups by Hieronymus Jansens and a royal group like Pot's *Charles I, Henrietta Maria and the Prince of Wales* (Royal Collection), which separates the king from the rest of his family by an extraordinarily long table on which rest his crown, sceptre, and hat—a more grandiose version of the merchant Geelvinck. Against the father-dominated grouping the few exceptions stand out: in Gonzales Coques' *Verelst Family* (Royal Collection) the mother flanked by her children is central and the husband stands in attendance, his hand indicating his family; in Terborch's *Colenbergh Family* (Frans Hals Museum, Haarlem) the eldest son is tallest and dominant.[5]

The basic categories of conversation settings are indoors and outdoors, the former more conducive to the portrayal of a middle-class family and exact socio-personal definition, the latter to a kind of portrait group that displays an aristocratic family, garden imagery, and symbolism relating art and nature. The outdoor setting, showing wide expanses, tended to develop a composition in which the family is on the small side of a golden section balanced by the long stretch of their property as nature ordered by art or tilled by husbandry. We might suspect that the indoor scene began with secularizations of pictures concerning the Holy Family, and the outdoor of pictures of Adam and Eve in the Garden of Eden and its classical analogues in pastoral.[6] The sources tend to be, respectively, Dutch and mercantile, Flemish and aristocratic. The outdoor scene begins with a picture like Rubens' *Self-Portrait walking with Hélène Fourment in their Garden* (1630–31, Munich, Alte Pinakothek), in which the balustrades and garden statuary serve as indications of the art with which man now controls and imposes his own order on nature. This is not the Garden of Eden but the garden man makes for himself in the fallen world, and one end of this particular tradition is the group portrait in which the sitter's status is emphasized by the presence of artifacts he has gathered, including his manor house, within a natural setting.

Historically, as the garden group implies, other aims jostle definition. Subdivisions of indoors and outdoors might include (to use Praz's categories) around a table, before a porch or balustrade, in a courtyard, against foliage, with a landscape view, in a boat, groups of children only, the couple only, sporting and musical groups, the painter's family, and mourning pictures. Each has its own emphasis and its own intention. Around a table, for instance, is 'a means of establishing a natural relationship amongst' the people sitting around it;[7] but the crucial question would seem to be what kind of a table. In England, there are basically three portrayed: the tea table, the convivial or drinking table, and the gaming table. The second and third—leading from Hogarth's *A Midnight Modern Conversation* to Rowlandson's drinking and gambling scenes—were quite different from the first as commissions, were hung in a different room of the house, and inevitably pushed portraiture further in the direction of genre and story-telling.

Mourning pictures may merely relate the living and the dead—by including a bust of the deceased, by showing him as a member of the family but having his hand rest on a skull or other symbol of mortality, or, if the dead are children, by showing them as hovering cupids

or cherubs. There are few examples in the eighteenth century, where the symbolic mode was (via such forms as the conversation piece) being replaced by the realistic: but both Hogarth and Troost produced one.[8] There are many in which busts or portraits on the wall show ancestors, dead or living heroes or friends who served as ideals upon which the family modelled its behaviour, or even, at a social gathering, the discretely absent host and hostess:[9] in other words, a dimension of duration and permanence, perhaps the ideal, contrasted to the extreme particularity and transience of time and place in the momentary encounter beneath. The presence of a skull or an hour-glass in one of these pictures affects the whole conception, transforming it into a *Vanitas* scene or (to quote Ellenius) 'a general representation of the course of human life'.[10] There remains a whole area of the conversation piece, both Dutch and English, in which the objects portrayed are less defining than admonitory. As late as Hogarth's *Graham Children* (1744, Tate Gallery) the children portrayed are surrounded by clocks with figures of Father Time, cats greedily eyeing caged birds, and other images of *Vanitus* and *tempus fugens*, warning them of the course of life ahead.

Pure example or admonition follows from disguised symbolism in the parrot, the cats and dog, the veiled picture, the legal document, and the bowl of fruit in Metsu's *Family of the Merchant Geelvinck*. Alternatively, too much emphasis on expression, action, and symbolic objects or relationships (e.g., between playing animals and playing children) tends to draw the conversation piece in the direction of either genre or history painting. Van Dyck and William Dobson, for example, seek a kind of history-portrait group by juxtaposing their sitters with symbolic objects or attributes on a scale that makes them (and not their milieu) dominate the picture space. Gonzales Coques' groups, on the other hand, if compared one with another, are seen to use the same studio properties over and over; there is therefore no specificity of place, no milieu that meaningfully corresponds to the particular sitters.[11]

In the tendency toward definition, social history was one determinant. Furniture and furnishings had gradually become more important and distinctive elements of social and financial definition. Benches were replaced by single chairs, sofas, and other variants that could distinguish relationships and roles; the corridor led to the development of independent rooms within a house, and these were increasingly particularized and personalized—dining room separated from bedroom, with the cabinet the innermost reach of privacy and personal identity.[12] There are the further facts that around 1700 fashion became a concept of importance in its modern sense of 'keeping up with the times'; as Fernand Braudel tells us, 'Luxury' at this time becomes 'primarily the separation of the living habitats' or living areas; 'privacy was an eighteenth-century innovation'. The house structure offered three kinds of space: for comfort and utility, for good manners and society, and for ostentation; and to these we can add, for privacy.[13]

In the Netherlands the development was more clear-cut, schematic, and austere than in England. A nice example is Julius Quinkhard's *Paulus Determeyer Weslingh and his Accountant* (1765, Amsterdam). Originally Weslingh's wife and daughter had sat in the two chairs on the opposite side of the table, balancing Paulus and his accountant; but after a quarrel Paulus had them removed. The two empty chairs correspond to a reality that, in this particular case, can be documented. But even if we knew nothing else about the picture, the two empty chairs would designate the departure or absence of his family—by expulsion, escape, or death. Their absence is the most important thing about the picture. Just as, to begin with, the table Paulus Determeyer Weslingh put between himself and his family, keeping his accountant on his side, clearly established a meaningful relationship, characterizing Paulus. Whether the plan was Paulus' or the painter's, the spatial effect defines in a very precise way the relationships within his family.

The Dutch conversation and the De Hooch interior led logically to an intricate pattern of of intersecting lines as much for its own sake as for that of anything it represented. One finds depictions of rooms with open doors and windows, planes overlapping with tables and chairs, which are almost purely abstract design on the way to a Mondrian. People do not matter at all except as a formal emphasis.[14] Then there is the intellectualism of Cornelis Troost, who painted a *Samson and Delilah* travestied that could have been the work of Hogarth;[15] he

73 Julius Quinkhard, *Paulus Determeyer Weslingh and his Accountant* (1765). Amsterdam, Rotterdamsche Bankvereniging.

was capable of a conversation like the *Family in an Interior* (1733, Brussel-Elsene, Museum) which shows the portraitist painting a couple on a narrow vertical canvas with their heads close together; but the husband and wife posing are far apart, separated by the artist's portrait of them. The artist has *by his act* of painting brought them together and created a picture that is not reflected in the reality outside it. Children and dogs are also present, with one active child repeated in a separate framed portrait exhibited behind its back.[16] Troost brings us close to the English situation, by which he may have been influenced.

The conversation piece, the *fête galante*, and scenes from the theatre arrived in England in the early 1720s in the work of Watteau, Mercier, and their followers.[17] And so, whether

fête galante or stage set, the outdoor scene was the essential one for the conversation piece as it developed in England. Philippe Mercier transmitted Watteau's *fête galante* with portraits and some real architecture as early as 1725–26, and Hogarth picked up the submerged but basic theme of art vs. nature from these or from knowledge of Watteau himself.[18] At the same time he was painting in the context of the literary controversy over pastoral, and the experiments of Ambrose Philips, Pope, and Gay, that made rival claims for the primacy of art and nature. Watteau presented a truly pastoral setting in the Popean sense: nature is controlled by art and art's artificiality held in check by nature, in a tension that realizes the futility of art while accepting it as the only way of holding off time. Gay's response was more ambivalent in the satire he wrote on Philips'

74

125

74 Philippe Mercier, *A Party on a Terrace* (1725). Viscount Rothermere.

primitivistic pastorals; in his *Shepherd's Week* (1714) and his 'Newgate pastoral' *The Beggar's Opera* (1728) he showed art as a metaphor for social fashion, with a lower class imitating a higher. It was *The Beggar's Opera* that elicited Hogarth's earliest conversation piece and set him on his way. Watteau and Gay showed the artist's and poet's way from the baroque topos of theatre-as-life (or the medieval-Renaissance world-as-a-stage) to the more alienated and contemporary idea of society as role-playing emphasized by Hogarth in the play of nature against art.

75 In *The Fountaine Family* (1730–31, Philadelphia Museum) some men stand in a real garden examining a painting of a Garden of Delights; the fountain shown in the painting puns artfully on the name of the host, Sir Andrew Fountaine. Hogarth's painting is

divided into three distinct compartments, separated by a V-shaped cleavage of foliage in the centre. Trees make the cleavage, which reveals a further distanced natural landscape in the background; to the left are the wives and to the right the men. The women are relatively lively and natural, with fruit spread in front of them (with the same significance of 'family' as in *Geelvinck and his Family*), while the men have turned away from them to assume the posture of connoisseurs before the painting. The natural extends from the vague foliage, beyond which is the V-shaped distant prospect, to a very lively dog chewing on the humans' picnic basket in the foreground, to the women, the men, and the painting. Rococo lines lead the eye from group to group, but the compartmentalization and the closures force stops that prevent one element from merging with an-

126

75 William Hogarth, *The Fountaine Family* (c. 1730). Philadelphia Museum of Art, The John H. McFadden Collection.

other in a Popean *concordia discors* or the flowing lines of a Mercier conversation.

The V-shaped cleavage in the Geelvinck group between father-son and the women, or the ontological spectrum which included fruit, children, and animals, has been turned into a little essay on art and nature. Moreover, an element of satire is hinted at in the men's unawareness of the women behind them and even (indicated by the visual pun on the name Fountaine) of the relation between the picture they look at and the one they are in. *The Beggar's Opera* and the Fleet Prison pictures of 1728–29 are merely more schematic representations of the same kinds of relationship—the exterior conversation with its art-nature conflicts moved into an interior without losing its basic properties.

Actors and audience, wardens-prisoners, and Parliamentary Committee as audience, children and parents, and humans and pets: these are the basic relationships. They are seen in a group of parents as audience to a performance of their children, who are elsewhere shown imitating their parents at war or love games, or merely kicking over a pile of books while their parents sit nearby being adult. Even more to the point is the dog, almost always present in the most dignified gathering, chewing on a picnic basket or wrinkling a table cloth or carpet. The dog may recall the bathetic touch introduced in the sublimest part of a garden (a memorial to a Signor Fido or Ringwood), or his ancient function as a symbol of carnal or gustatory appetite—or as an analogue to some human figure. But in Hogarth he is simply a touch of the unclothed, un-mannered, and un-stereotyped: of natural disorder in a scene of order.

127

More, he is often a pug, and becomes a kind of Hogarthian signature, parodying his host or strutting in the foreground; in *The Strode Family* (1738, Tate Gallery) he confronts the posing family's dog and needs only to be enlarged to find his place in the *Self-Portrait with Pug* (1740, Tate Gallery). Historically he relates to both the small lively dog that finishes off the family group in Dutch conversations and (ironically) to the handsome hound in Van Dyck portraits who vaguely resembles his aristocratic master the sitter.[19]

The painting within *The Fountaine Family* also prepares us for the sitter's collection that hangs behind him on the walls of his room in *The Strode Family*; the paintings here are complemented by the dog on the floor, as they are in *Harlot*, Plate 2, by the monkey. Because it is about man's relation to his home, possessions, habits, family, servants, and pets, the conversation piece is almost inevitably, in the hands of sophisticated English painters of Hogarth's time, about his place in a structure relating art and nature.

But it is also well to recall the idea of conversation as social talk, connected with the whole matter of social intercourse as outlined by Locke, Temple, Steele, Addison, Swift, Shaftesbury, Chesterfield, Fielding, and many minor writers who discoursed on the subject.[20] These books and essays were about manners, in action and in word; and the gist of them is that a formality of manners should be qualified by naturalness. As Congreve put it:

All Rules of Pleasing in this one unite,
Affect not any thing in Nature's Spight. . .
None are, for being what they are, in Fault,
But for not being what they wou'd be thought.[21]

—which, we have seen, becomes the subject of Hogarth's modern moral subjects. In his conversations this admonition, and the further distinctions made in other essays on conversation, become scenes of varying degrees of formality with the 'nature' or informality polarizing the formality in the figure of a dog or child. Like Fielding, Hogarth is more attracted to 'civility' than to 'ceremony'.

Hogarth initially adds to the conversation an incident or action of some kind. Something happens that brings the people together, and in the modern moral subjects that followed something that separates them. A letter is read, a picture is looked at, or one guest is introduced to another. The constant is the situation in which one person is reacted to as a person or as a thing by a number of other people, all of whom—essentially audience—are interacting only with this person, not with each other; or the situation in which one person is behaving in his own isolated, aberrant way among these people. These are, of course, satiric structures with an aim that is moral rather than definitive. But the modern moral subject remains within the area of the conversation piece in so far as both are anti-heroic. We cannot forget that part of Hogarth's intention was, according to his subscription tickets and the internal evidence of the prints, to produce a modern version of history painting. Despite the relatively strong interest in genre among serious artists—even academic ones—and some sectors of the public, upon which Hogarth drew,[22] he was not satisfied working within the genre mode, but carefully defined his own form in terms of history.

And the basic history painting structure of the seventeenth and eighteenth centuries was a circle of response: a central figure or action is responded to by a number of people. This was the artist's interpretation of *l'expression des passions*, the most emphasized category in the art treatises, which Reynolds later summed up, in his seventh Discourse, as 'the most essential part of our art'; only the highest art could 'aspire to the dignity of expressing the characters and passions of men'.[23]

Alberti, in his *Della pittura*, made expression one of the criteria for history painting; the subject was discussed at great length by Lomazzo, and the French Academy made much of it, conducting regular discussions and classes on expression.[24] What Du Fresnoy, Le Brun, and the academicians (and Dryden in England) emphasized in a history painting was the unity of passions even at the expense of the unity of action. The passions could be expressed either by showing through movement, colour, and light the passion felt by a character (or embodied in a scene), or by representing the passions of various characters within the picture. These two theories, one of expressive painting, the other of a certain subject or representation, existed side by side, but the second tended to receive the expansion that brings with it authority and emulation.

12

What the term came to mean is already implicit in Alberti's assertion that *istoria* should 'move the soul of the beholder', and would do so 'when each man painted there clearly shows the movement of his own soul'. Thus we, the viewers, 'weep with the weeping, laugh with the laughing, and grieve with the grieving'. This is accomplished through the artist's employment of expression—the movements of the body and of the face, which reveal the 'movements of the soul'; and as Alberti's figure suggests, this involves two circles of expression—that of responders within the picture and their reflection in the responders without. Alberti took as his example a Giotto painting of the disciples seeing Christ walking on the water: 'Each one expresses with his face and gesture a clear indication of a disturbed soul in such a way that there are different movements and positions in each one.'[25] Unfortunately, the example of Christ and the disciples had the effect of dividing the scene into (1) an actor and (2) observers who are not direct participants in the action but surrogates for the viewers of the picture.

The general tendency of art treatises that followed Alberti was toward simplification and rigid formulation along the lines he had laid down. Le Brun pushed expression in the direction of a mere spectrum or lexicon of facial responses. In England the Raphael Cartoons, an ever-present reminder of history painting at its most exemplary, consisted of scenes which could be interpreted as constructed on the principle of response to a central action: each figure responds differently to Paul's action, and the 'history' was interpreted as largely the variety of the gestures and facial expressions.[26] A history painter could either expand a central relationship or action to fill his whole canvas, or, if his assumptions remained academic, he could fill out the canvas with figures responding to the central action, relating only as observer to observed. He could also, of course, emphasize either the harmony or the divergence of response, but seeking unity he usually emphasized the former.

Hogarth was acknowledging the doctrine when, in his serious history painting *Paul before Felix* (1748, Lincoln's Inn), he showed the varying responses of Paul's opponent Tertullus, his judge Felix, and Felix's entourage, the scribes, and the Roman soldiers.[27] It is true that Hogarth's characteristic structures, more complex than mere action and response, are studies in choice and responsibility, and he characteristically stepped back, once he had finished *Paul before Felix*, and parodied the whole idea of expression in the subscription ticket he issued in anticipation of an engraved version.[28] But when he attempted the difficult task of raising contemporary genre and/or conversation to the level of history he made response one element of his composition. The *Harlot's Progress* was ushered into the world with a ticket in which putti and a faun respond in different ways to a statue of the goddess Nature. The first plate, which in fact is about a girl's choice between the passive virtue of the clergyman and the active vice of the procuress, was probably regarded by contemporaries, also brought up on assumptions about art based on the art treatises and the Raphael Cartoons, as essentially a central action surrounded by vivid responses. The girl is being responded to by the parson, procuress, rake, and pimp. Plate 2 shows the responses of a monkey, lover, servant girl, and wealthy keeper to the Harlot's kicking over a tea table. The responses, however, obviously lack unity; each is different, self-centred, and divisive, drawing the viewer in contrary directions. The final plate, showing the Harlot's coffin surrounded by mourners, is an anatomy of non-grief—of greed, lechery, pretence, unconcern, with one example of genuine grief. The stimulus—the Harlot—has virtually disappeared, and only the responses remain, filling the picture space.

It is difficult with Hogarth to draw a line between portraiture and expression: ability to achieve a likeness and a telling expression were his greatest contemporary fame. This was what Fielding praised in his preface to *Joseph Andrews*; and whenever a strikingly expressive face was needed, Fielding or another novelist invoked the aid of Hogarth's brush. The result is different from conventional history painting in which an agent and patient are related, or the martyr and martyrers, or any group that tells a known story. They show rather an interrelation of people about whom nothing extrinsic from themselves is known; in a sense when historical allegory goes, the relationship per se becomes primary, and it is therefore preferable to work out one of some complexity

21

11

12

than one of simple uniformity based on harmony. Hogarth's way, via the conversation, was to progress from the presence of a disruptive agent to total disunity of responses.

Although his conversation pieces are based on the relative unity of the family or group, his progresses reverse the ratio and show a lone individual cut off from his or her family and passing through a disorderly, responding, and threatening world. The scenes, though a series of separate moments in time, function as inter-relations of people, of 'family' groups of harlots or prisoners or madmen. And when this becomes a real family, as in *Marriage à la Mode*, the relationship is as much one of difference as of similitude, of fragmentation as of unity. Instead of acting as an ideal toward which the protagonist can pledge his allegiance as he makes his progress through the disordered world, the family becomes the world itself; instead of sending the hero out on to the road and pilgrimage, the family tries to keep him at home, where it oppresses and threatens him.

In prose fiction the change from a single hero on pilgrimage to the unit of a family begins to take shape in the 1740s. Behind it lie the narratives which in the 1720s were still essentially picaresque, though in English versions repeated encounters tended to produce simple relationships between the picaro and a foil, oppressor, master, or dupe. From the structure of a pilgrimage prose fiction moves toward a structure in which 'conversation' is essential, and the milieu narrows to a family and a country estate or a small part of London. In *Pamela* the milieu is restricted to the B. house in Bedfordshire (and then in Lincoln-shire), its rooms and grounds; and in *Clarissa* to the Harlowe house and family, until Clarissa finally flees into the old world of pilgrimage in which she is pursued, confined, raped, and permitted to die. With the journey minimized, the single location and common group maximized, the emphasis shifts from moral to inter-personal relationships and definition.

In historical terms this is George Eliot's 'mutual web' or, as John Holloway has called it, the 'post-picaresque world of communal integration'.[29] Continuity, causality, and the social web—that is, environment—have replaced the discontinuities of the pilgrimage or 'progress'. But only to intensify, as it happens, the discontinuities. The family begins to

dominate the picaresque narrative of *Tom Jones* and Smollett's *Peregrine Pickle*,[30] and from there it is not far to *Tristram Shandy*, where the pilgrimage is relegated to a digression (Bk. VII), and to *Humphry Clinker* and the first part of *The Vicar of Wakefield*. The family is now dominant; it has become the norm, from which the pilgrimage is a deviation. But the central fact of the family remains that it is oppressive, prescriptive, or at the very least wildly foolish. It either forces the child to break away or, as in *Tristram Shandy*, it exaggerates the sense of chaos by dramatizing it in the smallest, most ordered and tightly-knit unit of society.

In both painting and prose fiction the meta-phor of social 'distance' has replaced traditional structures of analogy. *Joseph Andrews* is still defined, as are most of Hogarth's characters, in terms of prototypes like the Biblical Joseph and the fictional Pamela; these are constricting ana-logies that Fielding largely discredits, but they serve their purpose of relating Joseph to a series of concepts as well as to contemporaries within the novel, which relationships tend to be the simple, old ones of pilgrim and host or victim and Pharisee (or Samaritan). Not so in *Pamela*, where Pamela replies to Mr B. after one of his attacks on her virtue: 'You have taught me to forget myself and what belongs to me, and have lessen'd *the Distance* that Fortune has made between us' [italics added].[31] 'Distance' in *Pamela* refers to the relationship between Mr B. and Pamela's body, to the lay-out of the house in which he pursues her, and to the social hierarchy in which the pursuit takes place.[32] At least the first two categories are divided into discrete portions with varying amounts of value attached to them: Pamela's mistress' dressing room (setting for Mr B.'s first advance), the summer house, various bed chambers, the cabinet where she can be alone and write her letters or pray, and her own garments which are all that finally remain between her and Mr B., and in which she significantly hides her letters, those representations of her innermost personal integrity. The writing and the read-ing—the very nucleus of the Richardsonian novel—takes place in a small, private, quiet place, an inner sanctum or holy of holies.

The novel is constructed on the uneven flow of Pamela's letters, which amount to her diary; and counter to this, dividing it into manageable units, are the rooms in which she is attacked or

protects herself or from which or into which she flies. Coherence is given to the flow of consciousness by the emphasis on movement from one room to the next. These then are flights, pursuits, withdrawals and entrances. They take place in a complex of passages, halls, alcoves, bedrooms, dressing rooms, summer houses, and closets. Both place and distance are crucial for Pamela and for the subsequent novel in England. The rooms in which she is approached take on a powerful significance, and also the attack itself, which is the attempt to be physically one without the formalities of spiritual union. Perhaps behind these movements are the romantic metaphors of attraction, mixed with the motions of celestial bodies; and in more general terms the Newtonian universe held together by gravitational forces, a model of the sort of impulse or attraction supposed to exist between all bodies.

In 1745 Joseph Highmore finished his paintings illustrating *Pamela* and published them in twelve engravings. In the first scene Mr B. intrudes through the door into Pamela's closet where she is writing her letter home to her family, with on the wall a painting of *The Good Samaritan*. In another scene Pamela and the housekeeper Mrs Jervis, whose friendship Pamela uses as a buffer against her master's advances, take up the centre of the picture space with Mr B. only a tiny face peering at Pamela through a window in a door: the distances and spatial relationships tell the story virtually unaided. In another Mr B. is a lone figure off to one side, disguised as a maid, while Pamela prepares to get into a large, prominent bed she has to share with the odious Mrs Jewkes. These false and abortive couplings lead to the scene in which Pamela is reading nursery stories to her family (immediate and neighbourhood): the family unit has now been formed, and the large empty bed to the right of the group is balanced by the cradle, which connects Pamela's experience of avoided seduction with her happy conclusion.[33]

These illustrations, following upon the complex reading structure of Hogarth's series, are a test case for a certain kind of poetry-painting analogy. In a painting illustrating *Clarissa* (Lord Glenconnor) Highmore pushes the Harlowe family to one side, huddled together in consultation, and the large and unusual empty space on the left bespeaks the

absent member of the family, the all-important Clarissa. And finally, the painting called *Mr Oldham and his Friends*, probably by Highmore (Tate Gallery), illustrates nothing specific but is, Waterhouse has remarked, 'Shandean'. 76

Let us ask what this may mean. Why, for example, is Hogarth's chaotic *Election* I (Soane Museum) not Shandean? Because what is original in *Tristram Shandy* is the very small cast, of two or three at a time, seen in close-up and extravagant detail (it takes many chapters for Walter Shandy to get up from a bed or don his breeches); the scale in relation to the picture space, and the lack of enclosing background; the closeness of relationship as opposed to the absolute individuality of each person. The Hogarthian scene in the *Election* paintings may have an analogue in Fielding for its placement of figures in time and space. But in *Mr Oldham and his Friends* large figures, half-bodies filling the entire picture space, are shown in conversation reminiscent of the interminable Shandy conversations where the relationship of faces and gestures is all that matters.

But why not Johnsonian instead? Conversation in Boswell's *Life of Johnson* and in *Tristram Shandy* illustrates the two poles of the visual and verbal structures we have been discussing. Conversation in Dr Johnson's circle (the 'club') is a private but rational discourse; and what it defines is the fundamental assumption with which Boswell begins his biography. It is the civilized way of showing oneself. Interplay, exchange, enlarging and sharpening the judgment are extolled; isolation, atomism, and unclubbability deplored. The interaction and sensitivity to ideas in conversation are evident in the gentleman's eagerness to elaborate, generalize, and identify himself with the various topics of discussion. Conversation serves to reveal the many aspects of character and to show the manipulation of thought processes between close friends. This would seem to sum up *Mr Oldham and his Friends*, which shows the friends hanging on Mr Oldham's every word.

On the contrary, in *Tristram Shandy* the family unit is formally bound together but temperamentally so diverse that each word spoken is itself suspect, and no two characters can ever connect the meanings they see in it. They go off on their individual hobby horses, do not relate to each other, and are atomistic in the extreme. And yet Sterne opens up there-

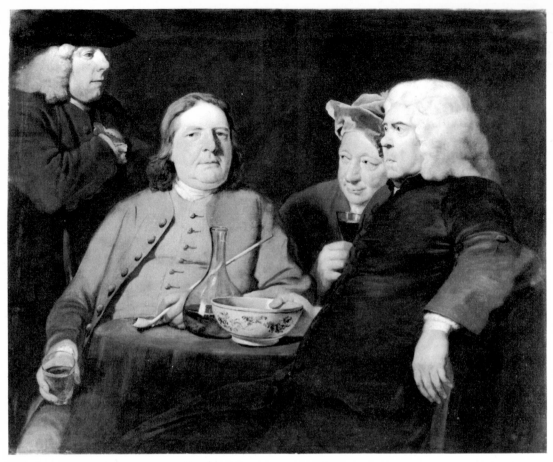

76 Joseph Highmore, *Mr Oldham and his Friends* (1750s?). Tate Gallery.

by a literature of sensibility in which inter-personal distances and differences are defined with the greatest delicacy. They are, in fact, aspects of an extraordinarily distracted circuit of response.

To return to *l'expression des passions*: like the painter who wished to raise genre to the level of history, the writer who wished to raise new, uncharted forms of fiction to a respectable eminence and produce a 'comic epic in prose', also regarded expressive response as of the greatest importance. Fielding devoted an essay to the subject, and in *Joseph Andrews* he introduced a literary variant of the Harlot's wake when he showed Joseph, robbed and left naked in a ditch, reacted to variously by a group of gentlefolk who pass by in a coach.[34] The analogical structure (already set in motion with

parallels between Joseph and Lady Booby and the Biblical Joseph and Potiphar's wife) defines the scene in relation to the parable of the Good Samaritan, and I rather suspect that this, and Hogarth's painting in St Bartholomew's Hospital, were the sources of Highmore's addition of the *Good Samaritan* painting to the wall of Pamela's late mistress' dressing room, where she is writing her letter when interrupted by Mr B. While Richardson had no need for such an analogy in his novel of purely interpersonal relationships, Fielding retains it but transforms it into a satiric catalogue of response.

'O Jesus,' cries a lady, 'A naked Man! Dear Coachman, drive on and leave him.' 'Robbed,' cries an old gentleman, 'Let us make all the haste imaginable, or we shall be robbed too.' A young lawyer responds that 'he wished they had past by without taking any Notice: But

that now they might be proved to have been *last in his company*; if he should die, they might be called to some account for his Murther. He therefore thought it adviseable to save the poor Creature's Life, for their own sakes, if possible'. The coachman objects: 'that he could not suffer him to be taken in, unless some body would pay a Shilling for his Carriage the four Miles'. And so on: the lady refusing to have a naked man in the coach and the old gentleman 'thinking the naked Man would afford him frequent Opportunities of showing his Wit to the Lady'. The only sympathy for the poor wretch is shown by the postilion, '(a Lad who hath since been transported for robbing a Hen-roost)', who lends Joseph his greatcoat for covering.

Both Hogarth and Fielding use expression in a special way, for the spectrum of expression surrounding the Harlot and Joseph is also a satiric exposure of the selfish responses elicited by a foolish or helpless object. The responses, though various, are all bad with one exception —a poor postilion, or an unlucky chambermaid, or a faithful but noseless servant woman. In these vivid scenes a conventional structure of history painting and of satire, an interest in expression and in satiric exposure, coalesce. The satiric structure, however, has the effect of cutting off all of the observers but one from the central object of concern; or put differently, the normative responses are reduced to one.

As he demonstrated in his burlesque of *Paul before Felix*, Hogarth was well aware of the limitations of the categories of expression as promulgated by the art treatises. In a print of 1743 used as subscription ticket for *Marriage à la Mode* (*Characters and Caricaturas*), he reacted against the stereotyped expressions of Le Brun's manual by including comic variants that have no place in the austere system that derives from Raphael's idealized faces; and in the plates of his comic histories he augmented facial and bodily expression with significant objects that reveal aspects of character unobtainable by Le Brun's method.[35] This was another way of showing his scepticism of the unity of action and response in the case of human beings.

Fielding's doubts about unified and stereotyped response are also implicit when he describes Tom Jones after his expulsion from 'Paradise Hall': 'He presently fell into the most violent agonies, tearing his hair from his head,

and using most other actions which generally accompany fits of madness, rage and despair.'[36] Himself something of an antiphysiognomist, Fielding argues in his 'Essay on the Characters of Men' that most expressions are difficult to judge; 'a formal, stately, austere gravity' tends to make most observers overlook other signs in a person's expression. Though he acknowledges that 'the passions of men do commonly imprint sufficient marks on the countenance', he argues that 'it is owing chiefly to the want of skill in the observer that physiognomy is of so little use and credit in the world'.[37]

His concern with the problematic nature of expression, in both object and observers, leads first to a greater discrepancy between responses —the spectrum of bad responses becomes a mixture of uncomprehending, mistaken ones— and then to the need for another observer, more skilled in physiognomy, who can penetrate behind a face and even words to actions and motives. This, of course, is the Fielding narrator, who shows the reader how to see and judge. Fielding is as interested in the problem of interpreting response as in the exposure of the hypocrisy and the cruelty under genteel exteriors in a satiric structure.

We must now bring yet another contemporary form into consideration, for both Hogarth and Fielding were closely connected with the theatre, and actors relied as heavily as painters on the theory of expression and Le Brun's illustrations of the passions. Though on a stage a series of different responses in space could conceivably be presented consecutively in time, in general the theatre requires a unified effect which synchronizes action and response; there is no movement from one point of view to the next, as in the stops of a pictorial circuit, or the responses of people enumerated on a page of *Joseph Andrews*, or even strung across a plate of the *Harlot's Progress*. The exception, significantly, is the rehearsal play, which Fielding made his own: here the scene is discussed and responded to—satirically commented on and interpreted—by an author, a critic, a theatre manager, and some actors, who are watching it being performed. In his *Beggar's Opera* paintings of a year or so before Fielding's first rehearsal play, Hogarth achieved a related effect by showing people looking at a play being performed, with quite different responses and degrees of involvement; and he repeated the

effect in portrait groups like *A Scene from 'The Conquest of Mexico'* (Viscountess Galway), but also in the interplay of action and observation in his comic histories.

When Fielding turned to prose fiction, he kept the context of the 'life is a stage' topos, constructing his novels on circles of response. Beginning with Joseph himself responding to Lady Booby, he worked his way out to the fools and knaves who respond to Joseph as he makes his way back to Booby Hall, and to the author and readers who (as patently part of the fictive structure as in the rehearsal plays) respond to them. In *Tom Jones* the action is dominated by the theatrical metaphor and structured on the assumption that an actor—Tom himself—playing a role (sometimes congenial, sometimes not) is variously applauded and damned by an audience of different characters within the novel as well as by the audience of readers—of the pit, boxes, and galleries—without. The Hogarthian work that sums up this aspect of *Tom Jones* is *The Laughing Audience*, which omits the performance altogether and shows only the pleased responses of the pit, the disinterested ones of the box, and the businesslike ones of the orchestra. As Partridge shows when, at a performance of *Hamlet*, he cannot distinguish the ghost until he sees Hamlet-Garrick's response to it, the response may define the object. Tom's actions finally exist largely in terms of the response or lack of response of the grave, sneering, prudent, virtuous, or critical auditors (or, as the metaphor shifts to that of a courtroom, to the judge and jurors), and Hogarth's etching is prophetic of the direction writers would take toward elimination of the performance altogether.

A variety of expressions responding to a central situation is also one explanation of Richardson's epistolary structure in *Clarissa*. His friend Aaron Hill's drama treatises would have made him familiar with the relevance of expression to acting,[38] but he was also interested in expression in a broader sense. He began his literary career by writing typical epistolary responses to the usual situations, and from these letters of gratitude or bereavement he moved into responses to unusual situations, and ultimately conceived the letters of Pamela.[39] For Richardson, who interposes no commentator or series of commentators as does Fielding, the primary aim is less understanding than the

excitement of expressive response—its psychology and variety, expressed in 'writing to the moment'. In *Clarissa* he abandoned the letter-journal of Pamela for the group of letters from different writers portraying responses to actions from their individual points of view. The letters reveal different aspects of a complex situation: how Clarissa's departure from the garden looked to her, how it looked to Lovelace, how his elaborate machinations affected the results, how Anna Howe responds from a distance, how the Harlowes respond, and how the 'editor' responds (he over-emphasizes Lovelace's control over events) in the notes—all fragmented, separated in time, and equally passionate and prejudiced. But we never see the scene itself, as we do the obelisk in a garden, or the Harlot or Joseph Andrews surrounded by exploiters. Clarissa's rape—the crux of the novel—is conveyed to us only by Lovelace's terse response ('The affair is over. Clarissa lives.') and then by Clarissa's own feverish, incoherent jottings, with lines running at random angles across the page; and only much later by her attempt to recall for Anna what actually happened. The complexity of the situation is revealed indirectly, but that of the responding mechanisms directly, vividly, and visually.

Clarissa writes at one point to Anna: 'I fancy, my dear, ... that there would hardly be a guilty person in the world, were each *suspected* or *accused* person to tell his or her own story, and be allowed any degree of credit.'[40] The reader begins to recognize the problematic nature of the actions, as he does in *Tom Jones*, by trying to determine the problematic extent of truth in Clarissa's or Anna's or Lovelace's response. Richardson tended to define the novel he was trying to write in terms of its response, reaching out to include the reader himself:

In this sort of Writing, something, as I have hinted should be left [to the reader] to make out or debate upon. The whole Story abounds with Situations and Circumstances debatable. It is not an unartful Management to interest the Readers so much in the Story, as to make them differ in Opinion as to the capital Articles, and by Leading one, to espouse one, another, another, Opinion, make them all, if not Authors, Carpers. . . .[41]

His own correspondence with his circle of admirers serves as a substantiation of such

commentary on the meaning of the novel. The criterion of involvement, if not of truth, is distance from the object—the degree of empathy or selfishness (or subjectivity) in the responder.

Here acuity of perception and subjectivity come together. At the same time that Fielding was trying to educate his reader to the most sophisticated sort of understanding by enumerating the possible responses to one action, Hogarth was arguing in his *Analysis of Beauty* that the individual should put aside all that he had read in art treatises and see with his own eyes and judge for himself. Richardson's practice was not very different: the tragedy of Lovelace is that he responds always within the stereotype of himself as machinating rake, and even Clarissa often seems blinkered by her own view of herself as daughter, rake-saviour, or spiritual paragon.

In retrospect, all these encounters have served to question some stereotype, whether that of the simple 'idea' of an object or the stereotype of response itself. Inappropriate roles assumed, words that confuse or conceal, and inaccurately appraised 'character', have been fragmented to expose their real complexity or reduced to their relative unimportance vis à vis the complexity of human experience, which is I suppose the subject matter of the novel as it was emerging in eighteenth-century England.

In Smollett's *Humphry Clinker* of 1771 the complex discrimination among the epistolary points of view in *Clarissa* has been expanded into comic incongruity. Here several grotesquely diverse travellers, a motley but blood-related family (which eventually is shown to include even the servant Humphry), visit a series of places (Bristol, Bath, London, York) and write letters on each spot that register their different responses. Lydia Melford sees everything through a romantic haze; Jerry Melford through the eyes of a sophisticated Oxford graduate; and Matthew Bramble through the eyes of a sick, crotchety old man. Tabitha Bramble sees no Bath or London at all but only her house in Wales and a projected husband, and Winifred Jenkins' servant's-eye view reveals sex and scatology in whatever it touches. There are similarly opinionated observers within the letters (Lismahago, Micklewhimmen, Humphry Clinker himself, and even S——t), who also fall somewhere along a spectrum of acceptance and rejection of what is seen. None of these views is valid in itself but a special circumstance of illness, callow youth, or young love, and must be sublimated, dehumoured, or in some way corrected, as many are by the end of the novel.

By implication there is a *real* Bath these views distort; or rather a Bath the reader reconstructs out of the sharp though partial view of Bramble, the less true one of Lydia, and so on. However, in *Tristram Shandy*, published a decade earlier, the object itself has virtually disappeared. The topics discussed in the Shandy household are those found in the *Critical* and *Monthly Reviews* of those years: books, usually translations, on fortifications; treatises on midwifery and medicine; travel, geographical guides, *The History of the Popes*, *Blackstone's Commentaries*, and publications relating to Locke, educational theory, wit and judgment, and the weather and national character. There is never agreement, even to the topic's essential being. An object or even a word—the death of Brother Bobby, 'curtins and horn works', a marriage contract, a nose, a bridge, sash weights—is responded to and misunderstood in as many different ways as there are people trying to understand it. But Bobby himself never appears, and his death remains only a series of completely subjective responses; even the hat Trim drops is not a hat to Trim or to his audience but 'the sentiment of mortality'. Unlike Clarissa's rape or the city of Bath, 'nose' is never more than a word, distinct from the nose on Tristram's face, and exists quite literally only in the minds of the various people who talk about it.

In retrospect, we have moved from a situation in which an object at the centre is grasped in its many-facetedness by a number of responders or passive participators in the action, to a situation in which the audience is a mixture of responses that renders the actor an uncertainty; from this to a situation in which the audience is responding without an actor or anything at the centre. In the simplest terms, this represents a transition from a heroic drama, fiction, or painting, about a lone protagonist, to one about a group of people and their relatively close or distant relationships with each other.

In the second half of the century we must put the circuit of response alongside an equally radical structure projected by the philosophy of

Hume: 'Beauty is no quality in things themselves: It exists merely in the mind which contemplates them; and each mind perceives a different beauty.' To which he adds: 'One person may even perceive deformity, where another is sensible of beauty; . . . To see the real beauty, or real deformity, is as fruitless an enquiry, as to pretend to ascertain the real sweet or real bitter.'[42] To this fact Hume offers alternative responses that may apply in the respective cases of Smollett and Sterne. The first is simply that different evaluations and estimates of a situation may be equally valid; 'they do not contradict one another; they supplement each other'.[43] Either scepticism or a kind of happy comic acceptance may be the result of the spectrum of discrepant perspectives.

The second response, which by-passes the question of relativist misunderstanding (and of all misunderstanding through structures of reason and the understanding), is feeling. The paradigm in this case is a scene like the one in *Tom Jones* in which Bridget Allworthy, Deborah Wilkins, and Squire Allworthy respond to the discovery of the foundling Tom. The two rational but discordant and utterly selfish responses of the women (equally hobby-horsical but with opposite ends) are followed by Squire Allworthy's feeling the 'gentle pressure' of Tom's little hand, which seemed 'to implore his assistance, [and] certainly out-pleaded the eloquence of Mrs Deborah'. The one good response becomes in *Tristram Shandy* the occasional intuitive understanding that leaps the barrier of conventional words and actions to unite Toby and Walter Shandy—as when Toby, his system having been verbally castigated by Walter, puffs vigorously on his pipe, causing Walter to choke on the fumes, which makes Toby leap to his assistance regard-less of the pain in his groin; and for a moment the two brothers are one. Though it never brings the object under observation any closer, this moment reveals that the real relationship is between subjects, not between subject and some imaginary or misconceived, perhaps non-existent object.

By the time of *Tristram Shandy's* publication, volume by volume across the 1760s, Capability Brown was ringing his gardens with a pictorial circuit while removing the obelisks, statues, and temples, leaving nothing at the centre except rolling landscape. The viewer had a much wider possible range of response. All he was presented with was the Beautiful, and within that category he could find as many different meanings—or perhaps impressions or feelings—as in the blank page on which the reader of *Tristram Shandy* is asked to imagine the Widow Wadman. When the poem was given precedence over the painting by Burke in his *Enquiry* (1757) it was with the claim that a word can evoke an image in the imagination that rivals the utmost efforts of an artist: the word can be vague and evocative just where the graphic image has to be precise.

One tradition, descending from Locke to Alexander Gerard and Hume (and Sterne), believed that the association of ideas in the mind is accidental, whimsical, and altogether diverse; that no two people will ever respond in the same way. Another tradition, supported by Mark Akenside, David Hartley, Burke and Reynolds, held faith in the power of the uniformity of the senses, if not the intellect. However broad or simple the categories (i.e. Beauty or Sublimity), two contrary relationships between subject and object are detectable as we enter the 1760s.

III

The Post-Hogarth Generation

9 Zoffany: Public and Private Meaning

The Tribuna

77 *The Tribuna of the Uffizi* (Royal Collection), which Johann Zoffany worked on in Florence from 1772 to 1778, is an interesting rather than a great painting, hardly to be mentioned in the same breath with the first scene of *Marriage à la* 57 *Mode*, let alone *L'Enseigne de Gersaint*. Zoffany himself painted better when he was less ambitious. But the *Tribuna* is the extreme case of what is strange and typical of one English painter of the next generation responding to Hogarth's iconographical innovations. An overcrowded canvas, equal emphasis upon objects and humans, inclusion of the artist himself as an odd distraction, and a plainly public iconography but a private meaning: these are the salient characteristics.

The *Tribuna* is also paradigmatic because it was commissioned by Queen Charlotte before Zoffany left for Florence, and so offers an easy charting of the ways in which he exceeded his instructions, putting in many more objects and people than the Queen had asked for, omitting pictures that hung in the Tribuna and adding others (from other rooms, from the Pitti Palace, and in one instance from Earl Cowper's collection), and even altering their size and shape when necessary to fit them into his scheme of the Tribuna.[1] Even if we assume that he merely substituted celebrated pictures from other galleries, a certain amount of personal choice was involved in the placement as well as the selection, and in the choice of which three walls to depict out of the possible eight.

The *Tribuna*, despite the complexity of its configuration, offers in a simple form the question of exactly what, consciously or unconsciously, a post-Hogarthian English artist was up to when he chose and arranged his people and art objects in a portrait group—what, in short, his picture means. The scholars who have dealt with the *Tribuna*, and in particular Oliver Millar who has fully researched and documented it, believe that it has no *meaning* at all. The painting, in so far as it is not graphic journalism is simply a formal construction. The *Venus of Urbino* is where it is because Zoffany needed that shape and those colours at that spot on his canvas: there are no historical or biographical

reasons for its inclusion. Guercino's *Samian Sibyl*, on the other hand, may lie where it does in the foreground because, as the historical documentation shows, it was newly-purchased. Raphael's *Leo X and Giulio de' Medici* was cut off by the edge of the picture merely by the exigencies of the canvas shape.[2]

I wonder if something else the same size and shape as the *Venus of Urbino*, but of a religious nature, might not more appropriately have replaced it at the centre front of a painting much given to *Holy Families*, in which the artist himself is depicted adjacent to a Raphael *Madonna and Child*. The *Samian Sibyl* might have been placed where this *Madonna and Child*, another to-the-moment art acquisition, was placed, rather than directly under the Raphael *St John the Baptist*. And as to *Leo X*, the edge of the canvas comes where the artist wishes it to come; the Raphael *Madonnas*, for example, were not cut off.

Behind the formalist interpretation of the *Tribuna* and other such paintings lies still the long shadow of Roger Fry: 'Zoffany [unlike Hogarth] has no axe to grind, no thesis to prove. He just looked at the spectacle of the life around him with a naïve, uncritical enjoyment and recorded his feeling in a simple, straightforward, unaffected manner.'[3] Fry's first sentence is literally true, but his second is quite wrong: not having a moral thesis does not preclude Zoffany's vigorously shaping his world.

Let us assume as a minimum, what Millar takes as maximum, that the picture shows the world of art as Zoffany would have liked to have it in a single picture. The *Tribuna* is related to the tradition of painted cabinets and galleries in which liberties were often taken with the size and placement of the pictures, and this undoubtedly accounts for something of the *Tribuna*'s welter, as also for its original commissioning by the Queen, who in a sense wanted these paintings and statues annexed to her own collection. Zoffany, however, set out to create his own ideal gallery—perhaps one related to those ideal galleries of the traditional 'gallery' poem, best known in Giambattista Marino's *La Galleria*, in which real pictures are

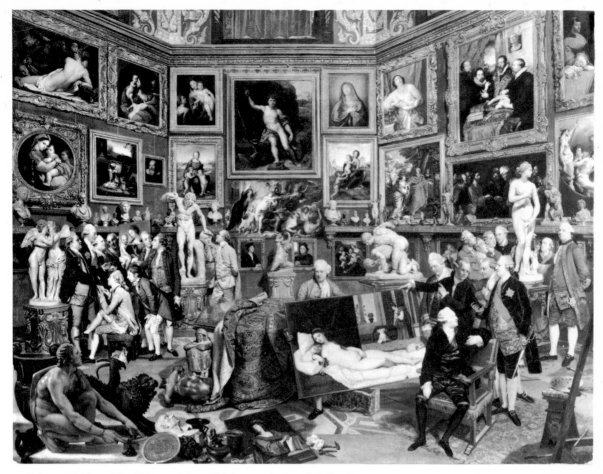

77 Johann Zoffany, *The Tribuna of the Uffizi* (1772–78). Royal Collection.

described alongside conventional kinds of pictures without particular models, and even quite imaginary pictures. Every object in Zoffany's painting has a real prototype, but this does not rule out the general idealism of Marino's *Galleria* or of Watteau's *L'Enseigne de Gersaint*.

Zoffany gives representation to all the important schools of painting, from that of Raphael and the Carracci to that of Caravaggio, but, as Millar admits, there is a loud 'paean of praise in honour of Raphael'.[4] Certainly enough Raphaels are shown, and imported into the scene, to give us an idea of Zoffany's high regard for the master, but it may also be significant that all but the great portrait of Leo X are related to the birth of Christ, and the *Leo X* being cut off by the edge of the canvas might indicate, besides the contingency of canvas shape,

how grudgingly Zoffany included portraiture in his conception of the Raphael oeuvre.

The world Zoffany shows consists, moreover, not only of art objects but of its characteristic denizens: the wealthy patrons like Earl Cowper holding forth, the artistic hangers-on like Thomas Patch, the Grand Tour 'companions' like Mr Stevenson instructing his ward Lord Lewisham, and the artist Zoffany himself—the only *live* artist present except Patch. Zoffany places himself and Earl Cowper, a special patron of his, looking at a Raphael, the so-called *Niccolini-Cowper Madonna*. We know that Zoffany and the *Madonna* were a later addition: Cowper had originally been shown lecturing on the *Satyr with Cymbals*. One politic reason for the addition might have been that Zoffany had apparently secured the 'Niccolini Madonna' for Cowper, who then offered it to

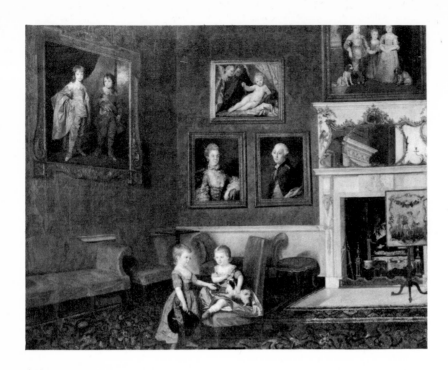

78 Johann Zoffany, *Prince George and Prince Frederick in an Interior in Buckingham House* (1765). Royal Collection.

George III.[5] But this grouping does bring in the artist himself and in peculiar conjunction with not only his patron but yet another Raphael *Madonna*.

The central display, which has been taken off the wall, removed from its frame, and is surrounded by eager 'art lovers' consisting of Thomas Patch, Mr Gordon, and Sir Horace Mann, is Titian's *Venus of Urbino*, and at the opposite side of the canvas from Zoffany and the *Madonna* are the Earl of Winchelsea, the two Mr Wilbrahams, and Mr Watts viewing the *Venus de Medici*. James Bruce looks with dignity away from her charms, and Thomas Wilbraham peers at her backside through an eyeglass. Valentine Knightley explains, while Viscount Russborough looks on, the *Satyr with Cymbals*.

The picture shows side-by-side immortal art and mortal, sometimes we suspect all too mortal, patrons and artists (fourteen may be said to be grouped around secular if not sexual art, and eight around a religious painting). The composition is anchored firmly on the statues of *Cupid and Psyche* at the left and the *Venus de Medici* at the right, the *Venus of Urbino* at the bottom centre, and Raphael's *St John the Baptist* at the top centre. The anchorage of the *Cupid and Psyche* is, however, some-

what blurred by the fact that the little group of men beside it are not (as are the similar groups at right and centre) regarding it but rather the *Niccolini-Cowper Madonna*, from behind which Zoffany himself is peeking. A viewer looks first at the *Cupid and Psyche* and then his eye moves to the *Madonna*. And this whole group is heavily weighted by the large, prominent figure of the *Arrotino* or *Knife-Grinder*, who looks across the scene like one of those people who lead the viewer into a Mannerist painting; he is looking specifically at the *Venus of Urbino* group and seems to be appalled at what he sees. It is relevant to recall, as Zoffany may have, that Smollett recorded in his *Travels through France and Italy* (1766) the story that the knife-grinder is portrayed as he accidentally overhears the conspiracy of Catiline.[6] The subject-object relationships of the picture—if we take it to be a picture about people looking at works of art—are put in question as an artifact looks back at the spectators.

Are these suggestive juxtapositions to be read at the level of generality of *L'Enseigne de Gersaint* or of the second plate of *A Harlot's Progress*? Perhaps the earliest sign of Zoffany's relating people and objects is *Prince George and Prince Frederick in an Interior in Buckingham*

House (Royal Collection), painted in the late 1760s, which offers an informative topography of the Warm Room in Buckingham House, but also contains above the princes on the walls an *Infant Christ* by a follower of Maratti and portraits of George III and Queen Charlotte—none of which appears to have hung in the Warm Room.[7] The last two cannot even be identified with surviving portraits. Whether or not Zoffany concocted them, they are clearly placed in the conventional conversation piece way to represent the absent father and mother above the heads of their two sons. Here the relationship of the parents to the children is almost that of a genealogical chart, and above them is the prototypical ideal child, the Infant Christ, with the inevitable suggestion of divine descent—a matter not absolutely forgotten with the end of the Stuart dynasty.

On the other walls are pictures that did hang in George III's reign in the Warm Room: above and to the right, Van Dyck's *Eldest Children of Charles I*, a reminder of the true English lineage of this German family of which only the present king was born an Englishman; and on the other wall, another Van Dyck, of the foster sons of Charles I, the Villiers brothers. These pictures make up the context in which Zoffany wishes to place Princes George and Frederick. He chose a room with certain pictures in it and then added others that were not in it or were of his own invention to produce a picture that relies as heavily on the emblematic as on the reportorial mode.

Zoffany elicits a related context in his conversation of the royal family in Van Dyck costumes (exhibited Royal Academy, 1770, Royal Collection). Ordinarily such costumed portraits were allusions to the pastoralism of the Watteau-Mercier tradition of conversation pieces, showing people who are supposed to have retired to a pastoral setting from the cares of the active life. But when Zoffany employs the convention here he is striking responsive chords. As the allusions to the time of Charles I establish, however tenuously, a genealogical continuity for the royal family, the Van Dyck paintings suggest an artistic continuum and an authority for Zoffany's portrait group. This slightly covert use of allusion may suggest that his great popularity with the royal family, at least before going off in emblematic directions

of his own in the *Tribuna*, was due to more than his Germanic verisimilitude.

The combination of Reynolds' tasteful kind of allusions with careful likenesses insured his success. But the allusions are not usually in the figures themselves but separated from them in their pictures. It is the Hogarthian room that lies behind Zoffany's royal conversations. Hogarth's engravings filled eleven lots in the catalogue of Zoffany's sale.[8] His earliest paintings of actors (*Garrick in 'The Farmer's Return'*, etc.) recall Hogarth's theatrical scenes, and his employment in England began with Benjamin Wilson, one of Hogarth's closest friends. An early theatrical scene (1762) shows Edward Shuter as Justice Woodcock in Isaac Bickerstaff's *Love in a Village* standing beneath a painting of *The Judgment of Solomon*, and this practice carried over into his conversation pictures: the *Group of Seven Gentlemen* (private collection) painted in Italy in the 1770s, shows Sir William Boothby flanked by male friends, and on an antique vase behind him appears a relief of Venus with Cupid and attendants, quite likely a comment on the group's avocation. A conversation picture of the Earl and Countess of Cowper just before their marriage (1775, Hon. Lady Salmond), in the midst of the *Tribuna* painting, has an elaborate painting of a Hymeneal scene with Hercules chasing away Envy equipped with Calumny's torch, which may refer to the gossip that seems to have surrounded Cowper's Jacobitism and his earlier infatuation with a Florentine lady.[9]

We learn from Henry Angelo's *Reminiscences* of Zoffany's tendency to be witty with scripture and his burlesquing Old Testament subjects, but there is also testimony that he was a devout Catholic, at least in his early years.[10] We know stories about his introduction into his paintings of rather heavy-handed practical jokes and personal references. He is said to have placed a tankard of stout and two crossed tobacco pipes above Richard Wilson's head in *The Life School of the Royal Academy* (1772, Royal Collection) but after the joke had served its purpose painted them out. This may refer to the 'replica' of the painting he made and showed his friends which included a portrait of Queen Charlotte before her marriage opposite one of her former German admirers.[11] He was given to introducing 'without the permission of the original and often in unflattering guise'

79

92

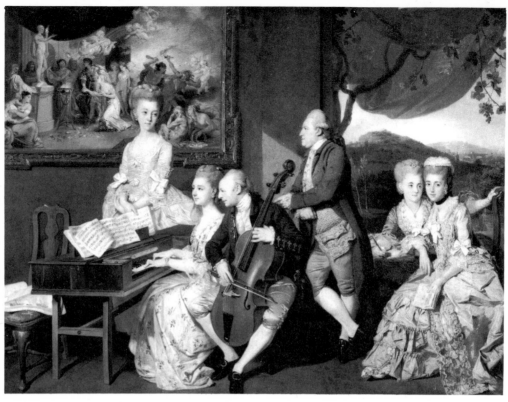

79 Johann Zoffany, *George, 3rd Earl Cowper, with the Family of Charles Gore* (1775). Hon. Lady Salmond.

acquaintances with whom he had quarrelled, including in later years both enemies and members of his family in a *Last Supper*.[12]

Although we can only speculate about the reputations of most of the men portrayed in the *Tribuna*, either public or vis à vis Zoffany, it is possible to say a few words about Thomas Patch, with whom Zoffany had recently quarrelled. Zoffany is supposed to have considered painting a black patch on the buttock of one of the *Wrestlers* at which Patch is pointing—a verbal pun in the Hogarthian manner.[13] As it is, our suspicion might be aroused seeing Patch chosen as the one man to hold up for display the central picture of the composition, the *Venus of Urbino*. There was some irony in the fact that the solemn etcher of Masaccio's frescoes in the Church of the Carmine (published in 1770) and of the works of Fra Bartolommeo (1772), whose chief fame, however, was as a caricaturist of visiting Englishmen in Florence, should be shown handling and displaying the most secular of pictures. The raised finger of his left hand does seem to point at the *Wrestlers*, as if to suggest some parallel between their activity and the reclining Venus.

The *Tribuna* can also be connected with a painting Patch himself executed around this time—one of his caricature conversation pieces.[14] This enormous picture (Brinsley Ford Collection) shows *The Wrestlers*, a *Mercury*, the *Venus de Medici*, the *Dancing Faun* (or *Satyr with Cymbals*), and the *Knife-Grinder* (all but the *Mercury* were in the Tribuna) in an imaginary, architecturally elaborate setting with a group of connoisseurs. Patch himself, Sir Horace Mann, and Earl Cowper have been identified; all, of course, appear in Zoffany's *Tribuna*. Patch shows himself measuring Venus' proportions with a pair of callipers. In another conversation, *The Cognoscenti* (Petworth), he appears in a portrait on the back wall dressed in Van Dyck costume, leaning out of his frame, and lifting a curtain to peer lewdly at the next picture on the wall, which is the *Venus of Urbino*.

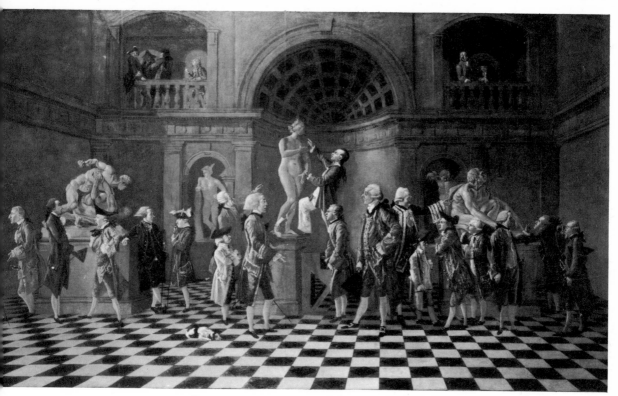

80 Thomas Patch, *Conversation* (1760–70). Brinsley Ford Collection.

81 Thomas Patch, *The Cognoscenti* (1760s). National Trust (Lord Egremont), Petworth.

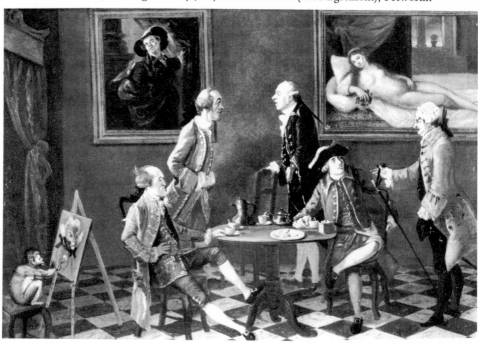

Patch's self-comedy is related to Zoffany's use of him in the *Tribuna*. He was known for his equivocal sexual tastes—the reason, apparently, for his banishment from Rome by the Pope. Zoffany has him holding up the *Venus of Urbino* but pointing to the equally naked *Wrestlers*. As F. J. B. Watson discreetly puts it: 'The patch is no longer to be seen and the joke now seems to be a feeble one, though there is reason to suppose that it may have had a more subtle point for the artist's contemporaries.'[15] The joke is still present, patch or no patch. Patch is holding on to the *Venus* but thinking about the *Wrestlers*.

The *Tribuna* may have offered to the members of the Florentine English colony a specific allusion to the Patch conversation in the Ford Collection; it certainly is connected with *The Cognoscenti* and its *Venus of Urbino*. Ford dates his picture around 1760–70,[16] but the one piece of solid evidence is that Mann wears the Order of the Bath in the *Tribuna* and not in Patch's picture. It would appear that Zoffany's is more likely a reference to Patch's picture than the other way around. (Though we must not forget how long it took him to paint the *Tribuna*.)

Behind the pictures of both Patch and Zoffany lies Reynolds' *School of Rome* (National Gallery, Dublin), painted before 1753. Reynolds built his portraits on the Italian caricature tradition, but not satisfied with the caricatures alone he grouped these English connoisseurs and collectors in the poses of Plato, Aristotle, and the rest in Raphael's *School of Athens*. The group is actually the School of Rome in the same sense as the other was the School of Athens; these foolish-looking, over-particularized connoisseurs and their own Gothic architecture are juxtaposed with the ideal shapes of the Raphael by which they think they guide their judgments in aesthetic matters.

What Zoffany would have seen in this painting was the contrast of the ideal of art with the reality of the connoisseurs' life in eighteenth-century Rome. Placing the English connoisseurs within the Florentine Tribuna, surrounded by the art objects that guide their lives, would have been an equivalent (governed more than Reynolds' paintings by the laws of probability) of the *School of Athens*.

Patch, who may have learned from Reynolds' example when they met in Rome in the 1750s,

omitted the structural allusions, probably developing his caricature conversation from the model of Hogarth's *Taste in High Life* (available in an engraving of 1747): people stand in a collector's room with pictures on the walls and art objects all around them. Now Zoffany had used art objects in the Hogarthian manner, but always, I believe, before going to Florence, as public iconography—or at most as royal iconography that might be something less than public to the world outside Buckingham House. Added to the relationship of the ideal and real explored by Reynolds, Patch offered a kind of picture in which Hogarth's irony was stretched to the very playful and the very personal.

Zoffany himself does not appear in any of his conversation pieces (except for his *de rigueur* appearance in the *Royal Academy* group) before his contact with Patch's conversations, though he does appear frequently thereafter. Indeed, the most immediate context for the *Tribuna* is the two self-portraits Zoffany painted just after adding his portrait to the group around Earl Cowper and finishing the picture—one in Florence probably datable in the spring of 1778 (he left Florence in April), the other painted shortly afterwards in Rome.

The first (Uffizi) shows him smiling, wearing a very luxurious, furry, voluminous robe; in his left hand he holds an hourglass in front of a volume labelled 'Ars longa, vita brevis', and in his right hand a skull. Behind him stands an *écorché*,[17] a man flayed to the muscles, closer to the fleshless skull than to the very fleshy, many-layered, muffled figure of Zoffany. The statue stands on a table next to the 'Ars longa, vita brevis' volume and Zoffany's palette and brushes, pointing toward a picture hanging on the wall. I have not identified this painting: is shows a hermit at a *prie-dieu*; tempting him are three nude females who resemble the Three Graces or the three goddesses of a *Judgment of Paris*. The Graces do not figure in temptations of St Anthony, though nude ladies do; the iconography, but not the form, rather resembles a *Temptation of St Jerome* like Zurburan's (Hieronymite Monastery, Guadalupe), in which the saint kneels at a rock covered with his writings and a skull, and is tempted by a group of music-making ladies. Perhaps Zoffany has merely combined two traditions, of temptation by nudes and of the Arts or Three Graces,

82

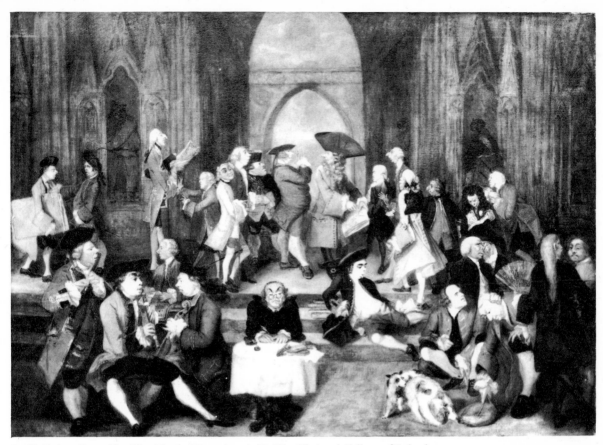

82 Sir Joshua Reynolds, *The School of Rome* (1751). Dublin, National Gallery of Ireland.

bringing together his three themes: art, sensuality, and *Vanitas* (or retirement).

To see that the *Vanitas* topos was not invoked as mere convention, we need to look into what is known of Zoffany's biography in these years. The garrulous Mrs Papendiek heard the story from the second Mrs Zoffany (the first had been deserted, or had left him in despair, on his first trip to Italy in the 1750s):

Mr Zoffany, talented as he was, and always in the best society, yet in his leisure hours prowled around for victims of self-gratification. He found out the humble dwelling of Mrs Zoffany's parents, and the beauty of their daughter he determined to possess. Very soon after he made her acquaintance came the order for him to proceed to Italy, to copy the Florentine Gallery, and as this poor child, who was at that time only fourteen years old, already bore the mark of criminality, she hastened to the vessel in which he was to sail, and got on board before Mr Zoffany and the other passengers arrived. During the voyage she discovered herself to him, and he resolved, on landing, to place her where she would be educated, and taken care of dnring her confinement. A boy was the child born.[18]

At this point Zoffany made enquiries about his first wife and, learning that she had died a few months before, he married the now fifteen-year-old girl, who, Mrs Papendiek tells us, was both noted for her beauty and 'a good mother to her boy, though still so young'. A year later, while Zoffany was at work on the *Tribuna*, his son fell down a flight of stairs and, though recovering for a time, 'at the end of three weeks he died of abscess at the back of the head'.

Mr Zoffany was not to be comforted, and, as I before observed [continues Mrs Papendiek], he never wholly got over this terrible calamity. However, he was encouraged to go on with his work in the Gallery, and though this interest, in a measure, dis-

145

83 Johann Zoffany, *Self-Portrait* (1778). Florence, Uffizi Gallery.

84 Johann Zoffany, *Self-Portrait* (1779). Parma, Palazzo della Pilotta.

tracted him from his own private sorrow, it had an evil effect in another way—for it was at this time that, in order to drown his thoughts, he overworked himself, which brought on the first attack of paralysis, when he lost the use of his limbs, and for some time his senses.

In this context, the first self-portrait becomes a suggestive if not puzzling document, with its isolated artist, its symbols of aging and death set against both symbols of art and of pleasure (or temptation) of a sexual nature.

The second self-portrait (dated 13 March 1779, Palazzo Pilotta, Parma) makes the public-private tension even more interesting: it is painted on the reverse of a Correggesque *Holy Family*, and it shows Zoffany, with a devotional expression on his face, donning the robes of a monk, turning his back on his palette and on a number of objects on the wall. A shelf holds a half-full glass and a bottle of wine, a pack of playing-cards, and a skull; hanging on the wall beneath are a print of the *Venus of Urbino*, a rosary, and a pair of prophylactic sheaths. The *Venus*, which was the central exhibit in the *Tribuna*, is torn across so as to conceal her pubic area; the rosary beads could indicate a turn to piety or to penance, and the sheaths could allude equally to his penchant for 'self-gratification' or to the baby boy he had unwittingly fathered—recalled so poignantly by the other side of the canvas. Certainly Zoffany was a very disturbed man at this time: first the disappointment of not being chosen to go as an artist with Captain Cook's expedition, which contributed to his going instead to Italy; then the matter of the young girl he seduced and married; and then the child and its death.[19]

Both self-portraits, whatever precisely they may mean, share a preoccupation with the subjects of art, love, and religion, with, just around the corner so to speak, fatherhood (the old Joseph—though Zoffany was only forty—musing over his young wife and miraculous child). These self-portraits must, I believe, be used as a context if we are to understand Zoffany's major work of these years in Florence, the *Tribuna*.

For other reasons as well as his relationship with Earl Cowper the place Zoffany gives himself in the *Tribuna* is appropriate; he is peeking around from behind the Raphael *Madonna and Child*, proudly or self-righteously, guiltily or

furtively, rather like the Joseph in his own *Holy Family*. He is decidedly not standing next to the *Venus of Urbino*, which evidently meant something special to him. Thought at the time to represent a Renaissance courtesan, it is one of the most erotic of nudes, and perhaps it was as disturbing and significant to him as it later was to poor mad George III, who removed Zoffany's *Tribuna* from the wall while his guards were out of the room and quite possibly at that time 'perpetrated the outrages' on the *Venus* to which Millar refers.[20] We can only speculate on the relation Zoffany may have seen between Titian's lovely young girl and the new Mrs Zoffany or other 'self-gratifications'. Directly under the *Venus*, however, is a child's sarcophagus and beneath that, in the foreground, Guercino's *Samian Sibyl*, exactly parallel to the prophesying *St John* at the top of the picture (the sibyls were incorporated into the Christian tradition as prophets of Christ's coming) and beneath it the *Infant Hercules slaying the Serpent* (also incorporated into Christian tradition). But of all these details the child's sarcophagus is the most telling.

The subjects of the self-portraits, love, religion, mortality, and art, inform the *Tribuna*. The contrast between the lure of the religious life (or perhaps subject) and earthly delights is the same, but the religious theme here (as on the reverse of the second self-portrait) is embodied in the *Holy Families*. Zoffany retains all but one of the *Holy Families* that actually hung on the centre wall of the Tribuna (the only wall that comes close to being a copy of the wall as it was), suggesting that this was the wall around which he wished to build his scene, and he adds a number of others—a total of seven, plus a *Charity* that resembles a *Madonna and Child* and a separate *Madonna*. St John is indeed surrounded by fulfilments of his prophecy.

Roughly speaking, a religious subject jostles a pagan and erotic one. The Carracci *Bacchante* was in fact on the wall of the Tribuna where it appears, and Zoffany added beneath it the *Madonna della Sedia* and the *Cupid and Psyche* to make a suggestive trio. Nobody can miss the similarity between Psyche hugging Cupid and Raphael's Madonna hugging the Christ Child; or, for that matter, between the Madonna with upturned eyes and the Cleopatra next to her, both by Guido Reni. All of these were inserted

and placed by Zoffany, and he must bear responsibility for the juxtapositions.[21]

In the context of the self-portraits and what we know of Zoffany's biography at this time, the *Tribuna* comes close to being a personal document, and it is understandable that, carried away with his subject, he exceeded his commission. Here the life of the flesh does blatantly mingle with art on the one hand and religion, connected with love of wife and child, on the other. Zoffany's position is as equivocal as in the self-portraits: he has lovingly painted the erotica, putting it in all the emphatic positions, but he takes his own stand behind a *Madonna and Child*, almost as if for protection.

Zoffany is an artist who, while abandoning the Hogarthian element of narrative, is totally aware of traditional iconography and utilizes it to the utmost; if the narrative structure is gone, the complex of meaning remains in the collection of symbols, or rather artifacts as symbols—serving as both themselves and iconographical systems. But this public imagery is now expressing a private content. No contemporary mentions having recognized its meaning, although

85 Johann Zoffany, *The Holy Family* (painted on the reverse of the *Self-Portrait*, Pl. 84; *c.* 1779). Parma, Palazzo della Pilotta.

some (like Mann) show puzzlement. The picture may have conveyed a sense of disquiet, as was demonstrated by both the immediate reaction of Queen Charlotte and the delayed one, disguised by madness, of King George. What the painting proved initially, perhaps to the Queen as well as to observers on the sideline like Mann, had to do with the genre itself and the underlying assumption that cabinet pictures were a way of possessing the paintings in other, inaccessible collections. We can project the vision of Queen Charlotte thinking she was possessing the Tribuna gallery, when in fact Zoffany himself had possessed it—had made it all his own. This was a fine irony that Zoffany doubtless appreciated as he carried out his commission, but which the Queen only vaguely sensed in her dissatisfaction with the picture. More generally the picture conveyed the relationship of humans with different responses to art objects of both a secular and divine nature, and so a disturbing interplay of these polar values. Then there was the semi-private sense, understood by the English colony in Florence, involving the placement of Patch and others; and finally the relationships between Madonnas and Venuses and children's coffins which were meaningful perhaps only to Zoffany's immediate family, or perhaps not even to his wife, or to Zoffany himself. In short, a conventional mode of communication has become, on the one hand, generalized; and, on the other, in so far as it is still an instrument of particularization, private.

The *Tribuna* is almost, in its way, as mythopoeic as one of Blake's engraved books: the materials are public ones, at hand in the Bible and classical mythology—the Old Testament God, Dionysus, Cupid and Psyche—but they are reinterpreted in terms of an invented myth, which on one level is even more general and accessible than the classical and Biblical stories, but which (as in parts of *The Four Zoas* and *Milton*) is about Blake himself and his relations with his wife, friends, and patrons. Zoffany makes his myth out of the art of the Renaissance, emphasizing the conflict of eroticism and religion in which the multiplicity of this fallen world (wine, painting, and sex) is related to the unity of the religious life, human procreation to the Holy Family, and his own confused personal life to the simplicity of the monastic rule. In terms of himself, he is trying to convey

in single pictures a narrative involving a fall into multiplicity and psychic fragmentation and a rise into reorganization and unity at a higher level of consciousness. But by presenting his myth in terms of art works, showing the men in the *Tribuna* living out their lives and dreams in art—in a Venus, a Holy Family, or the Wrestlers—or projecting their secret problems and limitations into these known objects, he is implicitly saying the same about himself.

A Digression on James Barry's Society of Arts Paintings

The reportorial Zoffany derives from Hogarth; Barry, deriving from Raphael and Reynolds, lays the heaviest demands of any contemporary on history painting as a requirement for the English painter. His close association with Burke leads him to emphasize the sublime in various ways. And yet, as we saw with the two apprentices, glaring differences sometimes conceal underlying similarities.

Barry's decoration of the Great Room of the Society of Arts (1777–83) was the one ambitious programmatic history undertaken by an Englishman since Thornhill's Greenwich paintings. Like Thornhill, Barry wrote an explication of his paintings; but unlike Thornhill's brief notes, explaining a national myth portrayed in graphic symbols, Barry's book-length work had to explain a mythos that was essentially his own, though constructed of conventional elements, and whose meaning did not always come across from the visual images themselves if we are to judge by his persistently plunging into accounts of his intention. The *Account of a Series of Pictures*, as he explains,[22] was written before the paintings were finished in order to elicit opinions, and he acted on some of these. Thus there was a real interdependence of word and thing here, with the paintings painted and revised in the light of a verbal description, which was then read by viewers of the finished work.

Barry consistently emphasizes the learning of the history painter, and in his *Inquiry* of 1775 he scorned the idea 'that an illiterate man could make any thing of true art'. Rather art requires

the acquisition of that comprehensive thought, that necessary knowledge of all the parts of history, and

the characters who act it; that power of inventing and adding to it, and that judgment of making the old and new matter consistent and of one embodied substance.[23]

When he comes to set down his ideas on the Society of Arts paintings, he also emphasizes the need of a great place, a factor that distinguishes the great painter from the work of the epic poet, which 'required neither a palace nor a prince, and is as much within the purchase of the mechanic, as of the sovereign'.[24] Though he has found no great patron (he is making these paintings gratis), he has found his great place and his great subject.

His aim is 'to illustrate one great maxim or moral truth, viz. that the obtaining of happiness, as well individual as public, depends upon cultivating the human faculties' (p. 40). By this he means that he will show the beneficent effects of civilization on man. His structure is the progress (his own term), though not in the ironic Hogarthian sense, from the savage state through 'several gradations of culture and happiness' represented by the Greeks and Elizabethans and contemporary Englishmen to the Last Judgment where 'after our probationary state here, [we] are finally attended with beatitude or misery' (p. 40).

In the passage quoted above he referred to 'that power of inventing and adding to' the conventional iconography of learned history. The Orpheus who dominates his first panel (the savage stage) is an example of invention. It is, he says, his own invention 'to represent him as he really was, the founder of Grecian theology, uniting in the same character, the legislator, the divine, the philosopher, and the poet, as well as the musician' (p. 42). Thus his Orpheus is shown dominating and instructing a savage countryside and people, turning a state of nature into the first stage of civilization.

In his myth art receives the credit for originating civilization: it is Orpheus who starts things, and Ceres is removed from the scene as a possible competitor;[25] in the fourth panel Dr Burney appears incongruously playing on his harpsichord in the middle of an ocean and symbols of commerce;[26] works of art dominate the premium-giving ceremonies of panel five (and lead to a long digression in the *Account* on the error of giving art premiums to children when they could be reserved for

mature artists); and in the final *Elysium* it is writers and artists who dominate, not the sort of people the Society of Arts was more accustomed to deal with.

Dr Burney is present in the midst of the ocean and the Elizabethan navy to keep in mind art, but also the present. For the present keeps intruding into the past and the unit of meaning in the two long panels, *Crowning the Victors at Olympia* and *Elysium*, which face each other, is the portrait or group portrait. And the two end panels of *Commerce* and *The Distribution of the Premiums in the Society of Arts* are, in effect, conversation pieces on a huge scale: the first mingling portraits of Raleigh, Gilbert, and others, the second portraying contemporary members of the Society of Arts. *Crowning the Victors* is derived from processionals like Carracci's *Procession of Bacchus and Ariadne* (Rome, Farnese Palace), but the progression from left to right is compromised by the fact that the centre of interest (in the *Account* at least) is the awarding of the prizes by Pericles; and by the particular density of the groupings and the refusal to focus or subordinate other groups like the old man held up by his sons. It becomes another group portrait, as does the *Elysium* across the way, which is overtly based on Raphael's *Disputa* and *Parnassus*, authorities for history painting as portrait groups. The compositions recall Reynolds' heroic groups, in particular the *Family of the Duke of Marlborough* (Blenheim) and the two *Society of Dilettanti* panels (Society of Dilettanti).[27] 'It was my original intention to bring in a much greater number of portraits', he tells us (p. 79), and where the paintings fail most seriously is when they become crowds of heads and little more.

Commentators have always been puzzled by the criterion by which Barry has introduced the portraits into these scenes, particularly into *The Distribution of Premiums*, where non-officers and even non-members appear. The Royal Academy in Somerset House is dragged in, and Edmund Burke can only be justified as a proponent of certain aesthetic doctrines more relevant to Barry than to the Society of Arts, and as moreover his own patron, advocate, and friend.[28]

To the wilful emphasis on art and the introduction of friends (and perhaps enemies too in the infernal part of *Elysium*), must be added the personal undercurrent of the whole series. Per-

haps we would be less aware of this had Barry not written his *Account*, but the personal is exactly the aspect of this public performance he most emphasizes. In the *Crowning the Victors at Olympia* the figure giving the prizes is Pericles: but having no bust handy, Barry says, he has used Plutarch's description of the great length of his head and joined this to the lower part, the features, of 'the late Lord Chatham being just then dead, and there being a striking resemblance in the character, and fortunes, of those two great men' (p. 54). He is picking out not the prize-giving aspect of the man, appropriate to the subject of the progress of civilization, but the feature that interests him most: both Pericles and Chatham, after giving their countries unexampled greatness in government, were removed from office. It is the defeat of great men, who give great benefits to their kingdoms, that is his real subject. Looking back to the first picture, we see that he has chosen Orpheus in the same way: here he is educating, but not long after the maenads will tear him limb from limb and his benefits will be forgotten (only to be resurrected by Barry). The reference to Aristophanes, who comes to laugh at Pericles (his face half hidden, so that, says Barry, he can be anyone you wish to make him) is along the same line (p. 53).

In this scene where he shows various examples of friendly contention, the group is flanked by statues of Minerva and Hercules. These two 'are comprehensive exemplars of that strength of body, and strength of mind, which were the two great objects of Grecian education' (pp. 55–56). But what he dwells upon in his *Account* is the Hercules: the great statues of Hercules, he says, omit one important feature, his trampling on Envy. But he has found a statue, poor in itself, but with the proper base, and so has joined them as he has the head and features of Pericles and Chatham. The trampling on Envy, a serpent, was Hercules' last labour, which 'cost him his life before it could be effected; by the bye,' he continues:

it is no doubt a good and wise distribution, that envy should continually haunt and persecute the greatest characters; though for the time, it may give them uneasiness, yet it tends on the one hand to make them more perfect, by obliging them to weed out whatever may be faulty, and occasions them on the other, to keep their good qualities in that state of continued

unrelaxed exertion, from which the world derives greater benefit, and themselves in the end, still greater glory (p. 57).

To this he adds:

On the basement of this statue of Hercules, sits Timanthes the painter, with his picture, which is mentioned by Pliny, &c. of the Cyclops and Satyrs; as there is no portrait of Timanthes remaining, (from a vanity not uncommon amongst artists) I shall take the liberty to supply him with my own.

Timanthes was chiefly noted for his *ingenium* or, to use Barry's phrase, 'power of invention', and Pliny remarked that his pictures were famous for suggesting more than they expressed.[29] Self-portraits were, of course, included in such other large projects as Thornhill's at Greenwich and Verrio's at Windsor; but these were of the artist signing, so to speak, his painting, and in no way interfered with the iconography. But Barry's self-portrait is part of the theme of the great-hearted being defeated by Envy.[30]

In *The Distribution of Premiums in the Society of Arts* we have noted one odd element in the presence of Burke; another is the inclusion of a painting by Barry himself: 'As the Society have given premiums for history, painting, and sculpture, I have introduced a picture and a statue in the back ground' (pp. 91–92). The former is *The Fall of Lucifer*, of which only St Michael appears, 'a design which I made about five years since' for another of the abortive schemes for public decoration by English artists—and, significantly in the context we are sketching, of Michael casting down Satan (analogous to the action of the Last Judgment in *Elysium* as well).[31] Michael is plainly, like Orpheus and Hercules, a Barry surrogate. In a nearby statue the dying Grecian mother, 'attentive only to the safety of her child, is putting it back from her breast, after which it is striving': another subject that, resembling a Charity group, proves to be a much darker conception and moreover one that has not been traced to any antique original. Like *The Fall of Lucifer*, this group and the bas relief medal of *The Birth of Venus* are probably the invention of Barry.

Burke's presence, the reference in Timanthes to the Cyclops, and the use of self-portraits all recall the painting of 1767 of *Ulysses and his Companions escaping from the Cave of Polyphemus* (City of Cork Vocational Education

86 James Barry, *The Distribution of Premiums in the Society of Arts*.
Royal Society of Arts.

87 James Barry, *Crowning the Victors at Olympia* (detail, left half; 1777–83).
Royal Society of Arts.

Committee), in which Ulysses is a portrait of Burke and his companion of Barry, who is evidently being guided by Ulysses' craft out of the cave and this brutal state of nature—which would have been Ireland, ignorance, and various other things. I suspect that the real import of the Society of Arts paintings follows from this: as the details and the off-centre allusions, the statements and innuendos of the *Account* attest, the message is that Barry is the representative of art who is trying to civilize England.

If we attempt to explain this series in terms of intention, we have to say that the patron, the commissioning body, does not determine it; we must look instead to the artist, who to make his meaning quite clear (the Timanthean suggestion of more than is expressed) writes it out for us as a programme. His intention is to produce a statement about civilization that is predominantly about the arts, and at bottom about the painter himself. This is an insistence on clarity that has little to do with Zoffany's resolute privateness of meaning, but it is based on as personal and idiosyncratic an intention. And though Barry claimed the authority of Raphael's Stanze, and drew on Reynolds' kind of historical portraiture for some compositions, he as well as Zoffany was painting in the tradition of the conversation piece as it had developed in England.

Zoffany's Conversation Pieces

The important factor connecting Hogarth's conversations and Zoffany's is the presence of the comic history paintings. After them the scene—the room with its objects—no longer seems innocent; its inhabitants' ontological status no longer seems secure. Something intellectually disturbing and challenging is going on. Although Hogarth's bent is toward moral statement and Zoffany's toward definition, without Hogarth it is hard to imagine those equivocal relationships between people and their possessions and often the artist himself in Zoffany's major paintings.

On his return from Italy, Zoffany in 1782 painted the collector Charles Towneley in a room full of the statues he had collected (Towneley Hall Museum and Art Gallery). Once again the room is an ideal one with objects gathered from all over the house,[32] and

behind the placement is the first plate of Hogarth's *Analysis of Beauty*, which is laid in a sculpture yard with the same relationship of real people to the heroic statues they dispose around themselves. By the quantity of the statues, by their scale, by the distance from which they are seen, and by the similarity in size and placement between the humans and the statues, it is clear that something further is being said about the relation between the worlds of life and art.

Towneley is set off from the rest of the room, seated on the far side, his distinct profile repeated in the more heroic equivalents of the busts behind him and the sphinx crouched beside him. The busts of Pericles and Homer were favourites, engraved on his visiting cards. On the other side of the room P. F. Hugues, known as D'Hancarville, Towneley's scholarly advisor, sits next to the famous bust of Isis (or Clytie) which was the basis for D'Hancarville's theory about the origin of Greek art in Egypt. It was Towneley's own most prized object (also engraved on his visiting cards), called by him (a bachelor) his 'wife'. During the Gordon Riots, two years before, the Isis was the one object he carried out with him from the threatened house. It is the centre of the composition, all the statues and people around it equally responding in some way, with Towneley strangely peripheral—rather like a preoccupied collector who leaves his flesh-and-blood wife to his friends; but here she is, ironically a piece of his collection, and the scholar D'Hancarville is where Towneley might be expected to be sitting. Charles Greville, better known for his love life than his archaeological interests, and about this time taking Emma Hart (later Hamilton) to be his mistress, has his right arm encircling the Isis, and his left arm gestures in the direction of her arm or breast.

Zoffany treats the collection simply as an extension of the collector, art objects as an extension of living ones. If Towneley's profile is perpetuated in the profiles of the busts on his side of the room, the other figures are also related in complex ways to the statues around them. Though slouching, D'Hancarville is in a pose (as far as the placement of his arms, legs, and head) parallel to that of the Venus by the fireplace, and the turn of his head and shoulders are the same as the bust of Isis toward which his

88

88 Johann Zoffany, *Charles Towneley and his Friends* (1782). Burnley, Towneley Hall Museum and Art Gallery.

attention is chiefly directed. In the pose of his arms, Greville roughly resembles the nymph behind him struggling to escape an attacker, though their heads are turned in opposite directions. The relationship is between people and art works only by resemblance, suggesting the transference of the real life of someone like Towneley into the ideal substance of art. The collector projects his dreams into his collection, grows to resemble his busts, and is a bachelor who calls a bust of Isis his 'wife'. Zoffany's little joke involves supposing a marital triangle, with the 'wife' surrounded by the friends of the distant husband.

There are other puzzling elements in *Towneley and his Friends*, such as the placement of the *Drunken Silenus* and the prominence it must have received before the *Discobolus* was added much later to intercede between it and the viewer. The *Silenus* is placed so that, like one of the Watteau dogs in an indelicate *fête*

galante, he is exhibiting himself to the viewer; the incline of Isis' head makes her appear to be regarding him, at the same time that he is repudiating her. This is still very much part of the conversation piece's spectrum of nature and art that runs from a dog to the men to the statues of the same scale to books in which these statues are formulated into theories and abstractions (by such as D'Hancarville). And the sitter is still being defined in terms of his milieu. It just happens that D'Hancarville, engaged by Towneley to document and catalogue his collection, *is* the human centre of this milieu, which is after all a collection, and Towneley the owner is peripheral; and the collection itself, with its prominent display of the confusion of art and nature in Silenus, overwhelms all the humans grouped within its ambiance.

In the same way, Zoffany portrays Sir Lawrence Dundass and his grandson (private collection) in a room full of pictures and

153

furniture that has been called by Sacheverell Sitwell 'an interior of live objects and inanimate persons'—which I think is closer to Zoffany's own intention than Sitwell realized.[33] He is not, as Hogarth would have been, making a moral comment on Sir Lawrence, but rather defining him in terms of his grandson (their relationship) and the room he has arranged as a projection of himself into things.

83 Zoffany's Uffizi self-portrait shows how both analogical and classifying structures could coexist in the same picture. As fleshly artist, wrapped in costly robes, Zoffany is judged and mused upon by juxtaposition with his opposite, the skull and the flayed man; but as an object of definition, he is part of a spectrum of being, at the far end of a classification beginning with skull and flayed man.

The symbolic, analogical, or moral structure remains in a number of the conversations, but in so vestigial a form as to be merely puzzling. Zoffany sometimes includes the sad, isolated figure of himself in a happy group, a Watteauesque touch indicating a sense of a private world present in the most social of gatherings. In the *Ferguson* group (1781, private collection) he shows himself as one of the group celebrating a coming of age, but utterly outside the celebration; while the others happily relate to one another, he is looking away in melancholy

77 meditation. As the *Tribuna* showed, his intrusion could be a very personal gesture. But in a portrait group this figure either frustrates the whole design, producing a counter-movement of meaning, or it acts as a *Vanitas* symbol, a reminder to these happy people of the excluded world. In another form this is the counter-energy that supplements the stolid dignity of the sitters. When he is not himself present sometimes, as Hogarth included his Pug, he introduces his dog Poma, who is as removed and self-contained as his master. Poma appears in the same pose at the feet of Mrs Francis Sharp in *The Sharp Family* (1779–81, Hardwick Court) and in *John Wilkes and his Daughter Polly* (1782, private collection): his nose is down and he is looking straight at the viewer, making a contact which ignores the social group.

If these vestiges look back to the conversations of the 1720s and 1730s, Zoffany generally subordinates them to the main end of public definition carried out through the iconography

of possessions. Earlier we distinguished between indoor and outdoor conversations; in the one architecture and spatial demarcation dominate, and in the other landscape and symbols. Zoffany makes full use of the manor's interior, as in the *Dundass* conversation, but he also frequently takes his family outdoors and places them around a tree, with the rolling park of their estate in the background, and a horse or two and a dog present. Out of the primitive groups painted by Hayman and Arthur Devis in the 1740s, Gainsborough had built a sophisticated conversation in a rural setting in the 1750s, the masterpiece being *Mr and Mrs Andrews* (London, National Gallery). This was the model Zoffany exploited.

The 1760s was the second great period of the conversation piece, when the domestic ideal of George III's reign called for the genre as insistently as had the Walpolean peace of the 1720s. Historically, sociologically, and aesthetically, the change is from interior to exterior, from city to country life, from power to retirement, and from portrayal with friends and patrons and collection to portrayal with family, estate, house, trees, horses and dogs, and implications of sports and hunting and racing. One reason for Capability Brown's success may have been the irrelevance of the 'garden' to the symbolism of the Great House at mid-century. The park was the important symbolic element, whose lawns and oaks could reach uninterruptedly to the house. With the house in the background, the tree is the centre of gravity for the sitters—often emphasizing the lines of a triangle—or even for a group of mares and foals. The tree represents nature, but it also anticipates Burke's metaphor of the great families standing out, taller, nobler, and more firmly rooted than others, like the great oaks among the lesser trees of the forest.[34] The connotations of the British Oak reach back to the *arbor vitae* and forward to Burke's metaphors of organic growth, Yeats' 'great rooted blossomer', Ford Madox Ford's Groby Great Tree, and Forster's wych-elm of Howards End. The importance is reflected negatively in the agonies expressed at the prospect of cutting down one of these trees.[35] Zoffany likes to arrange children—sometimes, like the Bute children (early 1760s, Marquess of Bute), divided according to sex—playing around the base of an enormous old tree, signifying the

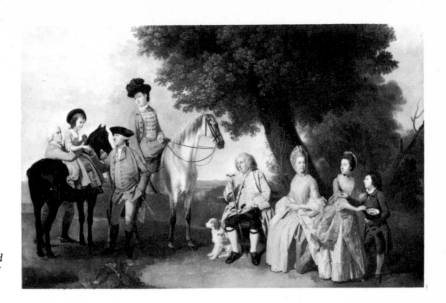

89 Johann Zoffany, *The Drummond Family* (1765–69). Collection of Mr and Mrs Paul Mellon.

continuity of the generations. In *The Drummond Family* (1765–69, Mellon Collection) three generations are shown grouped around an old oak tree, with two horses and a spaniel also present.[36]

The basic idea of the conversation of the 1760s onward was Burkean: society is a carefully balanced organic whole which embodies the accumulated wisdom of the past and sustains precious personal attachments. Unification is the basic metaphor, embodied in those wise men of the past who pursued a desire to derive 'all we possess as an inheritance from our forefathers. Upon that body and stock of inheritance we have taken care not to inculcate any scion alien to the nature of the original plant'.[37] Central is the sense of place which promotes the moral conditions necessary for a stable social order: a sense of continuity in the collective life of man, personal attachment to the past, and a sense of the firmness and gravity of land and society. The self only exists as a part of and in relationship to his society, its social forms, institutions, and past, and the imperatives its welfare makes upon the individual. Personal happiness comes through the fond memories and instinctual ties a society engenders.

Reynolds' portrait groups perfectly fit this picture; they come close to filling the picture space, the objects of their particular milieu are usually drastically reduced to a tree or urn and a stretch of landscape, and the effect is powerfully unitive. Zoffany's groups, constructed on the model of the conversation piece which contrasts as well as compares, to a much greater extent retain a divisive quality, a tendency toward fragmentation and disruption. I suspect that while he portrays the same elements that Burke was to consider essential to society—the 'presence' of social institutions, social forms, factors of time and place, or particularities of national history—he tacitly regards these (as William Godwin was to do in *Political Justice*) as merely social forms existing only as one possible solution to a given problem of social organization. Within the public iconography of the park and house he retains a melancholy undercurrent of the personal, as in those appearances of himself or his dog, or in some incongruous detail or merely in the awareness of distance as well as proximity in social relationships.

A kite appears in *The Bradshaw Family* (1769, Tate Gallery), flying off in the empty sky to the left, drawing one boy away from the tight pyramidal family group under an oak tree. This son is looking away into the sky after his kite; the other, on the far side of the family group but closely knit to it, is resting against his pony, the outermost boundary of the group. Whether we take the kite as a symbol related to bubble-blowing, or as coloured by Benjamin Franklin's experiment of 1752 (attracting electricity from the air to demonstrate the electrical nature of lightning), in the portrait context it suggests that one son has aspirations of a poetic or scientific nature which draw him away from

90

155

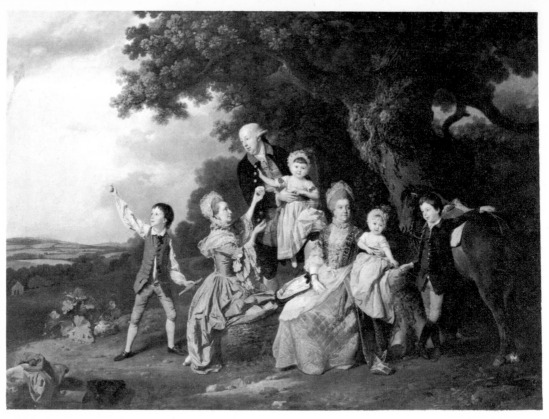

90 Johann Zoffany, *The Bradshaw Family* (1769). Tate Gallery.

the family group, while the other son holds to the group, its property and social function. The boy and kite also, of course, fit into the pattern of the boys kicking over a pile of books in Hogarth's *Cholmondeley Family*. Something of Zoffany's effect can be seen by contrasting *The Bradshaw Family* with a very similar conversation, doubtless influenced by it, Francis Wheatley's *Family Group* (early 1770s, London, National Gallery) in which the boy on the left is sailing his kite. But Wheatley has not grasped the significance of the kite; he keeps the boy within the family group by adding other figures to the left of him and simply lets the kite fly while turning the boy's head back toward the painter. The boy is paying no attention to his kite but merely posing for his picture.[38]

Another Zoffany conversation, *A Man and two Boys, one with a Kite* (Hatfield House),[39] shows the father and one son looking with amused detachment—and some evident condescension—on the other son, somewhat de-

tached to the right just in the act of trying to get his kite off the ground; its tail still overlaps the father's coat. The family dog, furthest to the left, also watches the kite-flying son, and behind is a plinth and a statue of the infant Hercules killing the serpent. This statue was presumably in the sitter's park, but by posing him and his two sons in front of it Zoffany has drawn attention to a relationship of some kind between the kite-flying son and the infant Hercules, the family group and the tangled coils of the serpent.

The basic formal structure of a Zoffany conversation is the triangle, which when used to define a group indicates solidarity. Thus when the triangle is splintered, solidarity is manifestly qualified, and smaller groups are defined in terms of affection perhaps or personal interests. In an interior group like *The Dutton Family* (Farley Hall, Berkshire) there is no apex to the triangle on which it is constructed; rather the family falls into two small, separate triangles. (We recall *The Fountaine*

156

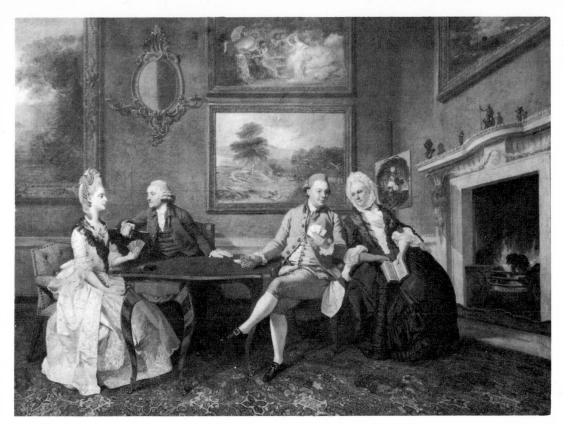

91 Johann Zoffany, *The Dutton Family* (1760s). Farley Hall Collection.

Family where the women were thus separated from the men.) The two couples are the father and daughter and the mother and her son (the father's step-son).[40] The heads of the father and daughter are compared; the mother-son are inclining together, while the other two are parallel. The little wizened father is fixedly watching his stiff, straight daughter, whose eyes are looking ahead at nothing or at her step-brother. At the other end of the card table, quite a distance from these two, are the step-son and Dutton's wife, looking as if he is showing her his cards, turning to her as an ally. If a clear division exists between the two couples, Mr Dutton is the protagonist of the picture, picked out by his placement in the only empty space between pictures-on-the-wall and beneath the mirror with candle sconces: the line of a corner of the room is reflected in the mirror, further centring him.

In a painting like this, or *The Drummond Family*, it is only important who is next to whom, who is how far from or inclining toward or away from or touching whom, whose eyes turn, whose eyes meet, and who is standing or sitting next to what. The precision of relationship recalls, perhaps partly derives from, the importance a painter like Canaletto placed on the correct perspective, correct placement of people within an accepted and recognizable structure, with coordinates of human-society, architecture-past-present. Both painters share the concern of the exploratory novelists, of Fielding and Richardson in England, of Marivaux in France, with the way something is put together, conveyed by careful definition of relationship and causality, which ties the individual down not just to time and place but to family, heredity, and environment in a present moment. There is no desire or attempt to recreate the past, except in the images on the walls; but immense pains are taken to evoke the present. Looking at a Zoffany interior, we can almost say (with Tristram Shandy) that this scene took place on 'this very rainy day, March 26, 1759, and

157

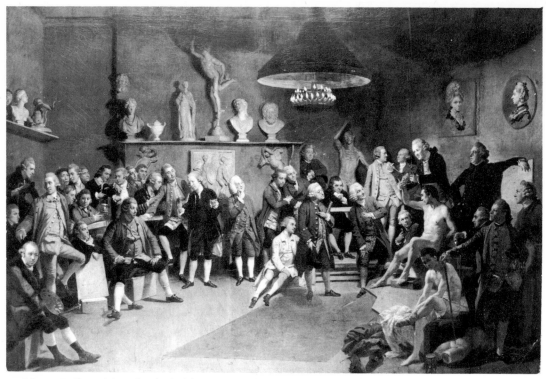

92 Johann Zoffany, *The Life School of the Royal Academy* (1772). Royal Collection.

betwixt the hours of nine and ten in the morning'.

We cannot know whether these configurations corresponded to reality or only to Zoffany's imagination. Where there is evidence, as in the conversation of Earl Cowper and his bride or in the *Tribuna*, we can see Zoffany reporting a truth about historical human relationships with as much accuracy as Fielding, Richardson, or Sterne. One such relatively public work is *The Life School of the Royal Academy* (1772, Royal Collection), painted just before he left for Italy. The Hogarthian structuring is still predominant: contrast the stubby little man with an ear trumpet and all grace gone with Sir Joshua Reynolds, the arch advocate of the great style. Among the other dumpy academicians, he slouches forward with his ear trumpet in his hand, straining to hear, juxtaposed with the antique statues and the appurtenances of the high art he advocated. (Even when he painted himself as deaf, with hand to ear, he echoed a Greuze of a nymph with her hand to her ear.)

The significance of this painting lies in the groupings, personal and political, of the Royal Academy in the 1770s. Reynolds is in a huddle with Wilton and Chambers; Richard Wilson stands aside isolated and moody; Hayman is bluff and burly but also alone, no longer a part of the controlling group, a shadow from the past. The two ladies who were members are literally removed and hung as portraits on the wall. It was, of course, indelicate to show women with the nude male model, and Zoffany places their portraits behind the model's back where they cannot see the side presented to the men. But his design and placement says that these lady painters are decorative, pretty pictures rather than a meaningful part of the real functioning of the Academy.[41] Zoffany himself, as usual, looks quizzically at the viewer, drawing us away from all of this world of politics mixed with academic art, to a real individual, the artist who has painted this and knows the truth, which is as separate and personal as it will be later in *The Tribuna of the Uffizi*.

92

158

10 Stubbs: a 'look into Nature'

THE THEME of Ozias Humphry's memoir of George Stubbs, based on Stubbs' recollections in old age, is repeated on nearly every page. After a disagreement with his master over copying a Van Dyck Cupid surrounded by symbols of the Arts and Professions and a Pannini *Ruins of Rome*, Stubbs decided that he 'would for the future look into Nature for himself and consult and *study her only*'.

Without seeking assistance from any one, he proceeded alone to make all his studies after nature, intending by every thing he did, to qualify himself for painting rural, pastoral and familiar subjects in history as well as portraits.

It does not appear that while he resided in Rome he ever copied one picture or even design'd one subject for an Historical Composition, nor did he make one drawing or model from the Antique either Bas Relief or single Figure.—by so much had he devoted himself to observe & imitate particular objects in Nature. . . .[1]

One possible formulation is that Stubbs, son of a tanner, simply liked to paint animals, especially horses. Stubbs' own memory, recorded by Humphry, is that he defined his art in terms of a reaction against the principles of academic art. What Stubbs demonstrates in particular is that there is no necessary correlation, as Reynolds still believed, between the subject matter or style and the importance of the painting. Most crucial of the St Martin's Lane Academy ideas for him was the play with genres that broke them up, either subverting or fragmenting them. Out of book illustration Hogarth, Gravelot, Hayman, and Highmore had developed a rococo which was less elegant curves than small, partial truths; which substituted natural for conventionally decorative patterns, everyday events for myths or religious subjects. Stubbs proceeds from this set of assumptions. The phrase 'in his particular department' applied to Stubbs (Anthony Pasquin wrote that he has 'become, by his genius and his researches, the example of Europe, in his particular department')[2] is the equivalent of the earlier statements that Hogarth was the greatest painter 'in his way' and Chardin 'in that field'.

One sign to an academician that he is looking at modern art has always been the sense that parts are developed at the expense of balanced totalities.[3] This is what Barry, the academic apostle, was referring to when he said:

Instead of expanding our minds so as to take in such an enlarged noble idea of art as was worthy a great and learned nation; our practice, until lately, has been rather to contract the art itself, to split into pieces, and to portion it out into small lots, fitted to the narrow capacities of mechanical uneducated people.[4]

Stubbs has first taken one element, rigorously subordinated in his source, from a classical history painting—for example, the horse from Veronese's *Mars and Venus*—an element to which Hogarth gave a relative self-assertion within the complex scheme of *Harlot*, Plate 1; and then he has created a new unity, perhaps even more intensely focused than Veronese's, around this fragment. The same will apply whether a horse or a comic narrative is the fragment, or (in neoclassic painting) abstract form or some emphatic aspect of style. Though the piecemeal way of teaching art in the academy may have contributed to this fragmentation of a totality into interesting parts, it was the anti-academic painter who began to develop directly along the lines of his studio life sketch or began to project pure subject or pure form or style without the attempt at unification or comprehension of so-called great art.

This is probably why a Stubbs looks so different to us than it did to a contemporary. Contexts change: paintings by Reynolds and West meant more to contemporaries who saw painting as the tradition of Raphael, Titian, and Poussin. Stubbs means more to us who see him as a progenitor of certain aspects of nineteenth- and twentieth-century painting. Doubtless Stubbs' reputation has benefited by the meticulous early style, the horses, and the jockeys of Degas, as well as the off-centre composition that used the golden section to suggest the immediate perception of a candid camera shot.[5]

There was, of course, a tradition, respectable if sub-artistic, with John Wootton as its most distinguished practitioner, of animal, hunt, and racing pictures for country gentlemen. But Stubbs made this kind of picture into high art

159

by painting as if he were not a mere mechanic like Wootton, and by producing a painting that was not just of a horse but of a scene in which man the hero, the cynosure of history painting, has been displaced. We shall have to see how he indicated this; but one result was that his situation vis à vis the Royal Academy, where he exhibited some of these paintings, was more difficult, say, than that of the adaptable Gainsborough. The horse, his chosen subject, was both the material of his portraiture and the source of his interest in form. It was the extensive patronage he received as a horse-painter in the 1760s and 70s that led to the stereotype he tried to live down in the 80s and 90s. The reason why he suffered remained, however, the academic categories, which typed him as 'animal painter' and led him occasionally to forget that he was developing a bold new art that in fact paid no attention to the categories. His mechanical attempts, analogous to Richard Wilson's in landscape, to add mythological figures to a horse picture were a failure, artistically and commercially. These attempts at conventional history painting should be kept to one side from the works of the real Stubbs, who launched out in the 1760s with *The Anatomy of the Horse* and the pictures for Lord Rockingham ranging from the monumental *Whistlejacket*, which recalls Titian's equestrian *Charles V* without either Charles V or a landscape background, to the friezes of *Mares and Foals* and the earliest horse-lion pictures.[6] With these he suddenly reveals the total rupture between the old academic categories of history, portrait, and landscape, and the altogether different categories of the beautiful and the sublime, which originate (or at least so the artist could tell himself) in nature rather than in art.

The horse itself was a profoundly interesting symbol as Stubbs developed it. He began to paint at just the time when the horse had become a major status and cultural symbol for upperclass Englishmen and he made of it—the only animal whose anatomy Leonardo and Dürer studied along with the human—a symbol of perfect beauty.[7] He certainly knew the physiognomical treatises in which a horse's head is related to the ideal beauty of a Greek bust.[8] Burke's *Philosophical Enquiry into the Sublime and Beautiful* (1757) would have confirmed for him that the horse in a race, hunting,

or by itself—not being 'useful' in front of a coach or plough—defines with its curving flanks and sleek coat the beautiful. Stubbs' paintings of horses are studies in formal beauty found in nature. But he also knew Burke's distinction between the horse as a useful animal and one (quoting from Job) 'whose neck is cloathed with thunder, the glory of whose nostrils is terrible, who swalloweth the ground with fierceness and rage'.[9] The sublime begins with the rearing Whistlejacket and proceeds to the lions and horses, and ends with Hambletonian. The same intention is pursued with the lions, tigers, panthers, and rhinoceroses, also animals singled out by Burke for their sublimity and linked with their habitat 'in the gloomy forest, and in the howling wilderness' in which Stubbs carefully paints them.[10]

To employ the sublime and beautiful out of Burke is a way of saying that nature has priority over art. Stubbs told Humphry that he went to Italy 'to convince himself that nature was & is always superior to art whether Greek or Roman & having received this Conviction he immediately resolvd upon returning home'.[11] But when he talked to Humphry he was re-interpreting in old age a time when he was probably more susceptible and less doctrinaire, and of course we know that he did in a sense imitate art in these paintings. As Basil Taylor has shown, the horse-lion composition derives from a Roman copy of a late Pergamene sculpture, available in Rome but also in England in the garden at Rousham.[12] The horse's expression derives from Le Brun's *Passions*, and in the Rockingham version at least (Mellon Collection) the horse's shape is adjusted to the artistic convention required, and is altogether more heroic and sculptural than the horses in Stubbs' more descriptive paintings. The landscape convention of the background replaces observed English countryside with Salvator Rosa's crags, abysms, waterfalls, and sinister darkness.[13] In this wild setting Stubbs creates his own myth of a beautiful creature turned into a sublime one by the presence of a lion and the terror of pursuit and attack. He raises the horse to his feet to emphasize the tension between two powerful but unequal forces; and later, exploring other aspects of beauty and sublimity, he sinks the horse to the ground, a pathetic victim.

An example with wider application is the frieze of mares and foals, which shows how

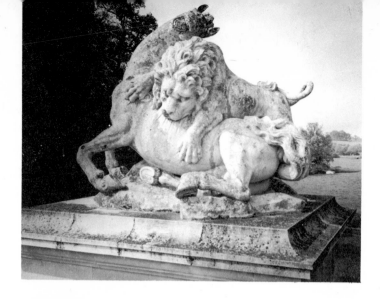

93 Peter Scheemakers, *Horse attacked by a Lion* (1740s). Rousham.

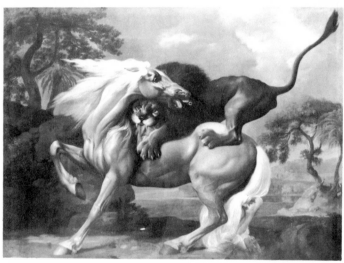

94 George Stubbs, *Horse attacked by a Lion* (1767?). Collection of Mr and Mrs Paul Mellon.

95 George Stubbs, *Horse attacked by a Lion* (1770s). Private collection.

161

Stubbs made use of his Roman experience to paint naturalistic representations of horses in an elaborately formal pattern. Granted the *Anatomy of the Horse* lent itself to the profile view (though Stubbs also uses sharply baroque views), and the horse portrait was expected to show the fine points of its conformation which could only be seen in profile, and with multiple horses in a frieze. Yet the striking features of Stubbs' paintings are the carefully planimetric structure, the refusal to break the limits of the picture space, and the meticulously unemphatic, often flat application of paint. Taylor shows that Stubbs' medium, especially in the enamel paintings with their 'bland, unemotive surface', is a good indication of the character of his art: 'clean and refulgent', 'a firm concentrated unity of effect', 'material durability of the paintings', 'physical permanence', and 'the formal stability of Stubbs' art' are the key phrases.[14] These paintings recall less the work of Gainsborough or Reynolds than the contemporary paintings of Benjamin West—but to a twentieth-century observer the analogues would be paintings like Seurat's *Baignade*, *Grande Jatte*, and *Parade* (as the velvety black of Stubbs' mezzotints strangely recalls Seurat's charcoal drawings).[15]

It is only apparently a paradox to say that this classical simplicity, recalling Roman bas reliefs, is an aspect of primitivism. As we pass from the generation of the 1730s to that of the 1760s, nature as a corrective to art becomes the conception of something original or quintessential or basic, a subject or form that existed before the overlay of sophisticated cultures. Stubbs was close enough to the transitional work that made this point, Hogarth's *Analysis of Beauty* (1753), to detect serpentine lines in natural forms and to understand this idea of nature as precisely the need to get behind the academic form to the real, essential shape. He found essential shapes not only in natural objects themselves but in their arrangement in space, which he transferred to his canvas as the golden section and the triangle, structures he embodied in the most naturalistic representations. The essential figure was the horse (as, for Hogarth, it had been the human female), reducible ultimately to muscular structure and skeleton.

The Anatomy of the Horse (1766) might be an epitome of Stubbs' art, accurate and scientific but at the same time elegantly stylized, re-revealing the formal potential in natural shapes.

All one needs to recall is the beautiful lines and the complex formal patterns he discovered in the actual gory corpses of those horses he anatomized in the farmhouse near Horkstow. Nature here means going back to origins *by means of* looking inside, cutting apart, revealing the bare bones in order to find how something really looks and operates. The rhetoric of Ruini's horse anatomy is deleted; there are no flowing manes and curling nostrils, no ropes and tassels or distant towns as in the *Anatomia del Cavallo*.[16] Stubbs' horses are depicted in simple poses against the clear, empty page, giving the effect of Whistlejacket and the friezes of horses, an effect of classical purity but also of the isolation and intense focus of technical illustration.

The first requirement of technical illustration was that the subject be clean-cut and precisely delineated, 'seen from a position chosen to give equal emphasis to all the details'.[17] The two basic methods followed were to compound natural appearance and diagrammatic section in a single scene, with often incongruous, even surrealistic results, and to separate them into realistic depiction and, abstracted to the border, details required for elucidation. The second was used by Hogarth in his *Analysis* plates and by Piranesi in many of his Roman structures—and, of course, by Stubbs in his early plates for Burton's *Midwifery* (1751). In his paintings Stubbs maintains natural appearances but does not altogether lose touch with the older form of technical draughtsmanship. One can still feel something of the strangeness of a Stubbs painting by looking at an early eighteenth-century engraving of a Newcomen engine, with the side of the engine house removed to reveal the operation within, and present off to the side, representing the reader, an elegantly dressed gentleman who watches the operation of the machine.[18] Something too remains of the combination of general view and detail, and in a picture like *Gimcrack* (Jockey Club) he shows both the general scene and, in the distance, the race itself, or different views of the same horse.

For all his stripping of accoutrements and his dissection itself, he remains the artist of an empirical world of appearances. He did not, for example, respond to Peter Camper's urging that he describe visceral anatomy. He repeats only a portion of Ruini's study, which also reported on the thoracic and abdominal vis-

cera, generative organs, the central nervous system, and the schema of blood supply to the entire body. His interests were satisfied when he had examined the skeleton and muscles and ascertained how a horse actually functions as well as appears.[19] The result is less the painting of an anatomist than of an artist who, through the training of anatomy (or the upbringing as son of a tanner), follows his particular way of getting back to essentials, of starting over again.

Reynolds makes the distinction clear in his third Discourse: 'This idea of the perfect state of nature, which the artist calls the Ideal Beauty, is the great leading principle, by which works of genius are conducted.' He advises the artist to make 'a close comparison of the objects in nature'—with the aid of 'a careful study of the works of the ancient sculptors'—and the end is to become 'possessed of the idea of that central form, if I may so express it, from which every deviation is deformity'.[20] An 'idea' and 'central form' created by 'study of the values of the ancient sculptors' is quite a different thing from the reductive, minimal, skeletal form Stubbs was seeking as the basis of art.

Stubbs is an almost too literal example of one kind of reaction to the academic; his removing of skin, muscles, and the rest is a way of stripping away convention until you get to the very skeleton or true structure. Cutting away the fancy work of the rococo as well as the overblown forms of the academic grand style, he found a style that served the same end of simplification as neoclassicism but without the sense of style for art history's sake. For him the planar structure and the geometrical forms are not attempts to evoke a classical past—there is no allusion at all—but only to simplify forms in the direction of natural observation. Stubbs' paintings take us back to the most basic and essential forms expressed in the most basic and essential representation—of animal, man, and landscape, in terms of triangles and the golden section. It is in this sense that his anatomical work is important evidence: while other artists, mostly centred in the Academy, were changing shapes to accord with an *a priori* antique standard—continuing to imitate art rather than seek a new understanding of nature—Stubbs was changing shapes by going back to nature in the simplest yet most radical sense. The result, even in *Gimcrack* and the harvest pictures, was not of course free of art conventions, but it represented a surprisingly functional austerity freer of convention than the work of any other contemporary artist.

The last we shall hear of the Choice of Hercules, the great paradigm of human choice and of homocentric art, is appropriately in the lists of Stubbs' lost paintings.[21] He undertook in the 1770s a cycle of huge (*c.* 5 ft. by 8 ft.) Hercules paintings, and three versions of the *Choice*, unsold at his death, were in his posthumous sale. The only Hercules subject of which a description survives, however, was *Hercules and the Cretan Bull*, in which the bull was plainly the dominant figure in a human-nature conflict the equivalent of the struggle in the horse-lion pictures between beauty and brute strength. A few unhappy cases, in particular versions of *Phaeton*, have survived to show that Stubbs still, upon occasion, continued to depict structures of analogy: behind this man and these horses are Phaeton and Apollo's horses-of-the-sun, and behind them the abstractions of man and uncontrollable nature; just as in Veronese's *Mars and Venus* there were, behind this naked woman and that man in armour, Venus and Mars, and behind them the abstractions Love and War.

As the horse-lion pictures show, Stubbs' more characteristic mode was to paint the unadorned man-animal or animal-animal, removing all the conventional iconography of, say, a lion—associations with Christ, Devil, Hercules, English strength (as in Hogarth's *Election* II), heraldry, ceremonies, processions, or spectacles; and reduce the two creatures to elemental natural forces, just as Venus might be reduced to mere woman-in-love. He employs a much lower level of literary denotation than is required of an analogical structure but a much higher one based on classification as to genera and species and occupation. For example, on a few occasions a half-remembered prototype intercedes, as when a monkey picking a peach (Liverpool, Walker Art Gallery) recalls all those monkeys holding apples that appear with Adam and Eve in portrayals of the Fall.[22] A baboon raises one hand as if in declamation and holds with his other a stick that resembles a staff (College of Surgeons). But the peach and the stick, and the monkey and the baboon, in Stubbs' precise representation show rather how closely an animal shape may approach that of a man, on the order of the relationships explored

114-17 in his final work, the *Comparative Anatomy* of man, cat, and fowl.

Analogy—Man-Mars-War—is replaced by analysis, by the examination in depth of biological or botanic nature: by the exact measurement of resemblance and difference, resulting in placement on a scale (or some such structure) of order. The golden section serves not only as a geometrical foundation for his painting but as a measured system of intervals, a complex interior scale of reference; and the reason for placing horses, and often people, on a plane parallel to the picture frame and rather close in is, as I have suggested, for the distinct and descriptive shape it gives. No longer a matter of analogy, metaphorical or otherwise, this is a relationship in terms of equality and inequality, of a scale running from the simplest to the most complex by the smallest possible degrees of difference. *This* resembles *that* is replaced by the successive degrees of likeness in a series; the mode is not poetic but taxonomic.[23] Stubbs is no longer concerned with a system of analogies or of moral structures—above all of those false analogies of romantic anthropomorphism between plant-animal-human life—but with one of order that shows how things are related or put together.

Stubbs the anatomist kept the artist relatively close to the scientific developments of his time. His way of painting was probably determined to some extent by the development of zoological parks, the tendency to see animals as objects of scientific enquiry, and the work of classification by Linnaeus (*Systema Naturae*) and Buffon (*Histoire Naturelle*) that contributed to the foundations of modern biology. In England John Hunter's museum of comparative anatomy opened in 1776, and the voyages of discovery were bringing back strange animals and sending out scientists like Stubbs' friend Joseph Banks with Cook's expedition (1769) to observe.[24] Scientific classification was as good a structure for the artist at the time as antique art; it had the same pitfall, the tendency to become over-stereotyped, but Stubbs came in at the beginning and was an artist of genius. (He was, for example, following Linnaean classification in limiting himself in his anatomies to merely morphological characteristics, paying no attention to internal structures of organs.)

Behind Stubbs, and quite different from the precedents of horse delineations, was the body of books on insects with plates showing the creatures in isolation from any milieu but in juxtaposition with other creatures.[25] The extension of the variety of animal life led to minute refinements that tended to place in perspective statements like that of Soame Jenyns, relating classification to the Great Chain of Being:

Animal life raises from this low beginning in the shell-fish, through innumerable species of insects, fishes, birds, and beasts, to the confines of reason, where, in the dog, the monkey, and chimpanzee, it unites so closely with the lowest degree of that quality in man, that they cannot easily be distinguished from each other.[26]

Stubbs sees the comparison from the other end of the telescope along a horizontal, not vertical, spectrum, with the structure of his scenes (sometimes marked by the regular intervals of fence posts) the line of beings and objects.

When he added humans to horses it was in the mode of the conversation piece with its relationships and intervals between kinds of art, beauty, man, and nature. He remains part of the tradition (e.g., Gainsborough's *Mr and Mrs Andrews*) in which these entities are kept quite distinct, down to the clear lines that separate each, emphasized by his method of completely finishing a figure or horse before starting the background behind it. The effect is quite different from the blurred outlines of a late Gainsborough, in which one species is shifting into another. Stubbs is concerned as much as Gainsborough with borderline states of being but for him each remains a distinct reality.

He retains the slightly comical juxtaposition of human and animal with which Hogarth enlivened his conversations, and he emphasizes the human imposition on the animal by showing horses swaddled in harness and being barked at by a free, unharnessed dog. The importance of all the bridles, stable-boys, trainers, jockeys, as well as owners in Stubbs' conversations can perhaps be traced back to the conversation conventions of art ordering (or compelling) nature, and now related also to the shapes of beauty in the horse, the natural setting, even the weather conditions, the light, and the seasons: all of those different states of being related along a determinedly horizontal spectrum within the picture space.

While Zoffany and the other artists who build their conversation pieces around the elements of family, man or house, tree or greensward, and horse, make them a spectrum of property, Stubbs does something different. He does not allow the usual interrelations, or he pursues the distinctions of difference (equally explored by Zoffany), and separates them, reduces the importance of the master, or even removes him completely, minimizing the sense of property in favour of the essential nature of the animal.

This animal, the horse, was part of Stubbs' *donnée* as a painter of horse portraits and conversations. It was partly, of course, his own creation. By the 1760s the horse, no longer merely the sign of a sporting picture, was a social symbol of a gentleman's relationship to the world of action and retirement; it implied the extent of his estate and his herds, of his responsibilities to his tenants and to the macrocosm of an expanding England. Like the Royal Oak, the horse parallels the family: its exquisite breeding, its animal beauty, and its surrogate quality as the racer that wins for the family. Basil Taylor's words sum up these animals who 'signalized their owner's authority or valour (as heraldic usage indicates), typified strength and instinctive tenacity, or, when under human control, asserted man's command of nature'.[27]

The great emphasis on the horse was another phenomenon of the mid-century, originating with the aristocratic status of horse-racing, 'the sport of kings', but now come to a focus in the obsession with thoroughbreds. The Jockey Club was founded in 1750, instituting a system of racing colours, laws for the regulation of betting, and genealogies for horses. The great sires, the Byerley Turk (1689), the Darley Arabian (1704), and the Godolphin Arabian (1730) had produced three of the great descendants, Herod (b. 1758), Matchem (b. 1748), and Eclipse (b. 1764). There could hardly be a better example of pure blood, of collector's mania, and of a status symbol than a thoroughbred in tail-male from one of the three great progenitors. By the reign of George III the descendants had, according to John Lawrence in his *History and Delineation of the Horse* (1809), 'rendered the English coursers superior to all others, not only in the race, where indeed he [sic] had long excelled, but as breeding stock'. As early as 1740 an act was passed to suppress small and weak breeds,[28] and in the portrait of horse and master the former was both an important piece of property and a symbol of the master's Englishness. 'The characteristics of the English Horse,' writes Lawrence,

are strength and speed; in their form, length, and in the best of them, symmetry; but there is in them generally a coolness and sedateness, and want of grace, which indicates their greater aptitude to solid use, than to parade and shew. A mixture of all nations, like their masters, they seem to have caught the same spirit and manner, as it were from the soil, or from that mixture.[29]

There is a fine schematic example, once attributed to Stubbs, *Henry Styleman and his first Wife Mary Gregg*,[30] which parallels Styleman and the trunk of the oak tree near which he stands; he is addressing himself to his wife, who places her hand on one of the horses' heads. The animal clearly represents good breeding in the biological sense while acting as a symbolic surrogate for the husband.

In Stubbs' *Colonel Pocklington and his Sisters* (1769, National Gallery, Washington) the man is in the very centre of the picture in front of his horse—near but not on the horse—and he is looking straight at us. His slim figure is central but overwhelmed by the larger shape of the horse. His two sisters, far to the left, close to the trunk of a great sheltering tree, appear to be bending obsequiously (though one is in fact seated on a bench) with their eyes full of admiration for their brother and his horse; the second one especially has her eyes on her brother but is offering his horse a nosegay. The sisters huddle (there is hardly a better word) near the bench and tree, while their brother stands out in an open space spreading into the distance behind him, in which the horse is normative.

If the *Pocklington* conversation shows the horse as part of a delicate series of relationships within a family, the mare-foal friezes use the serpentine lines to define a series of relationships within the families of animals. And in the frieze of dogs the two main dogs are in converse while the others relate, via differing intervals and turns of the head, to one or other of these. If these relationships might be thought germane to the conversation piece, Stubbs explored their potentials for sublimity in the simpler, cruder confrontations of a mare

96

96 George Stubbs, *Col. Pocklington and his Sisters* (1769). Washington, National Gallery.

97 George Stubbs, *Hambletonian* (1799). Private collection.

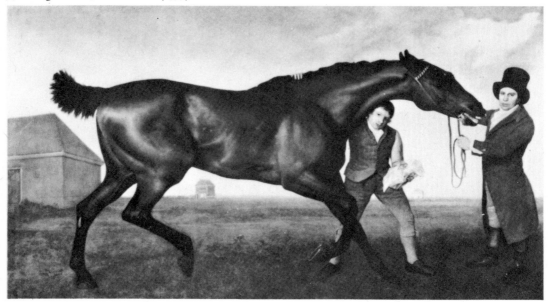

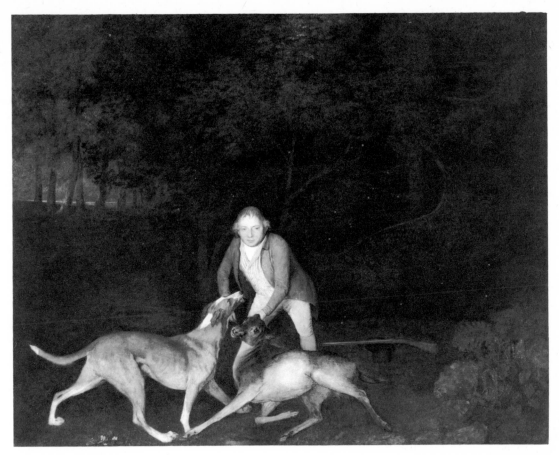

98 George Stubbs, *Freeman, the Earl of Clarendon's Gamekeeper, with a dying Doe and a Hound* (1800). Collection of Mr and Mrs Paul Mellon.

and stallion preparing to mate, two bulls fighting, and in the attack of a lion on a stag or horse. In the lion-horse pictures two hostile animals in a completely man-alienated natural setting draw closer and closer until they join in combat. It is interesting to recall that Stubbs' versions of the subject in fact develop backward from the combat—painted in the 1760s—to the more delicate relationships of approach and sense of proximity. These are much closer to the conversation pieces, which themselves are reducible to a confrontation only more refined than that of lion and horse: of rider-horse, trainer-horse, stable-boy-horse.

The ultimate in these encounters in conversation terms is the great painting of Hambletonian—one of the most remarkable paintings of the eighteenth century (1799, private collection). The power of this composition comes at least partly from the life-size canvas and the unaccustomed size of the horse in relation to the picture space (in the context of all those paintings of large skies around thin horses): the canvas as well as the trainer and stable boy can hardly hold Hambletonian, who is about to burst out of the picture. The tiny rubbing-house between his gigantic legs indicates what has happened to ordinary human scale.

In these terms the progression from conversation piece to history painting, from definition to image-making, from beauty to sublime is a matter of descending to more natural or elemental or savage forms of existence, contact, and surroundings; from a group of family or friends, clothed and domesticated, to a lion facing a horse or a cheetah or a stag, or a leopard or tiger alone, or with its mate, to a family of horses, pregnant mare with foals, or

167

mare and stallion; from human families to animal families, from lovers to stallion and mare, to horse and lion, and finally to Hambletonian and horse vs. man. The last represents a final confrontation Stubbs has hitherto concealed in the disguise of history paintings of Hercules and a bull or Phaeton and out-of-control horses. Until those last years he implies only harmony between contemporary man and his animals; warfare goes on between animal and animal, or hunter and animal. But in his later work Hambletonian is straining against his trainer and both a dying doe and a strangely equivocal hound are straining against Freeman, Clarendon's gamekeeper, in a dark woodland setting (1800, Mellon Collection). And these only bring into the open the ironic relationships suggested by the horses and soldiers painted for the Prince of Wales (1793, Royal Collection), lined up like wrapped packages and toy-soldiers, the latter already chicken-shaped, to be extended later into the curious man-animal relationships of the *Comparative Anatomy*.

Barry shows a lion-horse combat in the background of his *Orpheus* panel in the Society of Arts, and explains:

The want of human culture is an evil which extends (even beyond our own species) to all those animals which were intended for domestication, and which have no other defence but in the wisdom and industry of man.[31]

Barry's is the point of view of the artist, academies, and related forms of civilization. Stubbs' emphasis is on the relationship of ephemeral social forms to natural reality, and far from being the horse's defender, man is barely his witness. In Stubbs' work, as in Hogarth's, we can detect two levels, perhaps two audiences: he pleases by representing a horse or a hunt, by being the craftsman or performer—in effect by being insincere; but he also produces a picture about the authenticity of something vs. the degrees of inauthenticity of other things.

He hardly fits at all into the tradition of animal and horse representation. In general composition, *The Grosvenor Hunt* (1763, Trustees of the Grosvenor Estate) strongly recalls Oudry's *Stag-Hunt at Fontainebleau*,[32] but the difference is far more apparent. Oudry's hunts and animals remain 'consciously decorative', as

Michael Levey has said, 'contained within the environment of civilized park or garden, often with suggestions of balustrade or wall, usually accompanied by glossy dead game or baskets of unblemished fruit'.[33] Charles Parrocel, on the other hand, offered the close, almost scientific observation that Oudry lacked, and Stubbs may have benefited from study of his *École de Cavalerie* (1733), in which man and horse are related psychologically as trainer and subject.

The only group comparable to Stubbs', however, was the sculptor Guillaume I. Coustou's famous *Marly Horses*. Unlike Coysevox's allegorical horses, 'divine, winged animals, effortlessly bounding skywards',[34] symbolizing the idea of military victory, Coustou's horses are natural embodiments of power. As originally placed at Marly, they were almost on a level with the real horses that drank from the other end of the pond (set up in 1745, they could have been seen by Stubbs in the 1750s). How different from Oudry's obedient creatures in the pursuit of a stag, or even Parrocel's scenes of horse training: in the *Marly Horses* the attendants are subsidiary to the horses, who are rearing up out of control, almost drawing the humans with them. They are engaged in a struggle for dominance, with the horse taking the upper hand; in essence, the forces of nature are overcoming human forces. This is approaching the world of Stubbs in which attendants cannot control their horses; in which, though the hunter is still 'subject', horses and dogs move instinctively ahead of their masters into the chase; and in which, in the moment of most intense conflict, man is absent altogether.

Fuseli was right to complain that Stubbs' figures when human were seldom more than the attendants of some animal.[35] Now it is true that much of Stubbs' composition can be explained in technical terms of the painter's profession. It was a rule of portrait painting that a light figure was painted against a dark ground, a dark figure against a light ground; Stubbs follows this rule with horses, and if he does less so with his humans, it is perhaps necessary to recall that animals were his subject. The animal painter naturally moves humans to the side of the animals. As naturally, if you want a descriptive portrait of a horse you have to profile him, and if a series of men and horses and dogs, you have to show them going in

99 George Stubbs, *A Lady Reading in a Wooded Park* (1768–70). Private collection.

some direction in some order. These were often painted in wooded settings in which the trees naturally dominate. But it is also well to remember Fragonard's contemporary scenes with 'a few ant-like figures, utterly dominated by the giant cypresses which shoot up to fill virtually the whole height of the composition', which is a way of making nature the dominant motif in a genre usually dominated by man.[36] Though spatially the effect is different, in absolute relationship nature impinges upon man in the same way in Stubbs' paintings.

Man is not the centre of Stubbs' universe, but only an element in the animal kingdom, a species to which no more attention is given than to the trees and plants. The golden section usually serves to indicate this de-emphasis. A simple, single portrait, *A Lady Reading in a Wooded Park* (1768–70, Bearsted Collection) is divided by the lady's body both horizontally and vertically, with the effect of making the subject the landscape, or a woman reading *in* a landscape. Stubbs is, of course, adapting a portrait convention that goes back at least to Frans Hals of placing the figures to one side so that their property or the natural setting to which they lay physical or spiritual claim can stretch across more than half the canvas. Gainsborough's conversations of the 1750s divided the canvas in this way, and Stubbs' *Lady Reading* (or *Sir John Nelthorpe with two Pointers*) directly reflects these; but his own effect is less to show off property than to move the human to the periphery of the natural setting.

The bench the lady is sitting on has a flowering vine growing around it, in a sense reclaim-

99

169

ing it. There is no merger or metamorphosis; the flowers overrun the bench but remain distinct from it, as the lady reading a book does from the wooded setting. And yet she is deep within the natural setting, being surrounded by it as the tree behind her bends down and around, almost cradling her in an enclosing gesture like that in the *Pocklington* conversation. There is also, however, access to an outside, a larger world still apparent through breaks in the forest, one a clearing, the other a glimpse of sky.

The essential relationship here is of the great leafy, fuzzy shapes and the soft lines of the lady and the sharp ones of the bench, or of an area of instinct underlying, indeed dominating surface pattern, social and human behaviour. The enclosing foliage is one way in which an enveloping environment subordinates man, even when he is the central figure (other examples are the young John Nelthorpe and Stubbs himself on horseback). There is also an opening in the enveloping forest that leads through the spatial focus to the periphery of the field to another, yet more encompassing world. But in most of the paintings—most obviously in the horse portraits, but also in many conversations (the pictures to which Fuseli was referring)—man is a peripheral observer presenting a large central animal or action, or he is isolated and subordinated to a catalogue of human and natural objects as only one sign on a spectrum. Notice that Stubbs' avoidance of breaking the limits of the picture space (except for the vague shape of continuing foliage) produces the sense of a total world within which he places people and things to imply their relation to each other, but also, invariably, to a larger world in which they are only specimens.

In this world the horse is the transitional element that relates man to the natural field. But the horse appears in the conversation pieces as part of a catalogue of possessions; and the double knowledge of his mediation and subordination to the human, of natural spectrum and human catalogue, produces an irony that underlies many of Stubbs' paintings.

The *Lady and Gentleman in a Phaeton* (1787, National Gallery, London) shows disposed across the canvas in catalogue form horses, carriage, and wife, with as much emphasis on the structure of the carriage as on the gentleman himself. The colours of his coat and trousers, shades of fawn, are off-shades of the trees behind him, and his black hat placed at the point of deepest shadow further tends to subordinate him. Conspicuous by contrast are the large dark horses against the light foreground and sky, and the light ovals of the wheels, and even of the white scarf and hat of his wife. The emphasis falls on the structure of the carriage and the horses: the extremes of the sharp (yet soft), intricate pattern of the carriage and the natural shapes of the foliage, with the horses between. A forest is behind the people, enveloping and embedding them in an instinctual realm independent of social and moral patterns of the sort epitomized by the carriage and harnessed horses.

The horse itself relates to nature but never merges with it, almost always silhouetted against a light sky or, as in *Park Phaeton with a Pair of Cream Ponies in Charge of a Stable Lad* (1780–85, Mellon Collection), light against dark, cream colour against dark foliage. The master himself is now absent; the carriage is unoccupied, the sky misty, and the woods shadowy. The boy's interest is directed back toward the horses, his straight back making a line of demarcation halfway between the instinctual darkness which envelops the horses and the illuminated but featureless path behind him. Now a dog is present, another link in the chain of trees-horses-boy; he crouches at the boy's feet, poised just at the demarcation of the closed, cave-like ground in which the horses appear and the open landscape with a path leading off into the distance. The crucial curve is the concave of the dog's back, echoed in the parallel curves of the phaeton's seat and chassis. These, and the regular circles of the wheels and straight lines of the spokes, the straps and reins of the rigging—the characteristic hard-edge lines—are contrasted with the soft convex of the horses' necks and rumps, contained and

opposite
100 George Stubbs, *Lady and Gentleman in a Phaeton* (1787). London, National Gallery.
101 George Stubbs, *Park Phaeton with a Pair of Cream Ponies in Charge of a Stable Lad* (1780–85). Collection of Mr and Mrs Paul Mellon.

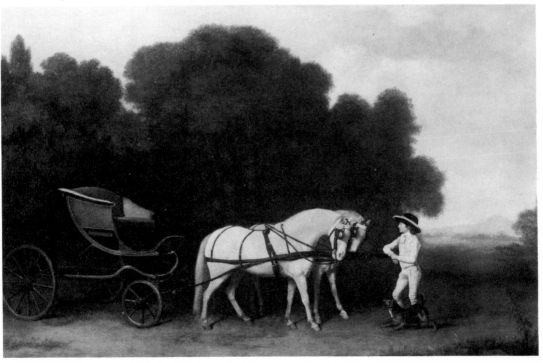

171

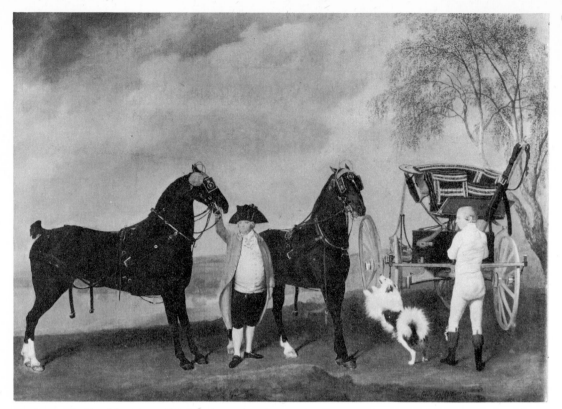

102 George Stubbs, *The Prince of Wales' Phaeton* (1793). Royal Collection.

paralleled by the gentle, fuzzy convex curve of the treeline beyond. The dog designates itself part of the human as the horses are part of the natural world.

102 *The Prince of Wales' Phaeton* (1793, Royal Collection) is even more obviously laid out as an indication of the power of the master who owns these servants, carriages, and horses. The golden section balances the two horses with the elegant carriage (the ornate trappings of the horses related to the webbing of the carriage); and it makes the central action the middle horse's rejection of the advances of the playful dog leaping from its place beside the servant. Our attention focused on this little drama, we note the hanging harness that detaches the horse from carriage and servant. Every detail maintains the separation of horses, servants, carriage, and presumed owner—the off-stage element, missing but assumed. The carriage, unhitched, is being physically supported by the stable boy; its shaft points up to the right, out of the frame of the scene, while the boy's head directs our attention back to the unhitched

horse, or, in conjunction with the older servant's glance off to the left, balances the direction of the carriage shaft—again leading our eye off the canvas to the *other*, the omitted. An empty sky, dominating the landscape, with no sign of road or path, of buildings or fence, emphasizes the isolation of these objects, as mere possessions, from owner or function.

In the ordinary Zoffany conversation man's use of possessions defines the man, indicates his ascendancy over nature, and serves as a sign of the power of will over instinct, of man over milieu. In Stubbs' conversations the opposite often takes place: the owner is de-emphasized or absent, his possessions take over the scene, and their functional associations are removed as each is detached from the other. The continuum of a catalogue of possessions is replaced by one of the horse and the natural landscape, in this case the horse's proud curves echoed in the leafy curve of the tree's silhouette.

More complex is *William, Third Duke of Portland, and Lord Edward Bentinck, with a Groom and Horses* (1766–67, Duke of Portland)

in which a wooden fence in the middle of the picture is the elaborate defining structure that relates the owner, trainer, and the saddled horse, with an unsaddled horse nearby in the process of being trained. Even the details of the empty saddle on the ground and the dog with its head turned toward its master contribute to elaborate the relationships.

The final, most subtle working out of the problem of man coming to terms with nature is in the reaper and haymaker pictures Stubbs painted in the 1780s. Another intermediate term, like the wooden fence in the *Portland* group, has been introduced in the crop that man has planted, ordered, and reaped, set against the rough outlines of the trees beyond and a church and spire beyond this (1784, private collection). The reapers, the foreman on a horse, and a dog in the foreground contribute to the general terms; the golden section is marked by the overseer and his horse. A series of varying intervals and angles made by the reapers and their sheaves, a band of complex interstices parallel to the horizontal lines of the wheat, is broken and set off by the figure of the horse and rider. In the *Haymaker* pictures Stubbs adds the construction of a right-angled triangle made by the lines of the rakes, and these lines support the major vertical of the end of the hay-stack, which divides the golden section. But invariably the golden section—the whole system of complex order—is overlapped and cancelled by the different pattern of the trees in the background, which in effect surrounds and contains all of this, and is itself floated in the larger encompassing sky.

But what of those wide and empty spaces beyond, in which all of these elements either float or at any rate are placed? At the very beginning of his career, even before he undertook *The Anatomy of the Horse*, Stubbs made a series of etchings of a human foetus enclosed in the cross-section of a womb, in various positions, trying to get out. These were made for John Burton's *Essay toward a complete New System of Midwifery* (1751), and in them Stubbs shows nothing but the foetus and the womb, giving a complete sense of isolation with no detail of any environment except the sac (further areas only occasionally indicated by a broken line). In Table 10 a hand appears from nowhere, grasping the infant by his feet inside the womb, and this is the only indication of the

outside world—except for the instruments for extraction that appear isolated in Table 16.[37]

Stubbs shows a human foetus, a pre-rational being, enclosed within an immediate sustaining environment. This subject allows him to initiate a sense of the figure's subordination to a ground combined with an invitation to extend the closed environment in time and space by reference to the exit from the womb into a larger world, which will similarly contain the adult. As in those catalogues of horses and carriages, what is not shown is as palpably present as what is. The choice of subject, however adventitious, shows Stubbs' obsessive use of both opening and closing frames to suggest a displacement from the rational human will to the instinctive realm—and a sense that the painting shows only *part* of a scene, with

103 George Stubbs, Burton's *Essay toward a complete New System of Midwifery*, Table 10. Etching (1751).

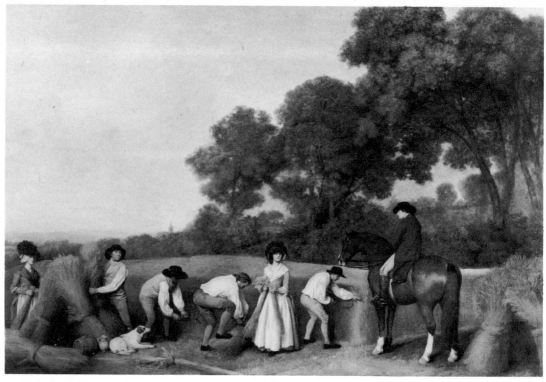

104 George Stubbs, *The Reapers* (1784). Private collection.

105 George Stubbs, *The Haymakers* (1785). Private collection.

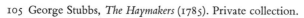

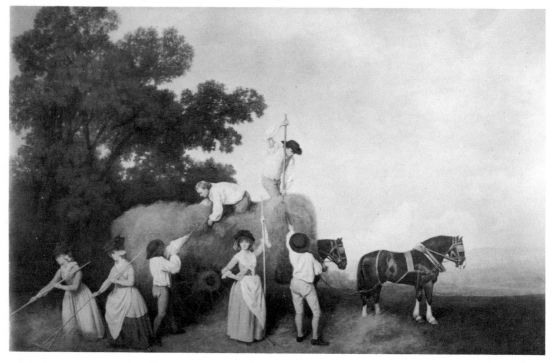

something crucial beyond; that a painting is an open frame leading through the spatial focus from the periphery of the field to an action whose completion takes place out of the frame of the field altogether.

If we put the midwifery plates against the conversation pieces we see the pattern that evolves: man can either participate in the natural spectrum or he can, like those absentee landlords, try to control and order it by his will into a catalogue of possessions. It is significant that when Stubbs painted an occasional history he chose a story of man demonstrating his inability to control nature by his will: Phaeton appears at the moment when he loses control of the chariot of the sun and the old woman when she superstitiously blames her horse's fall, due to natural decrepitude, on a raven.[38] He has not only chosen myths which have horse and rider in them, but the moment in which man attempts and fails to control nature. One thing the enveloping area does is to suggest that the relationships are not only that of a horizontal spectrum but of part to whole.

The extreme statement of these tendencies appears in the hunting pictures. The horses or dogs are mediators between man and a much more intense situation; they anticipate the confrontation with stag or fox, in which they will come to immediate terms with the prey, only observed obliquely by the hunters. Two large horses, a smaller man, and three small dogs move in procession to the left.[39] The three small dogs are directing the rest off to the left beyond the picture space, an area of which we get some idea by the large field that opens up in the distance. Or two hunters on horseback are on the right side of the scene, facing right, the left-most horse's tail marking the division of the golden section.[40] To the left is only space, with a house in the background, and a small dog-whipper; to the right the two horses and the dogs are all moving out of the picture—the horses still under the control of the horsemen, and the two dogs looking up to the first horseman for instructions, one with his nose to the ground, and the right-most dog already leaping out toward the prey which is somewhere beyond the edge of the canvas.

Though not so simply schematic as these, *Huntsmen setting out from Southill, Bedfordshire* (1763, Marquess of Bute) shows the primary movement of the action following the lines

106

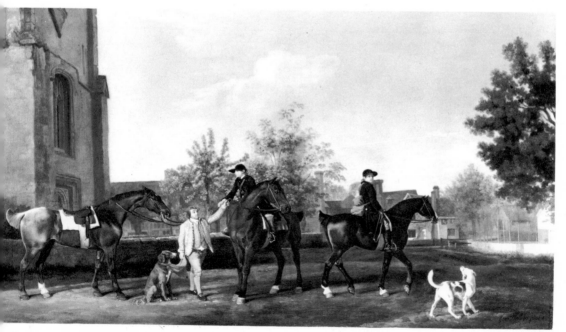

106 George Stubbs, *Huntsmen setting out from Southill, Bedfordshire* (1763–68). The Marquess of Bute.

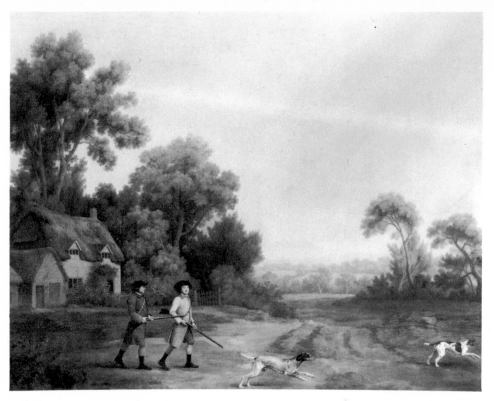

107 George Stubbs, *Two Gentlemen out shooting with their Dogs*, I (1767–68). Collection of Mr and Mrs Paul Mellon

and motions of the animals. As the men look back and loiter, the animals move effortlessly out toward the country and the hunt. On the left the church is a solid block, and out of sight somewhere to the right lies the hunt. We start at the left with the riderless horse, pointed right, then move to the seated but restrained retriever (nose pointed right), through the handkerchief that restrains it and the arms of the standing man to the expressive turn of the central horse's head. As the hunters look back, the saddled horse follows the direction of the pivoting horse, which turns its head to follow the lead horse, moving out unguided by its rider, looking back over his shoulder. The restrained retriever and the impatient hound waiting for the hunt to begin counterpoint this chain set in motion by the lead horse.[41]

Much of the power of these scenes derives from their treatment of the instinctive animal motions which will serve as the focus of the hunt itself. The horses and dogs remain mediators between man and nature, but the circular movement of the men looking back and the animals straining forward gives some indica-tion of a structure that develops out of the relationship of immediate to transcendent environment as part to whole.

Stubbs painted four hunting pictures of the same dimensions between 1767 and 1770 (Mellon Collection). If we accept the sequence of the engravings by William Woollett (presumably Stubbs' intention) we can see a characteristic progression.[42] To consult the engraved verses is to see what Stubbs has avoided in the paintings. In the verses the men dominate the scene, and 'The well taught Dogs wait but their Voice to run'. Plate II emphasizes the landscape, asking us to 'See Pan and Flora range the late shorn Plain'. The visual experience is quite different.

In the first scene the cottage (like the church) is at left and the two hunters are still close to it, almost overlapping it, and one is looking aside, away from the hunt and towards the viewer; the great empty space in the centre, an opening into a distant and peaceful prospect, shows the two dogs moving impatiently away from the cottage toward the right and the offstage hunt. Our attention moves from the spatial centre of

108 *Two Gentlemen out shooting with their Dogs*, II.

109 *Two Gentlemen out shooting with their Dogs*, III.

110 *Two Gentlemen out shooting with their Dogs*, IV.

108 the scene, via the dogs, out of the frame to the space and time of the anticipated shooting. The energy of the scene is the product of this anticipation, and the dogs are the means for its development. In the second scene the actual shooting takes place. The fluttering bird and the waiting dogs are at the extreme right, and the dogs are about to move from the periphery to the more vital confrontation.

109 In the third scene the hunters reload, both they and the dogs at the periphery of the scene. This is a gameless stretch with a mountain, a lake, and a mill with its wheel turning. In the centre is this turning wheel, which relates the human and natural through the transformation of water, the recommencing of the hunt and

110 the reloading of guns. In the fourth picture the hunters, with game and dogs, rest in the enclosure of a wood, far to the right in its darkest zone. To follow the direction suggested by the lines and expression of the dogs' faces is to move in to the illuminated trees and water in the background: no longer out of the scene toward less restrictive space and time but into the centre of a scene of pure nature in which man is a peripheral part rather than a controlling centre. And the water in the background turns back within the wood, merging as do the figures of the hunters, with a larger frame. The turning of the waterwheel in III, in the context of this last picture, is a symbol of the cyclic arrangement of all four pictures. The implication is that man the hunter is himself subject to the same environment and cycles of nature as the game he hunts.

The confrontation itself takes place in *The Grosvenor Hunt* (1763, Goodwood House). The flow of the water, of the thirty hounds, and of the horses is toward the tense but motionless figures which have arrived at the focal point of the hunt. But the dynamic rush receives a check from the halted figures. As the hounds converge on the stag, so the horses converge on the figure of Lord Grosvenor, a juxtaposition emphasized by the pointing of the first approaching huntsman's crop. Dividing the

horizon, as well as the flowing river, a monumental oak thrusts one massive green branch back toward the converging animals and huntsmen. As Taylor has noted, it 'embraces the figures like a half-open hand'.[43] But also, making a large C which is repeated in the curves of the hunting horns, the flank of Lord Grosvenor's horse, and groupings of the dogs, this tree, like the millwheel in the four hunting pictures, indicates a cyclic motion, involving the observing huntsmen and the director of the hunt, Grosvenor, in the same cycle. The tension one feels in this picture comes from the convergence of the frantic motion of hounds, horses, and men on the static central figures of men, horses, and stag, all containing their energy for a final confrontation. The huntsmen observe the turning point in the life of the stag, and, in doing so, activate the parallel to the pattern in their own lives.

The tensions implicit in the hunting scenes are quite openly expressed, indeed symbolic, in the lion-horse pictures. The most intense efforts to sustain life meet the overpowering force of the lion, without the presence of a man at all. In one way or another Stubbs has displaced the human figure—from the horse portraits and racing pictures where he was naturally peripheral, but also from the hunting scenes, in which he appears little more than an observer; and in the lion-horse pictures he shows a purely natural confrontation which implies (but does not portray) a yet more distant observer who can appreciate the scene because he is safe from its immediate danger. 'The passions which belong to self-preservation, turn on pain and danger,' writes Burke; 'they are simply painful when their causes immediately effect us; they are delightful when we have an idea of pain and danger, without being actually in such circumstances. . . What ever excites this delight,

94, 95,
112

111 George Stubbs, *The Grosvenor Hunt* (1763). Trustees of the Grosvenor Estate.

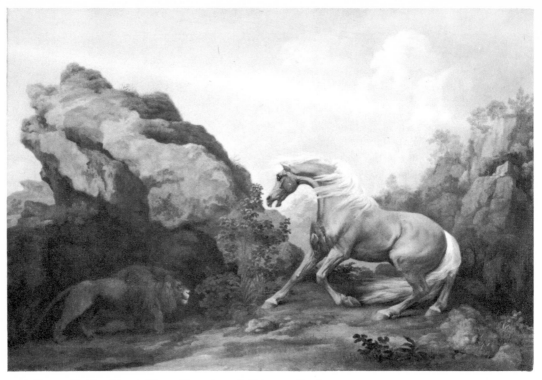

112 George Stubbs, *Lion stalking a Horse* (1770s). Private collection

I call *sublime*.'44 The sublime here means that the observer will anticipate his own role as a part of the cycle of death.

Chronologically, Stubbs starts with the confrontation and then (though he may produce redactions of this scene) develops the peripheral part, moving the combat itself to one side (Yale Art Gallery), or separates the lion and the horse, while keeping them both to one side of the picture, implying some larger combat or issue in the open area in the middle (Liverpool, Walker Art Gallery; another, Tate Gallery). In the racing scenes he seldom actually shows a horse racing (*Gimcrack* is an exception, where he shows the horse both in *and* after the race), but rather implies the race as having taken place. In the great *Cheetah with two Indian Attendants and a Stag* (1764–65, Manchester, City Art Gallery) the two human observers are arranging the combat, preparing to release the cheetah to attack the stag. The final relationship for Stubbs is this one: the smothered figures of the Indians with their cheetah, the ridiculous top-hatted figure trying to come to terms with a gigantic Hambletonian.

In Stubbs' last works ironic detachment breaks down into admission of the incommensurability of man and animal on the one hand and satire on the other. There seems to be a relationship of more than occasion between the painting of the Prince of Wales' trappings and the pendant of his troops, in which the soldiers are lined up like possessions on review. These pictures are so odd that they forced W. S. Sparrow to conclude that the first must have been painted 'in a very official mood' and the second must contain 'a touch of ironic humour in the official severity of the artist's mood'.

Are the soldiers too short, or is the charger uncommonly high, for the horses' crest is on a level with the tops of the troopers' black shakoes? There is certainly a mistake of proportion here, the troopers being tall men, as we can ascertain by comparing the size of their faces with the length of their bodies to the chin.45

As in other late paintings, Stubbs is subtly changing the shape of his humans, rounding their torsos, tapering their arms and legs, until the parallel drawings of man and chicken in the *Comparative Anatomy* do not come as a surprise.

113 George Stubbs, *Soldiers of the 10th Light Dragoons* (1793). Royal Collection.

The *Comparative Anatomy*, which ended a career begun with the *Midwifery* text and *The Anatomy of the Horse*, was made he said 'to show the analogy there is in the structure of the human Frame with that of various animal Quadrupeds, (Bipeds) Fowls and vegetables'.[46] Man is shown even in Plate I with the pelvic structure strangely enlarged and the upper chest under-emphasized; and in II, the back view, there is the distinct sense of the skeleton leaning forward. Once in Tables VI and VII, after the appearance of the cat and fowl (he did not get to the vegetables before he died), when the man is filled in he has sloping shoulders, tapering hands and feet and head, pointed fingers, and bulges out into a heavy, almost Michelangelesque torso and wide womanish hips. (The most grotesque of all the parallels, a straight-on view of man and a chicken, carried to the verge of Rowlandson's *Comparative Anatomy* of the same period, was not etched.)[47]

The effect is essentially to parallel man and chicken and contrast these almost comically ungainly shapes with the grace of the cat: the domestic man, the barnyard domestic the chicken, vs. the animal in nature, moving with incredible grace—but removed from all milieu, simply a complex of anatomical machinery that can be related to another such complex.

In this final reduction Stubbs finishes what he began when he rejected the subordination—academic or aesthetic—of instinctive energy to a social or moral frame, or to ornament or even personal mythologizing. Stubbs returns man to those scenes or relationships in which he is not primary or central but faces the most primitive forces, the most basic cyclic patterns in nature: the hunt, the horse unrestricted by human will, and the race. (The man, chicken, and cat are, in fact, shown racing.) His work, balancing a rationalist organization of detail with an enveloping emphasis on natural forms and instinctual responses, achieves finally the intensity of primary myth.

114 George Stubbs, *Comparative Anatomy:*
Man from Back. Etching (1795–1805).

115 George Stubbs, *Comparative Anatomy:*
Man Running. Etching.

116 George Stubbs, *Comparative Anatomy:*
Fowl Running. Etching.

117 George Stubbs, *Comparative Anatomy:*
Cat Walking. Etching.

TAB. X.

11 Wright of Derby: Nature Demythologized

JOSEPH WRIGHT has customarily been regarded as the great empiricist of English art, and one of the accomplishments of Benedict Nicolson's definitive study and catalogue is to place him in the historical context of the Industrial Revolution, the industrialists Arkwright, Strutt, and Wedgwood, and the scientific and social life of the Midlands.[1] But why, a reviewer asked, do Wright's industrial and scientific paintings 'still evoke in the spectator a genuine emotional response which neither the paintings of Benjamin West . . . nor Greuze's *drames larmoyants* can any longer convey'?[2]

One clue comes from the scholars themselves. When the French painter Louis Durameau painted a view of a saltpetre factory (exhibited in 1767) he made it, in the words of Robert Rosenblum, 'a rococo spectacle of sulfurous clouds and lilliputian figures'.[3] Nicolson reveals a sensitivity to the same sort of effect in Wright's pictures when he remarks of *The Alchemist* (Derby) that the protagonist's 'face is transfigured by light as though he were one of Christ's disciples witnessing the Breaking of the Bread'.[4] Of course nothing like this takes place in the picture, but *something* out of the ordinary is happening, as Nicolson senses, and it is not enough to emphasize (with Rosenblum) Wright's 'photographic truth, a flash-bulb record of the incontrovertible facts of modern life',[5] though the 'flash-bulb' also tells us something of the intensity of his effect.

One of the deterrents to analysis has been Wright's own comments about his work. In his account book among ideas for 'Subjects for Night Pieces', he gives his (probably original) idea for 'A Blacksmith's Shop', which ends with the addition of the people who appear in the adjoining room. They are there, he says, to give 'an indication of an incident having happened, and show some reason for shoeing the horse by candlelight'—a perfectly empirical explanation. He adds, 'The moon may appear, and illumine some part of the horses, if necessary.'[6] The written words of the artist (albeit written in an account book) tell us something of his intention: he was primarily interested in the effects of light on flesh, stone, and horse hide; and perhaps to elaborate the effect he introduced two different, contrasted sources of light. But the fact that these were specifically artificial and natural sources is also part of the picture's meaning. Again Nicolson, having quoted the passage proving Wright's clearheadedness, goes on to see the man Wright merely describes as an 'idle fellow' standing 'by the anvil in a time-killing posture' as having 'the dignified gaze of the philosopher'.[7]

Since the appearance of Nicolson's volumes it has become apparent that the much vaunted empiricism is curiously mitigated not only by an anecdotal content but by a reliance on topoi. Frederick Cummings has shown how the portrait of Brooke Boothby (Tate Gallery) is structured by the iconography of melancholy; from the wide floppy hat, the dark attire, and the prone position on down to the unbuttoned sleeves and vest, each detail can be documented as a commonplace of melancholy.[8] In another essay Cummings shows how *The Alchemist* and *Democritus in Meditation* (Derby) are constructed of topoi,[9] and it can be shown how the topoi of star knowledge vs. self-knowledge and the Ages of Man are used in some of the candlelight pictures.[10] Cummings, however, proceeds to argue that the important point is the reconciliation of Wright's conventional iconography with his empiricism. What distinguishes Wright's scientific or non-scientific subject is his need 'to research it thoroughly by reference to published accounts, personal experience, and by discussions with his contemporaries'.[11] It is true, the alchemist's laboratory apparatus is correct for producing phosphorus; but this formulation, though it does suggest that Wright uses iconography creatively, misses the point of both his empiricism and his iconography, connecting him with a far less interesting phenomenon, the increasing accuracy of historical detail in the work of contemporary history painters like Gavin Hamilton and Benjamin West.

The alchemist, Cummings shows, is lifting his eyes from his experiment, which inciden-

118 Joseph Wright of Derby, *The Alchemist*
(1771). Derby Museum and Art
Gallery.

tally has just produced phosphorus, to heaven
in prayer for the next stage, which he thinks
will be the philosopher's stone. Searching for
a way to transmute base metals into gold, he
has by accident discovered phosphorus; but
phosphorus happens to resemble the silvery
substance that was thought to be the penulti-
mate stage before the reddish, dry substance of
the philosopher's stone itself. The moon—
throughout these paintings the natural or real
source of light—echoes the colour of the phos-
phorus, telling us in effect that *this* is the real
thing, the real discovery of a fact of nature. But
the infatuated alchemist, missing what is under
his nose, looks into the problematical distance
instead. Cummings sees this as a statement to
the effect that modern science is based on the
lucky errors of ancient science; but is it not
rather a picture about a figure parallel to the
scientist of *An Experiment on a Bird in the Air
Pump* who is thinking about the proof of a
vacuum while the bird flaps helplessly within
his bell jar—or about scientific theory vs. nature
(as empirical fact), or about the different ends
of science? Real empiricism for Wright is

related to Stubbs' attempt to get at essentials—
the one working with body structure, the other
with the quality of light. In *The Alchemist* for
once the artificial source of light and the natural
coincide, and a real discovery has been made, of
the sort that Wright was himself seeking in his
paintings as he portrayed the ironies in the rela-
tionships between scientific models and nature
itself. But *The Alchemist*—and even more its
pendant *Democritus*—are cluttered and overly-
literary pictures compared to Wright's most
original works in contemporary settings.

I am speaking, of course, of the 'candlelight
pictures', which Wright began to paint in the
early 1760s. In *An Experiment on a Bird in the
Air Pump* (1767–68, Tate Gallery) a structure is
established which informs in greater or lesser
degree the other pictures of this sort (of which
The Alchemist is a conventionalized rendering).
The composition is a series of concentric
circles, at the centre of which is a bird, the
subject of the experiment; it is in a scientific
machine, a bell jar being drained of air by a
pump, which is being operated and demon-
strated by a scientist, and all three of these

119

elements are being observed by a group, perhaps including another scientist but certainly made up largely of laymen. Wright disposes across his canvas a pair of lovers, whose eyes are turned away from the experiment to each other; a student whose eyes are on the experiment; one little girl looking at the fluttering bird with sympathetic eyes, and another covering her eyes in fear for its life; a fatherly man who explains to them that the bird will not die; an old man, his eyes turned inward, submerged in his own thoughts; and a boy near the window, who looks straight at the final viewer, ourselves. The scientist, wild-eyed and wild-haired, looks straight at us as well. The spectrum of types from young lovers to children to an old man is presumably emblematic—a cross-section of ages and sexes, arranged in a formal order according to the Ages of Man: children, lovers, a parent, and an old man. Against the dishevelled scientist, and his man-made mechanism, their responses constitute a comment on what science means to human lives.

There is no need to go into the nature of the experiment itself, though it may be significant that Wright chooses the pumping of air out of a jar, illustrated not by a candle but by a living animal—a most Laputan experiment, carried out by a scientist with a Laputan stare. The living animal allows for the pointed contrast of science and nature, not only in the apparatus and the bird but in the source of light that illuminates the scene. The candlelight, emanating from his man-made experiment, is balanced at the far right by the natural source of light, the moon, glimpsed through a window and in process of being hidden by clouds.

This is no unambiguous celebration of science; at best it is a placing of it in a human and natural context. The execution of the painting itself—'photographic' or 'a flash-bulb record' is a way of saying that its verisimilitude is almost scientifically rendered—may be part of the commentary on the science-nature contrast. Discovery here is not of a new scientific truth so much as of something elemental and terrifying at the heart of nature, brought out by contact with a man-made scientific mechanism.

The sense of this major picture is clarified by earlier, more primitive versions of the subject. *A Girl reading a Letter by Candlelight* (1762–63,

H. Col. R. S. Nelthorpe) is a simple genre painting that shows a girl's face and the letter she is reading (as transparent as the bell jar) illuminated by a candle. Next to the candle on the table lies a manual on correct letter-writing, and the girl's features, transfigured as they are, show a discovery that cannot be explained adequately by such manuals. Already there is a witness present, a worried young man (a rival to the letter-writer?) who looks over her shoulder.

Between this painting and the *Air Pump* come two other experiments in the subject, *Three Persons viewing 'The Gladiator' by Candlelight* (c. 1764–65, private collection) and *A Philosopher giving a Lecture on the Orrery* (c. 1764–66, Derby). Their dating is not important since they explore two different possibilities (the *Air Pump* represents a third). In the first the candle is set to illuminate the object of meditation, the *Borghese Gladiator*, a work of art, and the faces of the observers; and in the second, the most ingenious of the series, the object at the centre is the light itself, the lamp which simulates the sun at the centre of a model of the solar system, the orrery. (The picture's secondary title is 'A Philosopher giving that lecture on the Orrery in which a lamp is put in place of the sun.') The group around it may be portraits, but the presence of a young lady and children serves to set off the contraption and the philosopher's books with a contrary indication of life as it is lived. To the children the orrery is merely a plaything, and the young lady is thinking of something else. The philosopher's eyes are on something else, unfocused, while he points at the orrery. The astrologer with his eyes on the stars, employed by Johnson in *Rasselas*, was the very topos of a foolish turning away from human concerns.

Before proceeding further, we should try to place Wright's candlelight pictures in art historical perspective. We cannot look at them and forget that the dominant form in which English painting expressed itself during almost the whole of the period was the portrait and the portrait group. Portraiture, at least by the time of Wright, was all mixed up with the problem of expression and expressive response, and there are many portraits of two or more gentlemen or ladies looking at some object, usually aesthetic. At length there is Zoffany's

119 Joseph Wright of Derby, *An Experiment on a Bird in the Air Pump* (1767–68). Tate Gallery.

120 Joseph Wright of Derby, *A Philosopher giving a Lecture on the Orrery* (c. 1764–66). Derby Museum and Art Gallery.

77 *Tribuna* of the 1770s, in which little circles of connoisseurs, artists, and hangers-on examining works of art are scattered about the canvas. Zoffany's picture is about art and artists and connoisseurs, only one aspect of which is the way they look at sacred pictures or profane, classical or modern, Venuses or Madonnas: more importantly, it is about how they appear alongside them.

Wright's candlelight pictures derive, in one sense, from the conversation piece with its ontological concerns and its use of an art *or* a natural object—but determinedly one or the other—as focus of human attention or part of a spectrum in which the human also participates. We can observe Wright moving in this direction from a pure conversation, the Shuttleworth group, to *Three Persons viewing 'The Gladiator' by Candlelight*, with the statue of the *Gladiator* appearing to be a unifying force, drawing the three men together. In *James Shuttleworth, His Wife, and Daughter* (Lord Shuttleworth) young Miss Shuttleworth holds up the bird which her father has shot and the dog retrieved, while her mother looks on. It is of course basically a portrait group, but it is virtually a study in responses to the dead bird, and as well an ontological spectrum reaching from the bird and dog to the hunter-father and the domestic mother, with the little girl the crucial bridge (the equivalent of the stable-boy in a Stubbs conversation). Recall

121 Joseph Wright of Derby, *Three Persons viewing 'The Gladiator' by Candlelight* (c. 1764–65). Private collection.

how in conversation pictures, and certainly in many of Wright's, a child's response or presence is contrasted with the adults'. In the *Air Pump* too the responses run from the child's incomprehension to the scientist's frenzy, and the states of existence from the scientific to the human and the natural. And as there is a child, so too there is often a spectator outside the canvas: we are implicated by the look, straight at us, of one of the participants, as by the photographic realism of the paint surface. And this participation makes the canvas, the representation itself, the last element in the spectrum of the real. The playing with senses of the real and illusory was a part of the art-nature theme that runs through a kind of group portraiture: we think of Velasquez' *Las Meninas*, Watteau's *L'Enseigne de Gersaint*, and Hogarth's *Beggar's Opera*, in which portraits are treated as illusions shared by the person who has just entered the room, the shopper before Gersaint's gallery, and the audience of Gay's ballad opera.

The hinge that connects response to being in Wright's portrait groups is diagrammatically clear in *Three Persons watching 'The Gladiator' by Candlelight*: the sketch of the *Gladiator* drawn by one of the observers is both another kind of response and another kind of reality which lies between the statue and the observation of it; which in effect makes the canvas itself yet another representation of a representation. But there is a further ambiguity: for everything about the statue, from its diagonal lunge to the muscular tension of its limbs, contributes to the sense of motion; while the three viewers, who are real and alive—the 'portraits'—are motionless. The *Gladiator* is in the direct light of the candle, which has the effect of reinforcing the sense of its motion; two of the men are almost totally in shadow and the third, who holds up his drawing, the copy of a copy, is less intensely illuminated than the statue. What unites artifact and viewers is the arched body of the *Gladiator*, continued in the curves of the men's backs and shoulders, and even the under-curve of the leftmost man's arm on the table: they are drawn into a close formal unity which further emphasizes the question of which is the most real, the men, the drawing of the statue, or the statue.

We have been looking at Wright's work from the vantage of eighteenth-century em-

piricism; if we look back from the Romantic
Age we may decide that his subject is less the
relation of art and reality than the nature of
reality itself. In the statue pictures, where the
question is most pertinent, it is the work of art,
inert or dead, which is filled with motion. It is
the object defined by light at the centre that
holds the composition together, and the light
tends to blur the distinction between flesh and
stone: the person or persons nearest the object
are related to it both by their fainter lighting
and by arch-like structures that contain them.

In *An Academy by Lamplight* (*c.* 1768–69,
Mellon Collection) the central object is the
statue of a girl, the *Nymph with a Shell*. One
student has put down his drawing and is
merely gazing with rapt attention into her
eyes, forgetting the distinction between flesh
and stone. Another has finished his drawing
and is turning away. Others are still engaged in
making their copies. One little boy at the right
looks straight ahead, uninterested in such
matters, but catching the eye of the viewer
outside the painting. Our first response as
viewers may be: Is she a model or a statue? Is
she looking at the boy or he at her? In this
picture even the statue is part of a circle of
response, which includes everything except the
one missing element: the real girl called to
mind by the statue. By the same token, the
dead bird in the *Shuttleworth* conversation
implies a live bird, and the struggling bird in
the air pump implies a free one, and the statue
of the *Gladiator* and the drawing the observer
holds up for comparison imply a real figure.

Much more than in the *Gladiator* the light
gives the statue and the boy closest to her the
same yellowish colour and texture, in the case
of the statue recalling the ambiguity of some of
the human-statue figures in Watteau's *fêtes
galantes*. A mutual look between these two
figures is suggested, if not reinforced, by the
way their bodies arch toward each other, and
the repetition of this shape in the arch over-
head that frames and connects them. None of
the other viewers is looking up at the nymph;
all are occupied by other less real imitations of
her—on paper or in the mind (one recalls the
putti in Hogarth's *Boys Peeping at Nature*). The
student who has closed his portfolio and is
looking off into space at the left, his back
turned to the nymph, is presumably one of
those who has her image in his mind. The

122 Joseph Wright of Derby, *An Academy by Lamplight*
(*c.* 1768–69). Collection of Mr and Mrs Paul
Mellon.

nymph's head is parallel with his and raises
the question of whether she is looking not at
the admirer but out of the painting into space,
enforcing perhaps the idea that the reality of
her beauty is in the mind rather than the
'flesh'. We begin to suspect that the object,
neither human nor natural, is *super*natural,
and that Wright's work is, like Keats' *Endymion*
and *Ode to Psyche*, about humans who are
enamoured of ideal being: a statue, an airless
jar, a man-made solar system. But once again,
to place the situation in human perspective,
Wright gives us the one small boy who looks
straight ahead out of the picture, breaking the
circuit of art and life and connecting the
pictorial image with the world of the people
who are looking at Wright's painting.[12]

There are other playful conversation piece
versions of the subject at the end of the 1760s.
In *Two Girls decorating a Kitchen by Candlelight*
(*c.* 1768–69, Mrs C. Margaret Riley) Wright
again shows something natural being ordered,
in this case humanized and made understand-

able to ordinary people. In the *Boys with the Bladder* pictures the candle functions to bring out the balloon's transparency, to draw attention to the sense in which it is a scientific phenomenon. There is still a mystery at the centre: one boy blows up the rubber balloon, and the other watches admiringly (Huntington). But this picture and the pictures of boys and girls blowing bubbles also carry the old *Vanitas* topos, which the candlelight brings into high relief in the young faces around the bubble, not admonished but entranced by it.

Wright's original contribution is to combine the English conversation piece with the Caravaggist and candlelight tradition. The Caravaggist painters first used one narrow point as the source of light to transfigure a religious subject or, at least, to render it dramatic. At one end of their range they merely heightened the contrast between the light and the dark in traditional scenes in which a holy figure is the source of light: one might compare Correggio's *Nativity* (Dresden) and Volmarijn's Caravaggesque *Supper at Emmaus* (Ferens Art Gallery, Hull), in both of which the source of light is the miraculous object. The painter of 'candlelight' pictures per se, however, simply illuminated some object and the face of the meditator by the naturalistic means of an unshaded candle. Honthorst's *Christ before the High Priest* (National Gallery, London) is such a picture, the candle being the single source of light, associated with nothing but itself. It illuminates the important elements, the faces of Christ and the high priest, and no more. Georges de la Tour, the best-known of these painters to the twentieth century, went so far as to include a candle in his *Nativity* (Rennes): the objects of meditation, the Christ Child and the Madonna, are illuminated by a candle held by the meditator, whose rapt face is also illuminated. The illumination of the supernatural is not itself supernatural; the point is not the holy radiance but the transfiguration of the meditator as well as of the holy object within the meditation. In one remarkable instance, *St Joseph the Carpenter* (Louvre), the object of meditation is Joseph at his carpentry, and the meditator holding the candle, whose face is more radiantly illuminated than Joseph's, is the Christ Child Himself. Another example of the complex relationships with which La Tour ex-

perimented is *Magdalen at her Mirror* (National Gallery, Washington): the skull, the beautiful woman's object of meditation, is both illuminated by a candle placed directly behind it and reflected in a mirror, where we would ordinarily expect to see the woman's face. In another version (Wrightsman Collection) it is the Magdalen's candle that is reflected in the mirror, emphasizing what we might not have noticed in the other paintings: the candle, which illuminates the object of meditation, is itself a symbol of mortality.

In short, behind the Wright pictures of air pumps and orrerys, statues and bubble-blowing, is the tradition of the candle flame itself as both secular illumination and transience—the merely human equivalent of God's candle. It should be remembered that the titles we give La Tour's paintings, though the obvious ones, may not have been La Tour's: they can be taken as either Caravaggesque Nativities and St Josephs, that is religious scenes seen as genre, or—as the source of light in the candle might suggest—these subjects demythologized into a mother and child or an old carpenter and his son. In such scenes of archetypes rendered special in their own terms, the transfiguration is man-made and transient, not supernatural.

Wright goes a step further, including more meditators and endowing them with a spectrum of reactions; instead of either a holy object or a memento mori, he uses, in turn, an art object, a scientific model of the solar system, and a scientific mechanism which contains a dying bird gasping for air; and in more than one case he indicates a natural source of light as a foil to the man-made one of the candle.

Between 1771 and 1773 Wright made a remarkable new start in a series of paintings of blacksmith forges. For one thing, the forge permitted him to change the predominantly yellow light of the candlelight pictures for shades of red. But again he shows man doing something to nature; the transformation of the metal at the centre now provides its own light which is reflected on the faces of the men who perform and those who watch. The setting is stark, rural, and primitive. With *The Blacksmith's Shop* (Mellon Collection) the relationship to the Nativity becomes too clear to ignore. Honthorst's Caravaggesque *Adoration of the Shepherds* (Uffizi) comes immediately to mind, but the general idea of a Nativity is

123 Joseph Wright of Derby,
The Iron Forge (1772). Earl
Mountbatten of Burma.

evoked by the half-open and ruinous building, the country folk, even the farm animals, and the unearthly glow at the centre. In fact, the curious ruinous structure in which the shop is lodged is constructed of Romanesque arches, over one of which is an angel carved in high relief. Whether or not Wright intended the building for an ecclesiastical structure, the hovering angel makes the necessary religious allusion. As in the *Air Pump*, the moon appears in the distance, a natural light; but now it is a comment of a different sort. In *The Farrier's Shop* (engraved by W. Pether) the source of light is completely hidden; it might be a white-hot piece of metal, a lantern, or a Holy Child. In the other versions the piece of metal is the child surrogate; in *The Iron Forge* (Earl Mountbatten of Burma) a child in her mother's arms is actually present, and the miracle appears to have been consciously displaced from the human pair to the piece of metal being under intense heat transubstantiated.[13]

The forge follows directly from the orrery, as Wright makes overt the fact that his subject is the secularization of miracle. This, he is saying, is miracle in the modern world, but to what extent he is consciously demythologizing, thinking perhaps of Hume's 'On Miracles', or to what extent he is placing scientific de-mythologizing in a religious (as well as natural) context we can only guess. This may be related to, but should not be confused with, Hogarth's travesties of classical myth in which heroic ideals are reduced to the real actors and actresses playing the roles of gods and goddesses (*Actresses dressing in a Barn*). A literary parallel, Fielding's *Tumble-Down Dick* (1736), used a lantern to represent the sun and candles for stars. Machine, the director, justified his production by saying: 'And what are all the suns, sir, that ever shone upon the stage, but candles? And if they represent the Sun, I think they may very well represent the stars.' In the *Orrery* the sun is simulated by a lamp, and in the blacksmith shop pictures the Holy Child is replaced by a piece of molten metal: a daring leap is involved in that modification, which raises the further possibility of the relationship between the bird in the *Air Pump* and the Paraclete.

191

124 Joseph Wright of Derby, *A Blacksmith's Shop* (1771). Collection of Mr and Mrs Paul Mellon.

Wright does not appear to be switching his allegiance to the scientific source of light, but rather opposing both the religious and the scientific to the natural, so that all three become part of a new construction. He may owe something of his conception to the contemporary poets who, no longer able to invoke with conviction the supernatural, either classical or Christian, were attempting to create their own mythologies out of natural objects.

Literary sources, however, tell us little about the power of these forge paintings. Their operative models are graphic, the traditions of Caravaggesque lighting, of Counter-Reformation religious painting, and of the secularization process that tried to apply history to a contemporary subject without losing the sense of wonder. These were also, of course, as Klingender pointed out,[14] years when artists, reared on Burke's sublime, began to be aware of the demonic or terrible sublimity of industrial sites like Coalbrookdale with their rough black hills, pits, and smoke, and of the great, powerful forms of steam engines and ironworks, as experience out of which to create a new and immediately relevant iconography. Wright offers a beginning, an early view of the independent riches of natural forces in relation to man's scientific engineering, and industrial exploitation of nature.

Wright's paintings anticipate those realist paintings of the nineteenth century which show the worshippers only, excluding the spirit worshipped,[15] but with the important difference that *something* is being responded to. Wright produces a picture about a kind of miracle or metamorphosis, which includes the audience, and is not merely a study in the psychological nature of religious experience.

The range of expressions is related to the tradition of expression of the passions, which tended to subordinate its central action to a

192

spectrum of responses. Wright was another artist like Hogarth who was trying to find ways to maintain the criterion of expression as he produced a history painting for his time. But he was also, it should not be forgotten, a contemporary of Burke, and he probably arrived at the need for the intensification of expression, which he then sought out in the candlelight tradition, through Burke's *Philosophical Enquiry* and the placement of the efficient cause of beauty and sublimity in the observer—in 'certain affections of the mind, that cause certain changes in the body'. When Burke takes the examples of pain, fear, terror, or love, his descriptions of the physiognomic responses involved come straight out of Le Brun's manual.[16] Wright shows anything but joy on the faces of the witnesses to his miracles. The mood of the blacksmith shop pictures, with the viewers revealing fear, turning away or inwardly musing, and with the blacksmith's upraised arms, may recall a Flagellation as much as a Nativity. In all of the paintings fear and incomprehension are the emotions expressed by at least some of the viewers.

Wright's habit was to turn expression into perception and emphasize the dissociation—epistemological and ontological—of subject from object. As we have seen, this was a concern shared not only by the artists but by the philosophers and novelists of the mid-century. While the statue of the *Gladiator* may draw art lovers together, Wright's basic situation is a muted version of Sterne's in which people gather around an object and understand it in radically, comically divergent ways, with a leap in sensibility effected, perhaps by a child present or by the eye of a lover that connects with the statue's or by one bystander who catches the viewer's eye and brings with it his own sympathy. The orrery certainly means one thing to the lecturer and his pupil, presumably something else to the glassy-eyed girl, and something else to the two children and to the musing man at the right. In the *Air Pump* there are the scientist, two lovers, two little girls fearing for the life of the bird, and an old man not even watching, meditating (probably on his own death). Once again, one recalls the responses to the death of poor Brother Bobby made by the philosophico-rhetorical Walter Shandy, the dress-conscious chambermaid, the Oxmoor-conscious Obadiah—all suddenly

brought together (all except Walter who was in another room) by Corporal Trim's graphic gesture of sympathy.

Also held in common with Sterne is the conviction that the object at the centre, whether marriage settlement or air pump or forge, is an attempt to in some sense impose order on the unorderable. Wright is making a distinction between that which is *considered* to be orderable—the objects of scientific investigation, or pieces of metal that can be transformed into horse shoes—and the unorderableness of human response. He stops just short of Sterne, for whom these very objects (hinges, sash-weights, bridges of various kinds) prove to be as unorderable as human response. But the unrelatedness of the world of *Tristram Shandy* tells us much about the effect of Wright's early paintings and more about their development into the later ones.

Already between 1767 and 1770, in one of the *Boys with Bladder* pictures (Charles Rogers-Coltman), Wright opens up this aspect of his work: he shows them fighting over the balloon. The experiment which was at the centre in the other versions has now become the occasion for a Shandean squabble and an overturned candle; raw, uncontrolled nature has reasserted itself, and the order of controlled, experimentally-determined nature is pushed aside.

In *The Earthstopper* (1773, Derby) something is again being done to nature: a man is filling up the fox's holes the night before the hunt so that he will have no hiding places the next day in which to escape the hounds and the hunters. This is not merely the picture of a labourer at work (compare Courbet's *Rock Breakers*, who completely fill the canvas). The pictorial design presents a stark contrast between the great expanse of untouched nature and the one small spot where the man is filling up holes—lit by the ever-present lantern, contrasted with the moon, visible over the tree-tops. Even the horse turns its back on the man and his treacherous, human, and ultimately Quixotic (or Sisyphean) activity.

The gap between man's art and nature has widened perceptibly here, and nature continues to gain ground in *The Old Man and Death* (1770–71, Hartford Athenaeum), a daylight picture in which the landscape again dominates, Death almost disappearing in the complex pattern of bricks, trees, and leaves behind him. Only the terrified shape of the old

125

125 Joseph Wright of Derby, *The Earthstopper on the Banks of the Derwent* (1773). Derby Museum and Art Gallery.

man stands out against this background, in the lower left corner (as in the earthstopper crouched in the lower right corner of his picture). The Aesop fable on which the picture is based tells of the old man, a wood-carrier, sinking under the weight of his burden, who calls upon Death to relieve him. Death does appear, ready to oblige him, and the old man in terror explains that he meant only to relieve him of the weight of the faggots he was carrying. It is the opposite of Stubbs' fable of the old woman who blames the supernatural for what was natural, or of Phaeton who attempts to duplicate the supernatural and falls back into nature. Wright's figures call upon the supernatural without much hope of a response and get a reply—a manifestation of one sort or another, which maintains if not the sacramental view of nature at least its animism in the face of man's attempts to impose his own order.

In *The Earthstopper* and *The Old Man and Death* the observers have disappeared, leaving only a single man coping with nature. In the next group of night paintings, made in Italy in 1774–75, man almost vanishes from Wright's scene, though his artifacts sometimes remain. He painted a series of views of Vesuvius, with the source of light this supernal fire in nature, erupting and quite beyond man's control. In the *Girandola* paintings it is in the fireworks, fire precariously harnessed by man, and in the closely-allied pictures of houses on fire, man's fire has got out of control again. In its most extreme statement, in the pictures of Vesuvius, the light or mystery now comes entirely from nature, and it illuminates only nature and bespeaks only terror. The spectra of sources and of responses have been radically narrowed.[17]

All of the Wright ingredients we have encountered so far are contained in the illustration for Ripa's *Physica* (physical science) in the 1758–60 Hertel edition of the *Iconologia*. Physica has machines around her dealing with water and air pressure, including a vacuum jar with a bird under it. In the distance is Vesuvius

erupting, and in its mouth the tiny figure of Pliny the Elder. This emblem, which appeared as Wright was beginning his career, relates human machines to natural ones like Vesuvius and (in its motto) deplores the fate of the man like Pliny who, 'being too curious . . . wished to penetrate into nature's mysteries'. The verse under the design reads: 'To research did Pliny dedicate his life, and met a tragic fate.'

Light is no longer homocentric as in the candlelight pictures. Thus Wright paints a series of views from the inside of caves looking out, and we see the water- or sand-filled cave mouths illuminated by the sun or the moon outside. Sometimes a human figure is isolated in the cave looking out at the light of day. In *The Captive, from Sterne* (1775–77, Derby) the prisoner is illuminated by the light coming from the high window in the wall of his cell: the *Air Pump* has been turned inside-out, and now it is the human who is imprisoned and the light is coming only from nature. In *The Earthstopper* the light was man's own feeble lantern, its limitations very evident in the huge dark night illuminated by a high moon. In *The Old Man and Death* man was tiny and power-less under nature's powerful light, and this is the version that is developed in *The Captive* and the grotto pictures.

Light has, from the start, shaped space for Wright. He seldom indicates the architectural structure of rooms; he defines space as a dark-ness hollowed out by light, and so basically a cave-like area. When he paints a prison cell in *The Captive* it has the same arched shape. His use of a circle of light (and response) produces such arch-like structures in which life exists as expressions, responses, and the intense aliveness of a statue of a gladiator or nymph. The illu-mination itself corresponds to a kind of vitality: children and lovers are often most intensely illuminated, linked perhaps to the imaginative potential of the object (say the air pump as terror rather than as scientific experi-ment); by contrast, the old meditative men and the scientists are in partial or sometimes almost total shadow.

In *The Academy by Lamplight* and *The Black-smith Shop* the rectangle of the architecture is divided into arches, and in the latter the three arches have each a different source of light. The first frames a group of men drawn together by the small glow of a candle—a farmer shoeing a

126 Joseph Wright of Derby, *The Captive, from Sterne* (1775–77). Derby Museum and Art Gallery.

127 Joseph Wright of Derby, *A Cavern, Morning* (1774). Mr and Mrs R. Kirk Askew, Jr.

horse. The second is not a structural arch but created by light and shadow and by the central figures themselves, by both the positions of their bodies and the light from the blinding glow of a newly forged iron bar. (In the Mellon version the arches are qualified by the strong horizontal of a roof beam.) The men's arms all point to the bar, and their eyes are all on it, but the rightmost man's uplifted arm

and hammer also point at the third source of light—the moon. In fact his arm and hammer draw a straight line from molten bar to moon. The arm points not just to two sources of light but to two relationships: to what man has created and what he has not created. Under this third arch, with the moon, is the bent head of the meditative old man, whose bodily shape completes the arch formed of men and yet also repeats both the third arch and the arched cloud shapes beneath it.[18] This is a conventional melancholic association, but here it is one side of a triptych with candlelight and ingot glow. (The final, and changing, element is the group of boys—in the Mellon version one boy looks at, the other away from, the forge; in another version the three children are all turned toward the old man.)

In the forge pictures and *The Captive* the arch is becoming the prison cell or cave that will continue to fascinate Wright, first in *Democritus* and later in the grottos of Virgil's tomb and the sea-grotto pictures, into which he introduces *banditti*, Julia lamenting her banishment from Rome, and Prospero. The cave is an open space embedded within a large impenetrable area of nature, whether in the form of a vault in Juliet's tomb (J. M. Oakes), a tent in *The Dead Soldier* (James Rican), or a dark arching cloud over Antigonus' fate (Lord Scarsdale). But it can be either looked into, as in these last three, or out of, as in the sea-grotto pictures. The arch is carved out of darkness as man-made space, or the arch itself is man-made with natural space visible through it.

The model for these works—related to the Nativity in the blacksmith shops—would seem to be the Platonic cave with figures lighted by a fire inside and the cave mouth open toward the light. When the prisoner is turned around to look out, at first 'he will be unable to see the realities of which in his former state he had seen the shadows'.[19] He is looking out at the real world from this world of illusion. And in *The Captive* the subject is not so much Sterne's anecdote as the Platonic metaphor—or its eighteenth-century version, the Lockean metaphor of mind itself, a cell cut off from the outside world of sense impressions. In *Virgil's Tomb* both outside and inside are visible, and moonlight on the outside is related to candlelight on the inside. For Wright, with his interest in effects of sun and moonlight, the Platonic and Lockean metaphors are related to the Plotinian one of poetic creation as a radiating sun—a power which 'gives a radiance out of its own store' to the inert world it sees; and to the Cambridge Platonists' image of 'the Spirit of man' as 'the Candle of the Lord'. The Creator Himself is 'the fountain of light', who has furnished us in this 'lower part of the World with Intellectual Lamps, that should shine forth to the praise and honour of his Name. . . .' This is the anti-empirical, anti-Lockean position in which man, as 'the Candle of the Lord', sheds 'more light upon' the objects of the external world than he 'receives from them'.[20] And this will become Wordsworth's 'An auxiliar light / Came from my mind which on the setting sun / Bestow'd new splendor. . . .'[21]

Wright takes the basic metaphors of eighteenth-century epistemology, religious and secular, and regards them coldly. In one sense he represents the extreme of empiricism, which even shows its own awareness of conflicting, anti-empiricist metaphors, absorbing them into an empiricist world view. Hume, it should be recalled, begins with the idea that heat, cold, sounds, and colours 'are not qualities in objects, but perceptions in the mind,'[22] and he follows this toward a kind of perception that is additive if not creative. Beauty, not 'a quality of the circle' itself but 'only the effect, which that figure produces upon the mind', is merely discovered by reason as it really exists in nature, 'without addition or diminution'; but taste, Hume argues, 'has a productive faculty, and gilding or staining all natural objects with the colours, borrowed from internal sentiment, raises, in a manner, a new creation'.[23] Wright too is concerned with the different realities of the natural world as it is transformed by the light of nature and by the light of man.

It remains the case, however, that the light, whatever its source, shapes a prison cell; and as the form reappears in painting after painting the only question is whether we are inside or outside, whether light is shaping a space in darkness or darkness filling a space. In the volcano pictures the form reappears in the clouds opening up in an arch around the mouth of the erupting volcano. It does not disappear in the later, more conventional landscapes, where it may be the arch of a rainbow. The arch reversed and filled in dominates many of the late

128 Joseph Wright of Derby, *Virgil's Tomb* (1779). Col. Sir John Crompton-Inglefield.

129 Joseph Wright of Derby, *Bridge seen through a Cavern* (1791). Derby Museum and Art Gallery.

130 Joseph Wright of Derby, *Erasmus Darwin* (1770). George P. Darwin, Esq., on loan to Darwin College, Cambridge.

131 Joseph Wright of Derby, *Mr and Mrs Thomas Gisborne* (1786). Collection of Mr and Mrs Paul Mellon.

landscapes which show slopes from right and left gently intersecting like an upside-down archway. In *Moonlight with a Lighthouse: Coast of Tuscany* (Tate Gallery) the clouds make an open arch over the lighthouse, repeated in substance by the closed hump of a hill in the distance.

Closed and open arches dominate the *Orrery* and the *Air Pump*, the space opened by the candlelight repeated in closed shapes of shadows—and in the *Orrery* both the machine itself and the philosopher repeat the arch, as well as the humped shadow cast behind his head. In *Two Boys Fighting over a Bladder*, the focal point, the balloon, gives the oval shape that is echoed in the shape of the fighting boys, and in the arching form of darkness that surrounds them.

Even Wright's portraits reflect the figure. In the portraits that are cut off at the waist, the sitter, given the volume and solidity of his head and shoulders, becomes a solid arch, like the *Erasmus Darwin* of 1770 (G. P. Darwin) or the narrower oval of *Mrs Catherine Swindell* (Leicester) and other portraits where the shape of the frame is itself an oval. This shape in the portraits probably derives from Reynolds and should not be made much of in itself. But Wright's predisposition for the rounded tops of tricorn hats is remarkable. Captain Richard French (L. B. Sanderson) wears a rounded hat that connects with the lines of his arms to make a large, encompassing oval. The arching trees of *Mr and Mrs Thomas Coltman* (Charles Rogers-Coltman) repeat the curves of the lady's arm and shoulder and the man's arms and the horse's neck, partly compensated for by the diagonal of the tree trunk. And an umbrella gives this shape to the portrait of the Gisbornes (Mellon Collection). Earl Howe stands before a great arched volume of rock (National Gallery, Washington). In all of these portraits the arch implies volume rather than space, essentially a darkness silhouetted rather than a light, except insofar as it is itself a hollowing out into a space of living motion and expression.

I do not think that Wright considers himself 'God's candle' transforming nature into certain shapes that are meaningful to himself; rather, isolating 'God's candle' as one element in his own painting, he continues to *find* certain shapes that are most basic to nature, as Brown elicited its 'capabilities'. In his later work, far

from celebrating the sort of irrational union Sterne or Hume emphasized as his solution to the discontinuities of human perception, Wright paints deserted or separated lovers. Like Sterne he is interested in the poetic or scientific act that controls or tames nature or mediates between man and nature, but he is aware of its transience, and his work develops into a study of nature's power pointed up by contrast with the small, helpless man who tries to tame it. These begin as exceptional acts, presented as miracles, and by the mid-1770s they have become secondary to the intransigence of nature itself.

Wright's progress is from the early candle-light pictures, with different 'readable' expressions responding to light, to the increasingly simple contrast between light and dark only in his landscapes: the light of man, dark nature, and nature's own light, the moon; the light of nature, the sun or a volcano, and dark-isolated man. The great ominous shape and the source of light tell the story. And in this sense, Wright as much as Stubbs is trying to get down to something basic and primary about the natural world.

The Return to a Text

Wright sums up the tendencies of all the English artists we have dealt with, from his extreme empiricism to his demythologizing and re-mythologizing of such basic topoi as the Nativity, the Platonic cave, the Lockean prison cell, and the Plotinian sun and candle. He is also typical in that he returns at length to the illustration of texts.

The questioning of old, inappropriate, and outmoded systems of signification with which we began naturally turned into a suspicion of books in general. Parson Adams' throwing his Aeschylus into the fire in his excitement at Joseph and Fanny's reunion was related to Tristram Shandy's questioning of the whole matter of sentence structure, syntax, and semantics; the Fielding narrator became at length the Sternean absence of controlling maker, the fragmentary jottings of *Sentimental Journey* and Mackenzie's *Man of Feeling*. And in painting, Hogarth's avoidance of all 'style' or artifice in his modern moral subjects, as indication of truth or sincerity, led to the attempt of the next generation to paint just what was there.

It was the anti-literary bias of sentimental fiction, with its emphasis on authenticity, to do away with the sense of artist or maker, skilled and in control like the Fielding narrator. The writers who try to give a sense of an object that was not made at all or else by someone who wrote just this once, out of deep feeling rather than skill or practice as a writer, are at one with the artists who produce paintings that do not draw attention to an artist, that eschew any reference to art of the past or to traditional styles of painting. Stubbs and Wright appear almost styleless. Without rhetoric or exaggeration, Stubbs replaces the models of past art with a close, literal representation that is supported by invisible structures based on geometry—structures not evocative of forms in earlier art but found in nature and carrying with them the same anonymous authority as natural law. Wright of course heightens and poeticizes, but he represents the process as taking place by natural means, by means of a lamp or a sun. We might say he creates a style by an internal feature, light, which need not be associated with the artist's own imagination.

But then, as if this was too difficult a pose to sustain, or as if the 'poetic' or stylistic quality of the lighting at length won out over its verisimilitude, Wright turned to illustrating literary texts. Perhaps this was a retreat. There was, from the beginning, a tendency to make a bold leap forward, as in the *Air Pump* and *Orrery*, and then follow with pictures that spell out the steps into originality. In 1772 he did four variants for over-doors: a letter-writer, a girl reading a letter spied on by a young man; a girl whose mother has confiscated her letter and is reading it; a boy and girl blowing bubbles; and two boys, one blowing up a bladder and the other watching him (W. Chandos Pole). The phenomena are thoroughly domesticated by this time: beginning boldly he ends with the merely picturesque. Indeed, his paintings can be said to be stocked with such sentimental conventions as the child and its awareness of the dead animal which is denied to the surrounding adults. Such conventions become more emphatic as Wright becomes more literary, turning to books and to the past for his objective correlatives.

Already in the early 1770s the works I have described are accompanied by others in which

132

199

132 Joseph Wright of Derby, *Boys with Bladder* (overdoor; 1772). Major J.W. Chandos-Pole.

Wright leaves the modern world to play with his themes in remote and romantic times. *Democritus in Meditation* (Derby) could as well have been painted by Salvator Rosa (whose *Democritus* inspired it) except that Wright uses the hermit and his meditation on human bones as a mystery which is observed by two distant strangers, one startled, the other meditative. There are topoi of various sorts employed in the picture—the stream that runs through his cave probably signifies transience, as does the hourglass and the skeleton Democritus examines. But the interesting point in the dull over-literary picture is the continuance of the structure of a mysterious object and divergent reactions to it. *The Alchemist* (Derby) attempts the same effect as the forge pictures but places it in a distant past, with two apprentices as the observers.[24] As the alchemist, searching for the philosopher's stone, discovers phosphorus, so the protagonist of *Miravan opening the Tomb of his Ancestors* (1772, Derby) searches for one thing (wealth) and finds something else (moral knowledge), of greater use to him and to the men who are observing his action. Learning, education, terror, and so on—these are still the central activities of the people observing. This is the first painting where the experimenter himself, rather than members of his audience, turns away from the miracle.

It is self-revelatory that Wright should have illustrated two scenes from Sterne's second novel, *A Sentimental Journey*. By the time he

painted *The Captive* and *Maria* (1781, Derby) he had stopped painting observers, and in *Sentimental Journey* too all that remains is the vivid scene witnessed (Maria) or summoned up (the Captive) and responded to by the memoirist, Yorick.[25] They are Wright subjects in that they show a human abandoned, cut off, alone— by death, false lovers, unfaithful animals, treacherous neighbours, legal machinery, and nature in general. *William and Margaret* (1784–85, Col. Sir John Crompton-Inglefield), with the ghost of the jilted Margaret appearing to William, connects with *Maria* before and *The Lost Lady in Milton's 'Comus'* and *The Indian Widow* after, each with its lone figure against the great stretch of nature, as isolated as the Earthstopper. *The Dead Soldier* and *Romeo and Juliet*, *The Corinthian Maid* and *Penelope unravelling her Web* are other variations on the theme of departed loved ones and personal isolation in an authentic but uninterested nature.

These last two show what has happened to the art theme. *The Corinthian Maid* (c. 1783–84, Mellon Collection) depicts the 'discovery of painting': to record her departing lover's form, to keep his memory, the girl traces his shadow on the wall. There is no audience here, but she is still learning and coming to terms with nature, producing a form which is to the real lover as the candlelit scene is to the sunlit one. Except that love too, in a sense, is shaping that outline. The fable is neat, the painting dull. What I take to be the companion piece, *Penelope unravelling her Web* (Mr and Mrs Hensleigh Wedgwood; same date, 40 by 50 in. vs. 42 by 50 in for *The Corinthian Maid*), shows another response to the same problem of a loved one's departure. Penelope, while the rest sleep, unweaves the work she has done in the day to keep from having to finish her tapestry and so commit herself to a suitor. Once again art stands her in good stead.

Finally, there is the picture of Antigonus pursued by the bear along the beach in Shakespeare's *Winter's Tale*, immediately prior to the devouring which is so vividly described in Shakespeare's text (Lord Scarsdale). Here Wright offers a final coda to his theme of nature versus man, which began so innocently with Miss Shuttleworth holding up the dead bird her father had shot.

Antigonus' sad end is described in Shakespeare's poetry; the stormy sky helps to define

118

Wright's version of Antigonus. But also in the illustrations a simplification of forms along the lines of neoclassical style is taking place; the text itself, or the artist who interprets it, is transforming experience in its own right. In this context of art imitating art, the moon or sunlight itself tends to become a surrogate for the artist. In Wright's later work there is still an occasional provocative combination of ingredients, as in the striking *Arkwright's Cotton Mills, by Night* (*c.* 1782–83, I. M. Booth), in which light comes from a pale moon *and* from the factory windows, *and* a man crosses the scene with his wagon. But in general there are only burning cottages and lighthouses in stormy seas to remind us of the exciting early works that depicted the contemporary world. With the end of the Vesuvius pictures Wright began to produce a long series, uninterrupted until his death, of landscapes in which the source of light is the moon. There is no longer any natural violence, no contrasting sources of light, only a special light to illuminate an aspect of nature for meditation or for poeticization. It is only a way of looking at, or of portraying, an object, and now the effect is of mysterious beauty: whether Matlock Tor or Roman ruins are painted by moonlight or, alternatively, by sunlight.

Contemporary with Wright's candlelight pictures and Stubbs' lion-horse pictures were history paintings that illustrated stories of a hero's death by depicting the responses of observers. There is, of course, a long tradition of death-and-response in art, both secular and religious: the former recommencing in the 1760s with Gavin Hamilton's deaths of Hector and Patroclus (derived from Poussin's *Death of Germanicus*) and the latter beginning again in the 1770s with West's modern-dress *Death of General Wolfe* (Ottawa, National Gallery of Canada). Not long before West began his

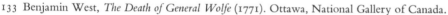

133 Benjamin West, *The Death of General Wolfe* (1771). Ottawa, National Gallery of Canada.

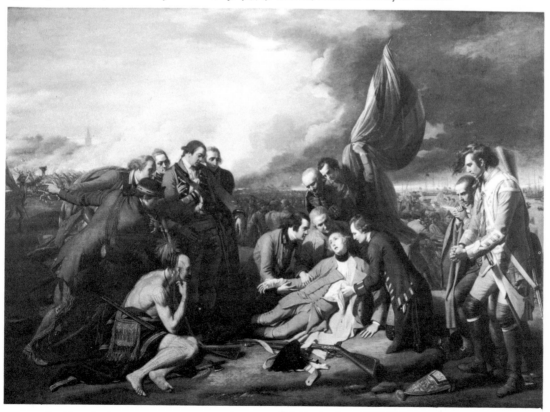

pictures, Diderot was remarking admiringly on the varying nuances of grief on each face in Greuze's *Death of the Paralytic* (Salon, 1763; Hermitage, Leningrad), each showing a different response and relationship to the dying man.[26]

I only wish to notice that the picture of a dead or dying person surrounded by mourners begins to flourish again in England at a time when writers and artists are portraying responses around an ambiguous or empty centre. West's *Agrippina landing at Brundisium with the Ashes of Germanicus* (1768) would fit into the same category with its central object, the urn of ashes, and the solemn responses along the quay. But these are not the same as Wright compositions, for no candle is needed or used; rather the composition draws on memories of Homer's text, national consciousness, or a Reynolds-like analogy. *The Death of General Wolfe* is constructed to recall a Pietà, and Wolfe is in some sense transformed into a Christ.[27] There is no question about the unity of responses to his death and, in this sense, of subject and object. West is painting a secular history subject, only a decade in the past, as if it were a religious picture. This death is indeed an atonement, taking place at the moment of victory and projecting ahead the British Empire in North America.

The tradition in which West is painting, even though he employs contemporary dress, is a continuation of Reynolds' search for a universal with which to express the particular. This is very different from the other tradition, beginning in England with Hogarth's comic histories, which showed how inappropriate history painting was to contemporary life. A glance back at the Pietà in which the Rake ended his progress, or at the Harlot's wake, with its shattering echo of a Last Supper, its twelve mourners plus the son sitting in the centre, emphasizes the discrepancy and the unrelatedness of the responses from the object, and of response from response. So too in Wright's forge paintings the blacksmith's forge replaces the Nativity and the spectators respond with such a variety of expressions as to leave in question the significance of the object.

But accepting the difference in intention, are they so unlike? The circle of response, however harmonious and uniform, is around a dead man—or a man expressively dead yet spiritually alive. The closest relationship to the dying Wolfe is with the soldier who reports victory, but it is not clear that any contact is made; and the other responses, as they recede from the centre, are to the death only. In John Singleton Copley's *Death of the Earl of Chatham* (Tate Gallery) at the end of the decade, the sense of discrepancy is clearer. Copley moves from the static West composition toward a more baroque and flowing one with a wide perspective. From the right, where Chatham lies, a series of shock waves emanate as from a pebble dropped in the water. Chatham's death is reflected intensely in the immediate circle of grieved heads and becomes less and less apparent until Lord Mansfield is found still sitting, unaffected. In *The Death of Major Pierson* of 1782 (Tate Gallery) the emotion is so intense at the centre that one mourner does take action, breaking the barrier between subject and object, by avenging his leader; but the agitation gradually subsides as it reaches the edges of the canvas. An intense activity round the centre, which is death, dissipates until at the periphery there is no expression at all.

Seen in the Reynolds context, these are contemporary heroes apotheosized; but seen in the Wright context, they are Pietàs demythologized, rendered actual. Copley comes closest to rendering another version of Wright's theme, emphasizing the responders' alienation from the stimulus, in his attempt at a modern history painting, *Watson and the Shark* (1778, National Gallery, Washington). Despite what we know of Watson's rescue, the rescuers' dangling rope in the painting and outstretched hands are out of the victim's reach. What Copley shows is the one-sided battle between the great, vaguely shark-like monster, mouth gaping, and the absolutely naked, wounded, and weakly floating man (is he dead or alive?). Watson and the shark are immersed in the shark's watery element, while above, on the surface of the water is a boatload of humans trying to save Watson. Above and beyond the little semi-circle of human observers is the horizon dotted with ships, a church, a fortress, and other habitations that are the outposts of civilization on the edge of the sea. The components of action and response, object and subject, and the apparently unbridgeable gap between, all remain. Here the civilized world

134 John Singleton
Copley, *Watson and
the Shark* (1778).
Washington,
National Gallery.

is witness to a plunge into the horror of elemental nature, evil, or the subconscious. The confrontation is the same explored by Stubbs, but like Wright Copley has succeeded in ordering his structure into an emblem as schematic as a morality play, with the watery element at the bottom, the bobbing boat and frantic rescuers and responders in the middle, and the horizon line, civilization, and sky above.

Watson is in some sense parallel to the object in *Tristram Shandy* that has no independent existence of its own, or the artifact at the centre of Wright's candlelight pictures—or even the empty open space in Stubbs' hunting pictures with the human observers at the periphery. What, to a large extent, art has been all about from Watteau and Hogarth onward is the replacement or displacement of the hero: a Hercules is displaced to a poor contemporary girl or to pictures and statues; an anti-hero is displaced by our attention drawn to the objects with which he surrounds himself and to the people who are responding to him; and from this figure as himself reduced to mere object—

at last a corpse in a coffin—to the object in Zoffany and Wright, the animals or the empty space pregnant with death in Stubbs, and the dead or dying but spiritually ascendant figures in West and Copley.

The difference is between the diverse responses of the Hogarthian audience and the harmonious one of the Reynolds audience. And yet the paradox remains; the mourners' very grief now expresses their alienation from the object. Being cut off is part of the experience of all of these pictures, if not by death or disaster then by an ontological barrier. The object is of an ambiguous status, whether absent, non-existent, a fabrication, dead, turned to ashes, or in some sense transcendent, with the human responses on the periphery, responses which, however intense, have lost touch with an objective centre. These are paintings of epistemological alienation in which man is only an observer to some sublime event; or perhaps they are not so much concerned with response or experience as with the degrees of truth, existence, and identity detectable in the contemporary re-enactment of myth.

12 Gainsborough: Form vs. Representation

THE TEST CASE for any investigation into reading structures in eighteenth-century painting is, of course, Thomas Gainsborough, Hogarth's antithesis, the least readable and most plastic of painters. My approach is through Gainsborough's vaunted formalism, but this formalism is initially misunderstood without our taking into account his anti-academicism. Hogarth, by comparison, had a strong streak of the academic conformist, exploiting the literary emphasis of history painting and building on the doctrines of Shaftesbury and Richardson. The result, though deeply subversive to these doctrines in his own practice, contributed no small amount to the proliferation of subject pictures in the age of Royal Academy shows. In their respect for a 'text' of *some* kind Hogarth and Reynolds marched together. Quite different was the case of Gainsborough. Keeping his views and the revolutionary element of his art to himself, he never suffered the distrust Hogarth attracted. He produced a good likeness and a graceful portrait that brilliantly adapted Van Dyck to the eighteenth century without violating his own principles of what a painting should be, and so he became professionally and financially secure. But at the same time he was the best example before Turner of the successful nonconformist painter, and of the reaction against meaning and morality in art—in short, against everything that both Hogarth and Reynolds stood for.

He was, as is well known, the least intellectual of those exceedingly literary eighteenth-century English painters. He 'avoided the company of literary men—who were his aversion', wrote his friend the composer and organist William Jackson, who adds that 'so far from writing, [he] scarcely ever read a book'.[1] He used the minimal literary trappings in his portraits, and in a letter (his only literary form) he chides himself for one occasion when 'I was willing, like an Ass as I am, to expose myself a little out of the simple Portrait way.' Another time he remarks, 'a handsome face [may] be overset by a fictitious bundle of trumpery of the foolish Painter's own inventing', as 'A Tune may be so confused by a false

Bass,' he adds, resorting to his favourite analogy with music, the most formal of the arts.[2]

There is no ulterior motive in a Gainsborough painting—no attempt to teach, disturb, or inform the reader. He advises Lord Hardwicke that he will not, like Paul Sandby, paint topography, and when a friend suggests that he include history figures in his landscapes, he replies:

But are you sure you don't mean instead of the flight into Egypt, my flight out of Bath! Do you consider my dear maggoty Sir, what a deal of work history Pictures require to what little dirty subjects of coal horses & jackasses and such figures as I fill up with.[3]

Gainsborough is reacting against the great style, against history painting, and even the portraiture he was himself forced to practise. 'Nature is modest and the artist should be so in his address to her,' he remarks to David Garrick; what he desires is 'the returning to modest truth'.[4] Attacking the great style and Reynolds' fifth Discourse, he advocates 'plainness & simplicity': 'there must be variety of lively touches and surprising Effects to make the Heart dance, or else [such pictures as Reynolds paints] had better be in a Church . . .'[5] To William Chambers, another representative of the Academy, he writes in 1783 of his *Two Shepherd Boys with Dogs Fighting* that what *happens* is less important than the relationship of the forms:

I sent my fighting dogs to divert you. I believe next exhibition I shall make the boys fighting & the dogs looking on—you know my cunning way of avoiding great subjects in painting & of concealing my ignorance by a flash in the pan. If I can do this while I pick pockets in the portrait way two or three years longer I intend to turn into a cot & turn a serious fellow; but for the present I must affect a little madness.[6]

Here he explains the cunning—partly the cunning of a man who does not care—with which he managed his revolt, at the same time that he proclaims it. The shape his anti-academicism took was to strip away meaning, subject, and theme, and 'make the Heart dance' merely through paint on a canvas, colour and texture arranged in a certain formal pattern. The letter

explaining why he does not paint 'flights into Egypt' in his landscapes continues with his best-known formalist manifesto:

But to be serious (as I know you love to be) do you really think that a regular Composition in the landskip way should ever be fill'd with History, or any figures but such as fill a place (I won't say stop a Gap) or to create a little business for the Eye to be drawn from the Trees in order to return to them with more glee....[7]

I have quoted at such length partly to demonstrate that this man who 'so far from writing, scarcely ever read a book', writes with as much flair as Hogarth or Reynolds, and writes as one who has read Sterne's *Sentimental Journey* if not *Tristram Shandy*.[8] It is also to demonstrate that he had a sense of humour. And finally I have quoted these passages to show that Gainsborough was not, as is still sometimes thought, a 'natural' but rather an artist who was consciously changing the basis of art from forms with tendentious moral interest or with literary associations to a much purer formalism.

But if he advocates formalism, he also desires to return 'to modest truth', a mere copying of nature. The paradox is only apparent. In middle age Hogarth himself turned into something of a formalist, on paper more successfully than on canvas, and his *Analysis of Beauty*, I hope to show later, had some effect on Gainsborough's particular kind of formalism. Certainly, the shaping force on the young Gainsborough was Hogarth's St Martin's Lane group of artists, which included Hayman and Gravelot, with its double doctrine of commonplace (non-mythological or religious) subject matter and decorative forms based on the serpentine line.[9]

Looking at the portraits Gainsborough painted from the 1760s onward, one is struck first by a formal emphasis and then by a representation—by the diagonals of William Wollaston's flute strengthened by the lines of his arm and leg and his eyes looking up in the same direction, balanced by the opposite diagonal made by the lower line of his vest (late 1750s, Ipswich). The portrait of Wollaston (or Mrs Thicknesse, or Johann Christian Fischer, or Carl Friedrich Abel) recalls a portrait like Cézanne's *M. Geffroy* rather than a Hogarth or

135 Thomas Gainsborough, *William Wollaston* (late 1750s). Ipswich Museum.

136 Thomas Gainsborough, *John, 4th Duke of Bedford* (1768). Dublin, Trinity College.

205

137 Thomas Gainsborough, *Mrs Thicknesse* (1760).
Cincinnati Art Museum, Mary Emery Collection.

a Reynolds. I doubt, however, whether
Cézanne would have made the flute's shape the
determinant—the line which all the other lines
in the picture echo or balance. We soon begin
to notice strange, perhaps distracting relation-
ships between form and representation for
which one searches in vain in a Cézanne.

137　　The portrait of Mrs Thicknesse (1760,
Cincinnati Art Museum) bears unmistakable
signs of Gainsborough's St Martin's Lane
heritage. She is defined by one great 'line of
grace' (to use Hogarth's term, distinguishing a
three-dimensional serpentine line from a two-
dimensional, which he called a 'line of beauty');
it runs from her jaw line down her right shoul-
der, arm, and right leg. But the general down-
ward-and-outward curve of this line is comple-
mented by a great many upward-converging
diagonals that in effect reverse the direction our
eye takes on the serpentine line. The strongest
of these outlines her whole right side (supported
by the parallel fold of her dress and the bottom
of the curtain); it is repeated by the not quite

parallel lines of the curtain behind her, her
neck, and the viol da gamba's bow, and by the
parallel lines of her right shoulder and the neck
of the guitar she holds; and complemented by
the uprights of the viol da gamba's neck, her
own straight neck, and the table's pedestal. The
other side of the acute triangle—going up
toward the left—is made of the border of the
rug, the lines of her feet, her leg through her
right hand, left arm, and left shoulder. All of
these make a series of intersecting acute tri-
angles, the only visible apex of which is Mrs
Thicknesse's head. The structure is almost stabi-
lized by her horizontal glance and her neck
band, supported by the table top and books and
the short horizontal part of the rug border.
But these are only short, fragmentary indica-
tions of the triangle's base. The wedge-shaped
effect is softened by the curves of her dress that
go against the upward-rising diagonals, and
by the curves of the bottoms of the two musical
instruments, making out of Mrs Thicknesse a
gigantic pear shape.

What is interesting about the picture is that
these formal elements bring out the play on
shapes that correspond to a viol da gamba and
guitar, their 'head', 'neck', and 'body' or
resonating chamber repeated in the same long
narrow neck-torso of the sitter that swells out
into the large shape of her skirt.[10] As repre-
sentation, the musical instruments tell us of
Mrs Thicknesse's interests; as shape, they sug-
gest some sort of a close relationship—perhaps
that of simile or analogy—between the per-
former and her instrument, quite different from
the contiguity of sitter and some appropriate
symbol or attribute employed by more conven-
tional portraitists. (As part of a visual construct
that still relies tangentially on the verbal, they
recall the habit of talking about stringed instru-
ments in anthropomorphic terms extending to
'back', 'ribs', and 'belly'.)

Gainsborough often employs his portrait
accessories as in some way formal parallels to
his sitter. *The Duke of Bedford* (1768, Trinity
College, Dublin) is constructed on a formal
resemblance between the Duke's shoulders and
the sloping shoulders of the urn behind him.[11]
Carl Friedrich Abel (1777, Huntington) is built on
the parallel lines of his arm and the table, his
shoulder and the viol da gamba, but also of
his downturned face and the face of his dog at
the bottom of the picture. The long-nosed face

of John Augustus Harvey (*c.* 1780, Ickworth) is repeated, emphasizing its long-nosedness, in the terrier at his feet, and these dog-human parallels continue in the portraits of Henry, 3rd Duke of Buccleuch (Duke of Buccleuch) and Sir Henry Bate-Dudley (Baroness Burton).[12]

Gainsborough is not, of course, innocent of the Van Dyck portraits in which handsome hounds and steeds acted as extensions of the sitter's aristocratic handsomeness. But in Gainsborough's portraits dogs more than vaguely resemble the sitter, producing a slightly comic simile. Reynolds never allows such a parallel except perhaps with a child, as in *Princess Sophia Matilda of Gloucester* (Royal Collection), but Gainsborough recalls Hogarth's conversation pieces in which animals often overtly ridicule the human sitters. Reynolds does produce an effect related to *Mrs Thicknesse* when he makes Lord Heathfield into a Rock of Gibraltar. The difference is between relating the sitter to a Michelangelo prophet or the Rock of Gibraltar and to a pet dog, a fiddle, or a garden urn (verbalized as fiddle- or jug-shaped). Iconography—traditional or learned meaning used to heighten the dignity of the sitter—has been expunged with a vengeance.

This we know to have been part of Gainsborough's intention in portraiture. But there is also his well-known impatience with sitters, and there is Uvedale Price's recollection that he had 'a lively and playful imagination yet was he at times severe and sarcastic'.[13] Very different from the formalism of a Cézanne, his expression of pure form is at the stage of iconoclasm, a celebration of the artist's freedom from subject and conventional imagery—of his freedom to construct his picture on related shapes, to relate a figure and background as he likes, to express himself in a kind of play at the same time that he is making this dull portrait to sooth a sitter's vanity. Play itself supports what we know of his intention: it has no practical purpose.

But the matter of intention is perhaps not quite so simple. There is *William Pitt the Younger* (1787, Kenwood), a very late portrait in which the formal emphasis is on his leaning.[14] The diagonal of Pitt's right side, arm, and button-line is repeated in the slant of his quill pen and the gold braid of the material against which he leans. The composition is stabilized by the bend of his left arm and the diagonal of

138 Thomas Gainsborough, *Carl Friedrich Abel* (1777). Henry E. Huntington Library and Art Gallery.

139 Thomas Gainsborough, *William Pitt the Younger* (1787). London, Iveagh Bequest, Kenwood.

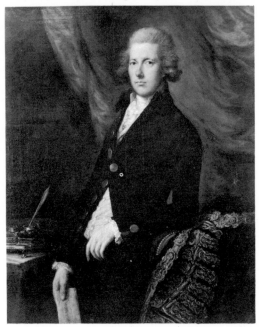

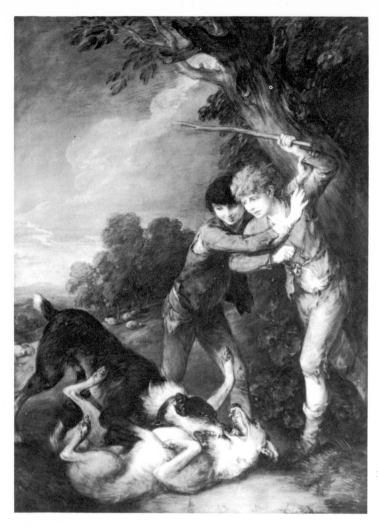

140 Thomas Gainsborough, *Two Shepherd Boys with Dogs Fighting* (1783). London, Iveagh Bequest, Kenwood.

the curtain. But the aspect of Pitt that is formally emphasized is his backward cant. I cannot suppose that here any comment is intended; any verbalism of bent reed or 'leaning'; any reference to the Giacometti-thin figures of Pitt by Gillray. Much more likely it is mere formal play, where a form has accidentally generated a meaning. The slight cant backward may be only a stylish, slightly languorous pose for the young statesman. A rococo emphasis on strong diagonals may have set Gainsborough going on a particular composition, with representation following. He compensates for these automatic twitches but they remain dominant in the leaning of Pitt.

We can venture to note, however, that a sitter-quill pen, a sitter-pet, a sitter-musical instrument relationship serves to make a very strong, though ambiguous, link between the figure and his surroundings. In the *Two Shepherd Boys with Dogs Fighting* (1783, Kenwood), which Gainsborough deprecated to Chambers, each boy parallels one of the fighting dogs: the boy who resembles the weaker dog is urging that they stop the fight, but the boy with the face and hair colour of the winning dog stays his friend's hand. The parallels are continued in the light boy's raised arm and the light dog's raised paw, and more generally in the tangles of the boys' arms and the dogs' legs. Recall Gainsborough's remark to Chambers: 'next exhibition I shall make the boys fight & the dogs looking on'.

In the portrait of Garrick with Shakespeare's bust (1766, destroyed 1946) the faces of the actor and the dramatist are paralleled through

the lines of their noses, and further by the fact that Garrick's pose is a slightly exaggerated version of Shakespeare's in Scheemakers' famous full-length statue in Westminster Abbey (so famous that it inspired a long succession of crosslegged full-length portraits in the 1740s and 50s).[15] It is as if Garrick were completing the figure of the bust, and in this way showing his close relation to the Bard. He is a lounging Shakespeare, with an over-casual slouch, his right arm having slipped from his chin into a sort of comradely embrace with the dramatist's bust. The nonchalance with which he leans against the bust, and his own parallel to the full-length statue, may suggest something about his well-known vanity or about the actor's feeling of his relation to the dramatist, which is that of a full-length representation to a bust (once again the visual is hovering on the edge of the verbal). At the least there is a clear but ambiguous association, almost a merger, of actor and poet, sitter and bust.

The *Garrick* is the closest Gainsborough approaches to the sort of literary allusion Reynolds and Hogarth employed. At the other extreme from this almost readable portrait are the portraits that employ no accessories at all. The contrast has often been made between Reynolds' *Mrs Siddons as the Tragic Muse* (1784, Huntington) and Gainsborough's more straightforward portrait of her (1783–85, National Gallery, London). It is sometimes underlined by a further contrast of Reynolds' words to Mrs Siddons as she arrived to pose: 'Ascend your undisputed throne, and graciously bestow upon me some good idea of the Tragic Muse'—which of course he fulfilled in his portrait; and Gainsborough's impatience with Mrs Siddons' most prominent physical feature, which gave him a good deal of trouble: 'Damn the nose—there's no end to it.'[16]

Gainsborough's straightforwardness aside, what makes the picture distinctive is that, though the general shape is again a long curve from lower left to upper right, or vice versa (like those diagonals in *Mrs Thicknesse*), this time there is no compensation but the downward curve of the swag of curtain; everything emphasizes Mrs Siddons' profile and its isolation on the right, with the thrust toward the great empty space on the left, led off by her nose, her penetrating look straight ahead, and what one scholar has called 'the extravagant

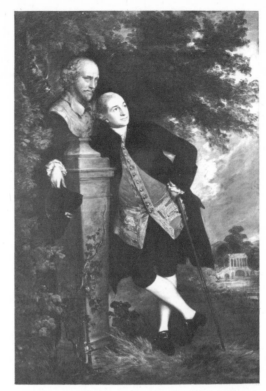

141 Thomas Gainsborough, *Garrick and Shakespeare's Bust* (1766). Destroyed by fire, 1946.
142 Peter Scheemakers, *Shakespeare* (1740). Westminster Abbey.

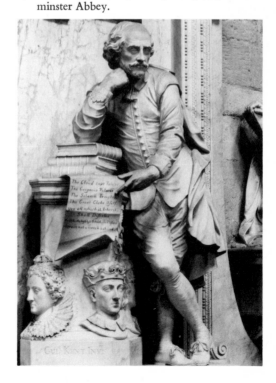

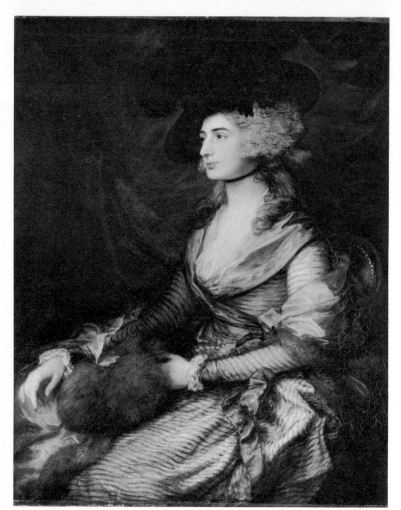

143 Thomas Gainsborough, *Mrs Sarah Siddons* (1783–85). London, National Gallery.

silhouette of her plumed hat'.[17] The slope of the bridge of her nose activates the long serpentine lines that zigzag down her body—one around her head and down her left shoulder and arm, another intersecting one down the back of her coiffure, her scarf, and the bottom of her dress. These are unlike the long, smooth line of *Mrs Thicknesse*, however; they are all broken in one way or another, forcing the eye to bridge gaps. *Mrs Siddons* is remarkably segmented, and this segmentation has, I believe, two effects.

First, it produces a series of relatively short, discrete lines that echo the line of Mrs Siddons' nose, slanting at approximately the same angle (from the upper line of her hat brim to her scarf, shawl, arm, etc.), balanced by only a few strong lines like her left shoulder, the parallel line closing the intersection of her dress front, and the stripes of her dress. Second, however, the segmentation of lines tends, with the distinctions in garments, colour, and textures, to emphasize volumes, and these areas roughly echo the shape of Mrs Siddons' nose. In fact the picture might be said to be constructed on a series of long slightly downward tilting ovals that parallel the shape of the famous nose: beginning with the brim of her black hat, continuing with her chin, her whole face including her hair cut off by the black ribbon on her neck, her face cut off by the curve of her jaw, and even her lower lip; then, moving down, the area of her neck demarcated by the black ribbon and scarves, the area of the scarves, and the lock of hair on either side of her neck; and, increasingly elongated, in the shapes of

210

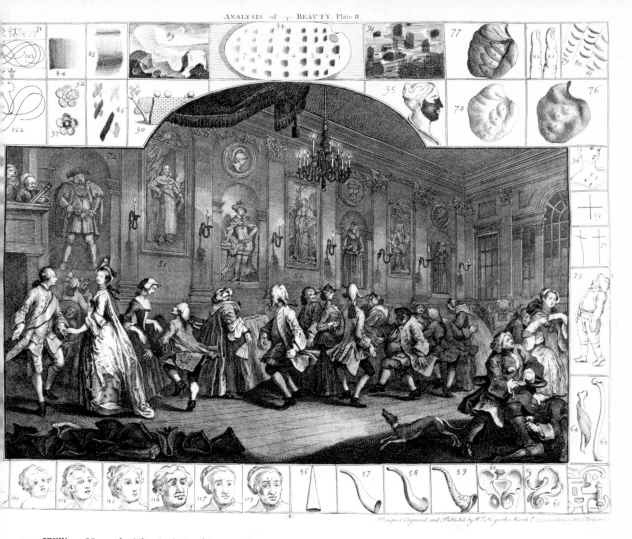

144 William Hogarth, *The Analysis of Beauty*, Plate 2.

her arms, her muff, and, largest of all, the area of her dress beneath her left arm. To get Mrs Siddons' nose into a formal scheme, Gainsborough simply made her all noses.[18]

Any artist of course builds his pictures on repeated or related shapes: the crook of an arm repeats the crook of a tree branch, or reverses it; one triangular grouping of people echoes another. But anyone using these purely formal relationships in the second half of the eighteenth century had Hogarth's experiments to contend with. In the *First Stage of Cruelty*, for example, a gallows with Tom Nero's name is scrawled on a wall and this shape is echoed in lampposts, creating a metaphorical equivalent of the gallows and extending its sinister prophesy for Nero to all of the other, equally cruel children around him.

The possibilities of relating form to aesthetic and moral, even verbal structures of meaning is the subject of the illustrative plates Hogarth made for his *Analysis of Beauty* (1753).[19] In the second plate at the far right in the margin he illustrates the 'one plain curve', which expresses 'the comical posture of astonishment' and is embodied in Sancho Panza watching Don Quixote demolishing the puppet show (after a well-known illustration by Coypel). In Hogarth's brand of formalism, the line is always expressive of something, always a representation. But here the plain curve of Sancho's 'comic posture of astonishment', Hogarth continues, is contrasted to 'the serpentine lines [of Beauty] in the fine turn of the Samaritan woman . . . taken from one of the best pictures Annibal Carrache ever painted' (Brera, Milan).

144

211

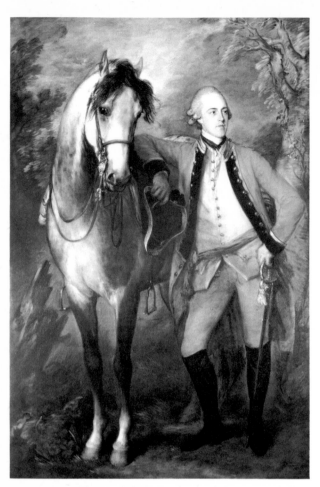

145 Thomas Gainsborough, *Lord Ligonier* (1770). Henry E. Huntington Library and Art Gallery.

Sancho is astonished therefore not by Don Quixote, who confused art with reality and attacked the puppets, but by his formal opposite the Samaritan woman (in a position exactly parallel in the opposite margin), whose equivocation about her morals did not deceive Christ (John I.18: 'thou hast had five husbands; and he whom thou now hast is not truly thy husband'). But then, in relation to the central picture of the dancers, Sancho's astonishment is directed at the young wife who, just under his nose, is deceiving her elderly husband (and she is an illustration, in the 'dance', of a graceful figure contrasted with the ungraceful figures of the rustics). An inelegant figure perceives the deceptions of two aesthetically pleasing but morally loose women.

The Samaritan woman stands next to the young nobleman who, within the dance, is clearly a model of graceful deportment: his sash and the turn of his legs are the mirror image of the Samaritan woman's. But again the moral significance of the parallel—with the young nobleman's partner nearby—is open to question. In a niche above the nobleman and his lady, moreover, is a very ungraceful statue of Henry VIII without *his* lady, adding to the context of the young couple. In the text, Henry represents simple uniformity and is said to resemble a perfect X (as opposed to beautiful serpentine lines like those of the young couple below him). A man standing beneath the portrait is embarrassing his lady by pointing out Henry's codpiece, his prominent sexuality, which, unconcealed by manners, is quite different from that of the young nobleman. Though contrasted in shape, iconographically he is linked to the Samaritan Wife of Bath with her five husbands-plus-one by his six wives; and his strident pose links him formally as well as intellectually with the collapsed X of the cuckolded husband on the other side of the plate: the king who chopped off his errant wives' heads and the husband who meekly points to his watch as his wife arranges an assignation.

The complexity of Hogarth's interplay between formal and intellectual content, between visual and verbal structures, and of course his iconographical allusions, go as far beyond Gainsborough as does his use of the comically-parallel animal. But we can see here the climate in which Gainsborough reacted against certain academic precepts. The play with forms is typical of him, and I suspect that he would have agreed with Hogarth in questioning the Shaftesbury-Hutchesonian equation of beauty and virtue, which was of course perpetuated in academic theory, replying that beauty may be aesthetically pleasing when it is morally meaningless.

The primary Gainsborough exhibit of this Hogarthian play of forms in a portrait is the splendid pair of Lord and Lady Ligonier (1770, Huntington). We have contemporary witnesses to the strangeness at least of the forms. One observer at the Royal Academy exhibition of 1771 noted of *Lord Ligonier*:

Though this piece be very well done, it is liable to one objection. Every picture ought to have some principal object. But this picture has none. The horse, being

represented as near to the spectator as the gentleman, and being a large object, and of a light colour, attracts the eye as much as the gentleman does. The eye is equally divided between them: and it is to be feared that such people as affect to be witty, will say the horse is as good a man as his master.[20]

Lady Ligonier also worries the observer, who remarks that she 'has something of a French look, has a remarkably piercing eye'. Horace Walpole wrote in the margin opposite the first of these comments: 'true'.[21]

The two portraits are mirror images; each with opposite arms crooked and supporting him/herself against an object. Hanging side by side, though with different settings—his outdoors, hers indoors—they become part of the same scene, as in the case of Hogarth's Sancho and the Samaritan woman. Lord Ligonier's eyes are directly on Lady Ligonier, and hers are slightly averted—on something else—with a look of faint amusement or disdain. He is leaning against his horse, which turns its head toward us, looks at us (as opposed to Lord Ligonier with his eyes on his wife), which has the effect of making its head as well as its body parallel to Lord Ligonier's: the same size, shape, and turn of face.

Penelope, Lady Ligonier, is shown leaning against a pedestal that holds a small statuette of a dancing Bacchante clothed only in a twining tendril.[22] The parallel is emphasized by the crook of the left arm, the turn of the body, and even the bend of the statuette's right leg which finds an echo in the most prominent fold of Lady Ligonier's gown. These are formal devices for holding the picture together. But they also set up equations between Lady Ligonier and the figure of an ecstatic semi-nude dancer, with perhaps verbal overtones of 'set on a pedestal'. The oversized pedestal, I would add, makes the little statuette look somewhat awkward and out of place. I doubt if the Bacchante carries any but the most general iconographical reference; and there is even less 'readability' in the other objects in the room. On the chair are casts of an old man's head by 'Fiammingo' and a putto, probably by him also, resting on a pile of sketches and propping up a portfolio. These were set pieces for students to copy, and—together with the brush in her hand—they indicate that one of Lady Ligonier's outlets was as an amateur artist.[23]

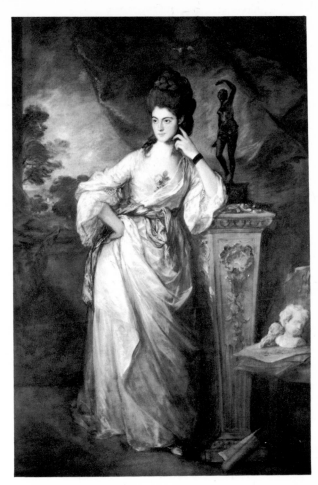

146 Thomas Gainsborough, *Lady Ligonier* (1770). Henry E. Huntington Library and Art Gallery.

If nothing more, the parallels suggest that Lord Ligonier, like the squire in Pope's lines, loves his wife 'best of all things—but his horse',[24] and that Penelope allows her drawing and whatever potential of herself is to be detected in the Dionysian figure to replace Lord Ligonier and his horse. In a variety of ways the husband and wife exist in contrasted worlds. He is standing outside in open country-side; she is inside a room, the outside visible only through a window, and the walls hung with heavy crimson draperies, which are even heaped on the window sill. With her art objects around her she is as decidedly cut off from nature as he is immersed in it. He, all straight, slightly diagonal lines, is a static figure; the two black diagonals of his coat diverge, emphasizing his nonchalant, open, literally unbuttoned look. She is all curved arms and drapery folds,

213

emphasized by the curving pirouette and tendrils of her alter-ego statuette. The only angular thing in the picture is the pedestal on which the statuette dances. Lady Ligonier's one spot of black, by no means balancing the long black bands of her husband's coat, is the band around her wrist; but she is also bound about the waist by a slate-blue sash that is strangely knotted and twisted, echoed in the knots in the pile of hair on her head. She seems to be held in with bonds which, if released, might allow the expansive gesture of the Bacchante behind her.

The colours too are part of the formal scheme. The basic colours are red, a buff yellow-gold, and greyish white, distributed and balanced between the two pictures. Lord Ligonier's coat is red, two small areas of colour boldly separated by the diverging bands of black, while the red curtains fill the whole background of Lady Ligonier. Ligonier's vest and trousers, conveying his casual stance, are yellow, and the horse he leans on is mottled grey and white. Lady Ligonier is herself white with greyish shadows,[25] with as mottled a texture as the horse, and the pedestal she leans on is yellow. I have said that the shape of the horse and its head echoes Lord Ligonier's shape, but in the juxtaposed pictures the horse and wife are related by colour and texture (and the bend of her head is the reverse of the horse's); the husband and the pedestal are related by colour and also by shape (it is, we noted, the only angular object in her room), for Ligonier's wedge shape of vest is exactly reversed in the tapering pedestal. And topping this husband-shaped and coloured pedestal is the statuette that echoes the wife's pose but with clothes removed and distanced by art.

Fortunately, we know some facts behind these paintings. They were commissioned under unusual circumstances by George Pitt, Lord Rivers, Lady Ligonier's father. In April 1770 Gainsborough went to spend two or three days with Lord Rivers, probably to sketch landscape, 'and behold [he wrote James Unwin] he had got two whole length canvasses, and his son and daughter, *Lord & Lady Ligonier*, in readiness to take me prisoner for a month's work'; according to a letter he wrote to Jackson, he was confined there three months painting the portraits.[26]

The great scandal of Lady Ligonier's adulterous affairs broke in the summer of 1771.[27] Her affair with Count Alfieri was only begun in November 1770, six months after the portrait was painted; the exposure came in the summer of 1771 when the groom, Alfieri's predecessor as her lover, told all to Lord Ligonier; it was then in the papers, with scandal, rumours, and perhaps lies added about all of her earlier affairs with menials, and was finally concluded by the divorce trial itself.

Gainsborough can at the most have heard rumours of Penelope's wandering eye; more likely, he knew nothing at all but after two or three months had a pretty good idea of what both husband and wife were like. The contrasts he presents are once again formal play engaged in by an ingenious artist; but he has accurately recorded the husband and wife's mutually-exclusive preoccupations, the husband's possessive surveillance and the wife's carefree glances elsewhere. Perhaps these suggestions began with a certain impatience with Lord Rivers for trapping him into painting the two portraits when he had expected to sketch landscape and be home in a day or so.

We have to conclude that he was having a witty, semi-private joke at the expense of his sitters (of the sort Zoffany sometimes engaged in), or that his desire for pure form was compromised by a subconscious expression of his real understanding of these two—feelings that happened to correspond to the biographical facts as we know them. In either case, his form is now engendering a content as real as in any of Hogarth's prints.

These portraits are of course exceptional; most of Gainsborough's best ones do not make such pointedly witty play with forms and representations. But these are only extreme cases of a formal play in all the portraits that can be generalized to a shifting relationship between sitter and setting. When the observer at the 1771 Royal Academy show noted that the horse 'attracts the eye as much as the gentleman does', and when we remarked on the formal resemblance between the two, we were indicating a parallel between the natural and human orders, which is perhaps the most characteristic thing about *Lord Ligonier*—as the *tension* between human, nature, and art is in *Lady Ligonier*.

Gainsborough's later work increasingly emphasizes the merger of the natural and human

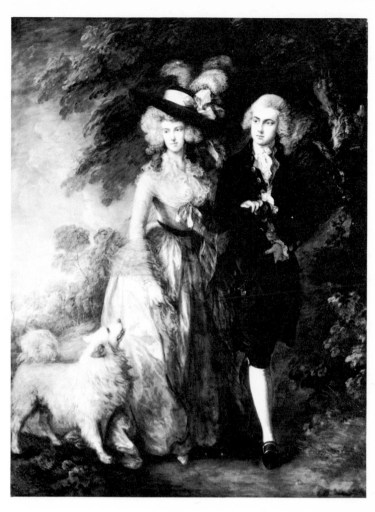

147 Thomas Gainsborough,
The Morning Walk,
or Mr and Mrs Hallet (1785).
London, National Gallery.

by a tendency to reverse the ratio of representation to form, to reduce the degree of specific denotation by not bringing the picture to a high finish. In the portraits that begin in the 1770s, the sitter is often in a natural setting, and both sitter and setting are laid in with what Jackson called 'an extravagant looseness of pencilling' and Reynolds described as dashes and daubs of colour: 'this chaos, this uncouth and shapeless appearance, which by a kind of magick, at a certain distance assumes form, and all the parts seem to drop into their proper places'.[28] These paintings are built on the same formal parallels, but play is now becoming the expression of deeply-felt psychological and ontological concerns.

What the blurring does is to give the scene back to the viewer, invite his participation and active cooperation, and, as Gainsborough says in one of his letters, give him a certain 'glee'.[29] It forces him to fill in the details from his own experience. To this function we shall return; but it also suggests, by reducing representation to its component virtually undifferentiated elements, deepseated affinities between different types of natural and human states.

The nature of the formal relationships in these portraits has been described tellingly by Emilie Buchwald, who says of *The Morning Walk, or Mr and Mrs Hallet* (1785, National Gallery, London): 147

The smooth darkness of the Squire's jacket and trouser leg are repeated in the deep shadows of the foliage and tree trunk. Mrs Hallet's hair, the fluffy mass of foliage of the single tree silhouetted against the clouds, and

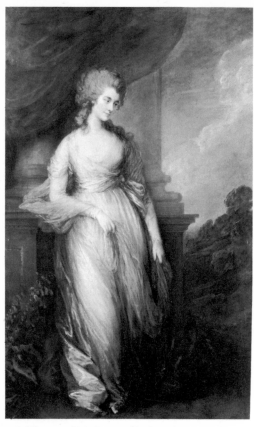

148 Thomas Gainsborough, *Georgiana, Duchess of Devonshire* (1783). Washington, National Gallery.

the dog's curled plume of a tail are echoes of one another in texture and in shape. The agitated ruffles and highlighted roundness of the lady's breast and the blowing puffs of clouds; the plumes of her hat, and the downward plumes of foliage directly behind her; these and several other details masterfully tie together the landscape.

'This technique of painting the Hallets and their dogs, as areas of varying texture,' Miss Buchwald concludes, 'admirably unites them with their landscape.'[30] And another scholar writes that they 'look as insubstantial as the landscape behind them'.[31] The point, I believe, is that at the heart of these mature portraits is an ambiguous relationship between people and nature. The colour, texture, and shape of the Duchess of Devonshire's gown (1783, National Gallery, Washington) are strangely but closely related to the clouds behind her, and the texture of the paint that forms her face connects her

148

with the paint that forms these clouds. On the other hand, the straight lines of column and plinth behind her set off both her cloudlike shape and the nature into which she seems to be merging, as the shapes of the swag of curtain across the top of the picture interposing between her and the natural setting, and the foliage itself across the bottom—both diagonals cutting across the Duchess—delimit the worlds of art, humans, and nature. Gainsborough's pillars in natural settings like this one are less heightening conventions than part of the play he has inherited from the school of Watteau indicating the point at which this person exists between the social and the natural. *Mrs Graham* (1777, National Gallery, Edinburgh) leans against a classical pillar wreathed in vines, herself virtually reclaimed by nature. The plumes of her hat turn to foliage before our eyes, and she seems barely clothed in her finery, which seems to belong to someone else.

In these portraits Gainsborough has, perhaps by transporting the assumptions of a Watteau *fête galante* into a full-scale portrait, questioned the very distinction between figure and ground. It was because they dealt with the human form that both history and portrait painting were higher genres than landscape. Gainsborough integrates figure and ground so that either one or both is the subject; so that it is an open question whether he is painting his beloved landscape or another drudging portrait. At one extreme he virtually blots out the human actors with an undifferentiated background; at another extreme is an experiment like *The Blue Boy* (1770, Huntington) in which he reverses figure and ground—displacing the blue of the sky to the garments of the figure, and rendering the sky itself a brownish grey.[32]

In his early portraits and conversation groups in the style of Cuyp or Berchem the figures and ground are quite distinct, each in clear focus. In the portrait of John Plampin (early 1750s, National Gallery, London) the man is leaning against a tree, which effectively, with the hillock he sits on, cuts him off from the countryside behind him. Indeed his back is turned to it, and he and it are quite separate and distinct objects, but his outstretched legs are precisely mirrored in the branches of the tree against which he leans. *Mr and Mrs Andrews* (c. 1750, National Gallery, London) is the masterpiece of these early conversation pieces. Here are a hus-

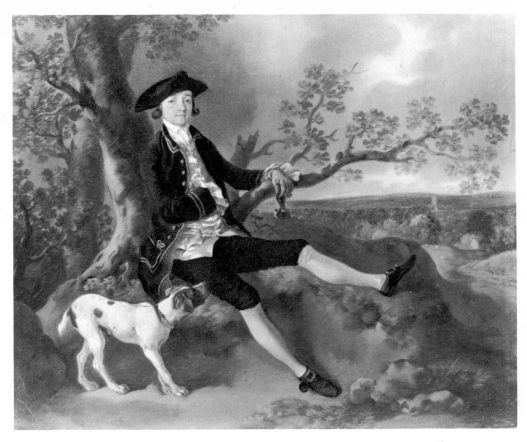

149 Thomas Gainsborough, *John Plampin* (early 1750s). London, National Gallery.

150 Thomas Gainsborough, *Mr and Mrs Andrews* (c. 1748). London, National Gallery.

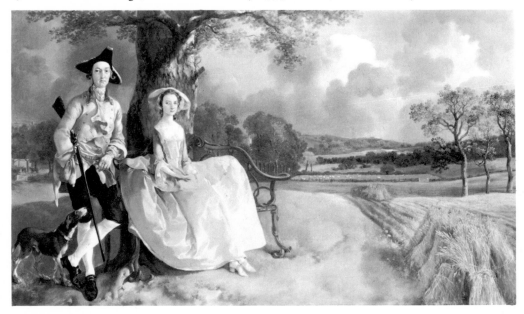

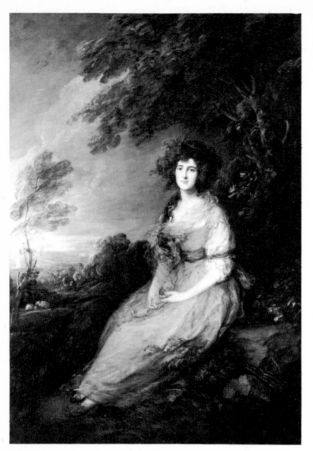

151 Thomas Gainsborough, *Mrs R.B. Sheridan* (1785). Washington, National Gallery.

band and wife, clearly set off from their dog, placed on a defined area of turf, all carefully separated from fields of wheat, which is cut and bound into sheaves, and from the ordered landscape of their park. Even the dog (with the gun) is clearly Mr Andrews' and the wrought-iron bench, which virtually encases her, Mrs Andrews'. This is the typical English conversation piece of the sort developed and elaborated upon by Zoffany a decade later. Demarcation and definition are all.

But in Gainsborough's later portraits—the ones we are now considering—his sitters bear a less proprietary, less distinct relationship to their setting. They are no longer resisting nature. *Mrs Sheridan* (1774, National Gallery, Washington), with her windblown hair related to the shape of the turning autumn leaves above her head, her fluttering diaphanous scarf like the clouds, her slender torso like the tree trunk behind her, is virtually a part of nature.

Reynolds' figures are also frequently in natural settings, but they remain obtrusive, firmly delineated, and separate from their surroundings. For to Reynolds man *is* art, or is defined by art, and not by nature. The pull toward merger appears only in his group portraits, and there it is people merging with people, a small group of individuals drawn into a tight family unit, an almost indistinguishable tangle of figures. The blurring process of a Gainsborough portrait was equally incomprehensible to a Reynolds and to a Zoffany, the one concerned with homocentrism, the other with classification.

The relationship of man and nature is complicated in Gainsborough's portraits by tensions generated by garments, architectural objects, and the personality of the sitter. But in his landscapes, and above all in the landscape sketches, the undifferentiation of figure and ground becomes one with the urge toward purely formal relations; and these become, as representation, the scene in which trees bend down toward peasants and their wagons passing beneath, as all three merge in a common substance.

Perhaps Gainsborough loved landscape because it was the one form that offered a relative freedom from connotations historical and mythological, from topoi and a multitude of non-formal considerations. As early as the 1750s he not only denies topography but his buildings 'can no longer be converted in imagination into their plan'—the sine qua non of a Zoffany or of a Canaletto.[33] His landscapes are no longer descriptive; they do not portray particular places or elm or oak trees but only a small repertoire of foliage, hills, shepherds, flocks, ponds, and cottages. They are studies of form first and representation second, evoking a mood of 'calm, relaxation, and utter peace with the world'.[34] The form, however, is distinctive and related to that of the portraits.

The landscapes are repeatedly—I had almost said obsessively—constructed on a downward slant, a slope going off to one side or the other, sometimes accentuated rather than corrected by a crooked tree that repeats the diagonal.[35] More often the diagonal is intersected by a less emphatic slope, or two Lines of Beauty intersect, producing a sort of lazy gamma with its tail disappearing to the right or left off the

151

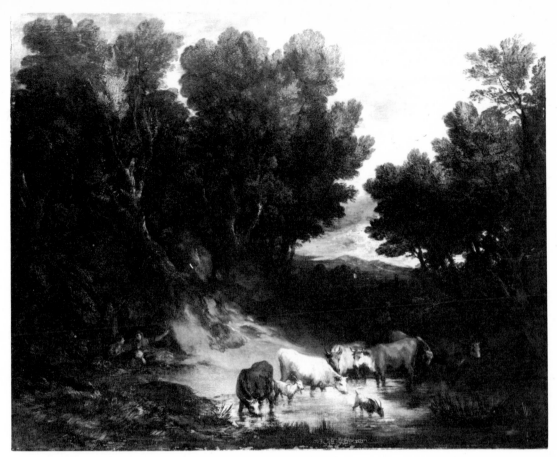

152 Thomas Gainsborough, *The Watering Place* (1777). Tate Gallery.

bottom of the canvas. This is not the Y-shape that was used as an emblem of Hercules at the Crossroads; the movement is not up but downward, and the emphasis is on the intersection, rendered dark and mysterious, or on the tail or path that plunges down from the intersection, disappearing off the canvas.[36] The prototypical Gainsborough landscape shows banks and slopes converging to make a single path that drops into darkness.

There are usually cattle or sheep on the slope, almost always on their way down to drink water, and sometimes standing in the pond that is formed out of the vagueness at the bottom of the intersecting hills.[37] Sometimes the pool itself nestles on a slope that continues downward out of sight.[38] When the horses or cattle are drawing a cart, they are descending toward the pond to drink or to ford it, and even when they ford the pond they appear to be descending still.[39] In the harvest wagon pictures, though

the wagon is in fact proceeding along a fairly flat road, Gainsborough has arranged his perspective to make it appear to be descending.[40] The tree trunks, branches, and heavy bending foliage all produce downward curves that emphasize descent.

If the animals are in the pond, the cowherd and various other humans are usually resting somewhere on the slope. Once in a while the men are at the bottom and the animals on the slope,[41] but the closest man gets to the pond and the darkness at the bottom is on horseback over it while his horse drinks, in a cart that is being drawn across the pond, in a boat on the pond, or on a bridge over the water while his herd drinks.[42] Occasionally cowherd and cows are crossing a bridge over the river with the usual descending banks, and appearing themselves to be descending.[43] In the less steep landscape scenes, they actually launch off into a pond or river; and the seascapes are only an enlarging of

219

153 Thomas
Gainsborough, *Cart
Horses drinking at a
Stream*. Tate Gallery.

154 Thomas
Gainsborough,
*Landscape with
Shepherd, Stream, and
Goats* (1780s).
Philadelphia Museum
of Art, The John H.
McFadden Collection.

155 Thomas Gainsborough, *The Market Cart* (1786). Tate Gallery.

the pond into an ocean with people pushing off their boats into it or approaching it.[44] The lighting effect is simple and fairly consistent: downward and to one side is growing darkness; above is a bright sky, and if the people look up their faces are illuminated by the light from above. Darkness, of course, is not so much the word to designate the opposite of sunlight (Gainsborough's paintings are never dark) as the greenish-brown of foliage; it is nature into which everything is descending.[45]

The characteristic scene shows a little clearing in a dense, disordered forest, with the trees and bushes bending in toward the clearing, as if to reclaim it; and the men and animals are in various stages of descent into this green shade. From a great many pictures we can infer a total structure that begins with a city, village, or villa atop the hill;[46] the villa's terraces and stairs reach down to the peasants who sit at their foot or further down the slope. Further down is their cottage with the woodman and his family about the door,[47] and as the hill descends from that we find the woodman gathering his wood from the edge of the forest and the shepherds conducting their herds downward into a pond or merely downward. In one landscape (Metropolitan Museum, New York) we see all of these in descending order: a church tower, cottages, a cart horse, peasants, a path, and a pond.[48] It is a hill that descends from signs of civilization and society to primitivism to primal darkness and/or water. The merger of human and nature is both compositional (via the downward path) and stylistic (via the undifferentiation of form, texture, and colour).

While the humans never quite reach the pond, they are always somewhere on the downward slope toward it, and within the patterns of the descending landscape the cottage, itself bleak and almost overtaken by nature, holds against the downward movement: the figures make a knot of intersecting lines that cancel each other but prevent a slide down and out of the picture.

The downward slope also appears in Gainsborough's 'fancy pictures'. A girl bathing her feet (Tate Gallery) has her foot plunged down into the water, and there is the same

221

sense of *down into* in *A Cottage Girl with Dog and Pitcher* (Sir Alfred Beit), where the girl's right foot is turned downward, her eyes down to the lower left corner, and the lines of her jug, the bottom of her skirt, the dog's face all lead down into that corner. The not-quite compensating line is a downward curve toward the other side of the canvas of another hillside with some sheep grazing. If the girl is going down to a well, the dogs in *Greyhounds coursing a Fox* (Earl of Rosebery) are pursuing downward, and when Gainsborough paints a pair of white dogs they appear to be sitting on a downward slope (National Gallery, London).[49]

138

143

The powerful diagonals of the portraits, though they naturally direct the eye up toward the face, also sometimes pull downward: Karl Friedrich Abel is drawn down almost out of the picture by his huge, trailing viol da gamba, and Mrs Siddons, as the noses of which she is constructed grow larger and heavier, sinks too. The people in some of the early portrait groups are sitting on the edge of ground that falls away from beneath their feet,[50] and in later portraits Dr Ralph Schomberg (National Gallery, London)—and indeed the Blue Boy—stand on

151

the side of a hill, and Mrs Sheridan, sitting on a slope, makes a bottom-heavy downward-sinking shape that leads the eye out of the picture. These sitters are sinking into, as well as merging with, nature, like the people in the pure landscapes.

The two girls in *The Painter's Daughters* (National Gallery, London) are running *down* a hill chasing a butterfly that is flying upward. In the intersecting arms and hands of these girls, where the ground is still sloping, or in *Haymaker and Sleeping Girl* (Boston Museum of Art),[51] where the ground is flat but the diagonals of the leaning boy and the sleeping girl intersect at his staff and her arm and trail down through her bent leg and dress: in both of these we have the same gamma shape as in the landscapes. Looking back to the portrait of Mrs Siddons, we find the same pattern in the intersecting lines from the two sides of her scarf meeting and going off downward to the right and off the picture. Among the many questions raised by Gainsborough's paintings is whether the meaning in these compositions is therefore the same as in the landscapes where the shapes are shepherds and their flocks descending paths and hills? Are

the portraits and subject pictures also about separate paths that somehow join and mingle in the characteristic Gainsboroughesque downward movement into a deeper, less conscious and more instinctual life?

The phenomenon is seen at its purest in the drawings. Even the earliest drawings reveal certain obsessive forms: in an early study of burdock leaves (Hayes, *Drawings of Thomas Gainsborough*, fig. 19) the most dramatic accent is the darkness that focuses at the point where the leaves and stalk intersect into a downward curve indicated by the dark demarcation between two lower leaves. By the Bath and London years these become sketches evolved less from memory of an observed scene than from formal relationships. These sketches were personal in the sense that Gainsborough never sold them and gave few to his friends. Here he could reduce subject and representation to even less than in the painted landscapes, and withdraw further yet into himself. In the Bath years he supplemented direct contact with nature with assemblages of stones, sticks, grass, and pieces of mirror on a little table. Later he apparently reduced even that small degree of contact with observed nature. After a hard day at portraits, where something specific had to be represented, at night he would let his hand relax and revel in doodles across blank paper, a form in search of a representation, which invariably found the same one.[52]

Hayes has shown beyond the shadow of a doubt how far form predominates over representation or any information or other interest in these drawings. But his analysis of their form as a perfectly balanced tension of compositional forces just misses the mark. Paintings by Poussin and by Gainsborough are both resolutions of thrusts and counter-thrusts, and yet their effects are totally different. Indeed, Gainsborough's landscapes are usually not, at least in the Poussin sense, balanced. I find it suggestive that all four of Hayes' primary examples of Gainsborough's 'balanced' compositions (his figs. 163, 181, 214, and 132) are representations of people going down into something: a man shoving off from a dark bank into the water; a shepherd standing at a watering hole, his sheep dawdling down the valley toward it; cows standing above a slope leading down into a pond; and, in the fourth, the cows are merely varying the pattern by

156 Thomas Gainsborough, *Horses under a Shed*. Drawing; Tate Gallery.

157 Thomas Gainsborough, *Figures and Horses in a Country Lane*. Drawing; Tate Gallery.

climbing up out of a hole. In many of the drawings the lines of shading themselves are diagonal, downward movements of the pencil. The form is not merely the tension of opposite forces but a downward thrust, sometimes a vortex with the sense of a stopper pulled out of a sink. This was the direction Gainsborough's basic doodles on paper took, and out of them he constructed his roads winding down to darkness and his plodding herdsmen and flocks.

I have saved for last Gainsborough's one history painting, his one mythological subject,[53] sketched repeatedly and painted near the end of his career. This is *Diana and Actaeon* (Royal Collection),[54] which shows Actaeon looking down at the nymphs who are already in the pond, and it is the look *down into* the pond at the figures of the nature spirits, turning and twisting so as to draw him and our eyes down and into the water, that transforms him into animal nature. Diana's gesture, which is in fact to fling water in his face and work the transformation, seems more a beckoning or an offering of her hand. Gainsborough has followed his text, Ovid's *Metamorphoses* (Bk III), closely—probably the Addison translation which emphasizes the dark, overgrown vale, the grotto, and the water at the bottom. In *Diana and Actaeon* he finally restates in the conventional terms of academic art the theme of all his landscapes and many of his portraits.

It is worth mentioning that if Gainsborough had carried out the illustrations he wanted to make for the Shakespeare Gallery, they would have been the grave-digger in *Hamlet* and Timon in solitude. The former, at any rate, would presumably either have shown the grave-digger in the grave, with Hamlet looking down at him, or standing above the grave that slopes down under his feet.[55]

I have tried to show how an artist attempts to break away from the old tradition of art as a sister to poetry or to moral philosophy, and what form in fact such a break took in Gainsborough's particular person, time, and place. What Gainsborough shows is the impossibility of a complete break, the tribute still paid to the conventions being reacted against, and the way a new system of meaning is formed to replace the old. For meaning is still being engendered by Gainsborough's forms, as they were by Hogarth's, though it is now largely

personal. In his public performances, his portraits, Gainsborough plays wittily with form and comes nearest to his own statement in those portraits in which man is part of a landscape. In his private performances, his landscape paintings and even more his drawings, he is expressing his own deepest feelings, developing a symbolism that minimizes conventional iconography or literary reference but that is as evocative to a viewer as to its artist. By means of his formal relationships between the shapes of nature and of humans, of areas of light and darkness, of powerful diagonals thrusting downward, he has created his own graphic language.

The downward descent, I have argued, involves not a resolution of formal elements but only a longing for resolution. We recall Gainsborough's own words in his letter to Chambers about wanting to retire to a cottage, or more poignantly his words in another letter: 'I'm sick of Portraits and wish very much to take my Viol da Gamba and walk off to some sweet Village when I can paint Landskips and enjoy the fag End of life in quietness and ease.'[56] Plainly, as Hayes notices, this is a reference to his arcadian subject matter.[57] But we also have to relate the idyllic world of the landscapes and fancy pictures—with its hazy forms, its descents into dark, deep, wet, womblike peace, perhaps death and/or rebirth, certainly primal nature—with Gainsborough's evenings of doodling, his dissatisfaction with wife and daughters and society and painting its portraits, and his desire to escape into some such world as he portrayed.

It would be dangerous to extend this analysis further into psychoanalysis. But a new language cannot be created out of nothing, and it is necessary, however tentatively, to speculate whether the form or the representation takes precedence in Gainsborough's imagination. There are a few obvious models in art: the Rubens landscapes of shepherds taking their flocks down into a pond or stream (three in the National Gallery, London, and *Landscape with Shepherds* in the Dulwich Gallery). To walk through the Dulwich Gallery is to encounter precursors of the Gainsborough landscape in Wouwerman's *Halt of Travellers*, which has the downward slope supported by the curve of a stunted tree, and Pynacker's *Bridge, Italian Landscape*, with the cattle leaving the bridge to

158

158 Thomas Gainsborough, *Diana and Actaeon* (late, unfinished). Royal Collection.

descend toward water. Murillo's *Two Spanish Peasant Boys* has the foot of one turned down to lead the eye off the canvas, like so many of Gainsborough's peasant girls and boys (though the two boys' mutual glance holds the centre of the picture in a tension avoided by Gainsborough).[58]

Gainsborough draws on such pictures, but he exaggerates and repeats, concentrating their multifold qualities into a single set of forms, a single theme, on which he works variations throughout all of his landscapes, virtually without exception. Perhaps what leads to his simplification and stylization of these landscape tendencies is a contemporary rococo emphasis. I must admit that after appearing in a great many paintings these shapes, the leafy foliage, the sketchy tree trunks, become mainly a mannerism. One realizes that the background is not reconstituted, or rethought, with every

picture but simply repeated. This stylization may distinguish Gainsborough from the first rank of artists; it may confirm the view that he is after all a pure formalist; or it may only be evidence that he is to be treated as a temperament rather than an intellect. It may even suggest that we have to regard every one of these backgrounds qua representation as virtually nil, with meaningful content only as far as they relate to foregrounds; and that we must push back the meaning to the very first performance —the rest being all repetitions or variations of this; and even at the first performance there is the strong possibility that Gainsborough is painting so fast, reacting so automatically to formal demands, that the form is far more important than any meaning generated; the representation merely follows as the most conventional, the most ready-to-hand. If so, we must nevertheless demonstrate what may

225

159 Antoine Watteau, *La Pellerine Altérée*. Engraving by Huquier (1715).

have directed that automatic hand and indicate that these are still empirical images, however close they may approach on some level of intention to the Blakean visionary image.

We might suppose that Gainsborough shapes experience according to a mode of picture-making he derived from Gravelot and Hayman and the St Martin's Lane artists, carrying it a bit further, making it more elegant, and following it naturally into certain representations. He would have known the French pattern books of the 1730s through these artists, and he began his own career in the 1740s working on decorative patterns like those surrounding the Houbraken heads.[59] As

159 early as 1715 an engraving after a decoration by Watteau showed two large S curves in the representation of the intersecting slopes of a

hillside, emphasized by twisting trees, with a rustic couple lingering in the intersection.[60] But a very similar rococo form and representation, not long after Gainsborough's in the painting of Philippe Jacques de Loutherbourg, produces a very different representation. In Loutherbourg's formulation people are coming up out of the valley onto a jutting promontory of land. If Gainsborough's mythic prototype is *Diana and Actaeon*, Loutherbourg's is the Deluge with a small band of survivors that have struggled up to a high point, or a raft of survivors from a sea disaster.[61] His is actually a Tiepolo-like rococo, appropriate to a ceiling, of people rising against a sky which fills much of the picture.

From the rococo pattern books, however, Gainsborough could have selected representations that corresponded to one emphasis of the serpentine form. At the beginning the C and S curves were embodied in rocaille, shells, and cartouches, and the basic rococo representation is, of course, the conch shell, whose sense of coiling inward to some unknown interior recalls the origins of rococo in the rocaille of a grotto. (The shell could, of course, also point upward, as in Hogarth's crest, with a totally different effect. Gainsborough's is turned on its side and we look into its coil.) The grotto of eighteenth-century paintings and gardens, toward which rococo pattern books tended to gravitate in their representations, was a place of 'water, sea shells, rocky concretions and moss', which terminated in water, the sacred

springs of the Greeks and Romans.[62] In some of the designs 'the water and the rocks have almost become amalgamated, forming a new, unreal, ambiguous substance'. In the designs of Meissonier and La Joue the rococo

cartouche itself simply melts into these grotto-shell shapes of indeterminate substance, whose effect has been described by such phrases as 'soft zoomorphic', 'layers of raw-tripe', and 'partly shell and partly flesh'.[63]

That Gainsborough's landscape scenes are so evocative may not be due to their forms alone but to what these forms have come to represent—to our memories of certain scenes. What we may detect in *Diana and Actaeon* is the paradigm from which the landscapes and fancy pictures derive by a process of subtraction, rather like that of Thomson's *Seasons*, where the pagan gods were replaced as presiding deities by the seasonal cycle and weathers. Behind the landscapes and fancy pictures can be sensed not so much Dutch landscapes as Titian's *Diana and Actaeon* (Edinburgh), or rather its contemporary versions, best known in Boucher's scenes of nymphs in grotto-like surroundings. In the 1740s he was producing his *Leda and the Swan* (Stockholm), *Diana's Return from the Hunt* (Musée Cognacq-Jay, Paris), and *Diana's Bath* (Louvre), in which nymphs are descending, preparing to descend, or virtually sinking into a pond at the bottom of steep banks.[64] Perhaps what Gainsborough has produced is a demythologized (or *re*-mythologized) grotto from which the nymphs, mermaids, and sea monsters have been removed, or replaced with neutral herdsmen and flocks, leaving only the sense of the conch shell of indeterminate substance, probably more verdure than rocaille, and the descent into water.

160 J.-A. Meissonier, rocaille decoration, no. 32 from *Livre d'ornamens*. Engraving.

161 Jacques de la Joue, rocaille decoration. Engraving.

162 François Boucher, *Diana's Return from the Hunt* (1740s). Paris, Musée Cognacq-Jay.

Looked at in one way, such a remythologizing turns a figure like Mrs Sheridan, introduced into this setting, into a *genius loci*—equally a naturalization of the human and a humanization of the natural. As the place associated with a Horace or a Shakespeare is consecrated by his genius, so is this place by the presence of Mrs Sheridan. Words applied to Collins' personification of Evening apply equally well to Mrs Sheridan: 'As spirit of place, she is both spirit and place', both 'a divine person who governs the scene' and 'immanent in the scene itself'.[65] But even when she is absent, the landscape remains numinous or semi-divine.[66]

The direction in which Gainsborough is carrying the rococo forms and representations is toward the labyrinth Georges Poulet describes as an expression of both a search for the infinite and the paradox of enclosure within infinity.[67] (Poulet refers to the labyrinth in which Theseus wandered, but the term is also applicable as the coiling, conch-like structure of the inner ear.) Poulet's example is Piranesi's *Carceri*, which show stairways disappearing off the bottom of the picture but also into its upper reaches, and yet enclosed by huge implied over-arching structures and the known confinement of a prison. Piranesi is a useful analogue to Gainsborough, because he too has been described as a formalist: 'As near as the eighteenth century gets to abstract art outside music, [his *Carceri*] are purely formal designs exploring problems in spatial composition.'[68] The first state of the *Carceri* (1745) with their Tiepolo-like light and rising forms, are not too far from the light, delicate, even elegant forms, the airiness and fancy of the Gainsborough landscapes, with also perhaps something of the decorative quality. Quite different then are the 1761 *Carceri* in which he darkened and emphasized depth, moving toward the Burkean sublime. With them we move into the effect of Vathek's damnation in the Halls of Eblis, the terror of the fleeing maidens through the Gothic tale's endless corridors and suites of chambers, and the fascination with maelstroms, pits, and chasms.[69] In the next stage these become Turner's vortical compositions of the 1830s and 40s, which, however, go off into the depth of the picture space rather than downward, and which Lord Clark has interpreted as 'the expression of Turner's deep pessimism, for the thought of humanity as doomed to a senseless round, which ultimately sucked man to his fate'.[70]

But already by the 1730s, in the pattern books, Meissonier is exploiting the potential for grotesque distortion in the rococo forms, or (perhaps we should say) in the rocaille, shell, and cartouche shapes in which they were represented. The asymmetrical rococo cartouches have become monstrous architectural structures, but structures that waver and twist with a downward-moving effect like the cartouches.[71] In Filippo Juvara's *Prospettiva Ideale* of 1732 the shapes have already become stairways like Piranesi's leading downward off the page, partially closed by arches. By 1753 the designs (called *Holz und Stein*) of Johann Esaias Nilson have transformed the rocaille into gutted tree trunks, scooped-out hillsides, and deformed rock shapes close to the vortical.[72] It is plain that both Piranesi and Gainsborough were developing along the same line of natural representation and grotesque distortion and vortical hallucination—augmented in Gainsborough's case by his blurring of forms in the application of paint and chalk—that led to the apocalyptic fantasies of Meissonier and Nilson.

It is also, of course, quite possible that Gainsborough simply reflects a nostalgia for the Sudbury landscape of his childhood, exaggerated in recollection into a particular, simple shape.[73] I might hazard that his landscapes are like Piranesi's prisons in that both are formal constructions out of imagination, but with certain *données*, cultural and personal. Piranesi begins in Tiepolo's shop and there is an initial formal predilection, connected in Tiepolo's *Capricci* and in the stage sets he also helped to paint, with a certain content; but also with a real and personal content of his own: his obsessive memory of the harbour works, scaffolds, piles, and foundation stones of his youth. These, combined with memories of the Baths of Caracalla and other public works of the Romans, produced his designs, as the concatenation of circumstances I have outlined may have produced Gainsborough's.

Following from what has been said of a demythologized history painting, we might ask whether Gainsborough's intention does not also include a reaction against the conventional flat floors and closed perspective space of

Hogarth and George Lambert and, in larger terms, the classical formula of Claude which was essentially a stage design constructed on the 'wing' principle, planar in structure, closed and balanced (in Hayes' sense) by wings of trees on the sides and classical buildings in the distance.[74] Behind his particular forms and representations may lie a reaction against the history painter's use of architectural backgrounds as an objective and mathematically-constructed spatial container for the human form of rational Albertian proportions; and against the landscape painters who used this perspective box as a way toward the dignity of history painting.

The result was a radical displacement of perspective based on a spatial box and straight lines with one based on curves, as if seen through a convex lens; a displacement of the complex Euclidian universe with one constructed on the simple principle of a vortex or maelstrom with a vacuum at its centre which draws to it whatever it can affect. Space is open at the top and closed *and not closed* at the bottom, where the path trails off. The vortex is not a threat, as in Piranesi and the Gothicists, but is it an escape or a haven, freedom or a trap? The comfort of an implied closure is offered, and water, perhaps the nourishment of an amniotic fluid, but also the hint of non-closure and a continuous drop. The ambiguity may only express Gainsborough's exploration of representational possibilities within the S curve, or it may express his own fear that he did not certainly know which of these things nature, depopulated of its nymphs and familiar spirits, meant. The question of whether nature is friendly or threatening may have an answer in the fact that Gainsborough seems to be looking back from the centre of the vortex rather than from the outer rim inward. To pass through a vortex is to see nature from its own point of view, from which just those distinctions are blurred that Gainsborough blurs in his ultimate landscapes.[75]

Diana then is like the lady in shimmering pink in *L'Enseigne de Gersaint* who beckons one into the scene. But in his landscapes Gainsborough dispenses with the threshold of man-made stone separating us from the landscape. There is only the depth of nature, into which the figures are retiring, and a kind of beckoning. This metamorphosis may be the basic trans-

action of the painting; for the merger that was shown happening to Actaeon, to Mrs Sheridan, and to some shepherds, is also the effect on the viewer of the landscape, perhaps parallel to that on the painter.

As Reynolds' attempt to understand him in the fourteenth Discourse shows, Gainsborough was initiating a kind of communication that is quite different from the essentially literary associationism of the P.R.A. A welter of dashes and daubs of colour which makes no sense close up, at a distance becomes denotative; his portraits were successful as likenesses, Reynolds suggests not without some malice (he was aware that Gainsborough got better marks on likeness than he), because they leave so much to the imagination. 'It is presupposed that in this undetermined manner there is the general effect; enough to remind the spectator of the original; the imagination supplies the rest, and perhaps more satisfactorily to himself, if not more exactly, than the artist, with all his care, could possibly have done.'[76] The viewer can see what he wants to see; and if he knows the sitter, he will recognize him in the vague outlines of Gainsborough's face. (If he sees the portrait first, he may detect the *difference* once he sees the original subject.) What Reynolds with his customary astuteness remarks of portraits is also true of Gainsborough's landscapes. The vague shapes are recognized and filled in by the imagination and memory of the viewer, and they become his own.

Both Reynolds and Gainsborough represent solutions to the problem raised by the critical change from the desirability of a 'readable' structure of meaning in a work of art to the 'aesthetic' pleasure of an immediate psychological response to a visual stimulus. Clarity, an immediate comprehension unclouded by the need to interpret, was demanded of literature and art. Reynolds' solution was the single gestalt, the clearly delineated emblem, best seen in a masterful shape like his portraits of Samuel Johnson. Gainsborough's response was the opposite, the evocative. Accompanying a visual emphasis, a movement away from the verbal, intricate, and explicatory, is an unspoken suggestivity that can be produced by imprecision. In art the sketch held possibilities for this sort of evocation, but the theory was literary: 'A Break, or Pause in Poetry is sometimes more significant than any Thing, that might have

been said. . . .' Longinus' example, the silence of Ajax (*Odyssey* XI), was repeated throughout the century.[77] The effect may involve obscurity, but rather in the Burkean sense of the suggestive than in the unfashionable sense of a puzzle to be worked out intellectually. Obscurity is itself an impression, which is made on the mind instantaneously, requiring no interpretive effort. The deep shadows of Gainsborough's landscapes in those areas where water, trees, animals, and people drift together are evocative in this sense; and the imprecision of the portraits that Reynolds tried to understand can be seen as another way of arriving at the immediate and good gestalt he achieved himself through a pattern of chiaroscuro.

The literary equivalent is more easily located than the graphic: when in Sterne's *Tristram Shandy* the rational forms of communication collapse, an irrational one emerges made of hems and haws, glances of the eyes, the drop of a hat, dashes and squiggles on the page, and ultimately blank spaces or pages which are to be filled in by the reader's imagination. The graphic equivalent of Sterne's aposiopesis is Gainsborough's dashes and daubs of paint. Here we have the evidence of Gainsborough's letters written in the style of Sterne, with Sterne's distinctive punctuation;[78] and we know the general function of the rhetoric and punctuation to be the same in both—a sophistication and wit, and at the same time a close intimacy with the audience, which is invited to supply much of the meaning—and this itself a criticism of more fixed and formulated types of meaning, whether marriage contracts, novels, or history paintings.

This is a very different thing from the closed finished 'photographic' surface of a painting by Wright which, with its eye-catching figure within the scene, makes the viewer a spectator; while Gainsborough's makes him a participant. It is also different from the intimacy shared by a reader with a work of Hogarth or Fielding. When the narrator of *Tom Jones* says that Blifil is 'strongly attached to the interest only of one single person; and who that single person was the reader will be able to divine without any assistance of ours', the reader is asked to complete the narrator's idea, sharing his experience, but his choice of response is limited. The narrator shows, again and again, that he shares with the reader—at least the 'Observer of much Pene-

tration' vs. all those other less penetrating readers Fielding likes to categorize—a deeper understanding which makes further discussion simply unnecessary. When Tom has had his bloody battle with Thwackum and Sophia faints from the 'sight of blood, or fear for her father, or from some other reason', we know it was none of these but love of Tom.[79] The reader gains what *appears* to be, but of course is not, an active part in constituting the fiction he is reading.

Sterne points to the difference when he remarks, in a letter of 1768, the year *A Sentimental Journey* was published:

A true feeler always brings half the entertainment along with him. His own ideas are only call'd forth by what he reads, and the vibrations within, so entirely correspond with those excited, 'tis like reading *himself* and not the *book*.[80]

Sterne's aim is to present suggestive pictures, with language and typography, by the materials of the 'views' and 'designs'. The first attempt in *Sentimental Journey* to realize another figure is the monk's head, which 'was one of those which Guido has often painted', and 'The rest of his outline' is given by Yorick 'in a few strokes; one might have put it into the hands of anyone to design'—i.e., to carry out or execute.[81]

In Gainsborough's paintings we have the visual evidence—the use of paint and form—and his own statement in the form of his musical analogy: 'one part of a Picture ought to be like the first part of a tune, that you could guess what follows, and that makes the second part of the Tune'.[82] This could mean that he shows you one part and lets you imagine the other—a verbalization of the rococo structure of curves, one implying a resolution that does not appear—and that takes the representation of slopes into darkness. It also means that the viewer himself is made to take part in the metamorphosis that is at the heart of the painting.

But Gainsborough's peasants and mules are also, like those in Sterne's works, *seen* in a certain way by a Parson Yorick or a Tristram; exquisitely sentimental subjects here seldom strike us as sentimental (though they are often later rendered so by the copyist-engraver who reproduced Gainsborough's paintings) because they are distanced by style into an almost pure play with form. In terms of his viewer,

Gainsborough is painting these objects as they would be seen through a haze of sophistication and nostalgia. But the way the peasant girl or the landscape looks is both an open experience for the viewer and an expression of the ambivalence of Yorick or Tristram: the blank on the page that is to be filled in by the reader with a portrait of the Widow Wadman is also, like everything else in the novel, an emanation of Tristram's own mind, the stylistic imprecision qualifying the ordinary meaning of the content.

The original process of abstraction in Gainsborough's paintings is closely related to Hogarth's visual mnemonics, and may be a result of Hogarth's preaching at the St Martin's Lane Academy and in his *Analysis.* The difference, however, is that when Hogarth put his personal mnemonic abstractions on paper they materialized in complete representations, serving the function for him of shorthand. Only in the marvellous oil sketches, which he preserved, and which Gainsborough may have known, does he keep something of the purity of the mnemonic formulae; judging by the finished product—a *Marriage à la Mode*— he is trying to get the true, essential structure of a scene; whereas Gainsborough is trying to represent how that scene felt to him, and will feel to the viewer.

Like Hogarth, Gainsborough was recollecting forms, essentially as reflected in his memory, and was trying to recapture the part of the total experience which he felt to be important. But Gainsborough, as he must have realized, was transforming nature in the process. Perhaps as much as Gainsborough, Hogarth and the empiricists Stubbs, Zoffany, and Wright were concerned with metamorphosis, but in strictly human and social terms. They depict the *attempt* at metamorphosis, or role-playing, costume-assuming, with failure ending in discrepancy. Even in Wright this is only the attempt to turn a bird into a Paraclete, a white-hot ingot into a miraculous transubstantiation, which never quite works because we remain aware of the physical nature of the transforming imagination—the candle vs. the normative light of nature. The stubborn barriers remain, the various viewers *do not* all understand the metamorphosis, or each does in his own way. But in Gainsborough's paintings the transformation is taking place.

Gainsborough is the only painter of the group we have dealt with whose paintings can be regarded either as the case of a poet transforming reality or as a structure that requires the viewer's active participation.

One thing we learned from Hogarth was that dictionary definitions will never help us to a picture's meaning; we have had to explore usage, context, and relationship. The comic demonstration of this fact in Hogarth's work has proved paradigmatic for the operation of iconography in the second half of the century. The development we have traced is from Reynolds and a grammatical system, based on eternal normative laws of syntax and semantics, to Wright and Gainsborough and what we might call, by analogy, a philological system in that origins of images are sought and both artist and viewer reach back in search of an etymology (*etymos logos*, authentic meaning), which is, in effect, a new beginning.

Notes

Introduction

1. *The Poetry and Prose of William Blake*, ed. David V. Erdman (New York, 1965), p. 550.

2. Quoted, Suzi Gablik, *Magritte* (London, 1970), pp. 143–44.

3. The example is Robert Melville's in 'The Guiding Light', in *The Sunday Times Magazine* (London), 20 April 1973, p. 54. I do not mean to suggest the necessity of reference to objects in the real world. As Wittgenstein said, 'The meaning of a word is its use in the language', and not its correspondence to a real object; and the same is true of objects depicted in a painting. (*Philosophical Investigations*, tr. G. E. Anscombe [Oxford, 1953], p. 20ᵉ.)

4. Quoted, Rudolf Berliner, 'The Freedom of Medieval Art', *Gazette des beaux arts*, ser. 6, XXVIII (1945), p. 277.

5. *Symbolic Images: Studies in the Art of the Renaissance* (London, 1972); Gombrich also cites Hugh of St Victor, p. 212.

6. *Elements of Semiology*, tr. Annette Lavers and Colin Smith (Boston, 1968 [with *Writing Degree Zero*]), p. 10.

7. Svetlana and Paul Alpers, 'Ut Pictura Noesis? Criticism in Literary Studies and Art History', *New Literary History*, III (1972), p. 449. Cf. in the same periodical issue devoted to the subject of the relationship of art and literature, Jean Laude, 'On the Analysis of Poems and Paintings', p. 478. A number of suggestive works on the subject have appeared in the last few years; e.g., Jean-Louis Schefer, *Scénographie d'un tableau* (Paris, 1969) and 'Note sur les systèmes représentatifs', *Tel Quel*, spring 1970, pp. 44–71; Louis Marin, *Études sémiologiques: écritures, peintures* (Paris, 1971); and Jack Burnham, *The Structure of Art* (New York, 1971).

8. *The Pound Era* (Los Angeles and Berkeley, 1971), p. 32.

9. Gablik, op. cit., pp. 9, 25, 68.

10. I refer to both Levey's *Rococo to Revolution* (London, 1966) and (with W. G. Kalnein) *Art and Architecture of the Eighteenth Century in France* (Pelican History of Art: London, 1973). I should add that a few art historians have recently tried to show how some of the artists I deal with merely continue with traditional iconography. Frederick Cummings has done good work along this line. But I shall argue that the reconstitution is much more complex than a mere continuity qualified by eighteenth-century empiricism.

11. *Validity in Interpretation* (New Haven and London, 1967).

12. These are Hirsch's terms; echoed in Gombrich, *Symbolic Images*, pp. 4–5 and passim.

13. (Princeton, 1967): a study of great value in understanding the origins of the neoclassical movement and of French art in general.

14. (Philadelphia, 1965).

15. Letter to Thomas Butts, 6 July 1803. Rowlandson is the actual end of the road begun by Hogarth. I had originally intended to conclude my study with him, Blake's 'spectre' with virtually the same birth and death dates, but instead I published a separate book, *Rowlandson: A New Interpretation* (New York and London, 1972). See also 'The Spectres of Blake and Rowlandson', *The Listener*, XC (2 August 1973), pp. 140–42.

1. Illustration and Emblem

1. Derek Clifford, *A History of Garden Design* (revised ed., London, 1966), pp. 144–45.

2. Charles Lamb, 'On the Genius and Character of Hogarth', *The Reflector*, II (1811), p. 61.

3. *Tom Jones* (1748/9), Bk X, chap. viii.

4. *An Essay on the Theory of Painting*, pp. 44–45.

5. See, e.g., David R. Coffin, *The Villa d'Este at Tivoli* (Princeton, 1960).

6. Jean Hagstrum, *The Sister Arts* (Chicago, 1958), p. 107. See also Rensselaer W. Lee, 'Ut Pictura Poesis: The Humanistic Theory of Painting', *Art Bulletin*, XXII, (1940), pp. 197–269; Ralph Cohen, *The Art of Discrimination* (Berkeley, 1964), pp. 188–247; and for the application to Hogarth, Paulson, *Hogarth: His Life, Art, and Times* (New Haven and London, 1971), I, p. 262 ff.

7. These ideas are developed more fully in Paulson, 'The Tradition of Comic Illustration from Hogarth to Cruikshank', in *George Cruickshank: A Revaluation*, ed. R. L. Patten (Princeton, 1974), pp. 35–60.

8. See Gombrich, *Symbolic Images*, pp. 127–30.

9. One literary source would be Lucretius' appeal at the opening of *De rerum natura* to Venus to lure Mars to love and so bring peace to the Romans. The artist can also, of course, simply reverse this, as

Rubens does when he shows Mars shunning Venus' embraces in *The Horrors of War* (Pitti Palace, Florence; see Gombrich, p. 127).

10. See, e.g., Seymour Slive, 'Realism and Symbolism in Seventeenth-Century Dutch Painting', *Daedalus*, XVI (1962), 469–500.

11. See Julius Held and Donald Posner, *Seventeenth and Eighteenth-Century Art* (New York, 1972), p. 226; also Posner, *Watteau, A Lady at her Toilet* (London, 1973), chap. 5.

12. Earl R. Wasserman, 'Johnson's *Rasselas*: Implicit Contexts', *Journal of English and Germanic Philology*, forthcoming.

13. Or lemma (inscriptio, motto), icon (imago), and emblem (subscriptio). See W. S. Heckscher and K.-W. Wirth, *Reallexikon zur Deutschen Kunstgeschichte*, V (Stuttgart, 1959), 'Emblem', col. 88, 153; A. G. C. de Vries, *De Nederlandsche emblemata* (Amsterdam, 1809), p. 10; Hessel Miedema, 'The Term Emblema in Alciati', *Journal of the Warburg and Courtauld Institutes*, XXXI (1968), pp. 234–50, shows that this structure cannot be connected with Alciati himself, but it is nevertheless what we find in the seventeenth and eighteenth centuries.

14. See Richard M. Wallace, 'The Genius of Salvator Rosa', *Art Bulletin*, XLVII (1965), pp. 471–80.

15. *Mysteriously Meant* (Baltimore, 1971), pp. 282–83.

16. See G. L. Hersey, 'Associationism and Sensibility in Eighteenth-Century Architecture', *Eighteenth-Century Studies*, IV (1970), p. 77.

17. See Hagstrum, op. cit., p. 101.

18. *An Explanation of the Painting in the Royal Hospital at Greenwich . . . Published by Order of the Directors of the said Hospital, for the Benefit of the Charity-Boys maintain'd there*, pp. 5–6. The pamphlet is undated, but it is closely related to Steele's *The Lover*, no. 33, 11 May 1714. Although I believe Thornhill supplied the interpretation, if not the writing, it is quite possible that the final version is Steele's.

19. Discourse IV, *Discourses in Art*, ed. R. R. Wark (San Marino, California, 1959), pp. 63–64.

20. Levey, *Rococo to Revolution*, p. 30.

21. Gombrich, *Symbolic Images*, pp. 6–7 and passim.

2. The Poetic Garden

1. Part of this chapter appeared in an abbreviated form in *The Listener*, XC (27 December 1973), pp. 878–80.

2. Hannah More, letter to her sisters, December 1782; cited, Dorothy Stroud, *Capability Brown* (London, 1950), p. 199.

3. Hadrian's gardens were known to have included a wilderness as well as formal gardens; Renaissance gardens like the Villa Lante had shown some awareness of Hadrian's precedent. The Vale of Tempe was a wild landscape constructed to serve as a setting for the Temple of Venus on a hilltop overlooking it. While someone could perhaps have walked down into the landscape, terraces were constructed for an overview, and a picture was the essential object. See Georgina Masson, *Italian Gardens* (London, 1966), pp. 34–36; Maynard Mack, *The Garden and the City* (Toronto, 1969), pp. 21–24.

4. See Laurence Whistler, *Sir John Vanbrugh* (London, 1938), pp. 223–25; and for more recent opinion, Christopher Hussey, *English Gardens and Landscapes, 1700–1750* (New York, 1967), p. 130.

5. 'Unconnected Thoughts on Gardening', *The Works in Verse and Prose of William Shenstone, Esq.* (2nd ed., 1765), II, p. 113.

6. *The Work of William Kent* (London, 1948), p. 49.

7. See Gilbert West, *Stowe, the Gardens of the Right Hon. Richard Lord Viscount Cobham. Address'd to Mr Pope* (London, 1732), and the official guide, Seeley's *Description of The Gardens of Lord Viscount Cobham, at Stow in Buckinghamshire* (1744, *et sec.*). Both began at the south entrance at the Lake Pavilions and followed the general route I am pursuing. The *Guide* identifies the paintings and statues, transcribes and translates the inscriptions.

8. Robert Morris, Lecture X, in *Lectures on Architecture* (1734), p. 161.

9. Cf. Addison, *Spectator* No. 476: in the loose or Senecan sentence 'I fancy my self in a Wood that abounds with a great many noble Objects, rising among one another in the greatest Confusion and Disorder'; in the periodic or Ciceronian sentence, 'I am in a regular Plantation, and can place my self in its several Centers, so as to take a view of all the Lines and Walks that are struck from them. You may ramble in the one a whole Day together, and every Moment discover something or other that is new to you, but when you have done you will have but a confused imperfect Notion of the Place; in the other, your Eye commands the whole Prospect, and gives you such an Idea of it, as is not easily worn out of the Memory.'

10. *Dialogue upon the Gardens . . . at Stow . . .* (1748; pp. 15, 16, 57). In his 'Unconnected Thoughts on Gardening', Shenstone advocated a series of 'landskips' one could see from different viewpoints, and Robert Dodsley's 'Description of the Leasowes' tells how the seats were placed at intervals from which a cascade or a church steeple could be seen first in one way and then 'in a new light'. The statue of a piping faun 'not only embellishes this scene', we are told, 'but is also seen from the court before the house, and from other places'. We are referred to a bench that 'affords the first, but not most striking, view of the Priory', or one that gives 'a nearer view' (in *Works in Verse and Prose of William Shenstone, Esq.*, II, pp. 116, 291, 296–97, 305).

11. 'Essay on Homer's Battles', prefatory to *Iliad* II (1716).

12. Mack, *Garden and the City*, p. 28.

13. See Derek Clifford, *History of Garden Design*, pp. 141–43; Hussey, *The Picturesque: Studies in a Point of View* (London, 1927), pp. 130–31; preface to Stroud's *Capability Brown*, p. 18; and *English Gardens and Landscapes*, p. 158.

14. Gilbert West's walk around Stowe in 1731 defines the pictorial circuit, although he does not draw attention, as Gilpin does, to the effect; cf. Michael Gibbon, 'The History of Stowe—IX', *The Stoic* (Spring 1970), p. 59; and George Clarke's similar reconstruction of the walk and experience in 'The Gardens of Stowe', *Apollo*, XCVII (June 1973), p. 562.

15. *Description*, p. 12.

16. See John Wilkes in *New Foundling Hospital for Wit* (1784), III, pp. 104–07; J. Almon, *Letters of John Wilkes* (1774–96), III, pp. 60–63.

17. It does, of course, strike us as odd that a statue of Hercules vanquishing Antaeus should have stood at the entrance to the grazing area; Antaeus' connection with the earth was appropriate, but not his defeat, unless as a wry allusion to the infertile clay that made the land good for nothing except grazing.

18. The resemblance between the distant shapes of Rotondo and Temple of Ancient Virtue was stronger in the eighteenth century before the revision of the Rotondo's dome.

19. Clarke, 'The History of Stowe—X', *The Stoic* (summer 1970), pp. 113–21; 'Grecian Taste and Gothic Virtue: Lord Cobham's Gardening Programme and its Iconography', *Apollo*, loc. cit., pp. 566–71.

20. Gilpin, *Dialogue*, p. 21; also pp. 22, 34, etc.

21. See Laurence Whistler, Michael Gibbon, and George Clarke, *Stowe: A Guide to the Gardens* (Stowe, 1968), p. 6.

22. Noted by Clarke, 'Grecian Taste', p. 570.

23. This is the insight of John Dixon Hunt, 'Emblem and Expressionism in the Eighteenth-Century Landscape Garden', *Eighteenth-Century Studies*, III (1971), p. 298.

24. Clarke is wrong when he argues that the British Worthies are *behind* Ancient Virtue, as in the *Tatler* allegory. Ancient Virtue may have terminated the Cross Walk, but only as a view; the Worthies could not have been seen behind it, and the path that leads to and into Ancient Virtue is from the north entrance to the Elysian Fields: the steps and the door open onto this path. See Clarke, 'Gardens of Stowe', p. 562; and 'Grecian Taste', pp. 566–67.

25. Once again the meaning is underlined by the inscription under the bust of Mercury: 'Campos Ducit ad Elysios' (leads to the Elysian Fields).

26. Dodsley, 'Description of the Leasowes', in *Works in Verse and Prose of William Shenstone, Esq.*, II, p. 291. By 1753 there were sixteen editions of the guidebooks to Stowe (one in French) and two pirated editions, and two sets of engraved views.

27. Or, as George Clarke has put it, the visitor used the garden scenes for 'conversational topics during his afternoon walk' ('Grecian Taste', p. 566).

28. Shenstone, *Works*. II, p. 116.

29. This would be E. R. Wasserman's explanation in *The Subtler Language* (Baltimore, 1959), p. 170.

30. The Grecian Valley was originally planned to have a lake and be closed by a triumphal arch at the end of the valley, presumably seen from the Grecian Temple.

31. Gilpin, *Dialogue*, p. 41.

32. Ibid., p. 58.

33. For another explanation of the Vale of Venus group, see Hunt, op. cit., p. 303.

34. *Spectator* No. 412; *Dialogue upon the Gardens . . . of Stow*, p. 54.

35. Gilpin, *Dialogue*, pp. 11–12.

36. See Sir Richard Colt Hoare, manuscript memoirs, Stourhead; and Kenneth Woodbridge, *Landscape and Antiquity, Aspects of English Culture at Stourhead 1718 to 1838* (Oxford, 1970), pp. 32–37; also Woodbridge, *The Stourhead Landscape* (National Trust, 1971). Shenstone, in his garden the Leasowes, another one-man enterprise, also required that the visitor follow a particular path ('Unconnected thoughts', *Works in Verse and Prose*, II, p. 114). However, when Horace Walpole visited Stourhead (1762) he went straight to the grotto across the lake, then to what he called 'the temple of Hercules' (the Pantheon), and perhaps to the Temple of Ceres (though it sounds as if he only looked at it across the lake). See *Visits to Country Seats*, Walpole Society, XVI (1927–28), p. 41.

37. The natural garden at Stourhead again stretched out at a tangent—very far

off in this case—from the old formal garden. The only visual connecting point was the obelisk that closed the formal garden on the axis of the house, which could also be seen from the Temple of Apollo at the end of the natural garden's path.

38. *Aeneid* III, tr. W. F. Jackson Knight (London, 1958), p. 77. Woodbridge's suggestion (*Landscape and Antiquity*, p. 31) is that Hoare had in mind Claude's *Coast View of Delos with Aeneas* (National Gallery, London); this would be an appropriate picture, because it shows Anius receiving Aeneas and preparing to prophesy about the New Troy. There seems little chance, however, that Hoare could have known the picture, which was in a private collection in France, and none that his visitors could have recognized it. He himself owned a copy of Claude's *View of Delphi with a procession*, which has a roughly similar composition (a bridge, a round-domed and a square building), which was also known through an engraving of 1764. For the dating of all the temples and statues, see Woodbridge, *Stourhead Landscape*, pp. 20–22.

39. *Aeneid* VI, tr. Knight, p. 154.

40. Henry Hoare, to Lord Bruce, 23 December 1765, quoted, Woodbridge, *Landscape and Antiquity*, p. 35n.

41. *Aeneid* VI, tr. Knight, p. 151.

42. Ibid., p. 203; for the inscription, see Woodbridge, *Stourhead Landscape*, p. 20.

43. *Aeneid* VIII, tr. Knight, p. 204. The first statue on the left as you enter is St Susannah, perhaps in memory of Hoare's wife Susannah, who died as he was beginning to plan the garden in 1743 (*Stourhead Landscape*, p. 21). Opposite is a statue of Isis. The statues on either side of the portico are of Bacchus and Venus Callipygos.

44. The *Prodicus*, the *Tabula Cebetis*, and Epictetus' *Enchiridion* were repeatedly published together in the eighteenth century (e.g., in the text of Joseph Simpson, fourth ed., 1758). In 1735 the Cebes was part of the projected curriculum for Samuel Johnson's Lichfield school as one of the introductory Greek texts with Aelian, Lucian, and Xenophon's *Memorabilia*, which of course contained the Prodicus Choice of Hercules. (See Johnson's letter of 1735 to Samuel Ford, in *Letters of Samuel Johnson*, ed. R. W. Chapman [Oxford, 1952], I, 7; and Sir John Hawkins, *Life of Samuel Johnson*, ed. Bertram H. Davis [1961], pp. 20–21.)

45. For the use of Hercules in the Villa d'Este, see Coffin, op. cit., pp. 82–84. The Poussin *Choice of Hercules* was bought by Sir Richard Hoare, Henry's brother, from Cock the auctioneer in 1747 (lot 119); I do not know exactly when the picture arrived at Stourhead, but it was there by 1762 when Walpole noted its presence (*Visits to Country Seats*, p. 42).

46. Here combined with details from a temple in Wood's *Ruins of Balbec* (1757); see Woodbridge, *Stourhead Landscape*, p. 21.

47. Shenstone suggested that his path around the Leasowes may 'resemble an epick or dramatic poem' which builds to dramatic climaxes ('Unconnected Thoughts', *Works in Verse and Prose*, II, p. 114). The analogy of garden and epic poem was itself a commonplace, deriving from classical authorities, but Shenstone also plays on the association of his garden with a new Troy, inscribing his grotto with an *Aeneid* quotation and associating the grotto with the African shore on which Aeneas landed in Book I.

48. He often, we have seen, uses an object in more than one way: the River God who is the source of the Stour and the advisor of Aeneas also had, attached to his cave entrance, a wooden tablet with an inscription from Ovid's *Metamorphoses* that identified him as a river god sitting here 'dispensing justice to the waves and to the nymphs who inhabited his stream'— i.e., the local J.P. (Tr. M. M. Innes; cited, Woodbridge, *Stourhead Landscape*, p. 21.)

49. *Description* (4th ed., 1747), p. 25; also Gilpin, *Dialogue*, p. 34.

50. Gibbon (op. cit., p. 62) has shown how emblematically the original British Worthies were arranged around Gibbs' building and how these figures were later related to the Saxon deities in the Gothic Temple, known originally as the Temple of Liberty, with motto 'Libertati Majorum', translated 'to the Liberty of our Ancestors'.

51. *The Garden and the City*, Chaps. 1 and 2.

52. Spence, *Anecdotes*, ed. James M. Osborn (Oxford, 1966), I, p. 418.

53. To Martha Blount, 22 June (1724), *Correspondence of Alexander Pope*, ed. George Sherburn (Oxford, 1956), II, p. 238.

54. Gilpin, *Dialogue*, p. 30.

55. Walpole, *Visits to Country Seats*, p. 42.

56. Ibid., p. 41.

57. Woodbridge, *Landscape and Antiquity*, p. 50.

58. Walpole, op. cit., p. 43. He also mentions, without identifying, pictures of Salome, Dido, Helen, Venus, and Andromeda.

59. See Rudolf Wittkower, *Architectural Principles in the Age of Humanism* (New York, 1962).

60. *Holkham* (guide, Norwich, 1969).

61. Laurent Morellet, *An Historical Explanation of what there is most Remarkable in that Wonder of the World the French*

King's House at Versailles (London, 1684; French ed., 1681).

62. See Gillo Dorfles, 'Structuralism and Semiology in Architecture', in *Meaning in Architecture*, ed. Charles Jencks and George Baird (New York, 1969), p. 39. This collection of essays is useful as a whole for its exploration of the application of modern linguistic theory to architecture.

63. It might not be wide of the mark to recall Waterhouse's thesis (in *Three Decades of English Painting*) that the heroic, inflated portraits produced by Reynolds and his imitators in the 1760s and 70s contributed to the unrealistic image of itself that the English ruling class fostered, leading up to the American Revolution.

64. On the use of pictures for emulation, see Jonathan Richardson, 'Essay on the Theory of Painting', in *Works*, p. 6.

3. The Hogarthian Progress

1. See Paulson, *Hogarth*, II, p. 275; Woodbridge, a note of 1757 for payment for engravings, mentioned in 'Henry Hoare's Paradise', *Art Bulletin*, XLVII (1965), p. 113.

2. Though Holkham was begun in 1730, it was not completed for thirty years, but it represents the sort of house Hogarth would have known at first hand in Wanstead House and perhaps Cannons. Holkham and Walpole's Houghton were notorious by repute long before they were completed and visited by the likes of Hogarth.

3. John Russell, 'Sir Joshua, P.R.A.', in *Narrative Art*, ed. Thomas B. Hess and John Ashbery, *Art News Annual*, XXXVI (1970), p. 40.

4. *Treatise the Third: Concerning Happiness, a Dialogue* (1741), in *Works*, ed. Earl of Malmesbury (1801), I, p. 94.

5. I am of course aware of the changes made in topoi by individual painters before Hogarth. Panofsky has described how the meaning of *Et in arcadia ego* pictures, part of the medieval *memento mori* topos, was radically changed by Poussin: 'Et in Arcadia Ego: Poussin and the Elegaic Tradition', *Meaning in the Visual Arts* (New York, 1955), pp. 295–320.

6. See Noam Chomsky, *Syntactic Structures* (The Hague, 1957), p. 15, and his discussion of 'meaningful' and 'nonsensical' new sentences ('colorless green ideas sleep furiously').

7. For a more detailed account of the *Harlot's Progress* along these lines, see Paulson, *Hogarth*, I, pp. 238–59. I return to the *Harlot* because this series is Hogarth's first, his opening gesture, and in some ways the most audacious use he made of his restructuring of iconography. I have made changes and additions to the material in *Hogarth*.

8. The identifications were made in the 1730s by George Vertue and others (see, e.g., Vertue's notebooks, Walpole Society, III, p. 58).

9. See Lairesse, *Art of Painting* (1707); and Paulson, *Hogarth*, I, p. 259.

10. *Tablature*, in *Second Characters*, ed. Benjamin Rand (Cambridge, 1914), pp. 36, 58.

11. The emblem appeared in Gabriel Rollenhagen, *Nucleus Emblematum Selectissimorum* (1611–13) and was reprinted in George Wither's *A Collection of Emblemes* (1635); repro., Rosemary Freeman, *English Emblem Books* (London, 1948), opp. p. 9. Hercules' choice is shown in an urban setting, a city street which resembles a stage set in Geoffrey Whitney, *Choice of Emblemes* (1568), p. 40. For a discussion of the Choice of Hercules as transitional in Shaftesbury's account, see Freeman, pp. 1–18. For the general prevalence of the Choice of Hercules, see Panofsky, *Hercules am Scheidewege* (Leipzig, Berlin, 1930); Theodor E. Mommsen, 'Petrarch and the Story of the Choice of Hercules', *Journal of the Warburg and Courtauld Institutes*, XVI (1953), 178–92; Marc-René Jung, *Hercule dans la littérature française du XVIᵉ siècle* (Geneva, 1966). On English literature, see Hagstrum, *Sister Arts*, pp. 190–97. On Hogarth, see Paulson, *Hogarth*, I, pp. 271–77.

12. It is possible that the bawd was meant for Mother Elizabeth Bentley (see *Hogarth*, I, pp. 533, 539). But even if this were the case, the Christian name remains the same.

13. Matthew Pool, *Annotations upon the Holy Bible*, II (London, 1685), under *Luke* I.37 ff. See also, e.g., Fra Robertus Caracciolus, *Sermones de laudibus sanctorum* (Naples, 1589), clii r.–cliv r.

14. For a full analysis, see *Hogarth*, I, p. 261.

15. Ibid., II, p. 409.

16. Gombrich, *Meditations on a Hobby Horse* (London, 1963), p. 122; cf. Erwin Panofsky, *Early Netherlandish Art* (Princeton, 1953), I, pp. 140–41.

17. See C. C. Malvasia, *Felsina pittrice. vite de pittori bolognesi* (1678), I, p. 468; Posner, *Carracci* (London, 1971), I, p. 65. For the general matter of the play between name and form (instead of form and form), see Ludwig Wittgenstein, *Philosophical Investigation*, tr. G. E. Anscombe (Oxford, 1953), pp. 193–200 (II.xi).

18. 'Epilogue to the Satires', I, p. 88; 'Rape of the Lock', III, p. 158.

19. 'MacFlecknoe', ll. 106–07.

20. See William Ivins, Jr., *Prints and Visual Communication* (Cambridge, Mass., 1946), and Marshall McLuhan, *The Gutenberg Galaxy* (Toronto, 1962).

21. 'Autobiographical Notes', in *Analysis of Beauty*, ed. Joseph Burke (Oxford, 1955), p. 229.

22. See John White, *The Birth and Rebirth of Pictorial Space* (2nd ed., Boston, 1967), pp. 29, 31, 35–36. The readers' movement into the perspective box has been described by Mercedes Gaffron as the 'curve of the glance', the movement up and into the picture space from the lower left ('Right and Left in Pictures', *Art Quarterly*, XIII [1950], pp. 312–13; and Paulson, *Hogarth*, I, pp. 409–11; and Rudolf Arnheim, *Art and Visual Perception* [London, 1969], p. 24).

23. See Panofsky, 'The Mouse that Michelangelo failed to Carve', in *Essays in Memory of Karl Lehmann*, ed. Lucy Freeman Sandler (New York, 1964), pp. 242–51; *Problems in Titian, mainly Iconographic* (London, 1969), pp. 88–89.

24. See Locke, *Essay concerning Human Understanding*, ed. A. C. Fraser (Oxford, 1894), pp. 211–12 (II, xi, 17).

25. *Analysis of Beauty*, ed. Burke, pp. 42–43.

26. On Hogarth's use of contemporary furniture styles, see Ralph Edwards, ' "The Dumb Rhetoric of the Scenery" ', *Apollo*, XCIII (1972), pp. 14–21.

27. Fry, *Vision and Design* (London, 1940 ed.), p. 31. Antal (in *Hogarth and his Place in European Art* [London, 1962]) is one example of someone who thinks Hogarth a moralist *tout simple*.

28. Fry, op. cit., p. 72.

29. Hogarth's formal characteristics might be compared with the sort of syncopation Emil Kaufmann attributes to Burlington, in which 'concatenation, integration, and gradation' become contrast, juxtaposition, and 'disregard of the almost sacrosanct Baroque hierarchy' (*Architecture in the Age of Reason* [Cambridge, Mass., 1955], pp. 22–26, 42).

4. Transition

1. *Spectator* No. 411.

2. E.g.: 'we have no other *Faculties* of perceiving or knowing any thing divine or human but our *Five Senses*, and our *Reason*', or the school axiom, 'nil est in intellectu, quod non prius fuit in sensu' (Peter Browne, *The Procedure, Extent, and Limits of Human Understanding* [2nd ed., 1729], p. 53).

3. *Essay concerning Human Understanding*, IV.iii; also III.x.1 and II.xxxii.10.

4. *Principles of Human Knowledge* (1710), I.i.

5. Ralph Cohen's hypothesis of the Augustan 'imitative imagination, in which the controlling "life" in art can approximate but never equal the "life" God created', may oversimplify Pope's art-nature themes, but it points to a trend that becomes very clear in Fielding, Hogarth, Sterne, and Burke ('The Augustan Mode in English Poetry', *Eighteenth-Century Studies*, I [1967], p. 32).

6. *Science of a Connoisseur*, in *Works*, p. 178; also p. 6. The long tradition of the primacy of the sense of sight can be traced back at least to Cicero (*De Oratore*, III.161); and the old tradition that demonstration *ad oculos* has greater and more lasting effect than by words to Horace's *Ars poetica*: 'sequius irritant animos desmissa per aurem / quam quae sunt oculis subiecta fidelibus.' For the traditional associations of thinking and seeing, from Plato through the Renaissance, see F. G. Robinson, *The Shapes of Things Known* (Cambridge, Mass., 1972).

7. See Locke, *Essay*, III.i. The only major English attempt in the first half of the century to deal with the origin of language was Bishop Warburton's *Divine Legation of Moses* (1737–41), and his argument supported the visualist approach to meaning. Language, he argues, originates as involuntary response in action to desire, want, hunger, or fear: then with 'use and custom . . . improving what had arisen out of necessity, into ornament, this practice substituted long after the necessity was over. . . .' Thus the bodily gesture of head, hands, arms, and eye, in response to a particular need, had clear historical priority—and so naturalness and power—over language in human affairs; and the vocal gestures or cries were simply later examples of the same response. (See *Divine Legation*, IV, iv, in *Works* [London, 1788], II, pp. 405–08; in general, Pt. I [1737] and Pt. II [1741].) See Hans Aarsleff, *The Study of Language in England, 1780–1860* (Princeton, 1967), chap. 1. It is interesting to note that Warburton introduces the *Diana multimammia* Hogarth used a few years earlier in *Boys Peeping at Nature* to distinguish an enigmatic symbol: the Diana is a *curiologic hieroglyphic* in which universal nature is considered physically, vs. an enigmatic symbol in which nature is considered metaphysically (*Divine Legation*, IV. iv.).

8. Note to *Iliad* XIII, l. 471. Cf. Swift's blunter remark: 'It is *Homer* and *Virgil* we reverence and admire, not *Achilles* and *Aeneas*' ('Thoughts on Various Subjects', *Works*, ed. Herbert Davis, I [Oxford, 1939], p. 242). For the general issue, see Donald M. Foerster, *Homer in English Criticism* (New Haven, 1947), chaps. I–II.

9. *Sincerity and Authenticity* (London, 1972), pp. 58, 62.

10. Ibid., p. 97.

11. John Preston, *The Created Self* (London, 1970), p. 46.

12. Clark, *Looking at Pictures* (New York, 1960), p. 16.

13. Shaftesbury, *Second Characters*, p. 56; Reynolds, *Discourse VIII*, *Discourses on Art*, ed. R. R. Wark (San Marino, California, 1959), p. 146.

14. *Essai sur l'origine des connaissances humaines* (Paris, 1746), II.i.iv.51. Cf. Warburton, above, n. 7.

15. Whately, *Observations on Modern Gardening* (London, 1771; fifth ed., 1793), pp. 154–55.

16. Charles G. Osgood, *Boccaccio on Poetry* (Princeton, 1930), p. 621; Castiglione, *Book of the Courtier*, Bk. I, xxx.

17. Roscommon, *Essay on Translated Verse* (1784), in J. E. Spingarn, *Critical Essays of the Seventeenth Century* (Oxford, ed. 1957), II, p. 302.

18. 'A Parallel of Poetry and Painting', in *Essays of John Dryden*, ed. W. P. Ker (Oxford, 1926), II, p. 132.

19. See, e.g., Boccaccio, *Genealogie deorum gentilium*, 14.17.

20. Michael Murrin, *The Veil of Allegory* (Chicago, 1969), p. 11; see in general pp. 10–13.

21. *Spectator* No. 315 (1 March 1712).

22. Davis J. Alpaugh, 'Emblem and Interpretation in *The Pilgrim's Progress*', *ELH: The Journal of English Literary History*, XXXIII (1966), p. 300.

23. Mario Praz, *Studies in Seventeenth-Century Imagery* (2nd ed., Rome, 1964), I, p. 155.

24. *Emblemata* (1571 ed.; Leyden, 1593), pp. 17–25.

25. Ripa, *La novissima iconologia* (Padua, 1625), sigs. B–B2.

26. *Epistle to Burlington*, ll. 51–52.

27. Cf. Fry, 'Reflections on British Painting', in *French, Flemish and British Art* (New York, 1951), p. 145; also Bertrand Bronson, 'Strange Relations: The Author and his Audience', in *Facets of the Enlightenment* (Berkeley and Los Angeles, 1968), pp. 298–325.

28. *Dialogue on the Usefulness of Ancient Medals* (1726), pp. 30–31; cf. Shaftesbury, *Second Characters*, p. 36.

29. *The Laws of Poetry . . .* (London, 1721), p. 307.

30. John Jortin, *Tracts, Philological, Critical, and Miscellaneous* (1790), II, p. 529; see also John Constable, *Reflections upon Accuracy of Style* (2nd ed., London, 1738), p. 121.

31. See, e.g., Fénelon's 'Letter to the French Academy', in *Dialogues concerning Eloquence in General*, tr. William Stevenson (1722), p. 252. This was partly perhaps a 'rationalistic anti-intellectualism', as Lovejoy has called it ('The Parallel of Deism and Classicism', *Essays in the History of Ideas* [New York, 1955], p. 85). But it also has its roots in the discussions of clear prose style in the Restoration and comes as no great surprise to the literary historian. See also George Campbell, *The Philosophy of Rhetoric* (2nd ed., 1801), II, p. 58.

32. 'Third Letter to Euphorius' (1747), reprinted as *Pope's Iliad: An Examination by William Melmoth*, eds. Grover Cronin,

Jr., and Paul A. Doyle (Washington, D.C., 1960), p. 25. Cf. Voltaire: 'Any verse or any sentence which requires explanation does not deserve to be explained' (quoted, René Wellek, *A History of Modern Criticism: 1750–1950*, I [New Haven and London, 1955], p. 39).

33. James Beattie, letter 1 January 1766; in Sir William Forbes, *An Account of the Life and Writing of James Beattie, LL.D.* (2nd ed., Edinburgh, 1807), I, pp. 105–06.

34. See Hussey, *The Picturesque*, p. 4; Ernest Tuveson, *The Imagination as a Means of Grace* (Berkeley and Los Angeles, 1960), pp. 98, 102 and passim.

35. 'De Poesi Didactica', a lecture delivered in Oxford 'Term Pasch. 1711', in Richard Eustace Tickell, *Thomas Tickell and the Eighteenth Century Poets* (London, 1931), p. 203. Samuel Johnson, who agreed with Reynolds on the subject, wrote, again referring to 'pleasing': 'Whatever professes to benefit by pleasing must please at once. The pleasures of the mind imply something sudden and unexpected; that which elevates must always surprise. What is perceived by slow degrees may gratify us with the consciousness of improvement, but will never strike with the sense of pleasure' (*The Lives of the English Poets*, ed. G. B. Hill [Oxford, 1905], I, p. 59).

36. *Treatise on Civil Architecture*, title expanded in 1791 to *A Treatise on the Decorative Part of Civil Architecture*, ed. W. H. Leeds (London, 1860–62), pp. 281, 290.

37. The basic texts are La Font de Saint-Yenne, *Réflexions sur quelques causes de l'état présent de la peinture en France* (La Haye, 1747), Abbé Jean-Bernard Leblanc, *Lettre sur l'exposition des ouvrages de peinture, sculpture, etc., de l'année 1747* (Paris, 1747), and François-Cyprien-Antoine Lieude de Sepmanville, *Réflexions d'un amateur des beaux-arts* (Paris, 1747). For general background, see James A. Leith, *The Idea of Art as Propaganda in France, 1750–1799* (Toronto, 1965), pp. 8–14.

38. Anton Ehrenzweig, *The Hidden Order of Art* (Berkeley and Los Angeles, 1967), p. 67. For arguments for clarity in the allegories of history painting, see J. B. du Bos, *Réflexions critiques sur la poésie et sur la peinture* (Paris, 1719), I, p. 24; and Abbé Pluche, *Histoire du ciel* (Paris, 1748), II, p. 427. These strictures were reflected in England by writers like John Brown (a friend of Hogarth's), who, in his *Essays on the Characteristics of the Earl of Shaftesbury* (1751), argued that there is but 'one unvary'd Language or Style in Painting [which] . . . hath it's Foundation in the Senses and Reason of Mankind; and is therefore the same in every Age and Nation' (3rd ed., 1752, pp. 375–77). The only good style, that transcends fashion, is that of 'unadorned simplicity', free 'of every local, peculiar, and grotesque Ornament'.

39. Robert R. Wark, 'Hogarth's Narrative Method in Practice and Theory', in *England in the Restoration and Early Eighteenth Century*, ed. H. T. Swedenberg (Berkeley and Los Angeles, 1972), pp. 164, 165, 167.

40. *Analysis of Beauty*, ed. Burke, pp. 182, 123–24. See also, in praise of simplicity, p. 41.

41. *Essay on Taste* (1759), p. 3.

42. Ibid., pp. 3–5.

43. *Essai sur l'origine des langues*, first published in 1817; tr. John H. Moran (New York, 1966). Here is Rousseau's distinction between the admittedly powerful effect of a visual image and that of discourse (p. 8): 'The successive impressions of discourse, which strike a redoubled blow, produce a different feeling from that of the continuous presence of the same object, which can be taken in at a single glance.'

44. Frances C. Ferguson, *Language as Counter-Spirit: A Study of Wordsworth's Poetry* (New Haven, forthcoming); quoting Wittgenstein, *Philosophical Investigations*, p. 48.

45. Rousseau, op. cit., p. 21 (chap. V).

5. Industry and Idleness

1. *Rambler* No. 85, 8 January 1751: the intellect then 'will embrace any thing, however absurd or criminal, rather than be wholly without an object'.

2. See Gombrich, 'The Cartoonist's Armoury', *Meditations on a Hobby Horse*, pp. 127–42.

3. See also *Proverbs* XII.24, 27; XIX.24; XX.4. It should be noted that the scriptural passages were said to have been chosen for Hogarth by his friend the Reverend Arnold King (according to Dr Ducarel, reported in *Genuine Works of William Hogarth*, I [1809], p. 138). This may simply mean that King found the passages Hogarth wanted or that he pointed out appropriate passages which Hogarth then arranged for the effect he desired by editing and placing. But there is no reason to think that Hogarth was not thoroughly familiar with the Bible himself.

4. Gerard, *Essay on Taste*, pp. 50–51: when the imitation of virtue is 'pure and unmixed, we cannot question, that the whole pleasure of the sentiment produced, is owing to it alone'.

5. Left stands not only for sin but misfortune, malformation, ugliness. Among the many variations on the left-right opposition, see the poem by Callimachus in which Apollo explains his posture: 'In the left hand I carry the bow because I am slower to chastise mortals, but the Graces in the right hand, as I am always disposed to distribute pleasant things' (see Rudolf Pfeiffer, 'The Image of the Delian Apollo

and Apolline Ethics', *Journal of the Warburg and Courtauld Institutes*, XV [1952], pp. 20–32).

6. E.g., *Ecclesiastes* X.2; *Isaiah* IX.20; *Jonah* IV.11 suggests undifferentiation.

7. See, e.g., Cornelius à Lapide and the *Biblia Critica*. The old prejudice against the left side had begun to break down in the sixteenth and seventeenth centuries, especially with the location of the heart (and presumably the Sacred Heart). See Vladimir Gurewich, 'Observations on the Iconography of the Wound in Christ's Side, with special Reference to its Position', *Journal of the Warburg and Courtauld Institutes*, XX (1957), pp. 358–62; and 'Rubens and the Wound in Christ's Side', ibid., XXVI (1963), p. 358.

8. See above, p. 28.

9. Plate 2 uses *Psalm* CXIX.97, but verses 97–104 all apply to the Industrious Apprentice and fill in the story. So too in Plate 3 the 'judgment' referred to in *Proverbs* X.29 is in fact for sloth.

10. In the popular tradition there are many instances of graphic representations of the sin of idleness by a sleeping man.

11. See Ripa, *Iconologia* (1709 ed.), no. 118; but no source book is necessary for so basic an emblem. Cf. Hogarth's use of the Justice figure in *Paul before Felix Burlesqued*.

12. Verse 12, and also 'shalt not curse the deaf, nor put a stumbling-block before the blind, but shalt fear thy God. . . .' *Psalm* IX.11, under Idle, has to do with his own ensnaring; he is paying the penalty for his friends, who never betray him.

13. The dagger is also an attribute of Severity (see Ripa, added in 1645 edition [Venice], p. 568).

14. The ballad of Dick Whittington, Lord Mayor of London, in Plate 1 is one of these references. The Whittington ballad activates the cat who appears, most noticeably again in 4, representing the Counting House and the master and Goodchild against the intrusion of those types of the outside world associated with Idle. Note that his cat, and not Whittington himself, was the hero of the story: the cat acted, and Whittington's virtue was his ability to take Opportunity by the forelock on these occasions. In Plate 7 the cat by his rush down the chimney after the mouse is a terror to Idle and perhaps a reminder of the feat of Whittington's cat, who brought him prosperity precisely by devouring the rats that destroyed the cargo of his master's ship. To judge by these scenes, the cat back in Plate 1 is a Whittingtonian cat too, trying in vain to awaken the sleeping apprentice and make him into as much a Whittington as Goodchild.

15. Pope, 'Epistle to Bathurst' (1732), ll. 339–40. The inscription was erased in James II's reign, restored in William III's, and not finally removed until 1831. See also Addison's *Freeholder* No. 47 (1 June 1716) in which a visiting Tory from the country looks down from the Monument and mistakes the surrounding warehouses for meeting houses. With its references to Catholics, however, the inscription might also have had a certain topical relevance a year or so after the Rebellion of '45.

16. These adages were copied down by Sir Isaac Newton as a lad; quoted, Frank Manuel, *A Portrait of Isaac Newton* (Cambridge, Mass., 1968), p. 58. 'Almost all the statements are negations', Manuel remarks,' admonitions, prohibitions.'

17. Part of the title of *The Apprentice's Faithful Monitor*, advertised in *The London Magazine*, II (October 1733), p. 534.

18. Samuel Richardson, *The Apprentice's Vade Mecum* (1734), pp. 27, 8–9.

19. Ibid., pp. 33–35. Richardson is connecting delinquent apprentices with Hogarth's theme (expressed in the 1730s in the Harlot and the Rake) of the young man or woman who apes fashion and comes to grief. Fashionable dress and other luxuries such as gambling lift 'up the young Man's Mind far above his Condition as an Apprentice'. After a long description of apprentices emulating the fashion, Richardson concludes with his charge to Hogarth. And Hogarth does begin with both apprentices and their models—Whittington and Moll Flanders—and ends with the logical consequences of such emulation.

20. Criminal biography, an important segment of the popular fiction produced for an audience of shopkeepers, their servants and apprentices, habitually romanticizes the 'flamboyant independence of the highwayman because it is unreal enough to serve as a pleasant fantasy which has no direct relevance', but whenever an apprentice strays he is condemned in no uncertain terms and pursued to a grim end. See John J. Richetti, *Popular Fiction before Richardson* (Oxford, 1969), p. 56.

21. See M. Dorothy George, *London in the Eighteenth Century* (London, 1966), pp. 181–87.

22. Lowth's 'The Choice of Hercules' appeared anonymously in *Polymetis* in 1747 and was reprinted in Dodsley's *Collection of Poems* in 1748 and in the same year the *Preceptor: Containing a General Course of Education . . . for . . . Advancing the Instruction of Youth* (1748). Handel put Lowth's verses, adapted by Morell, to music in 1750 as *The Choice of Hercules* (publ. 1751). For other examples: William Shenstone, *The Judgment of Hercules* (verse, 1741); John Baillie, *An Essay on the Sublime* (1747), p. 15, in which he says Prodicus' parable is 'universally allow'd noble and sublime'; John Gilbert Cooper, in *Dodsley's Museum* (1746), II, pp. 48–49; Peter Layng, *The Judgment of Hercules, Imitated . . . from Prodicus* (Eton, 1748); [Thomas Cooke of Braintree], *The Tryal of Hercules, an Ode on Glory, Virtue, and Pleasure* (1752); and translations by William Duncombe (1745) and Spence, in *Moralities: or, Essays, Letters, Fables, and Translations* (1753), by 'Sir Harry Beaumont'. Maurice Greene (whom Hogarth discusses in a well-known anecdote) set a *Judgment of Hercules* to music (*Apollo Society Collection* of 1740), and John Stanley also produced a musical setting in the 1740s. For references to the general prevalence of the Choice of Hercules, see above, Chap. 2, n. 44.

23. 'Johnson's *Rasselas*: Implicit Contexts', *Journal of English and Germanic Philology*, forthcoming.

24. Ibid.

25. *Pleasures of Imagination*, II, ll. 381ff. A. O. Aldridge, who pointed this out, interprets the passage to mean that 'the path of virtue is at the same time the path of pleasure and that one way cannot be attained without the other', a view 'less stoic and severe than Shaftesbury's' ('The Eclecticism of Mark Akenside's *The Pleasures of Imagination*', *Journal of the History of Ideas*, V (1944), pp. 312–13).

26. Patrick Murdock, 'Life of Thomson', in *The Works* (1762), I, xiv; and cf. Johnson's 'Life of Thomson', *Lives of the Poets*, III, p. 297. Johnson himself projected a *Palace of Sloth—a Vision* (Life, IV, 382n.).

27. *Poems on Several Occasions* (1729), I, p. 55. In 1731 Mitchell had published *Three Poetical Epistles*, one of which was to and in praise of Hogarth. In 1740 Hogarth etched a ticket for Mallet and Thomson's *Masque of Alfred*. His roots went back originally to Scotland, and he was a friend of both Ramsays, father and son, and a supporter of the Scots prime minister Bute.

28. These verses have been dated 1742; see A. D. McKillop, introduction, James Thomson, *The Castle of Indolence and Other Poems* (Lawrence, Kansas, 1961), pp. 6–8.

29. Thomas Adams, *Works* (1630), pp. 197; Alexander Ross, *The History of the World* (1652), preface, attributing this to the Church Fathers; and James Howell, *Parly of Beasts* (1660), p. 134.

30. Tacitus, *Agricola*, sec. 3; Pliny the Younger, *Epistles*, Bk. viii, epist. 9. Also cited were Scipio Africanus, 'I am never less idle than when I have nothing to do' (Nunquam se minus otiosum, quam cum otiosus) or Atilius, 'It is better to be idle than busy about nothing' (Apothegm, quoted Cicero, *De Officiis*, Bk. III, chap. 1, sec. 1; Atilius, quoted Pliny, *Epistles*, Bk. I, epist. 9). For yet other examples of praiseworthy *otium*, see Masenius, *Speculum in imaginum veritatis occultae* (1664 ed.), p. 189.

31. For Thomson, see also *Spring*, ll. 275–308; *Autumn*, ll. 56–106; *Liberty*, V, pp. 381–88; III, pp. 370–82 and p. 404 ff. For Shaftesbury, see *Characteristicks* (6th ed., 1737), II, pp. 133–34, 155, 160. Addison

had attempted to apply Shaftesbury's indictment of 'indolence' to the idle, dog-feeding gentry (*Spectator* Nos. 55, 115). For Bolingbroke, see 'On Luxury', in *Works* (Philadelphia, 1841), I, p. 474 ff.; *Remarks on the History of England*, Letter V, *Works*, I, p. 324; Letter XIV, p. 375. For the general background, see McKillop, *Castle of Indolence*, p. 2; Isaac Kramnick, *Bolingbroke and his Circle* (Cambridge, Mass., 1968), pp. 199, 247–48.

32. See Brown, *Enquiry*, I, pp. 151–61, 173–74, 184–85, 217. Something of the paradox behind Hogarth's plates can be sensed reading Francis Hutcheson on the use of wealth: too much money leads to sloth and contempt for our fellow creatures, while poverty produces humility and industry (*Essay on the Nature and Conduct of the Passions and Affections*, 3rd ed., 1742, pp. 195–96).

33. *Rasselas*, ed. G. B. Hill (Oxford, 1887), pp. 107–08.

34. *Ecclesiastes* III.9; commentary, Cornelius à Lapide, p. 215.

35. See *Spectator* No. 411.

36. Thomson's Knight of Industry and Art works hard at the plough and loom, and also 'To solace then these rougher tools he tried / To touch the kindling canvas into life; / With nature his creating pencil vied– / With nature joyous at the mimic strife. . . .' (II, xiii).

37. His trouble, as Boswell defined it, was 'the listless torpor of doing nothing', the 'dismal inertness of disposition' (*Life of Johnson*, ed. G. B. Hill, I, p. 56). In Johnson's own experience industry and idleness, as contraries, were associated with his two early friends, the industrious Edward Cave and the idle but endearing Richard Savage; and his remarks from time to time contain something of the ambivalence he showed in his *Life of Mr Richard Savage* (1744). For his remarks on Cave, see his biographical sketch in *Gentleman's Magazine*, XXIV (February 1754). For the general subject, see W. J. Bate, *Achievement of Samuel Johnson* (New York, 1955; 1961 ed.), pp. 9–10; and Arieh Sachs, *Passionate Intelligence: Imagination and Reason in the Work of Samuel Johnson* (Baltimore, 1967), pp. 12–14, 54–65.

38. *Dictionary* (1755): sense 1 is 'Laziness; sloth; sluggishness; aversion from labour' (with South's sermon cited, '*idleness* is both itself a great sin, and the cause of many more'); sense 6 is 'barrenness; worthlessness', and no. 7 is 'Unreasonableness; want of judgment; foolishness; madness', and his quotation is from Bacon's *War with Spain*: 'There is no heat of affection but is joined with some *idleness* of the brain.' In his periodicals, he comes down hardest in *Rambler* No. 85, 8 January 1751; see also Nos. 67 (6 November 1750) and 155 (10 September 1751).

39. See Michel Foucault, *Madness and Civilization* (New York, 1965), which has shown the centrality of idleness within the general category of unreason used in the period to cover the poor, unemployed, and insane.

40. The complexity of his, and perhaps Hogarth's, attitude may be suggested in a letter in which he explains why we delay those things we most desire to accomplish: 'What we think of importance we wish to do well, to do anything well, requires time, and what requires time commonly finds us too idle or too busy to undertake it. To be idle is not the best excuse, though if a man studies his own reformation it is the best reason he can allege to himself, both because it is commonly true, and because it contains no fallacy, for every man that thinks he is idle condemns himself and has therefore a chance to endeavour amendment, but the busy mortal has often his own commendation, even when he engages himself in trifles only to put the thoughts of more important duties out of his mind, or to gain an excuse to his own heart for omitting them' (*Letters*, ed. R. W. Chapman [Oxford, 1952], no. 29).

41. Hogarth was, of course, only figuratively apprenticed to Thornhill, though for him this would have been the real apprenticeship, the official one to Ellis Gamble's illusory one. It should be remembered that Richardson, the author of the *Apprentice's Vade Mecum*, also like Goodchild married his master's daughter; indeed, he married two masters' daughters, a second after his first wife died. For the Hogarth background, see Paulson, *Hogarth*, I.

42. This appears in Hogarth's list of the plates on the back of a first sketch for Plate 10 in the British Museum. It is also interesting to note that among these jottings he originally included an explicit reference to *The London Merchant*: Idle's name was to have been Barnwell. The choice of Barnwell may also indicate something of the ambivalence of his own feelings, for in *The London Merchant* Barnwell is, in the last act, with his punishment about to be carried out, forgiven by all the other characters, including the master he has betrayed. Among other literary sources, Fielding's *Jonathan Wild* (1743) presented the bad and good merchant prototypes that might have lodged in Hogarth's mind: Heartfree is made a merchant in order to set off Wild, the criminal 'merchant'. And finally, it is interesting that Hogarth knew a City merchant named Goodchild, who was with him a governor of St Bartholomew's Hospital in the 1730s and 40s. Unfortunately, nothing is known of him except his attendance at board meetings.

43. *The Gate of Calais* painting is in the Tate Gallery, engraving published August 1748; Roubiliac's bust is in the National Portrait Gallery, London. The strange muffled shape of Idle's mother, repeated from print to print, which we have seen recalls the symbol Idleness, bears a disconcerting resemblance to the single portrait Hogarth painted of his own mother, hooded and in mourning attire, which must have hung in his house (now private collection).

44. Bate, *Achievement of Samuel Johnson*, p. 154.

45. *Autobiographical Notes*, in *Analysis*, ed. Burke, pp. 201, 208, 209, 211, etc.; also p. 195.

46. See Paulson, *Hogarth*, II, p. 274.

47. Gilpin, *Observations, relative to Picturesque Beauty . . . particularly Mountains, and Lakes of Cumberland, and Westmorland* (1786), II, p. 44.

48. 'Instructions for Examining Landscape', pp. 17–18 (MS., Fitzwilliam Museum, Cambridge).

49. In Hogarth's paintings the picturesque had been achieved at a somewhat earlier date. Indeed, everything I have said about readable structures applies much less well to the paintings (which ordinarily preceded the prints) with their colours, textures, and simplified forms. The subject of the function of colour in Hogarth's paintings will have to be passed over here because it is not strictly relevant to my main argument. Only later in the case of Gainsborough do I detect any traces of the witty use that Hogarth occasionally makes of colour. More often, Hogarth lets colour go its own way, producing an alternative structure of meaning to that of the engraving. I have discussed the matter, with illustrations, in *Hogarth*, I, pp. 405–16, and more recently in 'Hogarth the Painter: the Exhibition at the Tate', *Burlington Magazine*, CXIV (1972), pp. 71–79 and in *The Art of Hogarth* (London, 1975), introduction.

6. Reynolds

1. See Horace Walpole, *Anecdotes of Painting*, V, ed. F. W. Hilles and F. Daghlian (New Haven, 1937), p. 61; and Hilles, 'Walpole and the Knight of the Brush', in *Horace Walpole: Writer, Politician, and Connoisseur*, ed. Warren H. Smith (New Haven, 1967), pp. 141–46. But we can imagine that Reynolds got ideas from other clients (e.g., the Montgomery Family) and then made them his own. See Edgar Wind, ' "Borrowed Attitudes" in Reynolds and Hogarth', *Journal of the Warburg and Courtauld Institutes*, II (1938–39), p. 182; R. E. Moore, 'Reynolds and the Art of Characterization', in *Studies in Criticism and Aesthetics*, ed. H. Anderson and J. S. Shea (Minneapolis, 1967), pp. 332–34; also Panofsky, *Hercules am Scheidewege*, p. 133.

2. Walpole's interpretation of the picture was that Garrick seems to be yielding to Comedy 'willingly, though endeavouring to excuse himself, and pleading that he is forced' (*Anecdotes*, p. 61). In fact, Comedy

tugging, Tragedy reasoning with Garrick, carry on the spirit of Shaftesbury's advice. Cf. Rubens' version (Uffizi), which shows Pleasure trying to draw Hercules to her in a gesture similar to Comedy's, though with her head bent toward him rather than, as with Comedy, coyly cocked to one side (and looking straight at the audience). In Rubens' painting Hercules' head and lower body are inclined toward Pleasure, his upper body and arms toward Virtue. I should not fail to mention Angelica Kauffmann's painting of herself choosing between the arts of music and painting (probably 1763–65, Nostell Priory). It surely depends on Reynold's painting (which was engraved by E. Fisher in 1762): here Painting is Virtue or hard work, pointing up the steep slope to the Temple of Wisdom. Music is the soft, languishing Pleasure. Angelica's gesture, holding Music's hand, addressing her, and motioning toward Painting, says in effect: 'Dear Music, I like you too but I must abandon you to follow the hard path of Virtue.'

3. *Essay upon the Genius and Writings of Pope* (1756), I, pp. 122–23. Garrick, who has tried to reconcile Warton and Hogarth on the matter of the offending passage, may have told Reynolds the story. See Paulson, *Hogarth*, II, p. 293.

4. Charles Mitchell, 'Three Phases of Reynolds' Method', *Burlington Magazine*, LXXX (1942), p. 36.

5. See Moore, op. cit., p. 334.

6. See Mitchell, op. cit., p. 36.

7. Reynolds, Discourse IV, *Discourses on Art*, ed. Wark, p. 72.

8. Discourse VI, pp. 106–7, 110. Cf. Walpole (*Anecdotes*, ed. Wornum, I, xvii): 'Sir J. Reynolds has been accused of plagiarism for having borrowed attitudes from ancient masters. Not only Candour but Criticism must deny the force of the charge. When a single posture is imitated from an historical picture and applied to a portrait in a different dress and with new attributes, this is not plagiarism, but quotation: and a quotation from a great author, with a novel application of the sense, has always been allowed to be an instance of parts and taste: and may have more merit than the original.' Cf. Waterhouse's view in *Reynolds* (London, 1941), p. 7. All of the paintings referred to in this chapter are either reproduced or listed in Waterhouse's catalogue. A more recent and selective group is reproduced in Waterhouse's *Reynolds* (London, 1973).

9. Discourse VIII, p. 146.

10. Quoted, Robert R. Wark, *Ten British Pictures* (San Marino, 1971), p. 56. I am indebted to Wark's thorough discussion of *Mrs Siddons* (pp. 67–78).

11. Boswell, *Life of Johnson*, II, p. 422.

12. Burke, *Philosophical Enquiry into the Origin of our Ideas of the Sublime and Beautiful* (1757), passim.; Hartley, *Theory of the Human Mind* (1775), e.g., pp. 14, 22. As early as 1759 Mark Akenside rewrote his *Pleasures of Imagination* (first publ. 1744) in the light of Hartleian theory (see III, pp. 312–20). For the relativist view of associationism, see Locke, *Essay concerning Human Understanding*, II.xxxiii.18; and for general background, see Kenneth Maclean, *John Locke and English Literature of the Eighteenth Century* (New Haven, 1936), pp. 128–30.

13. Discourse VII, pp. 185 ff.

14. E. H. Gombrich, 'Reynolds' Theory and Practice of Imitation', in *Norm and Form* (London, 1966), p. 155 n. 6; for the painting, *Anne, Viscountess Townshend*, see Waterhouse, *Reynolds* (1941), p. 71.

15. Waterhouse, *British Painting*, p. 156. The Keppel 'presumably remained for a considerable time in the studio' to be seen by Reynolds' prospective sitters (Waterhouse, *Reynolds* [1973], p. 18).

16. For his satiric attacks on Hogarth, see Paulson, *Hogarth*, II, pp. 296–98, 276.

17. 'Reynolds' Theory and Practice of Imitation', pp. 132–33.

18. Cf. Peter Tomory, *Fuseli* (London and New York, 1972), p. 79, who raises but does not develop the idea. Fuseli, he suggests, chooses a maenad or a Medea for representing Lady Macbeth sleep-walking, not because he wants to associate Lady Macbeth with raving maenads or a vengeful Medea, but because he classified her as such. This would fit into the general trend toward classification, as seen in Lavater (inherited from the tradition of expression perpetuated by LeBrun's manuals) and developed by Stubbs and other artists.

19. See Gombrich, 'Reynolds' Theory and Practice of Imitation', pp. 129–34.

20. Moore makes this point, p. 350.

21. *Bareti* (Earl of Ilchester, Waterhouse, pl. 158), *Johnson* (National Gallery, London, Waterhouse, pl. 132).

22. The statuesque effect may well be related to Reynolds' recommendation to create the ideal figure by making 'a careful study of the works of the ancient sculptors' (Discourse III, p. 45). He also notes that 'It is the inferior stile that marks the variety of stuffs [drapery]. With him [the history painter], the cloathing is neither woollen, nor linen, nor silk, sattin, or velvet: it is drapery; it is nothing more' (p. 62).

23. See Waterhouse, pls. 37, 60.

24. Ibid., pls. 224, 238, 196–97.

25. Ibid., pls. 228, 229.

26. Ibid., pl. 294.

27. Ibid., pls. 267, 155.

28. See Edgar Wind, 'Charity: The Case History of a Pattern', *Journal of the Warburg and Courtauld Institutes*, I (1938), pp. 322–30.

29. Or see *Mrs Nesbit with a Dove* (Wallace Collection): she holds a dove whose wing is extended in a horizontal stroke that breaks the compressed oval of the sitter's body; but the whole, including this break, is contained by the oval picture frame. Sometimes one element points out of the tangle—a finger (*Miss Emma and Miss Elizabeth Crewe* [Marquis of Crewe, Waterhouse, pl. 113]), or a gesture that creates a larger gestalt that subsumes the sitter, as in *Lady Sarah Bunbury sacrificing to the Graces* (Art Institute, Chicago; Waterhouse, pl. 101).

30. See Lawrence Lipking, *The Ordering of the Arts in Eighteenth-Century England* (Princeton, 1971).

31. *Discourses on Art*, p. xvi.

32. Discourse I, p. 17. Cf. Discourse II, pp. 18, 31, on models.

33. Discourse V, pp. 66, 68.

34. Discourse XI, p. 190.

7. The Continent

1. *Discours sur les sciences et les arts* (Geneva, 1750), ed. G. R. Havens (New York, 1946), pp. 148–49.

2. For commentary and references, see Ettore Camesasca, *The Complete Paintings of Watteau* (New York, 1968), no. 212, pp. 126–27.

3. See Margret Stuffmann, 'Charles de la Fosse', *Gazette des beaux arts*, LXIV (1964), pp. 1–120; and La Fosse and Watteau, p. 52.

4. *Watteau*, tr. Barbara Bray (New York, 1970), p. 40. This is a translation of Huyghe's 'L'Univers de Watteau', prefixed to Hélène Adhémar's *Watteau, sa vie—son œuvre* (Paris, 1950).

5. Michael Ayrton, in David Piper, ed., *Enjoying Painting* (Penguin, 1964), p. 55.

6. Cf. Fry, *French, Flemish and British Art*, p. 34.

7. Levey, *Rococo to Revolution*, pp. 72–76; Held and Posner, *Seventeenth and Eighteenth Century Art*, p. 303.

8. See Panofsky, *Early Netherlandish Art*, I, pp. 140–41.

9. He picked up the subject of the Italian comedy while working in Claude Gillot's studio, but he made of Gillot's reportage a coherent world. There were, of course, a few purely mythological scenes like the *Judgment of Paris* and *Nymph surprised by a Satyr* (both Louvre), plus various seasonal deities for decorative commissions (*Complete Paintings*, nos. 107A–D). See Anita Brookner, *Watteau* (Colour Library of Art, Feltham, 1967), p. 7 and passim.; also Levey, *Art and Architecture of the Eighteenth Century in France*, pp. 12–15.

10. These are variants showing a young lover and Pierrot with a girl each, being watched by various figures including Mezzetin (*Les Jaloux, Pierrot content, La Partie quarrée*). In another (*Harlequin jaloux*) the pair of lovers are accompanied by Pierrot, sitting on the ground with his guitar, and Harlequin is watching angrily from behind a bush. (See Camesasca, *Complete Paintings*, nos. 80–83.)

11. *Watteau*, p. 60. There is also the historical fact that throughout Watteau's career the Commedia dell'arte was itself always on the verge of dissolution: either outlawed, peripheral, or being absorbed into French companies. In his pictures before 1716 the Commedia is a thing of the past, expelled in 1697 (a scene which he and/or Gillot reconstructed, showing the players disappearing down a long receding street), and surviving in puppet shows and French imitation companies. Once again not long before his death the Italian company was driven to leave France, this time for England.

12. Huyghe, op. cit., p. 69; also p. 28. Other important essays on the reading of Watteau's paintings: A. P. de Mirimonde, 'Les sujets musicaux chez Antoine Watteau', *Gazette des beaux arts*, LVIII (1961), p. 249 ff.; 'Statues et emblèmes dans l'œuvre d'Antoine Watteau', *Revue du Louvre*, XII (1962), p. 1 ff.; and Jean-Louis Schefer, 'Visible et thématique chez Watteau', *Médiations*, no. 5 (Summer 1962), pp. 37–56.

13. Repro. K. T. Parker and J. Mathey, *Antoine Watteau: Catalogue complèt de son œuvre dessinée* (Paris, 1957), no. 261.

14. See Huyghe, op. cit., p. 69.

15. Huyghe has argued that 'he introduced with greater verisimilitude the naïve attempt of the primitives to represent by successive episodes in space an action which really took place continuously in time' (p. 57; and pp. 57–58, 60). The phenomenon was originally remarked by A. Rodin, *L'Art. Entretiens* (Paris, 1911) on *Le Pèlerinage*. In this connection see Levey's argument that the journey is from, not to, the Isle of Cythera (*Burlington Magazine*, CIII [1961], p. 180 ff.).

16. Brookner, *Watteau*, p. 15.

17. Watteau may have picked up his habit from some of Rubens' sketches. But for earlier artists it had been a rather rare phenomenon. Either the artist occasionally did this for exercise—ordinarily picking the one significant view of the model for his composition, or at any rate using different sheets—or he might try variations in getting a figure just right for a specific composition. Raphael, in sketches of this sort, is searching for the right composition or grouping.

18. Fry, op. cit., p. 39.

19. Cf. Levey, *Art and Architecture of the Eighteenth Century in France*, p. 19.

20. The painting originally measured around 355 cm. instead of the 306 cm. today, being the shape of an archway, and after a display of a couple of weeks bought by a collector who had it cut into a rectangle. A cartload of hay was originally to be seen at the left in the curve that was eliminated when the canvas was made rectangular; the top row of pictures was added, and the man with a stick at left, where part of the haywagon had been. It seems to me fairly obvious that the alterations were made under Watteau's supervision, if not by his own hand (the importance of the dating, which Gersaint placed in 1721, Alfassa near the end of 1720). They could have been carried out by his student Pater, who was working with him at the time. I am assuming that what is now in the painting was originated with Watteau, even though some weeks after the original conception was finished. (See Camesasca, *Complete Paintings*, p. 126.)

21. Clark, *Looking at Pictures*, p. 86.

22. Several, especially to the left of the door, refer to Rubens; the picture high on the left is a Van Dyck, the one below perhaps by Antonio Moro. A Ruysdael may be detected in the landscape on its immediate right; a J. Fyt in the still life above the oval *Baignade*; perhaps a Potter in the peasant scene high above, and below this a Van Ostade or Teniers. The white monk praying, to the right of the door, is an arrangement of Watteau's own *Penitent Saint* (engr. by Filloeul, Camesasca, *Complete Paintings*, no. 50). Above the shop girl is a Leda, between a Rubensian Drunken Silenus and a pair of Rubensian children; below this a *Mystical Marriage of St Catherine*. I presume (as above in note 20) that Watteau dictated the subjects, if he did not paint the pictures, in the top row.

23. In the engraving the Daphne tilts more than in the painting and destroys the parallel.

24. Levey, *Rococo to Revolution*, p. 83.

25. Fry, op. cit., p. 43. See his analysis of *Benedicité*, which is almost pure spatial relations.

26. Malraux, *Voices of Silence* (New York, 1953), p. 295.

27. Georges Wildenstein, *Chardin* (New York, 1969), p. 14.

28. *Lettre sur la peinture, la sculpture et l'architecture* (Paris, 1748), p. 8.

29. Cited, Wildenstein, pp. 20, 25.

30. *Windsor Forest*, ll. 115–18.

31. Noticed also by Levey, who adds that it was described in the Salon *livret* as 'l'amusement frivole . . .' (p. 138). Cf. the copy after a lost Frans Hals, *Vanitas: Boy with Bubbles* (Virginia Museum of Fine Arts, Richmond); see Seymour Slive, 'Realism and Symbolism in Seventeenth-Century Dutch Painting', *Daedalus*, CXI (1962), p. 489, figs. 19, 20; also Allan

Ellenius, 'Reminder for a Young Gentle, man: Notes on a Dutch Seventeenth-Century Vanitas', *Figura (Idea and Form)*-n.s. 1 (1959), 111–12, 117–18.

32. *Watteau, The Lady at her Toilet* (London, 1973).

33. Levey, *Art and Architecture of the Eighteenth Century in France*, p. 140.

34. Ibid., p. 142. For the art-nature controversy, see p. 3, and passim. Levey makes the various senses of nature (vs. art) his unifying motif in the Pelican volume, showing by quotation how prevalent was its advocacy in eighteenth-century France.

35. Cf. Levey, pp. 137–38: 'From kitchen objects, brooms, pans, a few vegetables, Chardin was naturally led to depict their users: and use extends into a subtly moral domestic climate where work and industry are tacitly praised, and sheer order, duty, even education, focus on women. There are no fathers in Chardin's domestic interiors, and sons usually require training. It is the mothers who prepare the meals and the children for church or for household tasks.' Such remarks are extremely interesting and indicate lines of questioning that will perhaps be pursued in a study devoted entirely to Chardin.

36. It was in the Académie Royale de Peinture when Hogarth visited Paris in 1743 (and perhaps again in 1748, just before he painted *The Gate of Calais*).

37. Reynolds, Discourse IV, in *Discourses on Art*, ed. Wark, p. 65. On Veronese, see Philipp Fehl, 'Veronese and the Inquisition: A Study of the Subject Matter of the so-called "Feast in the House of Levi" ', *Gazette des beaux arts*, LVIII (1961), pp. 325–54.

38. For Longhi, see Pignatti, *Pietro Longhi, Paintings and Drawings: Complete Edition* (London, 1969). Of the general works on Venetian art of the eighteenth century, Levey's *Painting in Eighteenth-Century Venice* (London, 1959) is full of acute perceptions (as are the Venetian sections of his *Rococo to Revolution*), and Francis Haskell's *Patrons and Painters: A Study in the Relations between Italian Art and Society in the Age of the Baroque* (London, 1963) includes a brilliant study of the social history of this art.

39. Pietro Gradenigo, Gaspare Gozzi, and Goldoni himself, quoted by Pignatti, op. cit., pp. 1, 58, 60.

40. Pignatti's view is supported by Jean Cailleux, 'The Art of Pietro Longhi', *Burlington Magazine*, CXI (1969), 657–68.

41. For Crespi, see Rudolf Wittkower, *Art and Architecture in Italy: 1600–1750* (Pelican, 1958), pp. 310–11.

42. Pignatti, being short on commentary, may make these paintings more enigmatic than they in fact are. If he had deciphered more of the inscriptions Longhi likes to attach to walls or pillars (though some are

only the names of the people portrayed), identified obscure background objects and pictures, or clarified matters of place and costume, we might find a clearer, perhaps satiric meaning in some of the paintings.

43. See Levey, *Rococo to Revolution*, p. 90.

44. Haskell, *Patrons and Painters*, p. 323.

45. Levey, *Rococo to Revolution*, pp. 43, 30.

46. See Antonio Morassi, *Complete Catalogue of the Paintings of G. B. Tiepolo* (London, 1962) and *G. B. Tiepolo: His Life and Work* (London, 1955). Giandomenico Tiepolo's drawings have been selectively catalogued by Byam Shaw (London, 1962) and his paintings definitively by Adriano Mariuz (Venice, 1971).

47. Quoted, Levey, *Painting in Eighteenth-Century Venice*, p. 82.

48. See Giuliano Briganti, *The View Painters of Europe* (London, 1970), which brings together a cross-section of cityscapes from northern as well as southern Europe, helping us to place and assess the originality of the great Venetians; also his earlier study, *Gaspar Van Wittel e l'origine della veduta settecentesca* (Rome, 1966); and J. G. Links, *Townscape Painting and Drawing* (London, 1972), especially Chap. V. For Canaletto, see W. G. Constable, *Canaletto* (Oxford, 1962) and Giuseppe Berto and Lionello Puppi, *L'opera complete del Canaletto* (Milano, 1968).

49. See, e.g., Robert Campin's *Annunciation* (Merode) altarpiece in the Metropolitan Museum, New York. For studies of spatial structures in Dutch interiors, see Paul Claudel, 'Introduction à la peinture hollandaise', in *L'œil écoute*, in *Oeuvres completes de Paul Claudel* (Paris, 1950 ff.), XVI, pp. 20–21 (tr. Huntington Cairns and John Walker, *A Pageant of Painting from the National Gallery of Art* [New York, Washington, 1966], I, p. 240); Erwin Strauss, 'The Upright Posture', *Psychiatric Quarterly*, XXVI (1952), 5, quoted by Tarmo Pasto, *The Space-Frame of Experience* (New York and London, 1964), p. 16; and Roland Barthes, 'The World become Thing', *Art and Literature*, No. 3 (1964), pp. 149–50.

50. See Aldo Rizzi, *Luca Carlevasijs* (Venice, 1967), pls. 39, 41.

51. Ibid., pls. 42, 57.

52. Ibid., pls. 96, 101, 104, 119, 127, 135. A good example is pl. 86, the Piazza San Marco with the emphasis on the right side and the Campanile (also toward the right side) rising up out of the picture; cf. Canaletto's well-known view of the Piazza (Berto and Puppi, pls. xlvi, 84A, 165A, B). For the pillar, see pls. 108, 112, and 142. Being a Fleming, Carlevarijs also introduces more genre, more incident than Canaletto, and overcrowds his squares. Early Canaletto is not without strong traces of Carlevarijs' influence.

53. Levey, *Painting in Eighteenth-Century Venice*, p. 81.

54. Brandi, *Canaletto* (Milan, 1960), p. 34.

55. It is perhaps significant that Canaletto began by painting imaginary emblematic tombs for Owen McSwiny and ended by painting to order *capricci*—imaginary combinations of unrelated buildings or even imaginary ones; in both cases, relationship of the parts was the essential feature. Hogarth may well have seen and been influenced by the emblematic tombs, some of which could be seen in London in the 1720s–30s.

56. See Briganti, *View Painters of Europe*, pls. 204, 220 (Berto and Puppi, pls. 261, 288).

57. Roberto Longhi, *Viatico per cinque secoli di pittura veneziana* (Venice, 1946), p. 37; Briganti, 'La mostra del Bellotto a Vienna', *L'Espresso*, No. 31, 1965; see Briganti, *View Painters of Europe*, pp. 21, 26.

58. The Guardi brothers are best represented by the catalogue of the huge 1965 exhibition of their work in Venice (ed. Pietro Zampetti).

59. It is interesting to compare the metaphor A. Hyatt Mayor uses to describe Piranesi's method (*Giovanni Battista Piranesi* [New York, 1952], p. 13): 'He went at Rome's weedy lumps of ruin like an anatomist at a cadaver, stripping, sectioning, sawing until he had established the structure in all its layers and functions. . . . His method is the method of autopsy and his books rank with the great books of anatomy, for he was the first, and remains the most dramatic dissector of ruins.'

60. 'The Art of Piranesi', in *Changing Taste in Eighteenth-Century Art and Literature* (Los Angeles: William Andrews Clark Memorial Library, 1972), pp. 5, 20. Moore argues (pp. 12–13) for the intensifying effect contact with baroque Rome had on his work, particularly as shown in the 1761 revisions of the *Carceri*.

61. Cf. Emil Kaufmann's view of Piranesi's prisons: 'They are crammed with a great variety of nonarchitectural objects which visualize space by their contrasting directions and their different levels. . . . The elements act against each other; each is a menace to all. It is a pandemonium of hostile forces; disorder and uproar are regnant. Thus the objects visualize and, at the same time, decompose space' (*Architecture in the Age of Reason*, p. 106).

62. Since this chapter was written I have tried to sketch out some of the directions a further study of the Venetian and English topographical painters might take in 'Types of Demarcation: Townscape and Landscape Painting' (*Eighteenth-Century Studies*, VIII [1975], 337–54), which fills out sections on Bellotto, Guardi, and Richard Wilson, pointing toward the generation of Turner and Constable.

8. The Conversation Piece

1. Johnson's *Dictionary* (1755), where 'familiar discourse' is followed by 'Commerce; intercourse; familiarity . . . Behaviour; manner of acting in common life. . . . Practical habits; knowledge by long acquaintance.'

2. B. Buckridge, *An Essay Towards an English School of Painters*, appended to R. de Piles, *The Art of Painting* (2nd ed., 1744), p. 396; George Vertue, *Notebooks*, Walpole Society, II (1932), p. 128; I (1930), p. 128; III (1934), p. 81; Hogarth, *Autobiographical Notes*, in *Analysis of Beauty*, ed. Burke, pp. 215–16.

3. *The Conversation Piece in Georgian England* (catalogue of the 1965 Kenwood exhibition), p. 5. The other basic works on the subject are G. C. Williamson, *English Conversation Pictures* (London, 1931); Sacheverell Sitwell, *Conversation Pieces* (London, 1936; reissued, 1969), Ralph Edwards, *Early Conversation Pictures from the Middle Ages to about 1730: A Study in Origins* (London, 1954); and Mario Praz, *Conversation Pieces, a Survey of the Informal Group Portrait in Europe and America* (London, 1971).

4. This is a convention going back at least to *The Van Berchaum Family* painted by Floris in 1561 or *The Anselme Family* painted by Martin de Voos in 1577: the family sits around a table laden with fruit. Fruit bowls were used by Rubens too as a swelling image of life.

5. These are all reproduced in Edwards, *Early Conversation Pictures*.

6. See Panofsky, *Early Netherlandish Painting*, chap. V, pp. 131–48; .also V. L. Tapié, *Le Baroque* (1957), p. 256; Philippe Ariès, *Centuries of Childhood*, tr. Robert Baldick (London, 1962), pp. 343, 353, 356.

7. Praz, *Conversation Pieces*, p. 95. See my review of Praz, *Art Quarterly* (forthcoming, in which parts of this chapter appeared in an earlier form).

8. Troost's *Johanna Susanna Teding Van Berckhout (represented posthumously) with her Three Sons* (1723; Middelburgh, private collection), is clearly a memorial picture, with something very like a sarcophagus at the centre with the deceased rising out of it; Hogarth's *Cholmondeley Family* (Marquess of Cholmondeley) is another.

9. See, e.g., Hogarth's *Scene from 'The Conquest of Mexico'* (Viscountess Galway).

10. Allan Ellenius, 'Reminder for a Young Gentleman: Noted on a Dutch Seventeenth-Century Vanitas', *Figura* (*Idea and Form*), n.s. I (1959), p. 116, and pp. 115–20. See also Herbert Rudolph, 'Vanitas', in *Die Bedeutung mittelalterlicher und humanistischer Bildinhalte in der niederländischen Malerei des 17. Jahrhunderts: Festschrift Wilhelm Pinder* (1938), pp. 405–33.

11. Noted by Praz, p. 113.

12. See Lewis Mumford, *The Culture of Cities* (New York, 1938), p. 115; cited Praz, p. 23.

13. Braudel, *Capitalism and Material Life, 1400–1800* (London, 1973), pp. 231, 201, 224.

14. See, e.g., Wybrand Hendriks' *Upstairs Corridor, 21 Damstraat, Haarlem*, in *Dutch Masterpieces from the Eighteenth Century: Paintings & Drawings 1700–1800* (exhibition, Philadelphia Museum of Art, 1971), cat. no. 31 (pl. 106).

15. See J. W. Niemeijer, *Cornelis Troost* (Assen, 1973), cat. no. 459 and p. 58 (pl. 11).

16. Niemeijer, op. cit., cat. no. 232A; *Dutch Masterpieces*, pl. 32, cat. no. 86.

17. See Waterhouse, 'English Painting and France in the Eighteenth Century', *Journal of the Warburg and Courtauld Institutes*, XV (1952), p. 122 *et sec.* J. F. Nollekens sometimes combines the figures of a *fête galante* with a detailed painting of a country house—e.g., *A Musical Party* (Williamson, pl. xxii; cf. M. J. H. Liversidge, 'An Elusive Minor Master: J. F. Nollekens and the Conversation Piece', *Apollo*, XCV [1972], pp. 34–41, pl. vii). Even the Watteau colours are present here. For other conversations with actual settings, see Liversidge, pls. 7 and 12, and perhaps 11. Plate 8 is an indoors conversation.

18. See above, p. 102.

19. There is also, historically, the fact that George II kept pugs around him. But whatever the reason, the dog remains a convention of the English conversation piece. Knapton's huge family group, *Princess Augusta and her Children* (1751, Marlborough House) contains all the conventions: Prince Frederick, dead, is represented in a portrait on the wall above the heads of his two eldest sons; and a pug at bottom left is pulling disrespectfully at a red ribbon.

20. For an extensive bibliography, see H. K. Miller, *Essays on Fielding's Miscellanies* (Princeton, 1961), pp. 166–67n. and 174–75, 177–78 and notes.

21. 'Of Pleasing', in *Works* (5th ed., 1730), III, p. 334.

22. See Anita Brookner, *Greuze* (London, 1972), pp. 38–43.

23. Reynolds, Discourse VII, *Discourses on Art*, ed. Wark (San Marino, California, 1959), pp. 130–31.

24. Henri Testelin devoted a third of his *Tables de préceptes* to the passions and Félibien emphasized expression in his introduction to the Académie's *Conférences*. Le Brun spent a whole conference on expression and published a separate illustrated treatise, *Traité sur les passions*, which was popular during the eighteenth century among artists, writers, and actors.

25. *Della pittura*, tr. John B. Spencer (New Haven, 1956), pp. 77 (cf. 75), 78.

26. See *The Conference of Monsieur le Brun . . .*, tr. J. Smith (London, 1701); *A Method to Learn to Design the Passions Proposed in a Conference on their General and Particular Expression*, tr. John Williams (London, 1734, to which is appended a partial translation of Le Brun's *On Physiognomy*). Le Brun emphasizes facial expression: 'The whole man is seen in the head . . . if man be truly said to be the Epitome of the whole World, the Head may well be said to be the Epitome of the whole Man' (1734 ed., p. 55). For bodily gesture, see Gerard Lairesse, *Groot Schilderboek* (tr. 1738) and in the eighteenth century Aaron Hill's *Essay on the Art of Acting* (1746) for adaptations of the art treatises' doctrines to the stage. For background, see Dean Tolle Mace, 'Ut Pictura Poesis: Dryden, Poussin and the Parallel of Poetry and Painting in the Seventeenth Century', in *Encounters, Essays on Literature and the Visual Arts*, ed. J. D. Hunt (London, 1971), pp. 58–81; for the stereotypic tendencies of the traditions, see Brewster Rogerson, 'The Art of Painting the Passions', *Journal of the History of Ideas*, XIV (1953), pp. 68–94; and for a general survey of expression as used in painting and on the stage, see Alastair Smart, 'Dramatic Gesture and Expression in the Age of Hogarth and Reynolds', *Apollo*, LXXXII (1965), pp. 90–97.

27. For the influence of these treatises on Hogarth, see Paulson, *Hogarth*, I, p. 264.

28. *Paul before Felix Burlesqued* (1752), repro. Paulson, *Hogarth's Graphic Works*, pls. 205, 206; for the 'serious' engravings, see pls. 207, 280.

29. John Holloway, 'The Black Dog & King of the Fishes', *Encounter*, XXXVIII (1972), p. 67.

30. See Paulson, 'The Pilgrimage and the Family: Structures in the Novels of Fielding and Smollett', in *Tobias Smollett: Bicentennial Essays presented to Lewis M. Knapp*, ed. G. S. Rousseau and P.-G. Bouce (New York, 1971), pp. 57–78.

31. *Pamela*, ed. T. C. Duncan Eaves and Ben D. Kimpel (Boston, 1972), p. 35. Another of Pamela's phrases is 'by degrees' (e.g., pp. 34, 78, 104, 224, and 279).

32. See Cary Mackintosh, 'Pamela's Clothes', *The Journal of English Literary History* XXXV (1968), pp. 75–83; Robert Folkenflik, 'A Room of Pamela's Own', *The Journal of English Literary History* XXXIX (1972), pp. 585–96.

33. *Mr B. coming upon Pamela writing a Letter* (Tate Gallery); *Pamela having divided her Clothes . . .* (National Gallery of Victoria, Melbourne); *Pamela preparing for Bed* (Tate Gallery); and *Pamela telling Nursery Tales* (Fitzwilliam Museum, Cambridge). For *The Harlowe Family*, painted before 1748, see Eaves, 'The Harlowe Family, by Joseph Highmore', Huntington

Library Quarterly, VII (1943–44), pp. 89–96.

34. *Joseph Andrews*, ed. M. Battestin (Oxford, 1967), pp. 52–53.

35. For Hogarth's statements on the problem, see *Analysis*, ed. Burke, pp. 136–38, 160–61.

36. *Tom Jones*, Bk. VII, Chap. xii (Modern Library ed.), p. 255.

37. Fielding, *Works*, ed. Leslie Stephen (London, 1882), VI, pp. 337, 332.

38. See Hill's *The Prompter* (1734–36) and *Art of Acting* (1746).

39. See Robert Adams Day, *Told in Letters: Epistolary Fiction before Richardson* (Ann Arbor, 1966), for an account of one source of Richardson's epistolary form in the passionate speech derived from Ovid's *Heroides* and its many imitators including *The Letters of a Portuguese Nun*.

40. *Clarissa* (London, 1905), I, p. 263.

41. *Selected Letters*, ed. John Carroll (Oxford, 1964), p. 296. For other such comments, see pp. 257, 287–89.

42. 'Of the standard of Taste', originally in *Four Dissertations* (1757), no. xxii in *Essays, Moral, Political and Literary*, ed. T. H. Grose (London, 1882), II, pp. 268–29. See also *An Enquiry concerning the Principles of Morals*, ed. L. A. Selby-Bigge (Oxford, 1894), Appendix I.

43. Ralph Cohen, 'David Hume's Experimental Method and the Theory of History *The Journal of English Literary Taste*', XXV (1958), p. 283. See 'Of the Standard of Taste', p. 281.

9. Zoffany

1. See Oliver Millar, *Zoffany and his Tribuna* (London, 1966), which offers most of the facts available concerning the picture (though, we shall see, strangely omitting the biographical), with reproductions of the whole and many details.

2. Millar, in correspondence with the author following the original publication of parts of this section in *Eighteenth-Century Studies*, III (1969), pp. 278–95.

3. 'The British School', in *French, Flemish, and British Art*, p. 150.

4. Millar, op. cit., p. 18.

5. Millar speculates (p. 28) that perhaps the whole passage was painted in for George III's benefit since Cowper badly wanted the Order of the Garter, which he thought he might buy with the Niccolini-Cowper Madonna.

6. *Travels through France and Italy* (ed. Dublin, 1766), II, pp. 76–77.

7. See Millar, *Zoffany and his Tribuna*, p. 5, and *Later Georgian Pictures in the Collection of Her Majesty the Queen* (London, 1969), cat. no. 1200, p. 149.

8. See his sale catalogue, Robins, 9 May 1811, nos. 3–13; and Lady Victoria Manners and G. C. Williamson, *John Zoffany, RA* (London, 1920), p. x and appendix. He also, in the 1780s, painted a portrait of Hogarth's widow, now in Castle Howard.

9. Manners and Williamson, p. 51. Walpole called him 'the Hogarth of Dutch painting, but no more than Hogarth, can [he] shine out of his own way' (to Mann, 17 April 1775, *Walpole's Correspondence*, Yale Edition, XXIV [1967], pp. 92–93).

10. Angelo, *Reminiscences*, quoted Manners and Williamson, p. 12 and p. 15.

11. *Literary Gazette*, 8 July 1826; cited, Manners and Williamson, p. 29. X-rays now show no signs of the tankard and tobacco pipes above Wilson's in the Royal Collection painting. See Millar, *Later Georgian*, cat. no. 1210, p. 152.

12. Manners and Williamson, p. 100; for the *Last Supper* painted in Calcutta, see pp. 100–02; and the same subject and treatment when he returned home, pp. 118–19.

13. *Literary Gazette*, 15 July 1826, the source given as Zoffany himself. See Manners and Williamson, p. 63, citing without giving a source except 'a writer of this period', and presumably referring to the *Literary Gazette*.

14. See Ford, 'Thomas Patch: A Newly Discovered Painting', *Apollo*, LXXVII (March 1963), pp. 172–76. Also F. J. B. Watson, 'Thomas Patch (1725–1782)', *Walpole Society*, XXVIII (1940), pp. 15–50.

15. Watson, op. cit., p. 29. Watson is very discreet about Patch's sexual adventures, but the letters quoted from on pp. 18–22 make it fairly clear what at least one of Patch's problems was. The quarrel with Zoffany, in March 1778 (Watson, p. 29), was over payment for two pictures Patch had entrusted Zoffany to deliver to a Mr Durad in Geneva: Zoffany apparently 'had to foot M. Durad's bill'. That Zoffany was earlier an admirer and friend is clear from Mann's letter to Walpole in August 1773. Watson connects the quarrel with the addition of the patch, but we do not really need a quarrel to appreciate Zoffany's joke —one which Patch himself echoed in his own paintings. Manners and Williamson allude to Zoffany's inclusion of 'a caricature portrait of a well-known man in Florence of notoriously bad character, with whom he had a bitter dispute' (p. 100).

16. Ford, p. 176. Other examples are, besides *The Cognoscenti*, *A Party at Sir Horace Mann's in Florence* and *A Conversation* (both in W. S. Lewis Collection).

17. Houdon's *écorchés*, made under the eye of the surgeon Ségnier, were to be seen at the French Academy in Rome in the 1770s.

18. *Court and Private Life in the Time of Queen Charlotte: Being the Journals of Mrs Papendiek*, ed. V. D. Broughton (London, 1887), I, 86–88; the whole account, pp. 82–89. To judge by her grave marker in the Kew cemetery, however, she was ten years older. Besides the boy, Zoffany's eldest daughters Theresa and Cecilia were born before he left Florence (p. 88).

19. He also completed a *St Cecilia* and a *Sibyl* before leaving England and painted a *Repose on the Flight into Egypt* while in Italy—the only work he sent back to London for exhibition (cat. no. 352). Of the same time are the stories of his proprietary feeling for the Tribuna gallery (as when he conducted the Duke of York around it) and his calling himself 'the Queen of England's State Painter in Ordinary, a title to which he had not the slightest right' (Manners and Williamson, p. 54).

20. Millar, *Zoffany's Tribuna*, p. 33. The *Arrotino*, we have said, is looking up from his work, his eyes frozen on the *Venus of Urbino*; it also looks as if the Etruscan chimera is roaring at her and Julius Caesar is lying back apparently insensate before her charms. Zoffany is very much concerned to show her powers.

21. X-rays reveal that Zoffany originally painted the *Apollino*, which actually stood directly beneath the *St John the Baptist*, and then replaced it with the statue of *The Infant Hercules slaying the Serpent*.

22. *An Account of a Series of Pictures, in the Great Room of the Society of Arts, Manufacture, and Commerce at the Adelphi* (1782), p. 26.

23. Barry, *An Inquiry into the Real and Imaginary Obstructions to the Acquisition of the Arts in England*, 1773, in *Works* (1809), II, p. 252.

24. *An Account*, p. 18.

25. He originally showed Ceres landing on a distant hill (p. 46), but since this does not appear in the finished painting he must have decided that one centre of civilization in Orpheus, the artist, was enough, and that cultivation of crops like everything else could follow from him.

26. The source for the scene may have been the peroration of Pope's *Windsor Forest*. The reason for the inclusion of Dr Burney doubtless goes back to the Orpheus: 'music is naturally connected with matters of joy and triumph' (p. 62); but then Barry proceeds to the subject of English vs. Italian musicians, and to a plea for a national school of music which he associates with Burney (p. 64)—i.e. parallel to the Royal Academy reference in the next panel.

27. An example of the conversation piece as history before Barry is Gavin Hamilton's *Dawkins and Wood discovering Palmyra* (Glasgow University, on loan from the Dawkins family), which shows contemporary men making a discovery. Hamilton distances them by their remote, exotic location and desert dress, as Barry does by his allegorical structure and classical trappings.

28. Referring to the presence of Burke, 'my former friend and patron', he says that 'to the conversation of this truly great man, I am proud to acknowledge, that I owe the best part of my education' (p. 76).

29. Pliny the Elder, *Natural History*, ed. H. Rackham (Loeb Library, 1952), p. 315. Pliny refers to the small panel of a sleeping cyclops, in which the figure's magnitude was suggested by the insertion of some satyrs. One may even detect another self-portrait of Barry in the lower right of the Orpheus panel.

30. A passage in the *Account* (see note 22) sums up the implicit relationship between Barry, Orpheus, Chatham, and Hercules: 'I shall perhaps secure a kind word from posterity, for the goodness of my intention, but that is all; the faction against me is five hundred odds, and they and their assistants are too extensive in their influence, and too industrious, not to be an overmatch for the little vigilance of indifferent spectators, or for any exertions of mine in my own defence, which are daily growing less and less: I am heartily sick of the scuffle . . .' (pp. 62–63). This goes on for a while longer, into a digression on his unsuccessful project to remove Reynolds' portrait of Lord Romney and Gainsborough's of Lord Folkstone from the decorative structure of the Society of Arts paintings and replace them with portraits by himself (pp. 65–66).

31. The print of *The Fall of Satan* was published in February 1777 with an inscription explaining that this was a design executed for St Paul's, for the scheme for decorating the Cathedral with Royal Academicians' paintings, which came to nothing and about which Barry felt strongly.

32. See Mary Webster Lightbown, 'Zoffany's Painting of Charles Towneley's Library in Park Street', *Burlington Magazine*, CVI (1964), pp. 316–33.

33. Sitwell, *Conversation Pieces*, p. 40.

34. For the basic metaphors Burke used, see his *Reflections on the Revolution in France* (1790), and James T. Boulton, *The Language of Politics in the Age of Wilkes and Burke* (London, 1963), pp. 110–14. The important element in the house and garden was organic conservation or development, a sense of tradition; in the family unity as well as tradition, with reference to 'inheritance', 'fore-fathers', 'posterity', 'records', and 'titles'. Burke's vocabulary makes heavy use of nouns like 'plant', 'body', 'root', and 'stock', and verbs like 'graft' and 'inoculate', which apply equally to trees and families.

35. For example, M. St Aubert's great chestnut in *The Mysteries of Udolpho* or the

trees Mr Rushworth plans to cut down in *Mansfield Park*.

36. It is not easy to establish priority between Zoffany and Stubbs, who were both developing this conversation piece iconography in the 1760s; but the crucial works of Zoffany can with some confidence be dated in that decade (*The Athol Family*, 1765–67; *The Drummond Family*, 1765–69; the conversations of the Earl of Bute's children, to judge by the age of the children, mid-1760s), while Stubbs' equivalent paintings begin to appear at the very end of the decade. Stubbs' earlier conversations had developed the horse, racing, and hunting. (See below, Chap. 10.)

37. Burke, *Reflections on the Revolution in France* (ed. New York, 1953), p. 53.

38. See Mary Webster Lightbown, *Francis Wheatley* (London, 1970), p. 25, fig. 28; and Praz, *Conversation Pieces*, fig. 88.

39. See Sitwell, pl. 42; and Praz, pl. 284, in *Conversation Pieces*.

40. The explanation is Praz's, p. 101. A word should be said about Arthur Devis, who already in the 1740s and 1750s was introducing in a naïve form the elements we have discussed into the conversation. No longer decorative or pastoral, the balustrade or porch, the courtyard or distant prospect of the country house, become the milieu or habitat for the family portrayed. Distance is an important element in these conversations: many of Devis' people hold or look through telescopes, as if to emphasize the extent of the park, but incidentally also the distances between them and between their little group and their house. The effect is stranger inside, where the great spaces between the people suggest an isolation from each other and a tenuous relation to the room and house in which they uneasily reside. See *William Atherton and his Wife Lucy* (Walker Art Gallery, Liverpool) for an indoor scene, and *Robert Vernon Atherton and his Family* (Mellon Collection) for an exterior.

There is one painting by Devis, called *An Incident in the Ground of Ranelagh during a Bal Masqué* (Lt Col. W. S. W. Parker-Jervis, DSO), which is almost a parody of the use of distances and intervals. The husband and wife have come to the masquerade and fallen in love with each other, only to discover when their masks are removed that they are themselves. They stand far from the house of the party, a lake separating them from it and the other revellers; both lean on a circular pediment of some kind (which looks as though it should hold a sun dial but does not), and she looks distinctly disappointed. The great spaces around them, the distant perspective from the house, the circular pool: all of these things define the situation of the couple far better than could symbols. (See Sydney H. Paviere, *The Devis Family of Painters* [Leigh-on-Sea, 1950].)

41. We can also be sure that Zoffany had something in mind when he showed Richard Cosway posing prominently in the right foreground with his walking stick supported on the pubis of a prone female cast. Cosway's chief reputation, of course, was as a dandy, but by the 1780s there were a good many references to him as pimp and pander and to his house as a place of assignation for the aristocracy. (See Whitley, *Artists and their Friends* [London, 1928], II, pp. 115–17.) Zoffany may also have attached meaning to the relationship in which he placed the hour glass (used for the life-class posing) adjacent to the female torso.

10. Stubbs

1. Ozias Humphry MS., Picton Library, Liverpool, pp. 16, 28.

2. Antony Pasquin, cited Constance-Anne Parker, *Mr Stubbs the Horse Painter* (London, 1971), p. 47.

3. Cf. Leo Steinberg's discussion of the element of 'sacrifice' in modern art, in *Other Criteria* (New York, 1972), p. 9.

4. Barry, *An Inquiry into the Real and Imaginary Obstructions to the Acquisition of the Arts in England*, 1773, in *Works* (1809), II, p. 252.

5. Geoffrey Grigson's essay on Stubbs in 1938 saw him as someone who painted wonderful details, which if blown up and given a whole picture would remind one of modern art; as totalities, they remain for Grigson still eighteenth-century disunities. ('George Stubbs', reprinted in *The Harp of Aeolus* [London, 1947], pp. 13–23.)

6. Almost all of Stubbs' characteristic subjects were established in the 1760s, including the *Phaeton* (1762, Society of Arts Exhibition), to which he returned years later. Quotations substantiating his concern about the status of history come from later in his life. See Josiah Wedgwood in 1780 to Thomas Bentley, in *Letters of Josiah Wedgwood to Thomas Bentley*, ed. Lady Farrer (1903–06), II, p. 486.

7. See Girolamo Cardano's panegyric on the horse in *De Subtilitate* (Basel, 1745), p. x. See also Giordano Ruffo, *L'Arte de cognoscere la natura dei cavalli*, tr. G. Bruni (Venice, 1493), pp. b.iv.–b.iir.; Bracy Clark, *A Short History of the Horse* (1824), on horse literature, and on Stubbs, p. 47; John Lawrence, *The History and Delineation of the Horse* (1809), pp. 104–12. As Lawrence points out, there were also the books by farriers: William Gibson, William Burdon, and Henry Bracken in the 1730s to 1750s and James Clark in the 1770s. See also T. A. Cook, *A History of the English Turf* (1905), I, pt. ii, and II, pt. i.

8. See Peter Paul Rubens, *Théories de la Figure humaine* (Paris, 1773), plate 40; Peter Camper, *Discours prononcé à l'Académie de dessin sur le moyen de représenter d'une manière sure les diverses passions* (Utrecht

1792), fig. 13. In the illustrations Sawrey Gilpin made for 'Gulliver's Voyage to the Houyhnhnms' (1768–72), the horses, the Yahoos, and Gulliver are juxtaposed as the beautiful, the ugly, and the human. We can also trace Gilpin's response to Stubbs' stimulus toward making a horse into a history: in 1772 he exhibited at the Royal Academy his huge *Election of Darius* (York Art Gallery).

9. Burke, *Enquiry*, p. 66.

10. Ibid.

11. Humphry MS., pp. 29, 31.

12. Taylor, 'George Stubbs: "The Lion and Horse" Theme', *Burlington Magazine*, CVII (1965), pp. 81–86. In the group in the Conservatori the horse's head is turned in a different direction from the version once in the Villa d'Este, which was copied by Scheemakers for Rousham; and this second version is closer to Stubbs' paintings. It might be added that the figures in Vesalius' illustrations in his *Fabrica* were often based on classical statuary (see Moritz Roth, *Andreas Vesalius Bruxellensis* [Berlin, 1892], pp. 159, 171; and William M. Ivins, 'Woodcuts to Vesalius', *Metropolitan Museum Bulletin*, XXX [1936], pp. 139–42); and Cheselden's to his *Osteographia* were even more specifically based on the models in the St Martin's Lane Academy.

13. There is even evidence that the landscape in this case may have been painted by someone else: see John Hunter's undated letter to Edward Jenner, in John Baron, *Life of Edward Jenner* (1827), I, p. 34.

14. Taylor, *Stubbs* (London, 1971), pp. 16, 17. Most of the paintings to which I refer are reproduced in Taylor's book.

15. See, e.g., Taylor, pls. 78, 79.

16. See Carlo Ruini, *Anatomia del Cavallo, Infirmitata et suoi remedii* (Venice, 1599); cf. also Albinus, *Tabulae Sceleti et Musculorum Corporis Humani* (1747). Taylor notes the influence of horse patrons in this connection, who 'wished for a descriptive rather than an idealistic or aesthetic art' (*Animal Painting in England* [London, 1955], p. 13). Their interest also dictated the artist's interest in the depiction of the phases of racing, from the training gallop to the race itself to the rub-down afterwards.

17. F. D. Klingender, *Art and the Industrial Revolution* (London, revised ed., 1968), p. 73; for a general account of technical draughtsmanship, pp. 65–82. For examples, see the *Encyclopédie* (Paris, 1751–65), the separate volumes of plates, and *Description des arts et métiers* (Paris, 1761–82).

18. Engraved by Henry Beighton, in *The Ladies Magazine* (1717); Klingender, *Art and the Industrial Revolution*, p. 73 and fig. 6, and also pp. 74, 76.

19. His plates also support those who were stressing structural anatomy as the basis of equine performance over blood. It

was still structural anatomy he had in mind as the basis of posture and movement for his treatise on the comparative anatomy of man, cat, and fowl. Stubbs must have been cognizant of the current theories on the value of mechanics over breeding (blood) as the explanation of speed and endurance found in English race horses. See William Osmer, *A Dissertation on Horses: wherein it is demonstrated, by Matters of Fact, as well as from the Principles of Philosophy, that Innate Qualities do not exist, and that the excellence of this Animal is altogether mechanical and not in the Blood—* i.e. in training or in nurture over nature (1756). The date of the publication coincides with Stubbs' move from Liverpool to Lincolnshire where, soon after, he commenced his dissection near Horkstow.

20. Reynolds, *Discourses on Art*, p. 45.

21. *Hercules and Achelous* (or *the Cretan Bull*) and *Nessus and Dejanira* were exhibited at the Society of Artists in 1770 and 1772; the description of the former was by Sir William Gilbey, in *Life of George Stubbs, RA* (1898), p. 150; see Taylor, *Stubbs*, p. 36.

22. On the monkey holding fruit and the Fall of Man, see H. W. Janson, *Apes and Ape Lore in the Middle Ages and the Renaissance* (London, 1952), pp. 109–36.

23. See Michel Foucault, *Les Mots et les choses*, tr. *The Order of Things* (New York, 1970).

24. Taylor, *Animal Painting*, pp. 33–36.

25. See, e.g., René Antoine Ferchault de Réaumur, *Mémoires pour servir à l'histoire des insectes* (Paris, 1734–42); Pierre Lyonet, *Traité anatomique de la chenille qui ronge le bois de saule* (Paris, 1760).

26. Jenyns, 'On the Chain of Universal Being', in *Works* (1790), p. 185.

27. Taylor, *Stubbs*, p. 31.

28. Lawrence, *The History and Delineation of the Horse* (1809), pp. 107, 106.

29. Ibid., p. 122.

30. Attributed to Stubbs in a Witt Library photo (Leger Galleries, 1953); it may be the picture exhibited at the Society of Artists by Zoffany in 1783 (no. 95), with the horses by Sawrey Gilpin and the landscape by Farington (now collection of Lady Thompson).

31. *Account of a Series of Pictures*, p. 45. (See Chapter 9, note 22.)

32. Oscar and Peter Johnson Ltd, London; photo A. C. Cooper; reproduced, Nancy Mitford, *Madame de Pompadour* (New York, 1954), pp. 48–49.

33. Levey, *Art and Architecture of the Eighteenth Century in France*, p. 26.

34. Ibid., p. 41.

35. Fuseli, in Pilkington's *Dictionary*; MS. copy in Fuseli's hand in the British Museum.

36. Levey, *Art and Architecture of the Eighteenth Century in France*, p. 179.

37. They are quite different from the illustrations for the rival work, William Smellie's *Anatomical Tables with Explanations and an Abridgement of the Practice of Midwifery* (1761), by Rymsdyke and Camper, which give the more useful total picture of what would be relevant to the physician, with a cutaway of what would not; the surrounding surface is portrayed in detail, including muscles and hair.

38. Versions of *Phaeton* are in the Saltram Collection and (in enamel) a private collection (Taylor, pl. 94); *The Farmer's Wife and the Raven*, from Gay's Fable 37, in the Lady Lever Art Gallery and the Mellon Collection, and a mezzotint of 1788.

39. Unlocated; Leggatt, 1927; photo in the Witt Library.

40. John Musters of Colwich and the Rev. Philip Strong of Lockington (Col. J. N. Chaworth-Musters; photo Witt Library).

41. I am indebted to one of my students, Peter M. Fitz, for many of the insights in the following pages.

42. Entitled *Shooting*, the four engravings by Woollett are dated August 1769, August 1770, September 1770, and October 1771 (a set is in the Boston Museum of Fine Arts).

43. Taylor, *Animal Painting*, p. 24.

44. Burke, *Enquiry*, p. 51.

45. Sparrow, *George Stubbs and Ben Marshall* (London, 1929), p. 11.

46. Humphry MS., p. 55.

47. The drawings are in the Worcester Public Library; reproduced, *Romantic Art in Britain, Painting and Drawings 1760–1860* (Philadelphia Museum of Art, 1968), pls. 15 and 16. Cf. Paulson, *Rowlandson* (London, 1972), pp. 66–70.

II. Wright of Derby

1. *Joseph Wright of Derby* (London, 1968), 2 vols. All of the works referred to are reproduced by Nicolson.

2. *Times Literary Supplement*, review of Nicolson's *Wright of Derby*, 21 November 1968.

3. *Romantic Art in Britain, Paintings and Drawings, 1760–1860* (Philadelphia, 1968), p. 12.

4. Nicolson, op. cit., p. 52.

5. *Romantic Art*, p. 12.

6. Quoted, Nicolson, op. cit., p. 51.

7. Ibid.

8. 'Boothby, Rousseau, and the Romantic Malady', *Burlington Magazine*, CX (Dec. 1968), pp. 659–66.

9. 'Folly and Mutability in two Romantic Paintings: The Alchemist and Democritus by Joseph Wright', *Art Quarterly*, XXXIII (1970), pp. 247–75.

10. See Paulson, 'Zoffany and Wright of Derby', *Eighteenth-Century Studies*, III (1969), pp. 286–95, which includes in somewhat different form parts of this chapter.

11. 'Boothby', p. 663.

12. The boy-nymph relationship is only the central example; a second, subsidiary arch frames another statue of *The Gladiator*. Rosenblum has noticed how the Gladiator 'seems to lunge out of the room, weirdly underlining the enrapt immobility of the other figures' ('Wright of Derby: Gothick Realist', *Art News* [March 1960], p. 26). The other figures are, of course, the live ones. And as he, a work of art, seems to be actually lunging out of his enclosing arch, so the boy with closed portfolio, a real person, seems to be psychologically leaving the arch he is enclosed by in the opposite direction.

13. We might compare these, as Nicolson does, with Velasquez's *Forge of Vulcan* (Prado), but there the centre of light is Apollo, not the forge, there is no mystery, and quite a different story is being told. The Le Nain *Venus at Vulcan's Forge* (Musée des Beaux Arts, Rheims) might offer a closer precedent.

14. According to Klingender, *Art and the Industrial Revolution*, p. 55: Wright's were 'the first paintings to express the enthusiasm of the eighteenth century for science', and they in fact are 'glorifying science'. But elsewhere Klingender realizes that Wright is rather in the tradition of mixing mythological figures and contemporary detail—cf. Jan Brueghel's *Venus at the Forge* (Berlin) and Velasquez's *Forge of Vulcan* and *Tapestry Weavers* (pp. 58–61). He notices (p. 60) that the *Blacksmith Shop* is not 'an actual workshop' but 'a ruined classical building . . . the kind of setting that Italian painters of the sixteenth century often chose for pictures of the Nativity or Adoration', and he thinks the picture specifically 'echoes the stable in Veronese's *The Adoration of the Magi*' (National Gallery, London). Still, although he refers to Wright's 'disguised allusions to the classical and Christian myths', what he believes distinguishes Wright (as well as Defoe) is 'his interest in the labour process as such' (p. 61).

15. E.g., Millet's *Angelus*, A. Legros' *Angelus*, or Wilhelm Leibl's *Three Women in Church*; see Linda Nochlin, *Realism* (Penguin, 1971), p. 90, pls. 45–47.

16. Burke, *Enquiry*, pp. 130, 133.

17. It is, of course, difficult to assess the influence of Vernet and Voltaire, who had already begun producing such paintings of erupting volcanoes, and in Vernet's case views out the mouths of caves; but the important thing is that Wright adopts them to his own continuing concerns.

18. For the similar use of arches in the *Academy by Lamplight*, see above, note 12.

19. Plato, *Republic VII*.

20. Plotinus, *Enneads*, tr. Stephen Mac-Kenna (London, 1924), IV.vi. 1–3; Nathanael Culverwel, *An Elegant and Learned Discourse of the Light of Nature*, in *The Cambridge Platonists*, ed. E. T. Campagnac (Oxford, 1901), pp. 283–84, 286–87, 292–93; all cited and discussed by Meyer Abrams, *The Mirror and the Lamp* (New York, 1953), pp. 58–60.

21. *Prelude* (1805), II, 378 ff.; cf. also XIII, 40 ff. ('The perfect image of a mighty Mind', referring to the naked moon over Snowden) and XI, 323–34 (nature transformed by 'youth's golden gleam' and 'radiance more divine').

22. *Treatise of Human Nature*, ed. L. A. Selby-Bigge (Oxford, 1896), p. 469 (III.i.i).

23. *An Enquiry concerning the Principles of Morals*, in *Essays, Moral, Political, and Literary*, II, pp. 263–65.

24. Cummings relates the two paintings as pendants: '. . . Wright's use of a scientist on the wrong path who, after a lifetime of energy spent, wastes a valuable discovery, as the moral counterpart of Democritus, an ancient scientist performing a simple, eternal experiment who is on the right path and knows it, is a stroke of harmonious and brilliant originality' ('Folly and Mutability', p. 270).

25. Cf. Mortimer's version of *Sterne's Captive* (engr. R. Blyth, 1781): no opening is shown but one is implied by the spot of light against which the captive's head is silhouetted. But the emphasis is on enclosure, his shape large in relation to the enclosing lines of the cell, which reflect or correspond to the general shape of his own body, and so appear to be all the more confining.

26. Diderot, *Œuvres complètes*, ed. Assezat and Tourneux, X, p. 208. See also, on the popularity of death scenes in France from the 1750s onward, Rosenblum, *Transformations in Late Eighteenth-Century Art*, pp. 28–39; Hugh Honour, *Neo-Classicism* (London, 1968), pp. 146–59; Geraldine Pelles, *Art, Artists and Society: Origins of a Modern Dilemma: Painting in England and France, 1750–1850* (Englewood Cliffs, New Jersey, 1963), pp. 127–28. In a Greuze subject like *The Bible Reading* (Salon 1755, engr. c. 1760) there are divergent responses, but the inattentive children do not distract so much as heighten our awareness of the absorption of the other figures in the reading. See de la Porte's description in his commentary on the Salon of 1755 (*Sentimens sur plusieurs des tableaux exposés cette année dans la grand salon du Louvre* [1755], p. 15); Michael Fried's forthcoming essay, 'Absorption and Theatricality in French Painting of the later 18th Century'; and Diderot's *Pensées détachées sur la peinture*

(composed in 1755–71), in *Œuvres esthétiques*, ed. Paul Vernière (Paris, 1959), p. 792.

27. See Charles Mitchell, 'Benjamin West's *Death of General Wolfe*, and the Popular History Piece', *Journal of the Warburg and Courtauld Institutes*, VI (1944), pp. 20–33. Barry also produced death scenes: of General Wolfe (New Brunswick Museum) and of Adonis (Dublin, National Gallery). In the latter it is Venus who mourns, with Cupid, a putto, and a pair of hounds, while around them Nature itself seems to echo Venus' pose of grief, bending forward, cradling the dead body. A dead branch lies in the foreground.

12. Gainsborough

1. William Jackson, *The Four Ages together with Essays on Various Subjects* (1792), pp. 179, 183.

2. *Letters of Thomas Gainsborough*, ed. Mary Woodall (Greenwich, Conn., 1963), pp. 67–68, 53.

3. Ibid., pp. 87–88, 99 (I read 'fill' for Mrs Woodall's 'full'). On his attitude toward history painting, Jackson remarks: 'He had no relish for historical painting'; 'G. either wanted conception or taste, to relish historical painting, which he always considered as out of his way, and thought he should make himself ridiculous by attempting it' (*Four Ages*, pp. 159, 179).

4. Ibid., pp. 63, 75.

5. Ibid., pp. 96–97 (he is praising Watteau).

6. Ibid., p. 43.

7. Ibid., p. 99. On why Gainsborough did not contribute to the Boydell Shakespeare Gallery, see W. T. Whitley, *Thomas Gainsborough* (London, 1915), pp. 269–70; and what his contribution *would* have been if he had, p. 368.

8. Jackson's quotation continues: '—but, for a letter to an intimate friend, he had few equals, and no superiors. It was like his conversation, gay, lively—fluttering round subjects which he just touched and away to another. . .' (p. 183). Jackson also noted that his epistolary style was very like the Sternean style but attributed to Gainsborough 'an originality that could be copied from no one' (p. 160).

9. See my discussion of Gainsborough and the St Martin's Lane group in *Studies in Burke and his Time*, X (1968), pp. 1080–82; and 'Gainsborough's Landscape Drawings', *Eighteenth-Century Studies*, VI (1972), pp. 106–17.

10. Cf. the pencil-watercolour sketch in which none of the relationships has been yet worked out; in the painting Gainsborough narrows the space to the left of Mrs Thicknesse so that all we get is the large swelling shape. (See John Hayes, *The Drawings of Thomas Gainsborough* [New Haven and London, 1971], pl. 327.)

11. Cf. *Col. John Bullock* (Baroness Binton, reproduced in Ellis Waterhouse, *Gainsborough* [London, 1958], pl. 139), where the Colonel's shoulders and the jar behind him are contrasted.

12. All of the paintings referred to are reproduced in Waterhouse, *Gainsborough* (pls. 171, 205, 120, 204).

13. Quoted, Whitley, *Thomas Gainsborough* (London, 1915), p. 41. Roger Fry, a great admirer of Gainsborough, notices of his portrait of Price's father, Uvedale Tompkyns Price (1760), that the artist detected Price's particular way of sitting and built his composition on it: 'the rectangles of picture and chair-back, reechoed with variations in the portfolios and the drawing which the sitter holds, play so ingeniously around the firm set and rectangular mask of the man' ('British Painting', in *French, Flemish and British Art*, p. 160). I should wonder if it is not also a witty comment on the forms of the sitter's rococo drawings vs. the geometrical forms of the contingent materials, framing, surroundings, and himself.

14. The portrait (which may have been left unfinished by Gainsborough) survives in several versions, none of which is beyond question from Gainsborough's own hand. The Kenwood version (which belonged to Pitt's secretary, Mr Smith) may be by Gainsborough Dupont. Others are in the collection of Earl Bathurst, Cirencester Park, and the National Museum, Havana. (See Waterhouse, cat. no. 545.)

15. For the 'progeny' of Scheemaker's statue, see David Piper, *O Sweet Mr Shakespeare I'll have his Picture* (London, National Portrait Gallery, 1964), pp. 24–28 (pl. 10 in sculpture alone). He traces its ancestry to Mattheis' *Choice of Hercules*.

16. See Charles R. Leslie and Tom Taylor, *Life and Times of Sir Joshua Reynolds* (1865), II, p. 422; Whitley, *Gainsborough*, p. 370. For dating, see Waterhouse, cat. no. 617.

17. Held and Posner, *Seventeenth and Eighteenth Century Art*. p. 371.

18. Gainsborough may also have been thinking of the art treatises that measured figures in 'noses'. See, e.g., Thomas Page, *The Art of Painting* (1720), p. 17: 'The inside of the Arm, from the Place where the Muscle disappears, which makes the Breast to the middle of the Arm, four Noses. From the middle of the Arm, to the beginning of the Hand, five Noses. The longest Toe is a Nose long.'

19. The following passage derives from my *Hogarth*, II, pp. 179–80.

20. R.A. Exhibition 1771, nos. 75, 76; in the anonymous *Observations on the Pictures now in Exhibition at the Royal Academy, Spring Gardens, and Mr Christie's. By the Author of the Remarks on the English Language. . .* (1771), p. 17. *Lady Ligonier* and *Lord Ligonier* appear in that order in the

catalogue, but to judge from the drawing of three walls of one room, hanging was not in order of catalogue numbers, and it does not follow that they were hung so as to look *away* from each other.

21. Walpole's comments are in his copy of the *Observations*, bound into his own copies of the catalogues, in the collection of the Earl of Rosebery.

22. The statuette is a small version of a Bacchante by Robert le Lorrain (1666–1743), a large lead version of which (with a young satyr) is in the Metropolitan Museum, New York. I presume that in the eighteenth century bacchantes carried associations (derived from references in Plutarch, etc.) less of wine-bibbing than of orgiastic revels engaged in by wild women, of madness, fury, and sexuality. The pedestal itself resembles a term without its Pan or Silenus or Priapus on a term. There are many antique statues of bacchantes *with* priapic figures; Montfaucon shows one standing next to a Priapus on a term.

23. Aside from the internal evidence, there is only Lady Ligonier's reference in her famous letter of 1791 to Alfieri: 'je me suffit à moi même par le moyen des Livres, du Dessin, de la musique etc.' (Vittorio Alfieri, *Memoirs*, tr. E. R. Vincent [London, 1961], p. 271). The roll of drawing paper at the bottom has been added (it is now partly transparent) simply to balance the diagonals of her wrist and paintbrush and of the dancer's upraised arm.

24. 'Epistle to Miss Blount on her leaving the Town after the Coronation', l. 30.

25. Lady Ligonier's dress has a brownish cast now because of the underpaint that shows through, as frequently happens with Gainsborough paintings. The dress would originally have been white with grey shadows.

26. See letters to Jackson, 9 June 1770, and to James Unwin, 10 July 1770; in *Letters of Thomas Gainsborough*, pp. 123, 167.

27. See Alfieri, *Memoirs*, pp. 106–23. For the transcript of the trial, see A. Moore, ed., *Annals of Gallantry* (1814), II; for Alfieri's missing letter to Lady Ligonier, see *Notes and Queries*, ser. 1, IV, p. 222. Lady Ligonier also sat for Reynolds in February 1771 (Leslie and Taylor, *Reynolds*, I, p. 426).

28. Jackson, p. 155; Reynolds, *Discourses on Art*, p. 258.

29. *Letters*, p. 99.

30. Buchwald, 'Gainsborough's *Prospect, Animated Prospect*', in *Studies in Criticism and Aesthetics, 1660–1800*, pp. 374–75. Miss Buchwald's argument is that Gainsborough reflects the development of garden design, from the *ferme ornée* to Brown's open, and then to the picturesque, landscape.

31. Held and Posner, *op. cit.*, p. 373.

32. The story of the argument with Reynolds originated in John Young, *A Catalogue of the Pictures at Grosvenor House* (London [1821]), p. 6; the passage in Reynolds' *Discourse VIII* (1778, Wark ed., p. 158) must have antedated *The Blue Boy*, which was exhibited in 1770, but this does not prevent the argument from having taken place earlier than Reynolds' remarks on it. See also Wark, *Ten British Pictures*, pp. 34–35. The principle that landscape could only aspire to the status of ornament in the nobler genre of history was established in England in Aglionby's influential *Choice Observations upon the Art of Painting* (1685). Nothing on landscape appears in Dryden's 'Parallel betwixt Poetry and Painting' (1695) nor in his translation of Du Fresnoy's *De Arte Graphica*; and for De Piles' words on landscape, see *The Art of Painting and the Lives of the Painters* (1706), p. 25.

33. Benedict Nicolson, referring to the little Charterhouse roundel Gainsborough painted for the Foundling Hospital, in *The Treasures of the Foundling Hospital* (Oxford, 1972), p. 28.

34. Hayes, *Drawings of Thomas Gainsborough*, I, p. 48.

35. See *Estuary with Church* (Ipswich, Waterhouse, pl. 25), or *Country Churchyard* (engr. 1790, Waterhouse, cat. no. 942); *Landscape with Cattle and Milkmaid* (Earl of Jersey, Waterhouse, pl. 124). This composition may appear more often in early paintings: Waterhouse, pls. 24, 25; also 41, 47, though here, while the slope continues unabated down to the left, a tree is inserted at the far left to compensate formally if not representationally for the descent.

36. The drawings offer the most schematic examples; see Hayes, pls. 3, 5, 16, 20, 24, 40; cf. from the late 1750s, pls. 72–76.

37. *Farm Cart and Cattle in a Woody Landscape with Horsemen and Sheep* (Worcester, Mass., Waterhouse, pl. 66); see also pls. 93, 124, 125, 135, 271; even on relatively flat ground they are still tending downward and off the canvas (pl. 272). In *Sunset: Carthorses Drinking* (Tate Gallery, Waterhouse, pl. 65) the pond is closed at the bottom, but the bridge across it leads off the bottom left of the canvas. See also pl. 122, and for an early example, pl. 24; and *Watering Place* (National Gallery, London, Waterhouse, pl. 181).

38. Waterhouse, pls. 258, 259. I do not mean to suggest that there are no drawings or paintings of flat or relatively flat ground, but there are not many (Hayes, pls. 104, 106). See below, n. 75.

39. See *The Market Cart* (Tate Gallery, our pl. 105); also Waterhouse, pl. 190; Hayes, pls. 87, 127, 149, 181, 334.

40. *Harvest Wagon* (Toronto, Waterhouse, pl. 270); and, to a lesser extent, the version in the Barber Institute, Birmingham (pl. 99).

41. *Woody Landscape with Figures* (Mrs R. L. Montgomery, Waterhouse, pl. 81).

42. Also *Woody Landscape with Horseman and Sheep* (Worcester, Mass., pl. 66) and *River Landscape with Cattle and Boat* (Philadelphia Museum, Waterhouse, pl. 122).

43. *Woody Landscape with Bridge* (National Gallery, London, Waterhouse, pl. 269); another, National Gallery, Washington, pl. 289; *Cattle crossing a Bridge* (C. A. Michaelis, pl. 220).

44. *Fishermen setting out* (formerly Mrs Robert Mellon Bruce, Waterhouse, pl. 224); also 224, 226, pls. 146, 151–54; and drawing, Hayes, pl. 224.

45. In an early work like *Cornard Wood* (National Gallery, London, Waterhouse, pl. 22), though the overall effect is of a level, it is made up of two steep declivities which are balanced. But already in this landscape the people have descended into the declivities, are cording wood and digging, and this is the pull felt in the later landscapes. By the time of the *View of Dedham* (1758, Tate Gallery) there is a fairly steep slope to the lower left.

46. *Mountain Valley with Figures and Sheep* (W. S. Constable Curtis, Waterhouse, pl. 260); also pls. 134, 191, 229; among the drawings, Hayes, pls. 166–67, 174, 294.

47. *The Cottage Door* (Huntington, Waterhouse, pl. 203); see also pls. 227, 246, 192.

48. *Upland Hamlet with Figures and Stream* (Waterhouse, pl. 191).

49. Waterhouse, pls. 273, 289, 290.

50. *Mr and Mrs John Browne and Child* (Marquis of Cholmondeley, Waterhouse, pl. 11).

51. Waterhouse, pls. 52, 277. Or take the curious example of the dark wedge of background shade in the drawing of another version of *The Painter's Daughters* (Worcester, Mass.; Hayes, pl. 90): this serves none but a purpose of design, and yet it dominates the picture, relating the picture to the shapes we have already discussed.

52. Hayes, pp. 12, 48; Reynolds, *Discourses*, p. 250; Jackson, *Four Ages*, pp. 167–68n.; Allan Cunningham, *The Lives of the most eminent British Painters, Sculptors and Architects* (London, 1829), p. 339.

53. I do not include his copies of old masters. The painting sometimes called *Musidora* (Tate Gallery) might appear to be a history painting based on a literary source. If, however, it referred to Thomson's Musidora bathing and being drawn by Damon ('Summer', ll. 1269ff.), the nymph would have to be in the pose of the Venus de Medici, and Damon ought to be included. In fact, the picture was called 'A Nymph at the Bath—a large oval' when catalogued for sale after Gainsborough's

death, and the name *Musidora* was added later. (For the source of the figure in a statue by Adriaen de Vries, see Graham Sawyer, 'A Note on Thomas Gainsborough and Adriaen de Vries', *Journal of the Warburg and Courtauld Institutes*, XIV [1951], p. 134.) But cf. Alexander Runciman's etching (before 1785) of Musidora and of course behind it a work like Lemoyne's *Baigneuse* (Leningrad), a girl, as Levey says, 'neither Venus nor Bathesheba', putting her downpointed foot into the water (Levey, *Art and Architecture of the Eighteenth Century in France*, p. 32). There is also a painting, now in the National Museum of Wales, called *Landscape with Hagar and Ishmael*, but there appears to be no very good reason for thinking the pair, a young woman with a jug and a boy, are not simply going to the well, like so many other figures in Gainsborough's fancy pictures.

54. For the three sketches, see Hayes, pls. 343–45; for the painting, see Waterhouse, pl. 288, and Oliver Millar, *Later Georgian Pictures*, cat. no. 806.

55. See above, note 7.

56. *Letters*, p. 115.

57. Hayes, p. 17.

58. Basically, he makes use of the seventeenth-century Dutch composition of converging diagonals of road and treeline, which sometimes, when there is a turn in the Dutch painter's road, forms a shallow version of the Gainsborough gamma. The scene of animals going down to water is a Dutch one, though the steep banks of southern rivers were added (as in the scenes of Cuyp, Jan Both, and Adam Pynacker). The general composition appears in some of Jacob van Ruisdael's forest scenes, and Philips Wouwerman's *Watering the Horse* (Leipzig) is compositionally rather close, but Gainsborough would never have employed a skyline slightly below the centre of the canvas with empty sky above. (See Wolfgang Stechow, *Dutch Landscape Painting in the Seventeenth Century* [London, 1966], pls. 38, 40, 139, 312, 313; also pls. 43, 142 and 329.)
An interesting contemporary analogue is Fragonard's landscape (Worcester Art Museum) with a dog, two cows, some sheep, and a steep hillside—behind them a windmill on a hill, before them darkness, the light and sky filling the upper right quarter of the picture diminishing into the dark lower left quarter (except for the light shapes of the descending cows). 'Down to dusty death', we feel, is the way the merrily-dancing couple, together with everything else, goes. But there is no merriness in Gainsborough's equivalent, cows with their herdsmen descending over a bridge. (See Hayes, *Drawings*, pp. 288–289.)
Gainsborough also derives something from those landscapes of Salvator Rosa that introduce a strong downward curve (see Luigi Salerno, *Salvator Rosa* [Milan, 1963], pl. 75, also pls. 4, 76, 79). There are

also precedents among the school of classical landscape. Adam Elsheimer's *Aurora* (Braunschweig) is built on a hillside slope down to the right, as in Annibale Carracci's *Vision of St Eustace* (Naples, Capodimonte); and one or two landscapes by Gaspar Duget also come to mind. See Francesco Arcangeli, ed., *L'Ideale classico del seicento in Italia e la pittura di paesaggio* (Bologna, 1962), pls. 106, 107, 108, 121, 150.

59. Hayes does not accept the drawings for the Houbraken decorations that have been attributed to Gainsborough, but other drawings may turn up, and he concludes that 'some such early exercise as the ornaments for the Houbraken heads seems necessary to explain the extraordinary power which curving and swirling rococo line held over his pictorial imagination throughout his career'. See the obituary in *The Morning Chronicle*, 8 August 1788; and Hayes, I, p. 55.

60. Interesting to note, Watteau, whose drawings are almost always from life, in one of his few drawings from imagination set down lines suggesting mounting flames and wreathing smoke. See Huyghe, *Watteau*, p. 45. Something of Gainsborough's sense of sitting on a slope can be detected in some of Watteau's *fêtes galantes*, and perhaps more in Pater's imitations, where the formal mannerisms are exaggerated.

61. See *The Deluge*, in *Loutherbourg Catalogue* (Kenwood, 1973), no. 63, but also nos. 34, 50, 51, and as early as nos. 2 and 4. For the raft of survivors, see *Battle of Camperdam* (1799) and *Battle of the Nile* (1800), both in the Tate Gallery. One like *A Distant Hailstorm coming on, and the Marching of Soldiers with their Baggage* (1799, Tate Gallery) emphasizes the wagons and horses coming up over the hill toward the viewer, but there is also a counter-movement down to the left—some soldiers going down into a ravine after a pair of mules.

62. See Peter Ward-Jackson, 'Some Main Streams and Tributaries in European Ornament from 1550–1750', *Victoria and Albert Museum Bulletin Reprints*, III (1969), p. 32. Ward-Jackson points to Gainsborough's contemporaries who saw the grotto as 'an early manifestation of that nostalgia for the natural and the pristine' (p. 34). He also notes the ear-like quality of the rococo shape, referred to as *le style auriculaire* or *der Ohrmuschelstil* because of the cartilaginous but also shell-like quality of the ear. See Ward-Jackson, *English Furniture Designs of the Eighteenth Century* (London, 1958), pp. 10–11.

63. See Ward-Jackson, op. cit., pp. 34, 37, 41; and the design by François de Cuvilliés the Elder, fig. 1. See also Hermann Bauer, *Rocaille: zur Herkunft und zum wesen eines ornament-motivs* (Berlin, 1962); he reproduces designs by La Joue and Meissonier, pls. 34 and 48.

64. Closer to home, Gainsborough could have seen Sebastiano Ricci's *Bath of Diana* in Burlington House. For Boucher drawings on the theme (including some that anticipate the downward-turned foot and slope), see Alexandre Ananoff, *L'Œuvre dessinée de François Boucher* (Paris, 1966), figs. 30, 121, 124.

65. Geoffrey Hartman, *Beyond Formalism* (New Haven, 1971), pp. 314, 321; Martin Price, *To the Palace of Wisdom* (New York, 1963), pp. 375–76.

66. In scientific rather than poetic terms we can add the coincidence of English and French thinking that saw nature no longer as the Newtonian inert matter but as the same live substance as man. As J. B. Robinet put it, 'All matter is organic, living and animal.' See *Considérations philosophiques de la gradation naturelle des formes de l'être* (Paris, 1768), p. 8; also Diderot, *Rêve d'Alembert*, in *Œuvres complètes*, ed. J. Assezat (Paris, 1875–77), I, pp. 139–40; and H. W. Piper, *The Active Universe* (London, 1962), pp. 3–28. The signs are clearest in the French tradition (Maupertuis, Diderot), but by the 1770s it was also being disseminated in England by Priestley, and later by Erasmus Darwin and others.

67. I think this may be a more precise way to discuss the matter than Poulet's reference to 'l'ensemble d' 'idées fixes' et de rêveries auxquelles les hommes de cette époque se sont livrés' ('Piranèse et les poètes romantiques français', *Trois essais de mythologie romantique* [Paris, 1966], p. 136).

68. See Moore, 'The Art of Piranesi', p. 5; also pp. 12–13.

69. See Poulet, pp. 135–87.

70. *The Romantic Rebellion* (London, 1973), pp. 236–37. Wilson, however, may have been a direct source in paintings like his *Niobe* (Mellon Collection), where the sky opens up into a vortical distance. See, e.g., Adele M. Holcomb, 'The Vignette and the Vortical Composition in Turner's Oeuvre', *Art Quarterly*, XXXIII (1970), pp. 16–29. For the use of vortical constructions by Blake, see Northrop Frye, 'Notes for a Commentary on *Milton*', in *The Divine Vision*, ed. V. de Sola Pinto (London, 1957), p. 133n.; Harold Bloom, *Blake's Apocalypse* (New York, 1963), p. 325.

71. Meissonier, *Livre d'ornamens*, dated by Bauer 1734, op. cit., pl. 34. See also designs by La Joue, such as 'Cascade' from *Livre nouveau de divers morceaux de fantaisie* (1736), in Bauer, pl. 48.

72. See, e.g., pl. 31; in Bauer, pls. 43, 79, 81, 82.

73. 'I fancy I see Gainsborough in every hedge and hollow tree,' wrote Constable about the Ipswich landscape (to J. T. Smith, 1799, *Correspondence*, ed. R. B. Beckett [Suffolk Records Society, 1964], VI, p. 160). But he does not comment on the terrain; and my own visits have not yielded any supporting evidence.

74. Despite Gainsborough's proclaimed admiration for Claude, his compositions fairly consistently avoid Claude's normative structures in favour of an expression of immediacy and freedom (cf. Hayes, pls. 276–77). Landscape theory does not tell us very much about Gainsborough's intention, although he may have known De Piles' division between heroic and pastoral landscape, and between ideal nature and the natural and figurative images of the passing moment; the first is a structure of norms, the second the expression of immediacy and freedom (*Cours de peinture par principes* [1708 ed.], p. 15). For Gainsborough's own time, see Diderot, *La Grande Encyclopédie* (1751) on three kinds of landscape painting: views, *style champêtre*, and heroic; the second is without artifice, artifacts, or other embellishments. (See H. Marcel, *Histoire de paysage français* [Paris, 1900], p. 156.)

Gainsborough was certainly aware of George Lambert's experiments in the 1730s, probably with Dutch prototypes, which challenged the classical formula before he retired into its conventional fold. His *Extensive Landscape with Four Gentlemen on a Hillside* (1733, private collection) abandons the 'wing' principle entirely by running a sloping hillside all the way across the picture and leading the viewer's eye down and off to the right. Carried further, this becomes the effect of a landscape like Gainsborough's *Country Churchyard*, and even further the dizzying effect of a hillside by J. R. Cozens that simply plunges off the page. (See *George Lambert* [Kenwood, 1970], cat. no. 6, p. 14; Hayes, *Gainsborough as Printmaker* [New Haven and London, 1972], pl. 22.) Richard Wilson's *Diana and Actaeon* (1753–54, Lord Wharton) characteristically takes place in a flat open space *beside* a lake which is closed at the bottom; the composition itself is open at the left where Actaeon is being pursued by his hounds. Diana as well as Actaeon is safe on the shore, beyond the carefully-contained body of water. As a landscape painter, thirteen years Gainsborough's senior, Wilson looks back for his iconography to Claude and Salvator Rosa: the figures in the foreground (Meleager or merely a group of *banditti* in the act of murder) served as an objective correlative of the natural action, which is usually a storm in a distant rugged landscape of mountains or sea-coast. This sort of picture relates the planes of foreground and background as human and nature in a fairly simple way. In the *White Monk* paintings, one of Wilson's favourite subjects, the young people bask in the sunlight in the foreground (in at least two versions holding an umbrella against it), and a hermit is in solitary devotion with his cross on a distant hilltop. This is a landscape made into a kind of *Vanitas* scene, with the message that 'the physical beauty of the universe is not the whole purpose of life' (Adrian Bury, *Richard Wilson, RA* [Leigh-on-Sea, 1947], pl. 33). The umbrella cuts off sight of the hermit as well as the sunlight, and with the ravine and the distance separates the young people from an unpleasant truth.

Besides these intellectualized landscapes, however, there are the many paintings in which what Wilson called 'the figures' are simply accents and topography is adjusted to the demands of form. One can imagine that the strange figures, the White Monk prostrate on a rock, and the unoccupied plinth in *The Tiber* (Mrs Richard Ford) *are* only there for purposes of form. The White Monk may have entered the composition in the same way as the spots of bright colour atop the rock in *The Waterfall* (Cardiff, National Museum of Wales): first a foreground is played off against a distant prominence, and then shapes of young lovers against the White Monk at his devotions.

The difference between Gainsborough's and Wilson's formalism, however, is simple: Wilson does not have Gainsborough's habit of drawing attention to his form. And without the formal peculiarities, Wilson may produce a formalist landscape that is impervious to analysis, one that has the quality Hayes attributes to Gainsborough's sketches. But there is another difference. Wilson's broad handling, which (like Gainsborough's) brought down upon him strictures of 'coarse and unfinished sketches', 'mere daub', and the like, does not transform nature into a fulfilled dream. Wilson's brushstrokes are descriptive, his paint lends a solidity to objects, and his textures define rather than smooth over difference. He often gets closer than Claude or even the Dutch landscapists to the actual effect of light on water, grass, and foliage at a certain time of day. Far from imposing his own mood on nature, making it over into his own theme or image, he identifies with the object and reports as accurately as he can the effect on his own optics. John Constable's words have never been bettered: 'He is now walking arm in arm with Milton and Linnaeus. He was one of those appointed to show the world the hidden stores and beauties of nature' (quoted, Bury, p. 36). He brings together the grand simplicity of Milton and Linnaeus' precise classification of fauna.

75. E.g., *Mountain Landscape with Bridge* (National Gallery, Washington) and *Romantic Landscape* (Birmingham). See Waterhouse, pls. 257–59, 287, etc.

There is one major painting, *The Mall* (1783, Frick Collection), that employs a flat ground. Of course, it is the only landscape in which the ladies from the portraits are shown strolling in groups among trees in an urban spot, along St James's Park on the Mall, which was flat. There remain, however, suggestive details. A line of cows appears to the left in the background. Cattle were milked in St James's Park and did cross the Mall; but these are shown in relation to the fashionable folk who are promenading, and they are tending downward off the picture, as if there were a slope dropping away from the Mall. The society women themselves are merging and not merging with the foliage behind them: their gowns are greens, neutral earth colours, and whites—mostly the last. But in fact the man in red, the one touch of colour that is at odds with merger of any sort with nature, prevents the white-clothed women in his group from losing their distinctness: he is a kind of barrier between them and the innermost recesses of the greenery. He stands, in fact, near the central vortex into which the greenery draws us. The vortex that has customarily gone downward in space here is turned and recedes back down the path into the trees—a horizontal vortex like those Turner will employ in the next generation.

76. *Discourses*, p. 258. Cf. Gombrich, *Art and Illusion* (London, 1960), pp. 199–200.

77. *The Works of Hildebrand Jacob, Esq.* (London, 1735), p. 405; *On the Sublime*, tr. W. Hamilton Fyfe (Loeb Classical Library, Cambridge, Mass., 1965), p. 145; see Samuel H. Monk, *The Sublime* (New York, 1936), p. 15; also Demetrius, *On Style*, tr. W. Rhys Roberts (Loeb Classical Library, 1965), pp. 365–66; and for the extension into art, Jacob, op. cit., p. 405.

78. Jackson notes the resemblance to Sterne's style, p. 160; see above, note 8.

79. *Tom Jones*, Bk IV, Chap. v; Bk V, Chap. xii; pp. 118, 209.

80. Sterne, *Letters*, ed. L. P. Curtis (Oxford, 1935), p. 411.

81. *Sentimental Journey*, ed. Gardner D. Stout (Berkeley and Los Angeles, 1967), pp. 71–72.

82. *Letters*, p. 109.

Index